The Illustrated Guide to
Rockingham Pottery and Porcelain

The Illustrated Guides to Pottery and Porcelain

General Editor

GEOFFREY A. GODDEN

Subjects include

LOWESTOFT PORCELAIN by Geoffrey A. Godden
MASON'S PATENT IRONSTONE CHINA by Geoffrey A. Godden
ROCKINGHAM CHINA by Dennis Rice
WORCESTER PORCELAIN 1751–1793 by Henry Sandon
VICTORIAN PARIAN WARE by C. and D. Shinn
STAFFORDSHIRE SALT-GLAZED STONEWARE
by Arnold R. Mountford

others in preparation

Also by D. G. Rice
ROCKINGHAM ORNAMENTAL PORCELAIN
(published by The Adam Publishing Company)

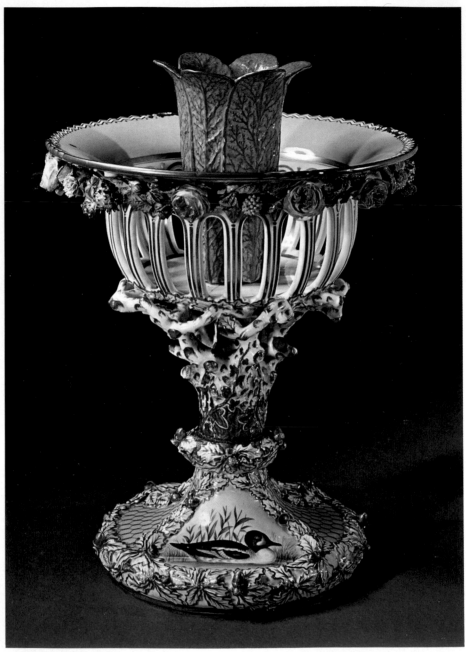

I. Comport of a kind similar to that supplied to the Royal Order, consisting of a pierced bowl supported on a stem of white and gilt oak branches, themselves standing on a circular base painted with two panels of eider ducks separated by two panels of gilt tracery on a light blue ground. The bowl—beneath the everted rim of which is a continuous chain of applied roses, shamrock and thistles in natural colours—holds a small overhanging vase moulded with primrose-leaf decoration in green; and the base and stem are encrusted with gilt acorns and white and gilt oak-leaves. 14½ inches high. See page 42.

The Illustrated Guide to

ROCKINGHAM POTTERY AND PORCELAIN

D. G. RICE
M.A., LL.B., Ph.D.

BARRIE & JENKINS

LONDON

© copyright 1971 D. G. Rice
First published 1971 by
Barrie & Jenkins Ltd,
2 Clement's Inn, London WC2
Printed and bound in Great Britain
by Butler and Tanner Ltd,
Frome and London
Colour Printing by Colour Workshop Ltd,
Hertford
Set in Monotype Imprint
SBN 257.65108.X

TO MY WIFE
whose enthusiasm has equalled
and often excelled my own

Stolen

Of the items illustrated in this book the following have recently been stolen

> Colour Plates I, II, III (pair), IV, V, VI; Plates 60 (eight), 76, 79 (seven), 81, 120, 130, 140, 141, 167

Also stolen are the following items illustrated in my *Rockingham Ornamental Porcelain*

> Colour Plates 5, 6, 7, 8, 11, 13, 15; Plates 25 (one), 36, 37, 38, 40, 45, 58, 65, 76, 97

Will any reader having any information relating thereto communicate either with the Police or with me care of the Publishers.

September 1970 D. G. R.

Contents

List of Illustrations

COLOUR PLATES

MONOCHROME PLATES

All between pages 138 and 139

General Editor's Foreword

If all the ware popularly attributed to the Rockingham factory had in fact been made there, this would have been a book about the largest porcelain factory in Europe—a factory which would undoubtedly have needed to occupy a considerable part of the county of Yorkshire. But the truth is that the Rockingham works was only a small Yorkshire concern. Its name is so well known and highly esteemed, however, that a large quantity of English porcelain of the 1820-40 period has long been, and still is, hopefully but erroneously attributed to it. Hence the fallacy of a prodigious output.

Dr. Rice's own magnificent collection was, indeed, started by the acquisition of pieces fashionably labelled 'Rockingham' but shown subsequently to have had no connection whatsoever with the factory at Swinton. These non-Rockingham items led him on to form what must surely be the finest and most instructive collection of *genuine* Rockingham pottery and porcelain in private hands. Many of the pieces in his collection are shown in this book, embellishing the telling of the true story of the popular factory and illustrating a fine and representative range of its products.

The history of the factory, as told here, is based on the author's lengthy research and personal knowledge of Rockingham pottery and porcelain, backed by a wealth of source material, original correspondence, company accounts, and the records of a large sale of Rockingham porcelain that was held in 1830. The result is a completely authoritative work on what is probably the most misunderstood of all English porcelain factories.

GEOFFREY A. GODDEN
General Editor
Illustrated Guides to
Pottery and Porcelain

Preface

Some years ago I was fired by the acquisition of certain unmarked 'Rockingham' pieces to find out more about the factory that once existed at Swinton, near Rotherham in Yorkshire, and the various products which earned for it, during the few years it operated as a manufacturer of porcelain, the patronage of William IV and other royalty and of many of the noblest families in Great Britain. I discovered that the ignorance that prevailed as to the true products of the factory was quite abysmal, that no real research had been done, that illustrations in ceramic literature depended on tradition and hearsay for their support, and that even museums and the most celebrated of dealers and authors had made their own contribution to the sum of human error.

I accordingly set about the task of gathering together as many examples as possible bearing the true factory mark. Eventually, from the collection I came to amass, I was able to establish the true characteristics that distinguished Rockingham ware from the output of other factories. It is one of the ironies of life that the initial pieces that had inspired the project were found quite early on to have no connection with Rockingham whatsoever; but by that time, I was caught up in the chase and have from then onwards pursued the subject with ever increasing zeal and enthusiasm. In no sense has anything like finality been achieved, especially where earthenware is concerned. But it is hoped that the account here given will provide a firm foundation for future study.

It will be seen that frequent reference is made to my earlier work *Rockingham Ornamental Porcelain* (generally abbreviated to *R.O.P.*). As a policy, it was thought best, with but few exceptions, not to include in this book illustrations that had already been reproduced in the earlier monograph. Moreover, as the terms of reference of this present work are wider—inasmuch as an attempt is made to embrace the whole range of the factory's output and not merely ornamental porcelain alone—it would clearly have been impracticable to have given here the same detailed treatment of ornamental porcelain as had been the case in the earlier book. However, in order that the student should have available to him as comprehensive a view as possible of this more

detailed theatre of the factory's activities, opportunity has been taken to refer him on frequent occasions to illustrations and subject-matter contained in the earlier monograph.

The text has been kept as short as possible, the emphasis being placed upon the illustrations. However, over and above a general description of the factory's earthenware and both its useful and ornamental porcelain (including figures) and an account of its history, artists and marks, several appendices have been added in the hope that a greater completeness could thereby be given to the book. Appendix A contains a list of all the different figure models recorded so far with details thereof; Appendix B deals in detail with the two Rhinoceros Vases which have done so much to undermine the standing of the porcelain over the years; Appendix C sketches the ceremony associated with the drinking of tea in the first half of the nineteenth century; Appendix D postulates a theory as to the origin of the pseudo-Rockingham figures; Appendix E gives an account of the London House in the light of the Rate Books and Post Office Directories in the Westminster City Archives and of other evidence; Appendix F lists the various lots appearing at a sale of Rockingham held at Christie's on 12th and 13th February 1830; and Appendix G contains correspondence relating to the factory in the Wentworth Wood-house Muniments.

But when all is said, so much still remains to be discovered of the factory and its activities. No higher goal is sought here than to indicate the essential threads that make up the Rockingham story. Much further research will have to be accomplished before the complete history can be written.

Acknowledgments

I wish to thank Mr. L. G. Lovell, the Director of the Museum and Art Gallery, Clifton Park, Rotherham for the supply of photographs and of information generally relating to the various specimens in this museum, and to express similar appreciation of the co-operation I have received from officials of the Weston Park Museum, Sheffield, the Central Library (Department of Local History and Archives), Sheffield, the Victoria and Albert Museum and the British Museum.

No less am I indebted to certain private collectors who have given photographs and/or details of interesting pieces in their possession, notably Dr. G. A. Cox, Mr. and Mrs. Arthur A. Eaglestone, Mr. and Mrs. J. G. Evans, Mr. and Mrs. John D. Griffin, Mr. Jack L. Leon, Mr. G. W. Selwood, Mrs. K. Stacey, Mr. Eric Thompson and Mr. T. A. Willis. Additionally, Messrs. D. M. and P. Manheim and Moss Harris and Sons have given permission for the reproduction of items which once passed through their hands, and Messrs. B. & T. Thorn & Son have made available photographs of a magnificent creamware jug that has recently come into their possession. Mr. Bryan Bowden of Doncaster has also given details of certain rarities he has handled. The colour photographs were taken by Mr. Derek Gardiner, A.I.B.P., of Worthing.

Messrs. Sotherby & Co. have freely given permission to reproduce various pieces that have appeared in their auction rooms, and Messrs. Christie, Manson & Wood have given me access to their muniment room and permission to reproduce here particulars of their sale of 12th and 13th February 1830. Earl Fitzwilliam and Earl Fitzwilliam's Wentworth Estate Company have also allowed the *Wentworth* correspondence contained in Appendix G to be published.

Finally, I would like to acknowledge especially the help I have received from Major G. N. Dawnay of Cardiff and Mr. Geoffrey A. Godden. The former has given of his experience and time in suggesting different lines of enquiry and by virtue of his position as the principal supplier of Rockingham to museums and private collectors has been uniquely situated to bring to my

attention rarities which might otherwise have been overlooked. Mr. Geoffrey
A. Godden, whose reputation in the world of ceramics needs no elaboration,
has, as general editor of the series of monographs on china of which the present
book forms part, encouraged this work right from its inception and made
many excellent suggestions in respect of layout and presentation. In addition,
he drew my attention to Christie's sale of Rockingham ware of 12th and 13th
February, 1830, referred to above, and forebore to publish it himself so that
it could form part of this present book.

Where illustrations appear without any specific acknowledgment, they
relate to my own collection.

The Illustrated Guide to
Rockingham Pottery and Porcelain

Introduction

Porcelain genuinely produced at the Rockingham works at Swinton, in Yorkshire, is rare; and rarer still is the factory's earthenware. Thus the considerable quantity of china optimistically labelled as Rockingham, whether passing through the auction rooms or offered for sale in antique shops throughout the country, should not succeed in deceiving the reader. The extent of the supply is strictly limited. It is only the liberality of attribution that is elastic. But how is the serious student ever to distinguish genuine Rockingham pieces from those that are spurious?

This problem has been discussed at length in my *Rockingham Ornamental Porcelain* (pages 1–5), where the significance of paste, palette, gilding, glaze and shape is considered. Each characteristic has a part to play in establishing provenance, but far and away the most important element is *shape*. Moulds were not normally pirated by other factories, nor were they employed to produce a mere handful of pieces. The sheer frequency of identical forms affords a clue to correct attribution, and shapes that are authenticated by their mark provide the criteria by which unmarked examples may be adjudged. Of course, paste, glaze, gilding and palette are significant, and often constitute the final confirmation or the ultimate condemnation. But it is on shape that the collector must essentially place his reliance. Once this is known to him, no great problem should confront him, even in the absence of a mark; and certainly he will be equipped to make his decision without dependence upon the mystical pontifications of dealers and others engaged in a trade noted for its commercial acumen but not always for its scholarship.

As a result of this approach, the number of acceptable Rockingham shapes will be found to be far less than that popularly credited to the factory. In particular, the variety of porcelain services is not noticeably large. Admittedly, the range of ornamental porcelain enjoys a remarkable diversity; and the acquisition of a collection of it, if it is to border on the comprehensive, poses virtually insuperable difficulties. But even here, the output is nowhere near as varied as tradition would lead the unwary to believe. As for pottery, though the range is considerable, its appearance is infrequent. It is this

rarity element that renders difficult classification and discussion of all Rocking-
ham products, whether porcelain—both useful and ornamental—or simple
earthenware. At any moment, a new shape is liable to emerge to undermine
the completeness of an account hitherto thought comprehensive. But never-
theless, even if we cannot hope for finality, this should not deter us from
attempting at least a partial record.

In collecting pottery, a special warning should perhaps be directed at the
so-called 'Rockingham glaze'. This is the brown glaze which is found on
pieces produced by many nineteenth-century factories and is, in fact, manu-
factured today. Although the Swinton works frequently used this glaze—
though in a particularly outstanding manner, so that most reproductions
undertaken elsewhere are but pale reflections—it is a *non sequitur* to assume,
as most of the antique trade regretfully has, that any specimen glazed in this
fashion emanates from the Swinton factory. No difficulty need normally per-
plex the serious student, who is prepared to abide by the rule of 'shape-
authentication'. But even here exception must be made. Cadogan pots, for
which Rockingham is especially famous, were also manufactured by Spode
and Copeland & Garrett and were reproduced in identical forms at both the
Yorkshire and Staffordshire factories. As for the glaze itself, to the naked eye
the effect from both factories is indistinguishable. Hence, it would seem that
a safe attribution cannot be made in favour of Rockingham *in the absence of a
mark* (see also page 11).

Finally, it must also be remembered that Isaac Baguley continued at the
Rockingham works after 1842, glazing both pottery and porcelain in this
same way, and that in 1865 his son continued the business at Mexborough
until his death in 1891. Great care must be exercised, where the brown glaze
is concerned, in distinguishing the genuine Brameld ware. The chemical
formula adopted by the Bramelds for the body of their products is not known,
but the materials used by Messrs. Brameld in the china and porcelain works
were Cornish stone and china-clay from St. Austell in Cornwall; calcined
bones, and flints from Ramsgate, Sandwich, Shoreham, and other parts of the
coast of Kent and Sussex, which were ground at the works. Clay was also
obtained from Wareham and other parts of the coast of Dorset.[1]

[1]*Handbook to the Collection of British Pottery and Porcelain* in the Museum of
Practical Geology, Jermyn St., S.W., 1893, p. 141.

Chapter I

Brief History of Rockingham Pottery and Porcelain Manufacture

Pottery

For an account of the history of earthenware production at the Rockingham works, Swinton, Yorkshire, we are indebted to the researches of Llewellynn Jewitt, who lived sufficiently close to the time of the factory's operation as to be able to interview the actual workmen and acquire further documentary evidence, now lost to us. In addition to this, we have the correspondence contained in the Wentworth Woodhouse muniments, directed largely to the financial circumstances of the concern and its relationship to Earl Fitzwilliam. It is no part of this monograph to deal exhaustively with the history of earthenware production at Swinton. But although our essential purpose is to describe the products, some short survey of the factory's history may prove interesting to the collector.

According to Jewitt,[1] pottery was first made in 1745 by a Mr. Edward Butler on a part of the estate of Charles, Marquis of Rockingham, near to a field known in Jewitt's time as Butler's Park. A 'posset-pot' is illustrated in his *Ceramic Art in Great Britain*[2] bearing the date 1759, which, on the evidence of a fragment of a label, Jewitt alleges was made by or for John Brameld.

In 1765 the works were taken over by William Malpass, with whom were associated in partnership John Brameld and, later, his son, William. In 1778 the principal proprietor of the Swinton works was Thomas Bingley, whose partners included John and William Brameld and a man named Sharpe. The firm traded under the name of Thomas Bingley and Co., and prospered. In the words of Jewitt,[3] 'an extensive trade was at this time carried on, and besides the ordinary brown and yellow wares, blue and white dinner, tea, coffee, and other services were made, as also a white earthenware of remarkably

[1] *Ceramic Art in Great Britain*, 1878, Vol. 1, p. 495.
[2] Ibid, Fig. 866.
[3] Ibid, p. 496.

3

fine and compact body, and other wares of good quality'. A two-handled drinking cup, 5¼ inches high, with 'William Brameld' written on one side and '1788' on the other, is illustrated by Jewitt.[1]

In 1787 some of the Greens of the Leeds Pottery became principal partners of the Swinton manufactory and, together with Messrs. Bingley and Brameld, took an active interest in the management of the Swinton works. Mr. John Green became its acting manager. The firm traded under the style of Greens, Bingley, & Co. until 1800. Jewitt notes[2] that 'the same price lists which were printed at Leeds with the Leeds pottery heading, had that heading cut off, and that of "Greens, Bingley, & Co., Swinton Pottery", written in its place. Later on large fresh price-lists were printed. They were headed "Greens, Hartley & Co., Swinton Pottery",' followed by a description of the wares being offered. The patterns used at Leeds were to some extent adopted at Swinton, the same designs having different numbers, depending on their place of manufacture (see also page 23).

In 1806 the firm of Greens, Bingley, & Co. was dissolved, and the business fell into the hands of John and William Brameld, who later took others of the family into partnership. The new style of trading was Brameld & Co. It is only from this date onwards that Rockingham ware is ever likely to be found by the collector.

Some correspondence relating to the dissolution of 1806 and its background is to be found in the Wentworth Woodhouse muniments. It is clear from these records that, although Earl Fitzwilliam was willing to renew the lease of the factory on its termination, for some reason unknown to us the Greens did not want to continue in production at Swinton. They did not openly admit this, but based their refusal to negotiate for a renewal of the lease on the manner in which they had been approached by Lord Fitzwilliam's agent, Mr. Charles Bowns. Judged by the admittedly one-sided correspondence, their complaint would appear to have been groundless. In any event, John and William Brameld, who were at variance with the other partners and had been ousted from the management of the Swinton Pottery since 1801, dissociated themselves from the views of the Leeds partners and supported Mr. Bowns. The latter was concerned lest the activities of the Greens, in failing to surrender the property on time and, in the interim, stopping production at Swinton, might prejudice the value of the pottery. In the outcome, Earl Fitzwilliam—after refusing to buy out the interests of the Leeds partners and to operate the factory directly himself—did subsequently agree to make advances to the Bramelds, and to grant them a lease of the works. Arrangements were also made for the Bramelds to take a short lease of the neighbouring Mexbro' Works, so as to continue the trade connections of the Swinton factory pending the latter's eventual surrender.

It was from this time that there developed the dependent relationship of the Bramelds on Lord Fitzwilliam, which was to last until, in well-justified desperation, all further financial support was withdrawn by the latter's

[1] *Ceramic Art in Great Britain*, 1878, Vol. 1, p. 495, Fig. 867.
[2] Ibid, p. 497.

successor in 1842 and the factory was closed. (In 1825, the Rockingham factory encountered a particularly severe financial set-back and faced ruin—but this story and that of the Bramelds' rescue belong truly to the history of porcelain production.) It is the period from 1806 to 1842 with which the collector of Rockingham earthenware is really concerned. Pieces made prior to 1806 are hardly likely to be encounted and are even less likely to be identified.

Porcelain

No porcelain was produced at Swinton (except for certain experimental pieces) before 1826. The previous year, the factory—which was now under the direction of the three sons of John Brameld, viz., Thomas (1787–1850), its driving force and inspiration; George Frederick (1792–1853), the firm's representative on the continent, who resided for a while at St. Petersburg; and John Wager (1797–1851), traveller for the firm throughout the United Kingdom and manager of the London House—had once again encountered grave financial embarrassment, despite the considerable help it had continuously enjoyed from Earl Fitzwilliam ever since 1806, and bankruptcy proceedings had been started. The reasons for the insolvency were (i) the great depression that followed the 'ratification of the Peace in 1815', (ii) the Bramelds' natural ambition to utilise the factory to the full, with the result that they succumbed to the temptation to export their production to the continent, (iii) the bad debts that ensued from such trading, despite the good auguries at the beginning, resulting in a cumulative loss of £22,000, and (iv) resorting to borrowing on bills, at an extortionate interest rate of from 12% to 15% per annum, to make good the aforementioned deficiency. Moreover, these external difficulties must have been aggravated by the Bramelds' own lack of managerial skill.

In January 1826, a meeting of the creditors was held and application was made to Earl Fitzwilliam for further financial support. The parties concerned, viz the Bramelds, the creditors, and those interested in the prosperity of the area and the employment that the pottery gave, all supported this approach. It so happened that at this particular time Thomas Brameld had brought to fruition his experiments in the production of porcelain, and it is said that Earl Fitzwilliam was so impressed with the results that he agreed to furnish fresh funds for the exploitation of Thomas's discovery. It was at this time that Earl Fitzwilliam gave permission for his crest, the griffin, to be used by the Bramelds as a trade mark and for the factory to be called Rockingham, after his kinsman Charles Watson Wentworth, second Marquis of Rockingham. The production of porcelain now really commenced. And to begin with, it was undoubtedly successful.

During the red-mark period, from 1826 to 1830, the fortunes of the factory prospered. In existence are the balance sheets drawn to 31st December 1827, 28th February 1829, 3rd April 1830 and 8th October 1831. The first three periods reveal profits respectively of £1,537 17s. 3d., £1,043 13s. 2d. and

£1,121 8s. 2d. It is only in the fourth accounting period that a loss was incurred, to the tune of £996 2s. 8d. During these first four years or so, it is clear from the correspondence and the wages paid that several hundred workmen were employed in the manufacture of porcelain and earthenware. Indeed, in the period immediately preceding the commencement of porcelain production, some two hundred and seventy employees were engaged in the manufacture of earthenware.[1] This tempo of activity doubtless accounts for the fact that the number of surviving red-marked pieces appears considerably greater—in relation to the total sixteen years' existence of the factory as a porcelain producer—than the shortness of the period would lead us to expect.

From 1831 the Rockingham works seems, from a financial standpoint, to have entered upon a downward path—although in 1838 it was stated that 'At the Rockingham Works and the Don Pottery . . . nearly 600 persons are employed'.[2] Jewitt[3] attributes its decline to its greatest triumph: the order from William IV for a dinner and dessert service comprising 144 plates and 56 major pieces, the contract price for which was an astronomic £5,000. Admittedly, at this juncture more artists were taken on, and the time and money expended on the Royal Service were alleged to have been so great that, despite the immensity of the contract price, money was in fact lost over the order. As a direct consequence, the firm's financial stability was, it is claimed, seriously undermined. However, it is difficult to believe that the Royal Service alone was the cause of the factory's ultimate collapse. The Bramelds, at about the same time, took on many other orders for services almost equally magnificent from, amongst others, the Duke of Cambridge, the Duke of Sutherland, and the King of the Belgians; and it is problematical whether the factory's costing system was any more adequate in the case of these services than it was with the Royal Service. Indeed, the Bramelds so much directed their energies to the attainment of artistic excellence that they paid no proper regard to commercial realities. Without the aid and advice of a true business man, it is difficult to see how the Bramelds could ever have succeeded in keeping the business in a state of solvency.

Their managerial weakness became even more significant when external conditions again started to operate against them. For it is clear from the Wentworth correspondence that in 1831 and 1832 sales were severely curtailed by political unrest and a vicious outbreak of cholera. The result was that the factory was working at only part capacity. As Thomas Brameld himself said in his letter dated 28th August 1832, addressed to William Newman, agent to Earl Fitzwilliam:

> The way we have been working the last two years, is, however, so cal-
> culated for safety that all we have the means of getting up is available

[1] See the memorial presented to Earl Fitzwilliam by his neighbours and tenants, Appendix G.
[2] *History, Gazetteer & Directory of the West Riding of Yorkshire*, William White, 1838, Vol. II, p. 215.
[3] *Ceramic Art in Great Britain*, Vol. 1, p. 514.

in the market—and there is no doubt whatever of a profitable result henceforth—if we can go on so as to fully employ the works; hitherto we have seldom done more than about half—and never more than two-thirds not having had the means in our power of going beyond it—we ought to manufacture to the extent of £400 a week—or £20,000 a year.

At this time industrial activity throughout the country was sluggish, and the Bramelds were quick to seek Earl Fitzwilliam's financial assistance.

It is to be regretted that the Wentworth correspondence breaks off in 1832 and is not resumed until 1842, by which time the new Lord Fitzwilliam had in well-justified exasperation finally closed down the factory. But in a letter dated 29th November 1842, in which Thomas Brameld seeks his patron's consent to a small-scale resumption of porcelain production, some of the difficulties encountered in the past are indirectly referred to. It is quite apparent from the terms of the letter that, irrespective of any external problems, the Bramelds had undertaken too much and given too good value for money. But apart from the correspondence, it is manifest from the sheer range of the production (examples of which will be discussed later) that the designs were too multifarious for the quantity of output; and the cost of producing the necessary moulds must have proved totally uneconomic.

In short, the Bramelds attempted too much. Commercial profitability—the only ultimate guarantee of continuance in business—was allowed to play second string to artistic achievement. As Thomas Brameld said in his letter to Earl Fitzwilliam of 29th November 1842:

> There is not any doubt but profits may be made upon the manufacture of china, and indeed have been, by us, but unfortunately they have merged in, and been swallowed up, by the general and sweeping expenses of the bad system we have so long labored under.

An indication of the quality of the management in the later years of the factory's existence is vividly given in a further letter dated 6th September 1839, written by R. Shillito, general overlooker, to T. Brameld in which, in addition to various strictures on the drunkenness, indolence and general discipline on the part of the workmen, one instance is cited of payment being continued fourteen or sixteen weeks after the recipient had in fact left the factory.

So long as Lord Fitzwilliam was prepared to subsidise the Bramelds' aspirations, insolvency could be warded off. But the moment the Earl's patronage was withdrawn, this short but sparkling interlude in the field of porcelain production was over for ever.

Postscript

Thereafter, John Wager Brameld took up residence in London at 7 Cobourg Place, Bayswater, in about 1846 and remained there until his death in 1851 (see also page 131). His two brothers remained at Swinton to run the flint mill, for the reopening of which they had obtained the permission of Earl Fitzwilliam. Thomas died in 1850; but George continued to operate the flint mill, with the aid of Thomas's widow, until his own demise three years later.[1]

As for the Works, Isaac Baguley continued there with his son Alfred, decorating porcelain and pottery brought in from other factories—their speciality being the application of the fine brown glaze originally produced by the Bramelds. Isaac died in 1855 but the business was continued at the Rockingham works by his son until 1865, when he removed it to Mexborough.

According to Jewitt,[2] in 1852 a small portion of the works was tenanted by some eathenware manufacturers who traded as P. Hobson & Son, but their occupation was of only 'short duration and now the whole place is closed'. Under the commercial addresses relating to Swinton as set out in the *Post Office Directory of Yorkshire*, 1857, the following entry is to be found:

Hobson, William & Peter, earthenware manufacturers, Rockingham Works.

[1] The final years of Thomas and George Frederic are treated more fully in *Rockingham Ornamental Porcelain*, pp. 10–11.
[2] *Ceramic Art in Great Britain*, Vol. 1, p. 507.

Chapter II

Pottery

Little of the immense output of pottery or earthenware that must have issued from the Swinton factory has survived, the present-day scarcity being accounted for in part by the large proportion of the original production that was exported. It is therefore extremely difficult, if not impossible, to give anything approaching a comprehensive account of the extent of the factory's production. All that can legitimately be aspired to is to describe a representative selection of the numerous shapes that owed their existence to the inspiration of the Bramelds. For clarity of exposition, the factory's output will be classified by the kind of decoration applied to it.

Brown Ware

The best-known variety of Rockingham pottery is the famous brown ware, which is particularly in evidence in the production of teapots, coffee pots, jugs and Cadogans. The glaze was extremely thickly applied (the treated object being dipped three times over), only the purest distilled water was used, and the resulting decoration was distinguished for its streaky chocolate effect. The brown glaze was not invariably applied to the inner surface of each piece. The inside was often left white. On occasion, the brown exterior was decorated with gilding (Plates 2, 3, 5 and 9) or enamel colours (Plate 4) or even classical figures in relief (Plate 12).

On the closure of the works, the formula was passed to Isaac Baguley (see also pages 83–4), a former employee of the Bramelds, who continued to glaze in the same manner porcelain and earthenware imported from other manufactories (Plates 13 and 14). Isaac's son, Alfred, assisted him; and on his father's death, in 1855, Alfred continued the business both at the Rockingham works and, later, at Mexborough—to which place he transferred his activities in 1865—until his death in 1891.[1]

[1] For further details of the Baguleys, particularly Alfred, see *Yorkshire Potteries, Pots and Potters* by Oxley Grabham, published in the Annual Report for 1915 of the Yorkshire Philosophical Society, p. 84 *et seq.*

Rockingham brown ware was extensively copied throughout the nineteenth century by other factories but is reputed never to have been equalled. Whether or not this claim is correct, collectors should be warned of the close similarity between the products of Rockingham on the one hand and Spode and Copeland & Garrett on the other, particularly where Cadogan pots are concerned. The output of brown-glazed ware was considerable, most of it apparently made after 1826: for all the marked examples I have seen so far, with the exception of some Cadogan pots, carry the 'Rockingham' and not the 'Brameld' mark. Some of the various shapes produced at the factory are listed below.

CADOGAN POTS

The origin of the Rockingham Cadogan pot is not altogether clear. According to the traditional account, the Honourable Mrs. Cadogan brought home a prototype from the East—Chinese and early Japanese examples are in existence today—and deposited it at Wentworth House, as a result of which Rockingham copies eventually came to be produced. According to another account, given by John Guest in his *Historic Notices of Rotherham*, 1879, the Marquis and Marchioness of Rockingham brought the prototype from Dresden and kept it at Wentworth. Some fifty or sixty years later, Earl Fitzwilliam—who had succeeded to the Rockingham title—asked Thomas Brameld to make a copy. The latter's chief chemist, William Speight, was consulted and three designs were produced, of which one was adopted for manufacture.

Cadogan pots are constructed on the same scientific principle as the well ink-pot. Being lidless, they are filled from the bottom through a hole that is the commencement of a tapering and slightly spiral tube extending to within half an inch or so of the top of the vessel. When the pot is turned over, the liquid will not spill. At the same time, it will retain heat and, according to the claims made for it, will conserve the flavour of the contents more successfully than the more conventional type of vessel.

If Jewitt is to be believed, the Cadogan pot was used to hold not tea but coffee—and he was at pains to make this point.[1] However, in his discussions of John Mortlock's of Oxford Street, the London retailers,[2] Jewitt refers to Cadogans as teapots. Moreover, in view of the undoubted association of Cadogans with China—a country noted for tea and not for coffee—it is difficult to regard them as coffee pots. It must be admitted that neither beverage (with the need to strain off the leaves or grouts) is conveniently accommodated in such a pot. A more natural use for it would be the dispensing of a somewhat more potent type of liquid. At any rate, the Chinese version would seem to have been used for holding hot rice spirit or something similar. A large quantity of Rockingham Cadogans was ordered by John Mortlock's, bearing their name impressed.

[1] *Ceramic Art in Great Britain*, Vol. 1, pp. 498–9.
[2] Ibid, p. 219.

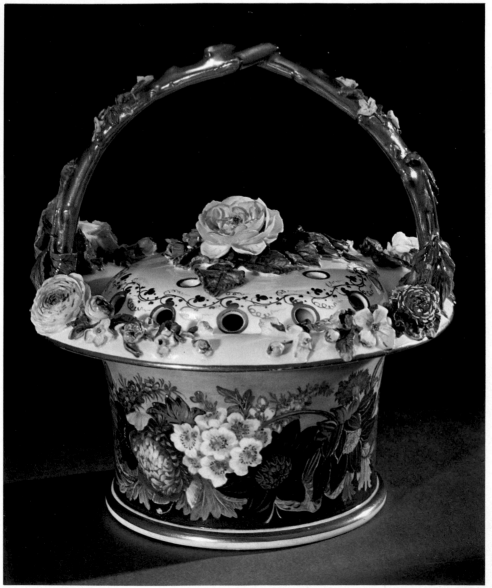

II. Deep pot-pourri basket and cover, with rustic handle in gilt, encrusted with coloured flowers and finely painted around the body (by or after Edwin Steele) with a continuous chain of flowers against a background of puce and indigo. $6\frac{1}{4}$ inches high. Puce mark. See page 59.

It is popularly stated that George IV had a strong penchant for Cadogan pots. In so far as this assertion is based on Jewitt's statement that 'George IV . . . used one of the then fashionable Rockingham ware pots',[1] it must be remembered that Jewitt was referring in this context to teapots, not to Cadogans. He confuses the issue, however, by stating in his discussion of John Mortlock's that 'when the Prince Regent . . . visited Wentworth House . . . these [Cadogan] teapots were then in use and were much admired; the prince, who was a great connoisseur in tea, I believe, bringing one of them away with him'.[2]

The essential shape of the Rockingham Cadogan pot is that of a peach ornamented with raised leaves and fruit, the whole being usually decorated with a brown glaze and sometimes embellished further with gilding (Plate 2), though apple-green examples are found on occasion. An example of the latter is in the Victoria and Albert Museum (Plate 33). Another, with gilt decoration, is in my own collection. The original Oriental model, on which the Rockingham version was probably based, represented a peach growing on a branch: but in the copy, the branch and leaves have disappeared into comparative insignificance.

Cadogans appear in at least three different sizes, measuring approximately $7\frac{1}{2}$ inches, $6\frac{1}{4}$ inches and $4\frac{5}{8}$ inches in height respectively. Similar types of pot were made by Spode and Copeland & Garrett and are found with the mark SPODE or COPELAND & GARRETT impressed. In the absence of a mark, they are indistinguishable from Rockingham specimens. At first sight, it might appear that an explanation of this remarkable similarity could lie in the acquisition of the original moulds by Mr. Copeland on the Rockingham factory's closure in 1842. Certainly his name appears among the successful purchasers of the stock and effects disposed of by Messrs. Lancaster & Sons in December 1843. However, although this theory might be compatible with the appearance of Cadogans impressed with the COPELAND & GARRETT mark, it cannot be maintained where pots bearing the SPODE mark are concerned. The latter mark would appear to have been discontinued in 1833— long before the Rockingham works ceased to operate. Accordingly, the theory must be rejected altogether.

It is interesting to note that in recent excavations on the site of the old Copeland & Garrett factory brown-glazed Cadogans have been unearthed which, although known from technical evidence to have been decorated there, are nevertheless impressed with the mark ROCKINGHAM.

There would appear to be no evidence that Baguley ever made or decorated Cadogan pots after the Rockingham factory ceased business in 1842. Presumably, the novelty of the invention wore off and it no longer exercised any appeal.

[1] *Ceramic Art in Great Britain*, Vol. 1, p. 499.
[2] Ibid, p. 219.

TEAPOTS

The extremely rare teapot illustrated in Plate 10a measures 8 inches in length and 3¾ inches in height. The cover is moulded with a flower design and the finial is conical in form. The body is melon-shaped and the whole is glazed brown, both inside and out. Another example (Plate 9), somewhat different in shape, with an essentially arc- or bow-shaped handle and with a pierced circular finial on the cover, the whole elaborately gilded, is to be seen in the Victoria and Albert Museum.

A further shape of teapot, totally dissimilar to the foregoing, is also illustrated (Plate 7). Unfortunately without its lid, it is in the form of a log, 4⅛ inches high, with a rustic spout and handle. It bears the mark ROCKINGHAM impressed.

COFFEE POTS

Although these are classified by Jewitt as teapots,[1] this can surely be no more true than his simultaneous description of Cadogans as coffee pots. They are high-shaped, the usual form being that of the example reproduced in Plate 4. This particular specimen measures, with its cover, 6¾ inches in height and is beautifully decorated with gilding and with butterflies and flowers in enamel colours, after the style of Wedgwood. Of the same shape are the two gilt examples likewise illustrated. One, 7¼ inches high, is embellished with Chinese figures and scenes in gilt (Plate 5b), while the other, 6¾ inches high, is decorated with gilt pansies on one side and morning glories on the other (Plate 5a). Unlike the other coffee pots mentioned here, the latter specimen is not brown-glazed all over but has a simple white glaze on the inside. A particularly fine example of the same shape, 5¼ inches in height, is also shown (Plate 3), exquisitely decorated with flowers in gilt. A still smaller example also in my own collection stands a mere 4¾ inches in height. It is totally without gilt ornamentation.

Two other coffee pots are, from the rareness of their shape, of particular interest. The first (Plate 10b), measuring 6½ inches in height with its cover, has a fluted body and a spout that projects forward in a distinctive fashion. The other (Plate 6) stands 6 inches high and is also of a different form—and the quality of the glaze falls much below that normally associated with the factory. But it is interesting for a very unusual mark in the form of the word 'Rockingham' written in script.

Jewitt refers to this variety of mark[2] and, in addition to his comment on its rarity, observes that it was the earliest form to be used. On this point, however, as the factory was not renamed Rockingham until 1826, it is difficult to see why an early attribution should be given. We would rather have expected Jewitt's comment to have related to the BRAMELD mark.

[1] *Ceramic Art in Great Britain*, Vol. 1, p. 499. [2] Ibid, p. 515.

CREAM AND OTHER JUGS

Rockingham produced a variety of differently shaped brown-glazed jugs. An extremely unusual cream jug, with a rather lighter brown coloured glaze than is normal, is shown in Plate 12. It is $3\frac{3}{4}$ inches high and is ornamented with classical figures in relief. Plate 8 shows another variety of jug, circular and low and similar in shape to the porcelain cream jugs of the early red period. It is in the possession of the Sheffield Museum. A further variety of cream jug, belonging to a private collection, has a double entwined handle and is decorated with gilt foliage and blue flowers.[1]

A completely different shape of jug is also illustrated (Plate 15). This one, 5 inches high, has an angular handle, and the neck is moulded with a series of raised concentric rings. Although buff in colour, for convenience it is classified under brown ware. Two other jugs of the same design are in the Yorkshire Museum, one of them with the identical colouring of the example illustrated here but somewhat smaller in size. A further specimen, in the Hanley Museum, is decorated with a purplish brown glaze; and yet another can be seen in the Rotherham Museum.

TOBY JUGS

Rockingham also produced Toby jugs portraying the 'snuff-taker'. Two examples with a really lovely brown glaze are in my own collection. One is 9 inches high and the other is 7 inches high (Plate 1).

BROTH BOWLS

A rare example of a brown-glazed broth bowl and cover is illustrated in Plate 11. It is $4\frac{1}{4}$ inches in diameter and $5\frac{1}{2}$ inches high. Both the bowl and cover are decorated with gilt.

Blue and White

Like most factories of the early nineteenth century, Rockingham produced for the cheap mass market a great quantity of blue and white earthenware in a variety of designs. Some of these are listed below—but this list is not, nor does it purport to be, exhaustive. Indeed, it is extremely doubtful at this distance of time from the factory's closure that anything like a comprehensive catalogue of patterns can be compiled.

Patterns

WILLOW

Services decorated with the underglaze willow pattern, so frequently found among the diverse output of the Staffordshire Potteries, were also produced

[1] *The Connoisseur Year Book*, 1962, p. 141.

at Rockingham. According to Jewitt,[1] the pattern was adopted at Swinton as early as 1788; but in any event, it certainly occurs on pieces bearing the impressed BRAMELD mark—which can, for convenience, be dated to around 1820.

In the absence of a mark, it is extremely difficult, if not impossible, to claim a Rockingham attribution. Even the neighbouring Don Pottery factory produced an identical pattern, and differentiation is not possible even by handling the pieces. The glaze and quality of the contemporary Don Pottery specimens are indistinguishable from those that characterise Rockingham examples.

The willow pattern can be seen on the asparagus dish, $14\frac{1}{2}$ inches long by $8\frac{3}{4}$ inches wide, illustrated with its holders in Plate 19.

RETURNING WOODMAN

This pattern, seemingly peculiar to Rockingham, is reproduced on the dinner service discussed later, some of the principal shapes of which are illustrated in Plate 16. It consists of a woodman or forester returning to his cottage, where his wife is sitting outside spinning and his small daughter is running to greet him.

CASTLE OF ROCHEFORT, SOUTH OF FRANCE

Specimen pieces from a service decorated with this pattern are illustrated in Plates 17 and 18. The meat dish and dinner plate are printed on the back with the name 'Castle of Rochefort, South of France' inset in a blue irregular floral garland.

TWISTED TREE

This design is in imitation of the Chinese and consists of an elaborate pattern, depicting stylised flowers and foliage, twisted trees and exotic birds in flight (Plates 30, 31 and 53). Pieces with this pattern are sometimes printed on the reverse with an Oriental figure over the words INDIA STONE CHINA.

This design often appears overpainted in polychrome colours.

DON QUIXOTE

Scenes from Cervantes' *Don Quixote* are reproduced on certain earthenware services decorated in blue and white. Some of the pieces from such services have printed on the reverse the words 'Don Quixote' within a shield.

It is interesting to note that a painting of Don Quixote riding on Sancho Panza appears on the famous Rhinoceros Vase painted by John Wager Brameld, which, after being at Wentworth House up to the middle of this century, is now in the Rotherham Museum.

[1] *Ceramic Art in Great Britain*, Vol. 1, p. 497.

SWEET PEAS

An octagonal plate has been discovered, 9¾ inches across, decorated with this pattern in underglaze blue (Plate 25b). The mark is impressed BRAMELD in a cartouche.

SPRAYS OF STYLISED FLOWERS ASYMMETRICALLY PLACED

An essentially round plate with this underglaze decoration is illustrated in Plate 25a. It is the same size and has the same mark as that in Plate 25b.

UNDERGLAZE BLUE FLOWER BORDER

The dish, 17 inches by 13½ inches, illustrated in Plate 26 has this underglaze blue flower border and is further decorated with flowers painted over the glaze in colour. The mark is BRAMELD + 1 impressed.

PARROQUET

This design comprises a pair of parroquets amidst a profusion of exotic foliage. The gadrooned plate with this pattern (Plate 21), apart from being impressed BRAMELD + 1, has a further notation on the reverse in underglaze blue transfer consisting of a parroquet over the words 'Parroquet Fine Stone B'.

FLOWER GROUPS

This pattern appears on the jug and cover illustrated in Plate 24. In addition to the mark BRAMELD + [?] impressed, the jug has the words FLOWER GROUPS GRANITE CHINA surrounding a floral motif printed in blue transfer.

The same pattern appears on the soup tureen and cover illustrated in Plate 20.

INDIAN FLOWERS

This design of flowers appears on a plate in the Rotherham Museum, impressed BRAMELD and printed on the reverse with the words 'Indian Flowers' within a floral design.

BURN'S COTTAGE

A small plate with a named view of Burn's Cottage, the inspiration for which is obvious, can be seen in the Sheffield Museum.

PARIS STRIPE

An unusual plate in a private collection has around its rim a pattern described on the reverse in script within a cartouche as Paris Stripe.

STEAMER 'FORFARSHIRE'

A single meat dish with a transfer print of the steamer 'Forfarshire' is in the possession of the Dundee Museum. This ship belonged to the Dundee & Hull Steam Packet Co. and was involved in the famous rescue operation carried out by Grace Darling in September 1838. The dish is impressed with the mark BRAMELD + 1.

BLACKBERRY

This drab and uninspired design, attributed to the genius of Llandig, is occasionally encountered. It appears on both earthenware and porcelain and is usually accompanied by flowers or other decoration. An example of the pattern is reproduced on the basket-weave cup and saucer in porcelain illustrated in Plate 109a.

Dinner and Dessert Services

As is apparent from various superficial excavations undertaken at the site of the Rockingham factory, the range of shapes and patterns was quite extraordinary. It is extremely doubtful whether a truly representative collection of Rockingham pottery, particularly of the quality produced for mass consumption, can now be assembled. Most of what was not exported must have been destroyed long ago.

The variety of output of blue and white earthenware was immense, and perhaps the most convenient starting point is a large blue and white part dinner and dessert service where the pattern depicted is of the 'Returning Woodman'. The various shapes represented in the service and shown in Plate 16 are as follows:

(1) *Small meat tureen and cover*
Square in shape, the body measures 11 inches (to the extremities of its shaped handles) by 9¼ inches by 2⅛ inches, the lid (with its finial in the form of an asparagus) 8⅜ inches by 8⅜ inches, and the pieces together stand 5¾ inches high.

(2) *Sauce tureens, covers, stands and ladle*
Of the same overall height as the above combination, the sauce tureens, covers, and stands measure respectively 6⅜ inches (to the extremities of the shaped handles) by 3⅞ inches by 4¼ inches, 4¼ inches by 3 inches, and 7¾ inches by 4½ inches. The finial on the covers is again in the form of an asparagus.

Two such tureens, covers and stands exist in the service, and one is remarkable for the fact that it still has its pottery ladle, 5½ inches long with its cup 2 3/16 inches in diameter.

(3) *Cheese dish*
Circular in shape, the diameter of the platform is 10¼ inches. The height of the piece is 1⅞ inches.

(4) *Sauce-boat*
Long and pointed, and with a loop handle, this piece is 7½ inches in length, and stands 4½ inches high.

(5) *Meat and fish dishes*
Various dishes of this type, essentially oblong in shape, with rounded edges and sunken centres, are included in the service. There is also a fish-strainer, which fits into the second largest dish. A further dish of this same size—i.e., 19¼ inches by 14¾ inches—is somewhat differently shaped, having its bottom grooved in the form of a leaf in order to enable the gravy to drain away. There are seven different sizes: 21¼ inches by 16⅛ inches, 19¼ inches by 14¾ inches, 17 inches by 13 inches, 14¾ inches by 11¼ inches, 12¾ inches by 9½ inches, 10¼ inches by 8 inches and 9⅜ inches by 7¼ inches.

(6) *Pie dishes*
Deeper than the foregoing but essentially of the same external shape, these are of two sizes: 5¾ inches by 4³⁄₁₆ inches by 1⅜ inches, and 8¼ inches by 6½ inches by 1¾ inches.

(7) *Soup plates*
These are hexagonal in shape, with sunken bottoms. They measure 9¾ inches across.

(8) *Dinner plates*
These are of the same shape and size as the above but, naturally enough, are much flatter.

(9) *Dessert plates*
Of the same basic form as the dinner plates but somewhat smaller, these measure 8¼ inches across.

(10) *Side plates*
These are identical with the above in shape but are only 6¼ inches across.

It is extremely rare to find a service anywhere near as extensive as that described. Normally, it would have been split up long ago: so we are therefore dependent for an understanding of Rockingham earthenware services on individual pieces that are extant. However, several interesting shapes survive from a service printed with the 'Castle of Rochefort' pattern. Illustrated in Plate 18 are a large tureen, cover and stand, 11 inches in all (the tureen itself measuring 12½ inches in length by 8¾ inches in width, the stand 14½ inches by

9 inches), a ladle 12½ inches long with a cup 3⅜ inches in diameter, and a broth bowl and stand 5¼ inches high. And in Plate 17 can be seen a large meat dish, 16½ inches by 13 inches, a dinner plate, a dessert plate (respectively 9⅞ inches and 8⅜ inches in diameter) and a dessert stand.

It is to be noted that all the plates so far recorded with the 'Returning Woodman' decoration are octagonal in shape; but not so those printed with the 'Castle of Rochefort' pattern. For although the meat dishes of both patterns—and those decorated with the 'Willow' pattern, too—seem to be identical in shape, the plates with the 'Castle of Rochefort' scene are essentially circular.

A particularly interesting piece printed with the 'Willow' pattern is illustrated in Plate 19. It is in the form of an asparagus dish (14½ inches long by 8¾ inches wide), together with holders. Equally arresting is the large tureen and cover 14¼ inches in length by 11½ inches in height, decorated with the 'Flower Groups' pattern (Plate 20). The handles and the finial of the lid are distinctive.

Blue and white decoration was also used on non-service pieces, such as the jug and cover reproduced in Plate 22. It stands 8 inches high and is printed with the 'Twisted Tree' pattern, the knob on the lid being moulded as a strawberry with leaf.[1]

Tea and Coffee Services

It is a remarkable thing, on the face of it, that although blue and white part dinner and dessert services have survived—and even more so, individual pieces therefrom—tea and coffee services and their constituent parts seem to be so extremely rare. The absence of cups and saucers is particularly noteworthy, as these at least must have been produced in quantity. In contrast, as far as porcelain is concerned, tea-ware—particularly cups and saucers—is more frequently encountered than are dinner or dessert pieces. Unfortunately, as earthenware was manufactured merely for use and not by way of ornament, and its cost was therefore slight in relation to porcelain, once any piece suffered damage it was simply thrown away. Hence, what was prolific and commonplace in the past becomes a rarity of the present and an eagerly-sought-after subject of research. This is one of the ironies of life. An example of a cup and saucer, albeit decorated in underglaze green, is illustrated with a matching plate and bowl in Plate 23. The teapot, cover and stand also exist, the body of the teapot being essentially of the same design as that of the porcelain examples in the early neo-rococo style (see pages 48–49) except that it stands on a solid base instead of scroll feet.

Black and White, and Green and White

Apart from the more common blue, an underglaze black or green was also employed. Presumably, the patterns listed under 'Blue and White' were also

[1] Compare the porcelain version illustrated in *R.O.P.*, Plate 97.

represented in underglaze black and underglaze green. Certainly a black and white dish with the 'Returning Woodman' pattern exists in the Sheffield Museum. Llandig's 'Blackberry' pattern is also found both in black and green, and so too are the 'Don Quixote' services. Specimen shapes from a really magnificent service of this last pattern in green are shown in Plates 27a–g.

Some 165 pieces survive and include one soup and several sauce tureens, covers and stands with, in some instances, the accompanying ladle (Plate 29a); soup, dinner, dessert and side plates, 10 inches, $10\frac{1}{4}$ inches, 9 inches and $6\frac{3}{4}$ inches in diameter respectively (Plate 29b); sauce-boats and stands (Plate 29c); vegetable dishes, covers and stands (Plate 29d); pie dishes in three different sizes (Plate 29e); meat dishes from $9\frac{3}{4}$ inches to 13 inches in length (Plate 29f); and a circular cheese stand (Plate 29g). A considerable variety of scenes—some ten in number—of Don Quixote's numerous activities appear on the pieces, accompanied by a quite elaborate floral patterned border. Sometimes, on the reverse of a particular piece, the pattern name DON QUIXOTE within a shield is printed in coloured transfer.

In addition to these designs, one plate of $7\frac{1}{4}$ inches diameter has been recorded with a comprehensive scene of town and country in underglaze black (Plate 28), and there are others decorated in the same colour transfer with a series of hunting scenes. Occasionally, children's plates are encountered. One of $5\frac{1}{4}$ inches diameter (Plate 29) is decorated in underglaze black with figures of children playing and has the caption 'For Martha—what pretty toys'. Another exists—also in a private collection—with a rocking-horse depicted, beneath which are the words 'For Samuel'.

There can be little doubt that, on occasion, other underglaze colours were also used at Swinton, e.g., fawn and red.

Hand Painted

POLYCHROME

Occasionally, pottery was produced with a polychrome decoration—as was sometimes the case with pieces decorated with the 'Twisted Tree' pattern. They were printed with an underglaze decoration but were partially enamelled, with colours applied over the glaze. This particular pattern can be seen on the very important garniture of hexagonal vases shown in Plate 53, and it also appears in underglaze form on porcelain.

Collinson is known to have decorated a number of white dessert services at Swinton between the years 1810 and 1815.[1] Life-size botanical specimens were painted in the centre of each piece, and the Latin names were pencilled on the back. A botanical plate, probably by Collinson's hand, can be seen in the Victoria and Albert Museum, inscribed on the reverse 'Dilwynia floribunda' in red.

[1] *Ceramic Art in Great Britain*, Vol. 1, pp. 508, 509.

Three other plates are worthy of comment. The first, which is octagonal in shape and is in a private collection, has a chinoiserie pattern in underglaze but is overpainted in bright shades (Plate 48). The second, from the Sheffield Museum (Plate 50), is decorated with painted flowers and is particularly interesting for the fact that the moulding of the border is suggestive of porcelain. Its affinity with the superior material is indicated by the nature of the mark, which consists of the griffin in red, followed by 'Rockingham Works Brameld 567' and also the word KAOLIN impressed. The third plate, $7\frac{1}{4}$ inches in diameter, is painted over a printed background of shaded hexagons with an exotic bird and elaborate foliage in the centre and a Greek key design around the rim (Plate 49).

Two dishes, impressed BRAMELD, with quite exceptional painting of views are illustrated in Plate 495 of Geoffrey A. Godden's *An Illustrated Encyclopaedia of British Pottery and Porcelain*.

MONOCHROME

Hand-painted pottery decorated with a single colour is occasionally encountered. A set of five plates—10 inches, 10 inches, $8\frac{3}{4}$ inches, $8\frac{3}{4}$ inches and $6\frac{1}{2}$ inches in diameter respectively, each painted with green leaves—is shown in Plate 47.

Green-glazed

This form of decoration, which consists of a green glaze applied all over the body of the pottery and is much rarer than blue, black or green underglaze printing, can be found on variously shaped pieces from Rockingham dinner and dessert services. Three different varieties of plates have so far been recorded. The first, $7\frac{1}{2}$ inches in diameter, is moulded with an all-over leaf motif, the edges of the rim being serrated (Plate 34). The second, $8\frac{11}{16}$ inches in diameter, is plain in the centre but is moulded around the border with an intricate basket-weave pattern (Plate 35); and the third, $8\frac{1}{4}$ inches in diameter, has a simple basket-weave centre and a foliate rim, the underside being moulded with a series of concentric grooves (Plate 36). These varieties of shapes and moulded patterns indicate that at least three different types of services were made in green-glazed ware. Matching dessert dishes, tureens and covers, etc., still survive, some examples of which accompany the plates in the illustrations (Plates 35 and 36). A rare pickle-dish, $6\frac{3}{8}$ inches long by $5\frac{7}{8}$ inches wide, moulded with the all-over leaf motif, and itself in the form of a leaf, is also shown (Plate 34).

This same coloured glaze is also found on non-service pieces such as, for example, jugs moulded with daisy-heads on the upper portion and primrose leaves on the lower portion (Plate 37)—identical, in fact, to the more frequent examples in porcelain[1] (see also page 72). Moreover, the 'lotus vases'

[1] *R.O.P.*, Plate 96.

described and illustrated by Jewitt,[1] of which unmarked examples 12½ inches high can be found in the Victoria and Albert Museum, also have this rich green glaze (Plate 32). Because the Museum pieces are unmarked, however, an unqualified attribution in favour of Swinton cannot be given. Undoubtedly, they must have been made from the Rockingham moulds; but in view of Jewitt's statement[2] that moulds 'passed into the hands of the late Mr. John Reed of the "Mexborough Pottery", by whose successor they continued to be made, both in the fine old green-glazed style, and enamelled', the origin of the examples in the Victoria and Albert Museum must remain uncertain.

On rare occasions, Cadogan pots were manufactured with a green glaze. One can be seen in the Victoria and Albert Museum (Plate 33). Another, further decorated with gilding, is in my own collection.

Cane-Colour

Perhaps the finest earthenware ever produced at Swinton on any scale was that with a cane-coloured ground on which classical figures (or floral or other decoration) were applied in relief, sometimes in the same cane-colour but more often in a white, a light or dark blue, a chocolate or an olive-green colour.

JUGS OR PITCHERS[3]

A set of three jugs or pitchers of this ware, each with a handle comprising a horse's tail joined to its lower leg, is illustrated in Plate 40. They measure 7½ inches, 6⅞ inches and 6¼ inches high respectively, and are decorated with raised ornamentation of classical figures in a dark blue. A larger specimen in my collection (8½ inches in height) has figures in a light blue, whilst a bigger example still (9¼ inches high) has white ornamentation. The mark—which seems invariably to consist of BRAMELD within a garland of roses, shamrock and thistles on a raised oval plaquette—is of the same colour as the applied decoration. This type of jug was made in direct imitation of Wedgwood.

Another species of jug, bulbous in shape with a simple loop handle, can be seen in the Rotherham Museum. Also recorded is a rare and somewhat macabre variant of this jug with a false spout in the guise of an open-mouthed snake's head, the body of the reptile split into two and modelled so as to form its handle (Plate 41).

Another shape of jug, belonging to a private collection, is basically that of the green-glazed example referred to above except that the lower portion has, instead of primrose-leaves, a distinctive fluted moulding. Another example, also privately owned, is fitted with a cover (Plate 42).

[1] *Ceramic Art in Great Britain*, Vol. 1, p. 509.
[2] Ibid, p. 510.
[3] See Appendix F: Christie's Sale 1830, 12th February. Lots 1–7, 70–75; 13th February 1–6; 70–75.

PLATES OR SAUCER DISHES

One of a pair of plates or saucer dishes made in cane-coloured ware, approximately 8½ inches in diameter, with the raised ornamentation in light blue, is illustrated in Plate 45. My own collection contains another, 8 inches in diameter, where the raised figures are left in the basic cane-colour.

These pieces originally came from cane-coloured tea services.

BREAKFAST CUPS AND SAUCERS

As explained earlier in discussing blue and white ware, pottery cups and saucers are extremely rare. Not surprisingly, then, the pair of breakfast cups and saucers, one of which is illustrated in Plate 45, are the only cane-coloured examples recorded to date. They measure 4⅜ inches and 6½ inches in diameter, respectively, and the applied classical ornamentation is in light blue.

SLOP BASINS

An example of a slop basin with applied classical figures in light blue is illustrated in Plate 46. It measures 6¼ inches in diameter and 3 inches in height.

TEAPOTS

A teapot and cover of cane-coloured ware is known to exist in a private collection. It measures 8¼ inches in length.

DISHES

The Sheffield Museum has an interesting cane-coloured dish with shaped sides, the edges of which are decorated with an applied flower and leaf pattern (Plate 43).

A square dish is also illustrated (Plate 44).

MUGS[1]

Mugs were certainly produced in cane-coloured ware. An example exists in the Victoria and Albert Museum, and is shown in Plate 39. As in the case of the jugs previously described, the handle consists of a horse's tail joined to its leg. The mark is the same as that employed on the jugs, viz. BRAMELD raised within a cartouche.

COFFEE CANS

Coffee cans in cane-coloured ware still exist. One, in a private collection, is 2¼ inches high.[2]

[1] See Appendix F: Christie's Sale 1830, 13th February. Lots 1–6, 70–75.
[2] *Connoisseur Year Book*, 1962, p. 141.

CANDLESTICKS

Candlesticks of cane-coloured ware have not, as yet, been discovered by me, but that they were produced at Rockingham is proved beyond dispute by their inclusion in lots 1 to 7 and 70 to 75 of a sale of Rockingham china held on 12th February 1830 by Mr. Christie at his premises in King Street, St. James's Square.

Cream-colour

Rockingham cream-coloured earthenware is extremely rare; but where it does appear, it reveals the factory's early connection with the Greens of Leeds. For the Leeds factory and the Swinton works were originally under the same ownership, the former being by far the more important. The result of the association was that Rockingham manufactured (though on a much smaller scale) some products that were identical to those made at Leeds, the only difference being that each factory operated a different numbering system in its pattern books. Thus, in teapots, Leeds No. 149 was Swinton No. 68; Leeds No. 133 was Swinton No. 69; Leeds No. 218 was Swinton No. 70, and Leeds No. 252 was Swinton No. 71.

After the Bramelds acquired control of the Swinton factory and operated it entirely independently of Leeds, according to Jewitt[1] 'this kind of ware became the staple production of the manufactory, and an immense trade was carried on in it in the Baltic and elsewhere. Not being marked, it probably often passes for Leeds ware in the eyes of collectors. In this material beautiful openwork baskets, and many other elegant articles, were made.'

Jewitt is not entirely accurate when he says that cream-ware manufactured at Swinton was never marked, for a few marked pieces have come to my attention—notably, a plate 8 inches in diameter with pierced edges, impressed BRAMELD, belonging to a private collection; and, far and away more important, a very large and magnificent jug, $9\frac{1}{2}$ inches high, beautifully painted on the front with a picture of a castle and on either side with two early cricketing scenes, and printed underneath with the words BRAMELD & CO. SWINTON POTTERY (Plate 38). This is probably the finest specimen of Rockingham earthenware of any type so far discovered. Clearly, the piece was specially commissioned; and for the subject-matter of the decoration alone, it is exceptionally interesting and important.

In addition, a sauce-boat, illustrated and described in the *History of the County of York*[2] is stated to be of cream-ware and to be marked BRAMELD impressed. It is in the shape of a melon, with leaves and stems on the lid and with a knob in the form of an acorn. The stand, which is attached, is moulded as a leaf, revealing a network of veins.

[1] *Ceramic Art in Great Britain*, Vol. 1, p. 510.
[2] *The Victoria History of the Counties of England*, Vol. 2, p. 442.

Yellow-glazed

Although Jewitt makes no mention of it, the Bramelds did occasionally manufacture pottery with a canary-yellow glaze. Indirect reference to such a production can be found in a manuscript notebook (now in the Victoria and Albert Museum library) containing the various glazes the Bramelds applied to their ware. But more significant, a marked example with this rare yellow glaze, in the form of a jug with pineapple moulding, is in the possession of the Smithsonian Institution in Washington, D.C., forming part of the Eleanor and Jack L. Leon Collection of Yellow Glazed English Earthenware. It is illustrated in Plate 51.

Blue-glazed

Another style of decoration unmentioned by Jewitt is in the form of a navy-blue glaze. How extensively this treatment was employed, it is difficult to say. To date, at least two marked specimens have been recorded. One, ROCKING-HAM impressed, is in the form of a coffee pot and cover with elaborate gilding. The other, marked on the stand, comprises a pierced basket, $8\frac{1}{2}$ inches by $5\frac{3}{4}$ inches, and stand, $8\frac{1}{2}$ inches by $6\frac{1}{2}$ inches, the borders of which are decorated with the same navy-blue over the glaze.

A Cadogan pot similarly glazed has also been seen; but as it was not marked, it would be precipitate to ascribe to it a Rockingham provenance.

'Chalk-body'

This is a fine white earthenware of which Jewitt says 'owing to its costliness through loss in firing, [it] was made only to a small extent, and is now of great rarity'.[1]

I have in my own collection a pair of plates $8\frac{3}{4}$ inches in diameter—one of them marked BRAMELD impressed—and a matching dish $12\frac{1}{2}$ inches long which must have been produced from this body. They are moulded with a basket-weave pattern similar to that found on green-glazed pieces and are painted in enamels with Bourbon sprigs in blue and green and with a blue ribbon around the edge.

Other Varieties

From a price list dated 1st February 1796 in the possession of Jewitt, it appears that:

> Greens, Bingley & Co. [that being the style under which the firm was then trading] Swinton Pottery, make, sell and export wholesale, all sorts of Earthen Ware, viz. Cream-coloured, or Queen's, Nankeen Blue,

[1] *Ceramic Art in Great Britain*, Vol. 1, p. 501.

Tortoise Shell, Fine Egyptian Black, Brown China etc. Also the above sorts enameled, printed or ornamented with gold or silver.[1]

The reference to 'Tortoise Shell' and 'Fine Egyptian Black' is particularly interesting as no marked example of either variety is known to be extant. But this was not entirely the case, it would seem, at the beginning of the century. For in 1904, A. H. Church wrote:[2]

A good plaque marked with ROCKINGHAM impressed is in the writer's possession. It is of black basaltes, with an amorino in relief in red ware.

The piece is illustrated in Captain Grant's *Black Basalts*.

Vases

Ornamental ware in pottery was but rarely produced at Swinton. Jewitt makes reference to certain 'lotus vases' formed of leaves, on which rested butterflies moulded in relief.[3] Two green-glazed examples (Plate 32) can be seen in the Victoria and Albert Museum (see also page 21).

A rare and important garniture, illustrated in Plate 53, consists of a set of three hexagonal vases—measuring $17\frac{1}{4}$ inches, $21\frac{1}{2}$ inches and $17\frac{1}{4}$ inches in height respectively—decorated with the 'Twisted Tree' pattern overpainted in polychrome colours and capped with overhanging covers, each surmounted by a gilt monkey. They comprise the same model as is found more frequently in porcelain (see also page 54).

Another rarity, illustrated in Plate 52a, is the cylindrical spill vase, 4 inches high, decorated with some underglaze blue but painted over the glaze with flowers and leaves in green, red, orange and yellow. Underneath is the unusual mark in red-brown script:

<div align="center">

Brameld

2017

*

</div>

Similarly marked, but this time with the number 2003 instead of 2017, is an equally rare shape of vase. It has interesting twin griffin head-and-neck handles in blue picked out in gold, and it stands 5 inches high on a square base. The decoration is rich, in the Imari style.

John Brameld Jug and Mug

Before bringing this chapter to a close, special mention should be made of a matching jug and mug in earthenware produced at Swinton for a member of the Brameld family—possibly John Brameld, the founder of the factory; or

[1] *Ceramic Art in Great Britain*, Vol. 1, p. 499.
[2] *English Earthenware*, 1904, p. 111.
[3] *Ceramic Art in Great Britain*, Vol. 1, p. 509.

John Wager Brameld; or even John Thomas Brameld, the second eldest son of Thomas Brameld. The jug is illustrated in Plate 54. It is $7\frac{1}{2}$ inches high; and inset in a circular flower-and-leaf decoration in green and blue is the name 'John Brameld' written in thick black script across the front of the jug. The back is painted with flowers in polychrome colours, and decoration in black is employed where one would have expected gilt to have been used. The glazing is considerably crazed and has a distinct bluish tint. The matching mug is also in existence, though heavily damaged.

Both pieces were, until quite recently, in the possession of a family claiming descent from a twice-wed lady who married into the Brameld family. My own extensive researches at Somerset House, combined with careful study of a genealogy of the Brameld family, have established an undoubted connection by marriage with a Brameld, but not necessarily with one who was a member of the potting family. Moreover, neither jug nor mug is marked, and their shape has not as yet been authenticated as Rockingham. Accordingly, the case must still be regarded as unproven. But should further research establish the genuineness of the tradition associated with these pieces, their historical importance in the Rockingham story will be considerable.

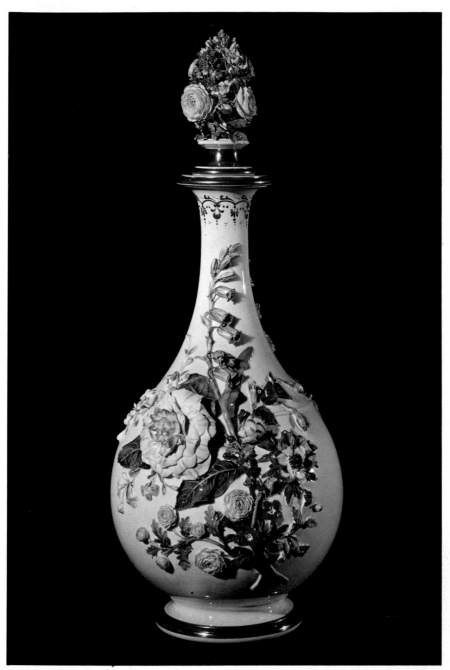

III. One of a pair of tapered scent bottles, with elaborate flowered stopper, encrusted with coloured flowers of exquisite delicacy. 16 inches high. Puce mark. See page 61.

Chapter III

Useful Porcelain

Rockingham porcelain can, for convenience, be classified as either ornamental or useful. The ornamental is generally finer in quality and the more desirable to acquire; but porcelain services too can, on occasion, be not merely utilitarian objects but something akin to minor works of art. Our attention will be directed first to the rare dinner and dessert services, and later we shall consider the far commoner tea, coffee and breakfast sets.

The distinction drawn in my earlier book, *Rockingham Ornamental Porcelain*, between plates and other service pieces meant for display and those intended for use is also maintained in this work (see also pages 70–73, Cabinet Service Pieces) and is undoubtedly helpful from the standpoint of classification. But whether, strictly speaking, it is valid is perhaps doubtful except in the rarest instances. The quality of some of the individual pieces from Rockingham dinner or dessert services is so high that where only a single item has survived there has been a tendency to ascribe to it an ornamental rather than a utilitarian function. There is, of course, no reason why the two purposes should necessarily be mutually exclusive. Moreover, the immunity from use which appears to have been the good fortune of some of the finest plates would suggest that, though forming part of a usable service, they were employed only to decorate the places of dinner guests between courses, and that the food itself was served on lesser quality plates or on silverware—a thought which perhaps gains support from the fact that the service made for the Duke of Sussex (see also page 36) contained, in addition to six dozen ordinary plates, sixteen 'dress plates' in three different sizes. In this sense, the most magnificent services were in effect display rather than utilitarian objects. In short, where the porcelain is at its finest, the distinction between ornamental and useful necessarily becomes blurred. Perhaps the clearest illustration of this last point is to be found in the Royal Service made for William IV, where the plates and comports were of such quality that they could each be regarded as a cabinet item. But this same standard of excellence is maintained in other services not destined for such august ownership.

Dinner and Dessert Services

Nowadays, it is exceptionally difficult to find dinner or dessert services complete, or in any way approaching that state. So many have been destroyed in the course of use; and others have frequently been shipped abroad, particularly to the U.S.A. and Canada. Plates, at any rate, have fortunately survived in quantity, and it is by reference to these that classification of the various types of services produced can most conveniently be accomplished.

Shapes

CIRCULAR WITH SHARK'S TEETH AND 'S' SCROLL MOULDING

Many if not most of the finest plates, belonging to both the red- and puce-mark periods, are fashioned after what can conveniently be called the 'Royal' shape—from the fact that this same moulding was used in the production of the plates for the Royal Service commissioned by William IV—where the rims are moulded with distinctive scrolls and shark's teeth edging. It is on this account that pride of place is here given to this particular shape. Two fine plates of this type, decorated by the same artist with fruit and flowers, are illustrated. One has a periwinkle-blue ground around the rim (Plate 59). the other is plain white (Plate 58). Another example, its border decorated with intricately patterned gilding and its centre beautifully painted with a display of flowers encircled by a fine pink ground, is also shown (Plate 56). Illustrated, too, is a pair from a rare set of twelve dessert plates with a green border richly embellished with gilding and yellow reserves, the centres finely painted with floral sprays (Plate 60).

As for the dishes that accompanied plates of this design, they had the same edging and normally assumed one of three different shapes—shell, oval or square. But circular dishes are occasionally found. The tureens, covers and stands were circular in shape, with the same edging that appears on the plates reproduced on the stands and on the rim and waist of the tureens themselves. The handles are rustic in form; and gilt acorns appear on the body in high relief. One of a pair of tureen covers and stands from the red-mark period, decorated with a rare apricot ground and painted with flowers, is illustrated in Plate 61.

CIRCULAR WITH SHARK'S TEETH AND ACANTHUS-LEAF/SHELL
MOULDING

This shape is similar to the foregoing but much rarer. One of a pair of such specimens, 9⅝ inches in diameter, with a green border on which groups of flowers are painted in white reserves edged with gilt 'C' scrolls, the centre finely decorated with painted flowers, is illustrated in Plate 63. And Plate 62 shows a plate of magnificent quality. It is painted in the centre with birds,

named on the reverse, and with butterflies and feathers around the rim. Whether this plate was meant as a cabinet piece or, as is more probably the case, was merely part of a superlatively-fine service is not altogether clear. Each of the above specimens bears the red griffin-mark, though others I have seen are marked in puce.

The matching dishes, examples of which can sometimes be found, follow the usual triangular or shell, square, and oval, forms. The tureens, covers and stands, and centre-pieces are unrecorded.

OCTAGONAL WITH MOULDED SHELLS

These are eight-sided, with moulded shells at each corner linked together with gadrooned edging. A splendid pair of such plates, 9 inches across, together with a shell-shaped dish, enriched with a periwinkle-blue ground and finely painted with floral bouquets, is illustrated in Plate 65. Beneath them stands the matching centre-piece. Immediately opposite are illustrated specimen shapes from a complete dessert service, decorated with transfer printed, albeit over-painted, flowers, reserved on a rich maroon ground. This type of service was produced in both the red- and puce-mark periods.

Sometimes, dessert services were decorated with fruit. A stand treated in this way, possibly by Thomas Steel, is shown in Plate 67.

CIRCULAR WITH MOULDED ANTHEMIA

Plates of this shape, circular in form, with gadrooned rims and anthemia moulded at intervals, are rare, and all the examples so far recorded have belonged to the red-mark period. An extremely fine pair, $9\frac{1}{8}$ inches in diameter, with a maroon border and a centre beautifully painted with soft and loosely arranged flowers, is illustrated in Plate 69. A particular feature is the iridescence around the edges of the painting—a characteristic more commonly associated with London-decorated Nantgarw. Another example, formerly in my collection, has a polychrome English chinoiserie decoration, essentially transfer-printed but over-painted in places. It measures 9 inches in diameter. A companion to it is to be seen in the Sheffield Museum. A particularly interesting specimen, after the Derby style, $9\frac{1}{4}$ inches in diameter, is illustrated in Plate 68. It is richly gilded, and the border is further embellished with a leaf motif in mauve, orange and green.

The exact form of the matching dishes of this type of service has posed some difficulty. In the case of a part dessert service decorated with a green ground and painted with floral bouquets, sold at Sotheby's on 31st January 1967 (Lot No. 146), where sixteen plates of the type under discussion were included, the matching dishes and centre-piece were of the 'Octagonal with moulded shells' design. However, in a part service which has just come to light, the dishes and principal pieces have the same moulding as the plates.

CIRCULAR WITH PRIMROSE-LEAF MOULDING

This design of plate, whose distinctive feature is that the borders have a moulded primrose-leaf pattern, is extremely rare. One of a pair of such plates, from the puce-mark period, the primrose-leaves being decorated in two tones of grey and the centre painted with floral bouquets, is illustrated in Plate 70. One of the two red-marked plates of this shape in the possession of the Victoria and Albert Museum is shown in Plate 71. A similar plate is in the Rotherham Museum. The painting is attributed to Edwin Steele.

A centre-piece from a service of this design can be seen in Plate 72. It measures 12¼ inches in length and 8⅜ inches in height. The leaf motif is strongly in evidence, particularly on the pedestal. One of the two matching tureens, covers and stands, with distinctive leaf finials and handles, is also illustrated (Plate 73). The quality of the gilding and painting is extremely fine. The plates, which originally accompanied these principal pieces and are now in the U.S.A., bore the red mark.

TWELVE-SIDED WITH GADROONING AND ACANTHUS-LEAF/SHELL MOULDING

These plates—which are really twelve-sided—are heavily gadrooned around the edges, with acanthus-leaves and shells forming a distinctive part of the motif. An example, printed with the red mark, is illustrated in Plate 74. It is decorated with a named landscape entitled 'Northern View of Rotherham'. Another plate from the same service is also illustrated (Plate 75).

In the Victoria and Albert Museum are a pair of tureens, covers and stands that accompany plates of this design. Measuring 7⅜ inches in height, the stands being 6⅝ inches in length, they are decorated with cornflowers and foliage in colour and gold and with scattered sprigs of rosebuds. The finials of the lids are in the form of shells.

MOULDED WITH FLORAL HEADS IN HIGH RELIEF

Only one example of this rare shape has been recorded to date. The plate (Plate 76) is shaped around its perimeter and is moulded at the edge of its maroon border with white floral heads in high relief. It is finely painted in the centre with fruit, possibly by Thomas Steel, and carries the red Griffin mark.

STRAIGHT-EDGED OCTAGONAL

Rockingham turned out a series of plates in direct imitation of the famille verte production of the Chinese Ch'ien Lung period. Though of soft paste, they were deliberately given the appearance of Oriental porcelain, being made extremely thin and tinted with grey. They are octagonal in shape, and decorated with a polychrome Chinese pattern of flowers and birds.

Three different plates from a dinner service are in my own collection. The

first measures 8 inches across, the second (Plate 77) 9½ inches. The third is a soup plate which has the same external dimensions as the dinner plate. Every plate of this type that I have seen—and they are distributed widely among public and private collections—bears the mark Griffin, 'Royal Rock^m Works Brameld' in puce, suggesting that only one service was ever made, perhaps in execution of a particular order or perhaps as a demonstration of the versatility of the Rockingham paste. The following advertisement[1] suggest the interesting possibility that it is this service to which it refers:

> Part Griffin-marked Rockingham Dessert Service, most beautifully decorated in colours in the Chinese style.

It is interesting to note that Lot 102 of the sale of the collection of E. M. Kidd[2] contained 'Pair fine Rockingham octagonal plates, decorated in Oriental style' which fetched £21. More significant, perhaps, was the sale held at Christie's on 23rd May 1905 when 'Twelve plates octagonal, painted with flowers and birds in colour, in stippled green and red borders, in the Chinese taste, Griffin mark. (From the Huth collection)' were acquired for £26 5s. od.

An alternative to the single-service theory, but less likely, is that these plates may have been made as replacements for broken pieces from genuine Chinese services. In any event, no item from a dinner or dessert service decorated with this pattern other than plates has so far been discovered. The pattern has, however, been seen on what is either a punch or salad bowl. If it is the latter, it would have belonged to the dinner service of which the plates described formed part. This same famille verte design has also been seen on a pair of cups and saucers from a tea service.

WAVY-EDGED WITH RAISED 'C' SCROLLS

These are, perhaps, the most frequently encountered plates and they appear to belong exclusively to the puce period. The edges are in a continuous serpentine shape and, in addition, the borders are moulded with a series of raised 'C' scrolls. An example, grey bordered, measuring approximately 9¼ inches across, is illustrated in Plate 82. It is richly gilded, and is painted in the centre with a view of a ruin beside a lake. A further example is unusually decorated with lilies in botanical style (Plate 83).

Individual pieces from a part service of this shape are also illustrated (Plates 78–81). The plate is 9 inches in diameter, and the square, lozenger and shell shaped dishes measure 8½ inches, 11⅜ inches, and 9¼ inches in length respectively. (Occasionally, the shell or triangular shaped dishes are simplified so that the elaborate scroll work at the top disappears altogether, and each of the three sides is moulded with identical form.) Each piece has a grey border enriched with intricate gilding, and the centre is finely painted with John Randall's tropical birds.

The tureens, covers and stands belonging to raised 'C' scroll services are

[1] *The Connoisseur Register*, September 1911, p. x.
[2] *The Connoisseur*, February 1904, p. 103.

somewhat elongated in shape, with rustic handles and gilt acorns in high relief. A pair of magnificent quality are illustrated in Plate 84, 7 inches high by 10 inches wide. They are beautifully painted with floral bouquets and are further embellished with a rich green ground.

Of particular interest is the plate illustrated, together with matching centre-piece, in Plate 85. Each item is white and gilt but decorated with an applied shell motif in dark blue. This is presumably the 'white with raised blue ornaments' type of service included by Jewitt in his description of the range of the factory's output:[1]

> Tea, coffee, dinner, dessert, toilet, and other services, were made in every variety of style, from the ordinary blue printed, or white with raised blue ornaments, to the most elaborately painted and gilt varieties.

Although neither of the pieces is marked, the plate can be authenticated by its shape, paste, glaze and gilding—and, more positively, by the applied decoration: for this appears also on marked cups and saucers. An original plaster mould used for this mode of decoration has been discovered on the site of the factory and was illustrated in *The Connoisseur*.[2] The centre-piece is the only example of this shape so far recorded and, with its swirling handles, it is particularly light and elegant. The style of design seems to owe its inspiration to pottery forms, suggesting that the piece was of early manufacture. When dealing with otherwise unrecorded and unmarked service ware, however, the possibility of importation from some other factory late in the life of the Rockingham Works and decoration at Swinton cannot be discounted. Far more usual is the design in the Sheffield Museum decorated with the 'blackberry' pattern in green around the borders and with a tropical bird by John Randall in the centre. It stands 5½ inches high.

The raised 'C' scroll style of plate has been seen in company with dishes and tureens quite out of spirit with shapes associated with Rockingham. The tureen and cover and pierced dish illustrated in Plate 86, for example, form part of a dessert service whose plates are of this same raised 'C' scroll design. The tureen, which is lightly gilded and poorly painted with floral bouquets, measures 7¼ inches in length and stands, with its cover—the finial of which is in the form of a strawberry—7½ inches in height. The matching dish is 9 inches in length and 8 inches in width, and it is conspicuous for its pierced handle and shaped edges. No other examples of these rare designs have so far been recorded, and I cannot dispel the thought that in the dying months of the factory's existence the tureens and dishes were bought in from some other manufactory, married up with genuine Rockingham plates and cheaply decorated in a desperate attempt to raise money.

For an excellent example of a soup plate of the raised 'C' scroll shape, the reader is referred to the specimen in the Sheffield Museum, on whose green border are reserved panels of fruit, butterflies and birds.

[1] *Ceramic Art in Great Britain*, Vol. 1, p. 511.
[2] April 1966, p. 224, Fig. 30.

WAVY-EDGED WITHOUT RAISED 'C' SCROLLS

Somewhat akin to the raised 'C' scroll shape is the plate shown in Plate 87. The border, which has similar wavy edges but no raised 'C' scrolls, is of dark blue on which a crest is reserved in the form of a snake on a bar.[1] The mark is in puce. Another plate of this same shape, also in my own collection, is of superlative quality. It is decorated in the centre with a common nuthatch named on the reverse and around the rim with fountains in gold are baskets (in raised gilt) full of coloured flowers. This particular plate, which carries the puce mark, once belonged to the Worcester Royal Porcelain Works Museum and is described in W. Moore Binn's, *The First Century of English Porcelain*, 1906, on page 234.

In the interests of completeness, mention should also be made of a further shape of plate to be seen in the Victoria and Albert Museum. Essentially circular, it yet has a slight shaping around the rim. It has a blue border and is painted in the centre with a rose. The plate, which is printed with the red mark, is heavily potted and generally unattractive. Perhaps it represents an early attempt to transfer a pottery form to porcelain.

So much for the various shapes assumed by the factory's dessert and dinner services. But what of their composition?

Composition

DESSERT SERVICES

As Rockingham dessert services are so rarely found in anything approaching their entirety, it is important to try and determine what was their exact composition. There would seem to have been the greatest degree of elasticity in the matter, the purchaser being free to order what he wanted. But the basic composition would appear to have been as follows:

 1 Centre-piece
 2 Tureens or cream bowls with covers and stands
 4 Oval or lozenger-shape dishes
 4 Square dishes
 4 Shell or triangular dishes
 24 Plates

to which ice-pails with liners would have been added where desired. Moreover, the survival of round dishes would establish that items of this shape were also

[1] Another plate with the same crest is in the Rotherham Museum. The Director, Mr. L. G. Lovell, has been able to identify the crest (from several etched or sandblasted windows in the locality and from *Pedigrees of the County Families of Yorkshire: Vol. 1—West Riding*, compiled by Joseph Foster, 1874) as belonging to the Walker family of Clifton, who were originally ironfounders and once owned Clifton House, the premises of the present museum. The heraldic plates were probably made for Henry Frederick Walker, who was born in 1807, married in 1833 and died in 1866. By this time, the Walkers had moved their principal place of residence to Blythe Hall in Nottinghamshire and retained Clifton House only as a pied-à-terre in Rotherham. Clifton House appears on a fine oblong octagonal basket in the possession of the museum.

sometimes included. However, it cannot be too strongly emphasised that there
were no set rules in the matter. Complete discretion lay with the purchaser.

An exceptionally valuable indication of the normal composition of a dessert
service is given in the detailed descriptions of various dessert services auc-
tioned at Christie's on 12th and 13th February 1830 (see Appendix F) on
the instructions of the proprietors of the Rockingham factory. The reason
given for the sale was the need 'to make room for a fresh selection now pre-
paring at the Works in Yorkshire'—and there may have been some substance
in the claim in that after 1830 the style and design of the factory's ware did
undergo a significant change. But perhaps the more obvious and cynical
explanation of the sale was the need for ready money. Set out below is an
analysis of the composition of the various dessert services auctioned by Mr.
Christie. Table A relates to the lots sold on 12th February, and Table B
to those offered on 13th February: and it must be borne in mind that these
services were in the nature of remnants and not necessarily complete sets.

TABLE A

Lot	Ice Pails	Centre	Cream Bowls[1] & Stands	Dishes	Plates	High Stands	
11	—	1	2	2	8	23	—
16	—	1	2	2	12	24	—
22	—	1	2	2	12	24	—
26	—	—	1	1	8	12	—
31	—	1	2	2	12	24	—
34	—	1	2	2	12	24	—
⌠42	—	—	2	2	8	36	4
⌡43	2	—	—	—	—	—	—
47	—	1	2	2	10	24	—
59	—	1*	2	2	8	20	—
66	—	1	2	2	12	24	—

* And 2 ends.

TABLE B

Lot	Ice Pails	Centre	Cream Bowls & Stands	Dishes	Plates	High Ends	
8		—	2	—	8	10	—
12	1 & Stand	2	2	12	24	—	
17	1 ,, ,,	2	2	12	23	—	
23	1 ,, ,,	2	—	12	24	—	
33	1 ,, ,,	2	2	12	23	—	
37	1 ,, ,,	2	2	8	24	2 & Stands	
44	1 ,, ,,	2	2	8	24	2 ,, ,,	
53	1 ,, ,,	2	2	8	24	2 ,, ,,	
58	1 ,, ,,	2	2	8	24	2 ,, ,,	
67	1 ,, ,,	—	—	8	24	2 ,, ,,	

[1] Nowadays, more frequently referred to as tureens.

From the above analysis, certain conclusions can confidently be arrived at. The number of plates and dishes was normally twenty-four and twelve respectively—the latter presumably consisting of four square, four shell and four oval shapes—except that where two high ends and stands were ordered the number of dishes was often reduced to eight. In all instances, it was normal to have two cream bowls, covers, and stands. Although covers are not specifically mentioned in the catalogue, their existence would seem to be implied. For the description of the tea services simultaneously offered for sale contains reference to teapots and stands, but the covers are not specifically included. Clearly, teapots were assumed by the cataloguer and his readers to have covers without the need to make the point, and the same principle must be deemed to have governed the description of cream bowls.

DINNER SERVICES

As the Royal Service made for William IV is still preserved at Buckingham Palace, its composition is ascertainable. The details are set out on page 38. Moreover, we learn from Jewitt[1] the composition of the services made for the Duchess of Cumberland and the Duke of Sussex. The former consisted of:

> 6 Plates Interiors
> 6 „ Shells
> 6 „ Birds
> 6 „ Fruit
> 6 „ Landscapes (real views)
> 6 „ Marine

and the comports elevetated [sic] (Des Assiettes Elevès) to be same of [sic] those of His Majesty; to be shewn to her as they are prepared in turns for the King to see.

> Price 250 guineas
> 36 Plates, gad.g.
> 12 Comports or W.S.
> 2 Cream Bowls
> 2 Ice Cellars.

[1] *Ceramic Art in Great Britain*, Vol. 1, p. 504.

The latter comprised:

> Forms same as H.M's.
>> Plate—Essex—but same size as H.M's.
>>> 4 Large Dress Plates
>>> 4 Second size　do
>>> 8 Small　do　　do
>>> 4 Ice Pails (Handles à la Warwick)
>>> 4 Pine and Grape Baskets
>>> 8 Peach Baskets—say 4 Mulberry and 4 Pine
>>> 4 Fruit Comports
>>> 4 Shell　　　„

> 40 Pieces　　　perhaps　500 guineas
> 6 doz. of Plates　. .　　will be　　360　　„

>　　　　　　　　　　　　　　860　　„
>　　　　　　　　　　　　　say £600
>　　　　　　　　　　　　　　　for ⅔

Furthermore, there must have been many other services produced on the same basis, e.g., for the Duke of Sutherland, the Duke of Cambridge, and the King of the Belgians.

When we come to consider the more lowly dinner services, made for the middle-class rather than the aristocracy, great difficulty attends the discovery of their composition owing to their failure to survive intact or in any way approaching that state. The problem is further complicated by the fact that, although plates are normally marked and therefore readily attract notice, the other pieces will in almost every case have been unmarked—so that, once separated from their plates, they are liable to pass from hand to hand unrecognised for what they are.

Accordingly, of inestimable importance is the detailed description of the four dinner services offered for sale by Mr. Christie on 12th and 13th February 1830. The catalogue reads as follows:

12th February

LOT 30　　A dinner service, painted with rose, thistle and shamrock, consisting of two soup turennes and covers, four sauce ditto, covers and stands, a salad bowl, four vegetables dishes and covers, thirteen dishes, seventy table and seventeen soup plates.

LOT 58　　A dinner service, painted with roses, consisting of seventy-three plates, twelve soup ditto, eighteen dishes, four ditto and covers, four sauce turennes, covers and stands, two soup turennes, covers and stands, and salad bowl; in all 134 pieces.

13th February

LOT 32 A dinner service, consisting of fifty table plates, seventeen soup plates, fourteen dishes, four dishes and covers, four sauce turennes and stands, two soup turennes, a fish drainer and a salad bowl.

LOT 52 A dinner service, consisting of seventy-one plates, seventeen soup ditto, fifteen dishes, four ditto and covers, four gravy turennes, stands and covers, two soup ditto and covers, and a salad bowl,—one hundred and twenty-eight pieces.

A larger service was put to auction on 7th July 1959:

A large Rockingham dinner service, each piece painted with floral bouquets within sky-blue borders and feather moulded rims comprising 2 soup tureens, covers and stands, 2 other tureens, 6 vegetable dishes and 4 covers, 18 dishes, 5 sauce tureens and covers, fruit dishes and 119 plates. Some pieces damaged. Some pieces marked with printed 'Griffin' mark.

It made £240.

Once again, we must bear in mind that these services were in the nature of remnants rather than entireties. However, from the earlier sale certain characteristics manifest themselves. First, a salad bowl appears to be a standard feature. There is no evidence as to its shape; but perhaps some of the circular bowls commonly called punch bowls are, in reality, salad bowls.

A second characteristic of a Rockingham dinner service is the presence of four vegetable dishes with covers, two soup tureens, covers and stands, and four sauce tureens, covers and stands. The number of plates seems to have varied, but they were supplied in considerable quantities. No indication is given of any variety of shape or size. Nor is it possible to lay down the number of soup plates and dishes.

Surprisingly, perhaps, no mention is made of broth bowls, although their existence is substantiated by the example in my own collection illustrated in Plate 88. It is circular in shape, 6 inches in diameter, with a cover surmounted by a twig handle in gold. The stand, 6 inches in diameter, bears the puce mark. The decoration consists of a flower pattern in underglaze blue.

One word of warning. Do not be misled by the numerous unmarked dessert and dinner services that pass through the auction houses and the trade generally and are described as 'Rockingham'. For all practical purposes, unless at least one of the plates is marked, a Rockingham attribution can be generally disregarded.

The Royal Service

The Royal Service is the property of Her Majesty the Queen and, needless to say, no part of it will ever come on the market. Moreover, it is not on public

display. However, its quality and historical importance are immense, and certain specimen plates are in private ownership as well as certain principal pieces of the same essential design.

The composition of the service, as it now exists, would seem to be as follows:[1]

Description	Height	Number
Three-tier compotier	22″	8
Two-tier compotier	19″	4
Cake comports (sheaf of corn stem)	9″	8
Dessert comports (pineapple stem)	10½″	4
Dessert comports (blackberry stem)	9¾″	3
Dessert comports (oyster coral-shell)	7″	4
Ice Pails or chalices (in Warwick style)	13″	7
Dessert comports on tree supporters with basket pattern bowl	12″	8
Small decorative pieces, vases	7½″	8
Decorative fruit comports (continental fruit sprays)	9″	8
Plates	9½″	119

Clearly, during the course of time, some twenty-five plates must have been rendered unserviceable, and presumably the same fate must have befallen one of the dessert comports (blackberry stem) and one of the ice pails. The appearance of the eight 'small decorative pieces, vases' is at first somewhat startling, but is understandable when it is realised that these were originally bolted into the 'dessert comports on tree supporters with basket pattern bowl'. They must subsequently have become separated. A vase properly attached to a comport essentially of this design can be seen in the example illustrated in Colour Plate I, which must have belonged to a service of similar standing.

For a detailed description of the Royal Service, one cannot perhaps do better than quote the observations of Jewitt:[2]

> The chef-d'œuvre of the Rockingham China Works was, however, the truly gorgeous dessert service made for William IV, which is now preserved with the most scrupulous care at Buckingham Palace, and is, we are credibly informed, justly prized by Her Majesty [Queen Victoria] as among her more precious ceramic treasures. This service, which cost no less a sum than £5,000, consists of one hundred and forty-four plates, and fifty-six large pieces, and is one of the finest produced in this or any other country. The plates have raised oak borders in dead and burnished gold running over a raised laced pattern, also in gold, and the centres are splendidly painted with the royal arms, etc. The comports, which were all designed by Mr. Thomas Brameld, are emblematical of the use

[1] As ascertained by A. A. Eaglestone and T. A. Lockett from Her Majesty's Master of the Household. See *The Rockingham Pottery*, p. 108.
[2] *Ceramic Art in Great Britain*, Vol. I, pp. 513, 514.

to which each piece has to be put. For instance, the comports for biscuit, are supported by ears of wheat; the fruit pieces have central open-work baskets of fruit; the ice pails are supported by holly berrics and leaves; and in each case the landscapes are also in unison with the uses of the pieces, which are of exquisite design, and have also oak-leaf and lace decoration, so massively gilt in dead and burnished gold as to have the appearance of ormolu laid on the porcelain, and each piece is decorated with views of different seats, the sketches for which were taken expressly for the purpose, and by groups of figures, etc. This service is, as I have said, at Buckingham Palace. In Dr. Brameld's[1] possession was the specimen plate which was submitted to, and approved by, the King, and some portions of the comports, etc: and in Mrs. Barker's[2] hands was one of the comports (with views of 'Langthwait Bridge', and 'Kentmore Hall', and a group of bird-catchers), which, for its extreme beauty and rarity, is an almost priceless treasure. She also possesses a cup and saucer of the breakfast service prepared for Her Majesty. In Mrs. Reed's[3] possession is a unique example, being one of the specimen plates submitted for royal approval in a competition with the principal china manufacturers of the kingdom for the royal order. In this competition, twelve plates of different patterns were specially prepared and submitted by the Rockingham Works. Of these plates, the examples in Mr. Reed's,[3] Dr. Brameld's, the Earl Fitzwilliam's, Mr. Hobson's[4] and other hands, form a part. In the centre are the royal arms, and the rim is decorated with oak-leaves and acorns. Another unique pattern-plate belonged to Dr. Brameld, and is of the most delicate and exquisitely beautiful character. In the centre are the royal arms, and on the rim are three compartments, two of which contain groups of flowers, and the third a view, while between these the 'garter' is repeated. The cost at which in the estimate it was calculated these plates could be produced, was twelve guineas each.

[1] Dr. Henry Edward Brameld (1821–1907) was the third son of Thomas Brameld. He qualified as a physician and surgeon, being so described at the date of his second marriage to Mary Hargrave on 18th May 1875. In White's *Directory of Sheffield, etc.*, for the years 1860 to 1865, he is described as 'Flint and Colour Grinder' at the Rockingham Works, doubtless having taken over the business from his mother on her death (see *R.O.P.*, pp. 10–11). At this date, his brothers had been ordained into the Church of England.
Dr. Brameld's first wife was a Mrs. Becket. Whether she was connected with the Beckitt or Beckett who was a partner in London of John Thomas Brameld (see also page 130) or whether she was the widow of or related to John Stainforth Beckett, Esq. who, according to White's *Directory of Sheffield* for 1845, was resident at 'Swinton House', poses an interesting line of enquiry. (Contemporary spelling was sometimes inclined to be a little inconsistent.)
[2] Doubtless the widow of Samuel Barker, once owner of the neighbouring Don Pottery, or of some other member of his family.
[3] Mr. Reed was presumably Mr. John Reed who was the proprietor of the neighbouring Mexborough Pottery until his decease.
[4] Presumably, William Hobson who, first with his father Peter and later on his own account, produced earthenware at the Rockingham Works long after the Bramelds had left it. See White's *Directory of Sheffield, etc.*, 1852, 1856 and 1860.

Although the figure of £5,000 is indeed astounding for a dinner service, particularly when this sum is translated into current monetary terms, it would seem that the aristocracy were accustomed to paying quite fantastic amounts for their dinner ware when it was executed in silver or silver-gilt. Thus, Richard Rush, American Minister at the Court of St. James from 1817 to 1825, observes on page 72 of his *Memoranda of a Residence at the Court of London*, 1833, as follows:

> I went into . . . Rundel and Bridge, on Ludgate Hill . . . In a room upstairs, there was part of a dinner service, in course of manufacture. The cost of an entire service, varied from thirty to fifty thousand pounds sterling, according to the number of pieces, and workmanship.

Despite the £5,000 paid for the Royal Service, the factory is said to have lost money over it, which loss in no small measure contributed to the factory's financial downfall. According to Jewitt:[1]

> Although so large a sum of money was paid for it, the cost of its production was so great, that the actual outlay was, I am told by those who are in the best position to know, considerably more than was charged. This royal service had some little to do with the embarrassment that caused the final stoppage of the Works.

Three of the twelve specimen plates referred to by Jewitt—each edged with shark's teeth moulding and 'S' scrolls, and measuring $9\frac{1}{2}$ inches in diameter—are illustrated here in colour. The first (Colour Plate IV) is decorated around the light blue rim with entwined oak branches and acorns and with four beautifully executed vignettes depicting sea scenes, one of which includes a flagship with 'W.R. 1111 A.R.' inscribed. In the centre, it is painted with the Royal Arms set against a rich background of purple drapery. The mark on the back is extremely interesting in that it consists of the griffin and the caption 'Rockingham Works Brameld', all in puce instead of the normal red. The armorial decoration was executed by George Speight, as indeed was the small pink rose charmingly interposed with the intricate design of the Royal Arms.

Before I acquired them, the other two specimen plates[2] belonged to the Worcester Royal Porcelain Works Museum—which has a portion of one of the plates actually supplied to William IV as part of his service but sent there from Buckingham Palace to enable the Worcester factory to match it up. (The cost was so great, however, that order was never given.) Both plates are decorated in the centre with the Royal Arms—hung in the one case with the George and the Golden Fleece and in the other with the George alone—but whereas one is painted around the border with a wreath of oak leaves and acorns on a green ground and with vignettes of ships and an exotic bird in

[1] *Ceramic Art in Great Britain*, Vol. 1, p. 514.
[2] Also illustrated in colour in W. Moore Binn's *The First Century of English Porcelain*, 1906, facing p. 232.

flight (Colour Plate V), the other has a gilt circle of fruiting vine surrounding the Royal Arms and an orange border decorated with oak, leeks, shamrock, roses and thistles (Colour Plate VI). It is interesting to note that on the back of the one shown in Colour Plate V, painted in old script, which if not contemporary with the plate's manufacture dates well back into the nineteenth century, are the following attributions:

> Speight arms
> Bailey gilding
> Brentnall wreath

Both plates are marked in puce—the first with the 'Manufacturer to the King' caption, the latter with the rarer variant 'Royal Rock^m Works'.

The present whereabouts of other specimen plates is known. So, too, is that of certain plates, which clearly must have been 'overs', identical with those actually supplied to William IV. These, when they appear in auction catalogues and other literature, are sometimes described as formerly belonging to the King. This claim is, of course, untrue. An example occurs in Mrs. W. Hodgson's *Old English China*, published in 1913, where the following caption appears relating to a royal plate illustrated facing page 122:

> Plate, royal arms in colours. St. George and the Dragon in green, wreath of rose, shamrock and thistle in colours, gilt. Branches of oak and acorns in matted gold moulded and chased upon pale blue ground, gold wire trellis, edged thick gold on moulded rim. Mark, griffin in pink surrounded by wreath and inscription; 1832 in gold. Bought at Christie's for 56 guineas. Part of Dessert Service made for William IV, which brought a heavy loss on the factory.

Two specimen plates are in the Victoria and Albert Museum, having been donated by the fifth Earl Fitzwilliam—one having a green rim, the other a blue rim, and both marked 'Royal Rock^m Works' in puce—and several are said to remain with the present Earl Fitzwilliam. As for the 'overs', one which is unmarked is in the Rotherham Museum (Plate 55), another is in a private collection, and one damaged example is in the Yorkshire Museum. A further example, together with the plate referred to by Jewitt as made for Queen Victoria, is reputed to have been sold in about 1952 by a Cambridge antique dealer and is thought still to be in the same private ownership.

Three royal plates—as to two of which it is unknown whether they were specimens or 'overs'—were acquired by a notable collector, Edward Bond, and were subsequently sold by him, along with another plate decorated with painted mushrooms, for 101 guineas at an auction held at Leeds in October 1884. The one which was undoubtedly an 'over' was later acquired by the firm of Stoner and Evans and advertised for sale, with a full-page illustration, in *The Connoisseur*, June 1911, page xvi. It is there described as also having once formed part of the Wentworth Wass collection. According to Chaffers'

Marks and Monograms on Pottery and Porcelain 14th edition this collection contained two royal plates. It is interesting to note that in the Fourth Edition of Chaffers', published in 1874, the following observation is made on page 780:

> A specimen plate of [the royal service] was recently sold by auction for the enormous price of £30.

However, at Christie's on 29th January 1909 a 'Pair of plates painted with the Crown, Lion, Rose, Thistle and Shamrock, the border gilt, with the Garter motto on dark blue ground (said to have belonged to William IV)' went for only £48 6s. od. Whether these two plates formed part of the Edward Bond collection, it is quite impossible to say.

An impression of the quality and style of the comports actually supplied to the royal order is vividly revealed in the magnificent comport shown in the Frontispiece. It consists of a pierced bowl supported on a stem of white and gilt oak branches, themselves standing on a circular base painted with two panels of eider ducks separated by two panels of gilt tracery on a light blue ground, and it is 14½ inches high by 10¼ inches wide. The bowl holds a small overhanging vase moulded with primrose-leaf decoration in green. The base and stem are encrusted with gilt acorns and white and gilt oak leaves; and beneath the everted rim of the bowl, decorated with a light blue ground, is a continuous chain of applied roses, shamrock and thistles in natural colours. A similar specimen with raised gilt tracery and painted views of Raby Castle in Durham and Netherby in Cumberland on the base and with raised gilt oak leaves and tracery on the rim of the bowl is to be seen in the Sheffield Museum. The centre is modelled in the form of fruit, branches and leaves (Plate 57).

Although the Rockingham factory is renowned in ceramic literature for its Royal Service—the order for which, according to Jewitt,[1] it received in 1830—no discussion has as yet been directed to the length of time involved in the service's actual production. Jewitt tells us[2] that he had in his possession the 'Original Designs for His Majesty's Dessert' bearing the date 12th November 1830. In the absence of further evidence, it would be reasonable to assume that the service was manufactured with normal expedition. The royal plate illustrated in Mrs. W. Hodgson's *Old English China*, facing page 122, is there stated to bear the date 1832 in gold. Accordingly, one would have assumed the service to have been completed by about 1832–33. But was this the case?

Without doubt, the service was not completed before 1833—for there are two references to its non-delivery in the Wentworth Correspondence. First, in a letter from Thomas Brameld to William Newman dated 28th August 1832:

> The service we are preparing for the King will now be completed with an outlay of from 5 to 700 £—and when we are paid for it we can pay you an extra sum of 2,000 £.

[1] *Ceramic Art in Great Britain*, Vol. 1, p. 504.
[2] Ibid, p. 505.

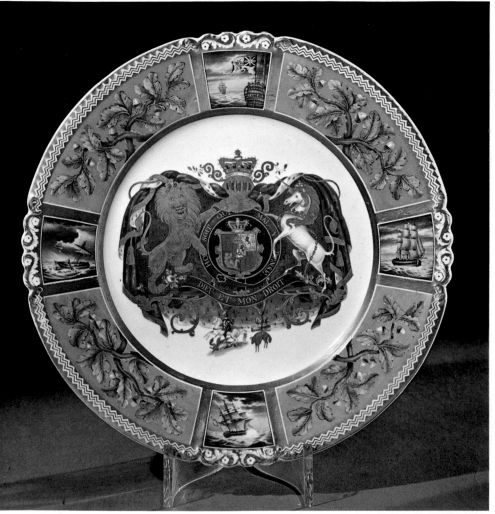

IV. Royal specimen plate, decorated around the light blue rim with entwined oak branches and acorns and with four finely executed vignettes of seascapes (one of a flagship inscribed "W.R. 1111 A.R.") and painted in the centre with the Royal Arms (hung with the George and Golden Fleece) set against a rich background of purple drapery. 9½ inches in diameter. Griffin mark, "Rockingham Works, Brameld" in puce. See page 40.

When this Service—and that for the Duchess of Cumberland are de-livered—we very confidently anticipate a considerable increase to our retale trade.

And again, in a letter from Thomas Brameld to The Rt. Hon. Visc. Milton, son of Earl Fitzwilliam, dated 8th September 1832:

. . . if you can have confidence in us so far as kindly to assist us with the loan of 2,000 £ until we can finish, and get paid for His Majesty's Service—we will then re-pay it.

But when, after 1832, was the service actually completed?

Unfortunately, Jewitt says nothing directly bearing on the question. How-ever, he does observe[1] that the Royal Service 'made for William IV was first used on occasion of the coronation of our beloved Queen [Queen Victoria] and has only, I am informed, been used on very special state occasions from that time to the present.' Now, if William IV had specially commissioned a magnificent service and had resolved to spend an astronomic £5,000 on it, it passes comprehension that he never bothered to use it—unless, of course, he never received it in his lifetime. If the service was not completed until 1837, the year of William IV's death, it makes perfect sense that the first occasion on which it was used was at Queen Victoria's coronation.

But this suggestion by itself would be nothing more than unsupported conjecture were it not for a most interesting statement by John Timbs in his *Curiosities of London*, 1885, at p. 606. There, he specifically observes that the service took five years to complete and that it was put on display at the factory's showrooms at 3 Titchborne Street in 1837. This statement cannot be entirely correct, as we know for certain that the order was given in 1830. In fairness to John Timbs, although the official order may indeed have been given in principle in 1830, it is possible that William IV might not have got round to stipulating his detailed requirements for a further eighteen months or so. He might well have taken until 1832 to complete his selection from the various specimen pieces, drawings, etc., offered up to him. But the fact is that the order was given in 1830. On the assumption that John Timbs was accurate in other particulars, however, the service must have taken seven years to complete. If this conclusion is correct, then everything fits into place. Moreover, there is the tradition that, despite the vast sum paid for the service, the Bramelds lost money over the order and that this loss con-tributed considerably to the ultimate financial collapse of the factory. Assum-ing that this was so, while it would be possible for the detrimental effects of an unsatisfactory order fulfilled in say 1832–3 to persist eight or nine years later, it would be far more likely for the impact to be felt in the factory's de-clining years if the order was not in fact completed until 1837.

[1] Ibid, p. 514.

E

Tea and Coffee Services

Rockingham is justly famous for its tea and coffee services. The variety of their decoration is immense, ranging from themes of simplicity and restraint to an exuberance expected of a late Regency production. But whereas it is impracticable to list the different kinds of decoration that might be encountered, classification of the various shapes assumed by the factory's services presents a more realistic goal. Of course, it must not be assumed that the forms discussed below are in any way exhaustive.

The normal composition of a full Rockingham tea and coffee service consists of a teapot, cover and stand, a sucrier and cover, a cream jug, a slop basin, two bread and butter plates, twelve tea cups, twelve coffee cups, and twelve saucers, the latter being employed as required with either the tea or the coffee cups. Apart from the evidence of surviving sets, more direct confirmation can be found in the details of the two sales of Rockingham ware conducted by Mr. Christie on 12th and 13th February 1830 which form Appendix F. Many of the lots consisted of tea and coffee services, and the normal composition was as described above. As the service discussed on pages 48–49 would indicate, sometimes, but very rarely, a coffee pot and cover and an additional cream jug were added. Some services from both the red- and puce-mark periods also had side plates.

The different varieties of services that have so far been recorded are set out below.

SCALLOP-EDGED

This, together with the circular variety discussed immediately following, constitutes the most common type of Rockingham service of the red-mark period. Its distinctive feature is a noticeable scallop-edging. In addition, a slightly ribbed moulding is found on the body of the pieces; and the handles of the teapot, cream jug and cups are markedly angular. A typical teapot with its cover and stand, decorated with a rare chinoiserie pattern, basically underglaze printed but enamelled in places with overglaze colours, is illustrated in Plate 89. Beneath it are the matching tea cup, coffee cup and saucer.

A fine example of a tea cup and saucer, measuring $4\frac{1}{2}$ inches and 6 inches in diameter respectively is shown in Plate 91. The cup is decorated with a single tulip and the saucer with a poppy, possibly the work of Collinson, both pieces bearing underneath the Latin names 'tulipa' and 'papaver' respectively. Another example of truly remarkable thinness, is also illustrated (Plate 105c). Both cup and saucer, $3\frac{7}{8}$ inches and 6 inches in diameter respectively, are enriched with a chain-link pattern in gold and with beautifully painted roses in pink. Finally, for excellence of workmanship displayed on an ordinary tea service, it is difficult to see how the painting on the turquoise-bordered saucer shown in Plate 105b could be easily surpassed.

The scallop-edged form of service usually appears with the red mark, but it was carried over into the puce-mark period. It must not be confused with a

remarkably similarly shaped service, which seems to be invariably unmarked and is variously ascribed by catalogues to Coalport, Spode, Rockingham, Minton, etc., according to their whim. Geoffrey Godden states that most examples of this form are of Ridgway manufacture—but they have nothing to do with Rockingham. A teapot from such a service is illustrated in Plate 89 with its cover and stand. It is slightly smaller than the Rockingham equivalent, and the handles are differently positioned. The same is true of the cups and saucers (Plate 90).

CIRCULAR-SHAPED

A service of this shape was auctioned by Mr. Christie on 13th February 1830, Lot 50 (Appendix F). The essential characteristic of this style is its circular form. Even the handles are upswept in the shape of an arc. In Plate 92 can be seen, from a service of this form, a teapot, cover and stand, together with a matching tea cup, coffee cup and saucer, decorated with an underglaze blue floral pattern enriched with gilding. A further pair of cups and saucers, this time painted with bouquets of flowers, is also illustrated (Plate 93) and is interesting for the fact that the ground colour is the extremely rare apricot. Another example illustrated (Plate 94) is, from its pattern number, clearly of early origin and has a very distinctive style of flower painting. And for sheer quality, it is not easy to contemplate anything that readily outshines in nineteenth-century useful ware the saucer shown in Plate 96 and now in the British Museum.

Circular-shaped services had their origin in the red-mark period but were carried on after 1830. Thus, the two saucers illustrated in Plate 95, $6\frac{5}{8}$ inches and $7\frac{1}{4}$ inches in diameter respectively, decorated with a chain-link pattern in gold, and painted in the one case with a named tulip and in the other with a named apple-blossom, carry the puce mark. From this same later period are a white and gilt breakfast cup and saucer in my own collection, 5 inches and 7 inches in diameter respectively.

EMPIRE-STYLE

These services are extremely rare. As their name suggests, they imitate the style of the French Empire period. Their proportions and quality are quite magnificent—particularly in the case of the teapot, with its bold and impressive phoenix spout. Specimen pieces are illustrated from two part services: one in white and gilt (Plate 99), the other decorated with a rich green ground and painted with floral bouquets in reserves linked by yellow festoons (Plate 98). The rose finials of the covers of each service are decorated in gilt and pink respectively; and both services are of particular interest in that the handles consist of a horse's tail joined to its lower leg, in direct imitation of certain of the factory's earthenware products. (See the mug and the set of three jugs made of cane-coloured ware, illustrated in Plates 39 and 40, and the cabinet mug in porcelain shown in Plate 144.)

Both the services illustrated carry the red mark on the saucers. Their measurements are as follows:

	Measurements		
	Length	*Height*	
Teapot	$10\frac{5}{8}''$	$7''$	(with cover)
Sucrier	$8\frac{7}{8}''$	$6\frac{1}{4}''$	(with cover)
Jug	$7\frac{1}{2}''$	$4''$	
Slop Basin	$6\frac{3}{8}''$	$4''$	

	Diameter		
Bread and butter plate	$9\frac{1}{4}''$		
Tea cups	$3\frac{7}{8}''$	$3''$	(with saucer)
Coffee cups	$3\frac{1}{8}''$	$3\frac{1}{2}''$	(with saucer)
Saucers	$6''$		

PRIMROSE-LEAF PATTERN

Services of this rare shape were moulded with a primrose-leaf pattern, the handles being of an entwined rustic nature. An example in white and gilt is illustrated in Plate 97. It suffers considerably from firing cracks, suggesting that the paste was early. But the feel is delightful, and the gilding is thickly applied.

These services had their origin in the red-mark period but were carried on after 1830.

	Measurements		
	Length	*Height*	
Teapot	$10\frac{1}{4}''$	$7''$	(with cover)
Sucrier	$7\frac{1}{2}''$	$6\frac{1}{2}''$	(with cover)
Cream jug	$7''$	$4''$	

	Diameter		
Slop basin	$6\frac{5}{8}''$	$4\frac{3}{8}''$	
Teapot stand	$8\frac{1}{4}''$	$1\frac{1}{2}''$	
Bread and butter plates	$9\frac{1}{2}''$	—	
Tea cups	$4\frac{1}{4}''$	$3\frac{1}{4}''$	(with saucer)
Coffee cups	$3\frac{5}{8}''$	$3\frac{3}{4}''$	(with saucer)
Saucers	$6\frac{1}{4}''$	—	

BUCKET-SHAPED

Rockingham produced services whose cups and saucers were shaped rather like a bucket, round in form and tapering from top to bottom. A service of this shape was offered for sale by Mr. Christie on 13th February 1830, Lot 64 (Appendix F). But these services must have been manufactured only on a

small scale in that, to date, the principal pieces have not been recorded. Only cups and saucers have survived, and then most infrequently. An example of such a tea cup and saucer, decorated with a green ground and a painted view (Plate 101), can be seen in the Sheffield Museum. The other specimen illustrated (Plate 100) has a most unusual puce ground on which coloured insects are reserved, and the inner rim of the cup itself is finely gilded with a motif of vine-leaves and tendrils.

Four sets of bucket-shaped cups and saucers—each comprising a tea cup, coffee cup and saucer—were sold at a sale at Bovingdon Lodge, Bovingdon, Hertfordshire in October 1961. They had a green ground and were beautifully painted with shells. They were eventually exported to Canada.

Most of the cups and saucers of this kind that I have seen belong to the early period.

CONTINENTAL-STYLE

The existence in the red-mark period of another variety of service, based on Continental models, can be inferred from the magnificent cabinet teapot, sucrier and cream jug illustrated in Colour Plate 13 of my *Rockingham Ornamental Porcelain*. These shapes must have been reproduced with simpler and less elaborate decoration than that found on the cabinet specimens. Proof positive lies in the unmarked white and gilt cream jug appearing in Plate 115, identical in size and shape to the cabinet cream jug except for the slightly less refined applied foliage and flower decoration. A white and gilt milk jug of this same shape, but without embellishment, 6½ inches high, is illustrated alongside the cream jug, together with an extremely rare toast rack, 8 inches long, and one of a set of three surviving egg cups and stands. The milk jug, the toast rack, and the egg cup and stand carry the puce mark and, like the little cream jug, are crested with an earl's coronet and the letter 'R', signifying that all four originally shared a common ownership—in fact, that of the Earl of Radnor.

FLUTED-DESIGN

On rare occasions, we encounter cups that have a slightly fluted moulding around the body, their handles being either rustic or angular in form (Plate 102). The accompanying saucers, both red- and puce-marked, are circular and deep.

This shape is, on occasion, found with an applied shell-motif in blue. (See also page 32.) An example can be seen in the Rotherham Museum.

The main pieces which must have accompanied these fluted cups and saucers have not so far been recorded, except for an individually marked cream jug decorated with moths and botanical specimens and illustrated in Plate 103.

EARLY NEO-ROCOCO

These services, which belong exclusively to the puce-mark period and are more frequently found than any other variety, are in the neo-rococo style and have, as a further distinctive feature, principal pieces with either scrolled handles and coronet knobs or else rustic handles and twig finials. As for the cups and saucers, slop basin, and bread and butter plates, these are moulded with either a basket-weave pattern, the handles assuming a rustic form, or raised 'C' scrolls, the handles being shaped with three distinctive spurs.

A service decorated with a grey ground and a seaweed pattern in gilt is shown in part in Plates 104a–e as an interesting illustration of the early neo-rococo style. Consisting of forty-nine pieces, it is remarkable for its extent in that it includes a teapot and lid, $7\frac{1}{2}$ inches high by $9\frac{3}{4}$ inches long; a coffee pot and lid, $8\frac{1}{2}$ inches high by $9\frac{1}{4}$ inches long; a sucrier and lid, $6\frac{1}{2}$ inches high by $7\frac{1}{4}$ inches long; two cream jugs, 4 inches and $4\frac{5}{8}$ inches high respectively; a slop basin, $3\frac{1}{4}$ inches high and $7\frac{1}{4}$ inches in diameter; four bread and butter plates, 9 inches by $10\frac{1}{2}$ inches; twelve tea cups, twelve coffee cups, and twelve saucers, $4\frac{1}{8}$ inches, $3\frac{7}{16}$ inches and $5\frac{7}{8}$ inches in diameter respectively. The finials on the principal pieces are in the form of coronets, and the handles are constructed with a scrolled moulding. The saucers, as was customary with Rockingham services of whatever period, were used with either the tea cups or coffee cups. In all probability, this particular service was originally large enough to accommodate twenty-four persons. The survival of four bread and butter plates and two cream jugs would seem to support this theory. It is also likely that there were side plates: an example with the same design and pattern number was subsequently acquired by me, but not from the same source.

Side plates, incidentally, are extremely rarely found—to the extent that writers have erroneously denied their existence in Rockingham services. However, they undoubtedly were produced (perhaps for breakfast rather than tea services)—several of different patterns being in my own collection—and were probably made more frequently towards the end of the factory's existence. Their eminent suitability for everyday use in Victorian households must, in most cases, have ensured their eventual destruction where the remainder of the service would, to a large extent, have survived. Thus, the dearth of side plates today need not be a true criterion of the quantity in which they were actually produced.

To return to the above-mentioned service, it has a special interest on account of its coffee pot (Plate 104e): for apart from the intrinsic rarity of this piece—no other example having been recorded to date—it provides a vital link between the early neo-rococo tea services and the later and rarer design shortly to be described. For this coffee pot, with its sweeping handle, double-branched at the point where it connects with the upper part of the pot, and with its solid albeit shaped base, appears essentially as the teapot of the later design—the only significant difference being that the cover of the latter is no longer shallow and surmounted by a coronet but is sharply pitched and

finished with a finial in the form of an acorn. Again, the larger jug of the service illustrated (Plate 104b) is likewise adopted by the later services, except for the substitution of the solid base of the coffee pot in place of scroll feet and the disappearance of the single scrolled handle in favour of the twin-branched sweeping variety.

The service illustrated in Plate 106, with its magnificent green ground offset with yellow, its fine gilding, and its exquisitely executed floral bouquets, shows some interesting variations from the grey service. The coronet finials are replaced by rustic knobs, and the handles likewise have a rustic form instead of a scrolled motif. The more rounded slop basin, with its reticulated or basket-weave moulding, matches cups and saucers of this same design—as did the two bread and butter plates, now lost. Another service in my own collection, this time with the rare turquoise ground colour, is of the identical shape of that just described, except that the slop basin and cups and saucers are not reticulated but are of the raised 'C' scroll variety seen in the large grey service already discussed, and the one surviving bread and butter plate is round.

Cream jugs accompanying early neo-rococo services with twig finials were normally about $3\frac{5}{8}$ inches high, but sometimes they were produced in a larger size. Where they were made with a scrolled handle to accompany coronet-knobbed principal pieces, their overall height was increased to about 4 inches. A further service in my collection, decorated with a claret ground and the same gilt pattern used on the green tea-set already described, has a cream jug measuring $4\frac{1}{4}$ inches in height.

A selection of basket-weave cups and saucers is illustrated in Plates 107 to 110, with decoration ranging from some exquisitely painted flowers on a coffee cup and saucer (Plate 107)—which virtually acquire cabinet status thereby—to a green underglaze pattern in a rare chinoiserie design (Plate 110). Included are a magnificent quality group of tea cup, coffee cup and saucer, brilliantly gilded and painted against a rare crimson ground (Plate 108); a tea cup and saucer printed in green with the so-called 'Blackberry' pattern attributed to Llandig and decorated in the centre with a flower (Plate 109a); and a breakfast cup and saucer painted with morning glories (Plate 109b).

An example of a three-spur cup and saucer is also given (Plate 105a). It is striped with grey and painted with floral groups.

LATER NEO-ROCOCO

Another variety of service in the neo-rococo style but clearly made at a later date, seemingly towards the very end of the factory's life, has as its distinctive features a tall teapot, upswept double-branch handles and a solid albeit shaped base on the principal pieces, finials in the form of acorns, and single-spur handles to the cups. This type of service has proved somewhat controversial, inviting doubt as to whether or not a Rockingham attribution should be assigned to it. An example is in the Rotherham Museum. It is decorated with

a grey ground colour and with landscapes. Specimen pieces from another service, this time decorated with an underglaze floral pattern in navy-blue, are shown in Plate 111 by way of illustration of the shapes. Both services are marked in puce on the saucers. But other services are sometimes encountered which are either unmarked or marked only on a few of the saucers. More significant, the quality of the paste is generally harsher to the touch than is usual with Rockingham pieces. It has also been argued that it is perhaps surprising to find, in addition to the normal neo-rococo style of service, another version in essentially the same spirit. Having regard to the immense cost of moulds and the financial straits the factory was in towards the end of its existence, it is difficult to see why this second form of neo-rococo service should have been produced. However, the decoration of these services would, at any rate, seem to be pure Rockingham. Accordingly, it has been suggested that perhaps the porcelain was imported into Swinton from some other factory and decorated there by Rockingham artists. This would dispense with the question of new moulds and would account for the difference in paste.

However, the remarkable similarity between the coffee pot of the coronet-knobbed style of service previously described and the teapot of this controversial production would lend some support to the view that the porcelain was of genuine Rockingham manufacture. Of greater significance are the excavations recently undertaken on the site of the old works which have revealed wasters of the single-spur handle that goes with cups belonging to this type of service. In any event, whatever doubt there might be is surely dispelled completely when we look at two green cups and saucers of this shape now in the Victoria and Albert Museum and illustrated in Plates 113 and 114. They must have been specimen pieces, rather like the specimen plates of the Royal Service, from which some member of the aristocracy was to select a particular design for the tea service he wished to order. The cups and saucers are of exceptionally fine quality, richly embellished with raised gilding and adorned with a coronet. It is inconceivable that they were produced from anything other than pure Rockingham porcelain.

It is clear, then, that this type of tea service is perfectly genuine Rockingham; but it must have been produced towards the end of the factory's existence—all the pattern numbers so far recorded seem to be rather late—when the paste appears to have deteriorated in quality.

However, this conclusion still leaves us with a problem which has not yet been properly explored. To what extent did the Rockingham factory, particularly in the final months of its existence, buy in ware from other manufacturers and decorate it at Swinton? A tea cup, coffee cup and saucer set, belonging to a service of the shape just discussed, is illustrated in Plate 112 for the rarity of its decoration—Japan pattern is not often found on Rockingham porcelain—and the unusual variation in shape of the handle of the tea cup. The abnormality of handle may invite rejection of the piece as being an import from another factory that was decorated at Swinton. This practice of buying it from elsewhere was certainly carried on by other factories, principally to make good production deficiencies. In the case of certain Rockingham tea

ware of clearly late date, some quite unusual variations of shapes have come to light. No attempt has been made here to list these oddities. At this stage in our knowledge of the factory's history, definite pronouncement on the origin of these pieces is impossible. Suffice it to say that they are invariably of poor quality, are worthy of attention only as curios and, in so far as they truly belong to the factory, are the products of its closing days when the works were bedevilled with insolvency and approaching extinction.

Breakfast Services

These were normally combined with tea and/or coffee services. Seemingly, in their simplest form, they were restricted merely to the addition of a dozen breakfast cups.[1] But frequently they were considerably more extensive in range. Sometimes they had separate saucers corresponding in size with the breakfast cups,[2] and often they included egg cups[3] with stands attached (Plate 115) or separate, or with a single large group holder,[4] a milk jug,[5] a butter tub and stand,[6] muffin dishes and covers,[7] a honey pot and stand,[8] a roll tray,[8] toast plates,[9] dishes,[10] and plates[11] (i.e., over and above the standard two bread and butter plates belonging to the tea/coffee services). In addition, the Rockingham factory produced toast racks, an excellent example of which in white and gilt, crested with an earl's coronet surmounting the initial 'R', is illustrated in Plate 115 together with the milk jug which went with it. The shape of the latter is most rare and corresponds with the cream jug shown adjacent to it, except for its greater size and its freedom from any form of applied decoration. The matching egg cup with stand attached is also illustrated (Plate 115).

[1] Christie's Sale, 1830. (See Appendix F) 12th February, Lot 48.
[2] Ibid, 12th February, Lot 69. A composite service in white and gilt sold in London in 1966 contained twelve breakfast cups and saucers.
[3] Ibid, 12th February, Lots 12, 17 and 69; 13th February, Lot 11.
[4] Ibid, 12th February, Lot 69; 13th February, Lot 11.
[5] Ibid, 12th February, Lots 12, 17, 69; 13th February, Lot 11.
[6] Ibid, 12th February, Lots 17 and 69; 13th February, Lot 11.
[7] Ibid, 12th February, Lots 17 and 69; 13th February, Lot 7.
[8] Ibid, 12th February, Lot 69.
[9] Ibid, 12th February, Lot 17.
[10] Ibid, 12th February, Lot 69.
[11] Ibid, 12th February, Lots 12, 17 and 69.

Chapter IV

Ornamental Porcelain

The finest production of the Rockingham factory was undoubtedly its ornamental porcelain. At best it equalled in quality, and often surpassed, anything manufactured elsewhere in the nineteenth century. It is only in recent years, with the immense quantity of pseudo-Rockingham correctly assigned to its undistinguished origin in the Staffordshire potteries, that the intrinsic worth of genuine Rockingham has come to be properly evaluated, and many of the disparaging remarks made by certain ceramic writers have been reassessed in the light of the new evidence available. In particular, the translucency and softness of the Rockingham paste far transcends that of contemporary Worcester, Derby, Spode, Davenport and Minton, and only marginally falls short of the excellence of Nantgarw. But unlike the Welsh paste, the Rockingham body was strong enough to assume a multitude of different forms and was in no way restricted to an essentially flat-ware production. Most of the ornamental shapes recorded to date have been discussed at length in my *Rockingham Ornamental Porcelain*, and the majority have been illustrated in that work. Accordingly, in order to keep this book, which deals with the whole range of the factory's output, within reasonable limits, a somewhat briefer though nonetheless comprehensive account of ornamental porcelain is given here; and the illustrations, generally speaking, relate to shapes that have not hitherto been reproduced. To assist the student further, where a particular shape has been illustrated in *Rockingham Ornamental Porcelain*, the appropriate reference is given immediately after the description of the shape.

Ornamental porcelain can be divided into two periods—the red-mark era, 1826–30, and the puce-mark era, 1831–42. After 1830, the style of Rockingham ornamental porcelain changed. Its previous dependence upon Derby and other contemporary factories for its inspiration gave way in the puce-mark period to a more individual style based on the neo-rococo, with its emphasis on flower encrustation and its more complex forms. The gilding, though still rich, lost some of its earlier lavishness.

Vases

Numerous vases and/or jars were included in Christie's Sale of 12th and 13th February 1830 (Appendix F). Unfortunately, no indication is given as to their shape. Some of the finest pieces emanating from the factory were in the form of vases. Sometimes they were produced as singles, but more frequently as pairs or garnitures of three, five or even seven. Certain shapes are reasonably common; others are almost unique. The classification adopted here will begin with the earliest designs. The two famous rhinoceros vases, whose existence—one at the Rotherham Museum and one at the Victoria and Albert Museum—has done so much to evoke the harsh and unjustified criticism directed at the alleged tastelessness of Rockingham, are by virtue of their special position discussed separately in Appendix B.

EMPIRE-STYLE VASES OF URN SHAPE

These are extremely rare, their ultimate inspiration deriving from the Continent but more immediately from the production of the Derby factory—to which the uninitiated could mistakenly assign this type of vase. A fine example is in the Sheffield Museum. It stands $10\frac{3}{4}$ inches high on a pedestal base approximately 4 inches square. The diameter at the overhanging rim is $8\frac{1}{4}$ inches. The piece belongs to the red-mark period and is finely painted on the front panel, reserved upon a green ground, with a basket of flowers placed upon a table.

R.O.P. Plate 23.

A further example from the red-mark period (Plate 116) measures $14\frac{1}{4}$ inches in height. It is painted on one side with an oblong panel enclosing a basket of flowers on a marbled plinth. The reverse is decorated with gilt foliate scrolls and a further basket of flowers.

EMPIRE-STYLE VASES OF AMPHORA SHAPE

No less rare are the amphora shape vases with loop handles. Standing on a square base, they have an ovoid body, a flared-mouth and loop-handles, finished with palmette and lotus flower terminals more characteristic of Derby. A garniture of three, having in addition to the red griffin mark the raised concentric rings often found on hexagonal vases, have been recorded measuring 11 inches, $13\frac{3}{4}$ inches and 11 inches in height. The front of each is reserved with a floral spray in a rectangular panel on a dark green ground. Another vase of this shape is reproduced in *The Connoisseur*, December 1912, page xxxii.

OVERHANGING-LIP VASES

Vases of this kind have as their distinctive feature a lip which overhangs the main body to such an extent that the overall diameter at the top approximately

equals the actual height of the vase. They are reasonably common, originating in the red-mark period but continuing over into the puce. The shape is rather peculiar to Rockingham and examples occur in varying heights, e.g., $3\frac{1}{4}$ inches, $4\frac{1}{4}$ inches, 6 inches, 7 inches and $8\frac{5}{8}$ inches.

An exceedingly rare pair of miniatures, only $1\frac{3}{4}$ inches high, finely painted with a continuous landscape and richly gilded, is illustrated in Plate 117. They belong to the red-mark period and have, in addition to the griffin, the 'Cl.' mark followed by the remarkably high number 17.

R.O.P. Plates 24, 25 and 33.

HEXAGONAL VASES

These, perhaps more than any other shape of vase, are nearest to the spirit of the eighteenth century. They are extremely tasteful, their inspiration probably deriving from the Chinese, and they generally have under their base a series of raised concentric rings. They are six-sided and have an overlapping cover surmounted by either a rose (Plate 119) or monkey finial. The latter type of knob is normally gilded, but a rare variant is in grey (Plate 118).

Hexagonal vases, which were also made in earthenware (see also page 25), appear in differing sizes—those with monkey finials being slightly taller than those with rose knobs—from $8\frac{1}{2}$ inches to about 3 feet. They have not as yet been recorded with flower encrustations. They belong essentially to the red-mark period, though they were also produced after 1830. They were supplied as singles and in garnitures up to seven. One set of seven is known where, in order to relieve the possibility of monotony in the design, two vases in the form of beakers were substituted for two of the conventional shape.

R.O.P. Colour Plate 2; Plates 26, 27 and 28.

TRUMPET-SHAPED VASES

The distinguishing characteristic of this type of vase is its flared mouth. It was manufactured in quantity in both the red- and puce-mark periods, and is very similar in form to the productions of many other factories. It occurs in varying sizes, from miniatures of $1\frac{3}{4}$ inches high to a full size of $7\frac{5}{8}$ inches high. No examples have been recorded where flower-encrustations were employed, but a pair is known, which is covered all over with raised floral heads in the 'Mayflower pattern' except for two rectangular panels painted with garden flowers and bordered in gilt.

R.O.P. Colour Plate 3; Plates 29, 30, 31 and 32.

An unusual variant is shown in Plate 123 in which the body tapers more sharply than is normally the case. It stands $3\frac{7}{8}$ inches high and is finely painted with flowers in a basket on a ledge, surrounded with a gilt border and reserved on a claret ground. The reverse is decorated with raised gilding. It is marked in red.

SPILL VASES

These vases, made to hold spills, are cylindrical in form with round bases. Similar shapes were produced at other factories, so great care must be exercised to ensure that a vase has the true Rockingham proportions before this provenance is accredited to it. Vases of this form, which belong to both the red- and the puce-mark periods, are known to have been turned out in two sizes, 3¼ inches and 4⅝ inches in height, normally in garnitures of three. They are not recorded as ever having been encrusted with flowers.

A fine example, 4⅝ inches high, from the red-mark period, is illustrated in Plate 121. It is beautifully painted with a continuous landscape and is extremely thickly gilded.

R.O.P. Plate 22.

A rare variant of this shape is illustrated in Plate 122. It stands 3¼ inches high and is painted around the body with a continuous landscape. It carries the red mark. Other specimens from the same period, measuring 4½ inches and 6 inches in height, are in the Rotherham and Doncaster Museums.

STORK-HANDLED VASES

Vases of this type have handles in the form of a stork's head, generally gilded, as their distinguishing feature.

They have an ovid body with a flared mouth, the edges of which are serrated, and they stand on four acanthus-shaped feet. They vary in size from 14½ inches in height down to miniatures of 4⅝ inches, and seem to belong to the puce-mark period only. Occasionally, applied flowers are used—but this is not normally the case.

An interesting pair of stork-handled vases can be seen in Plate 120. The front panel of each, reserved on a blue ground, is painted with views of 'Radford Folly' and 'Chatsworth' respectively, after drawings by Thomas Allom, engraved by T. A. Prior and J. Saddler respectively and reproduced in *The Counties of Chester, Derby, Nottingham, Leicester, Rutland and Lincoln Illustrated*, published in 1836 by Fisher Son & Co., facing pages 53 and 56.

R.O.P. Colour Plate 5; Plates 34 and 35.

Another variety of stork-handled vase has been discovered bearing the puce mark. It is approximately thistle-shaped, is pierced at its rim, and stands on shaped pedestal feet—a prominent feature being the acanthus-leaf mouldings. The only examples known to date are a pair with a light blue ground colour, 6 inches high, encrusted on the front with a floral spray and painted on the reverse with naturalistic birds. There are certain features of this unusual variation from the normal stork-handled vase which are essentially alien to Rockingham, and they pose the question whether this pair—which appear to be unique—was bought in from another factory and decorated at Swinton. If, for example, the production of stork-handled vases fell short of demand, did the factory import vases of the same spirit from elsewhere and pass them off as their own? This practice was adopted by all factories and it complicates the work of correct attribution.

POT-POURRI VASES OF CAMPANA SHAPE

Vases of this form, which stand on acanthus-shaped feet and have pierced covers surmounted by a stem of applied flowers, appear to belong exclusively to the puce-mark period, following closely the neo-rococo style. Recorded in two different sizes, 13¾ inches and 11 inches high—they were made to hold and disperse aromatic perfumes: a useful function in the days of indifferent sanitation.

R.O.P. Colour Plate 6; Plates 36 and 37.

POT-POURRI VASES OF GOBLET SHAPE

These vases have twin scrolled handles rising above the rim, similar to those on the cabinet cup illustrated in *Rockingham Ornamental Porcelain*, Colour Plate 14, and are mounted on a stem and round, flat base. An example is shown in Plate 124, 4 inches high, decorated with flowers. Unfortunately, the cover is missing.

DOUBLED-LIPPED VASES

Double-lipped vases, which seem to have been produced in the puce-mark period only, have an ovoid body and stand on acanthus-shaped feet, appearing sometimes with encrusted flowers. Their distinctive feature is their double-lipped mouth. Three heights are recorded—11¼ inches, 8¼ inches and 6 inches—and they match ewers with protruding lips and scrolled handles.

R.O.P. Plate 39.

EAGLE-HANDLED VASES

It would seem that these, too, were confined to the puce-mark period only; and on examples seen to date, applied flower ornamentation has not been employed. These vases are straight-sided and cylindrical in form, with a flared mouth. They stand on a square base, having for handles—located three-quarters of the way up from the bottom—eagles' heads inset with a ring held in the beak.

R.O.P. Colour Plate 4; Plate 40.

POT-POURRI JARS

These are of two kinds. In the one design only two examples, both bearing the griffin mark in puce, have been recorded to date. Their body is globular in form, with everted rim. They have double-entwined handles and are supported on four scroll feet. One of these (Plate 125b) is in the Sheffield Museum and is particularly interesting for the reproduction on the front of Wentworth House based on John Preston Neale's drawing, engraved by J. Henshall, published in Jones' *Views of the Seats, etc. of Noblemen, etc.*,

10th February 1830. The other is illustrated in *Rockingham Ornamental Porcelain, Plates 38a and 38b*, and has on one side a view of Eaton Hall after the drawing by John Preston Neale, engraved by W. Radclyffc, published in Jones' *Views of the Seats, etc. of Noblemen, etc.*, 1829, and a painting of shells and coral on the reverse.

Examples of the second variety of pot-pourri jars, with entwined branch handles and with three branch feet, appeared at Christie's on 17th November 1969, Lot 127, in the form of a pair 7½ inches high. Each one is decorated with a named landscape and encrusted with flowers in white. One appears in Plate 125a.

These jars, no less than the pot-pourri vases of campana shape, were made to hold and dispense various aromatic perfumes through their pierced covers.

PRIMROSE-LEAF PATTERNED VASES

A small vase, about 3¾ inches high, with primrose-leaf patterned moulding is to be seen in the collection of the Yorkshire Museum. It belongs to the puce-mark period.

The same style of vase would appear to have been screwed into certain of the comports belonging to the Royal Service. One such vase can be seen in the fine comport illustrated in the Frontispiece.

OTHER VASES

Vases other than those mentioned above must have been produced at Rockingham, though their output was doubtless very limited. Probably, a vase was issued to match the snake-handled ewers to be described later—just as the double-lipped vases complemented the more common scroll-handled type of ewers.

Again, an advertisement in *The Connoisseur*, December 1912, page xxxii, purports to show an unrecorded shape; and Jewitt's reference in his *Ceramic Art in Great Britain*[1] to the all too well known Dragon Vase, 3 feet 4½ inches high, establishes the existence of a particularly fine variety of vase, discussed fully in *The Connoisseur*, April 1970, pp. 238–43.

SPURIOUS VASES

The number of spurious vases graced with a Rockingham provenance in antique shops and elsewhere is unfortunately immense. The collector should never accept as genuine, therefore, examples which either do not bear the mark or are not at least identical in shape with a piece that is so printed. Moreover, the position is not helped by the reproduction in ceramic literature of pieces attributed to Rockingham but for whose authenticity there is not a shred of evidence.

A further warning should also be directed against the risk of accepting

[1] Vol. 1, p. 513, Fig. 877.

even the mark itself without discrimination. The possibility of forgery exists, and the Samson fakes are particularly worthy of note. However, the latter are of hard paste—and the mark, in a reddy-brown colour, is incorrectly printed. Such fakes will present no difficulty whatsoever to the serious student.

Ewers

SCROLLED-HANDLED EWERS

Scrolled-handled ewers, which appear both encrusted with flowers (white or coloured) and unencrusted and seem to belong exclusively to the puce-mark period, are companions to the double-lipped vases described earlier. They have an ovoid body and a protruding lip, and stand on acanthus-shape feet. Examples are recorded 6½ inches, 7 inches and 9 inches in height.

Identical ewers were produced at Derby, except for the fact that the handle is a single loop and not scrolled.

R.O.P. Plates 39, 41 and 42.

SNAKE-HANDLED EWERS

Unlike the scrolled-handled version, the snake-handled ewer has a stopper. It stands on a circular base, with a handle in the guise of a snake and with an ovoid-shaped body decorated with a moulded leaf pattern. It is rare, and seems to belong to the puce-mark period only. Sometimes, it has encrusted flowers.

R.O.P. Plates 43 and 44.

Baskets

These appear in at least nine different varieties and belong, for the most part, to the puce-mark period.

OBLONG OCTAGONAL BASKETS

Of all the different kinds of baskets produced at Rockingham, the oblong octagonal variety is perhaps the most appealing. Essentially rectangular in shape but with tapered ends, it is in fact eight-sided. It has entwined handles and is normally, though not invariably, encrusted with flowers either in white or in colour. These baskets appear in differing sizes, including 13½ inches by 10 inches, 12 inches by 8¾ inches and 9 inches by 6½ inches.

A fine example of the smallest size is illustrated (Plate 127). It is exquisitely painted with an arrangement of flowers in a basket on a table, after the style of, if not actually painted by, Edwin Steele. A magnificent version, 13½ inches

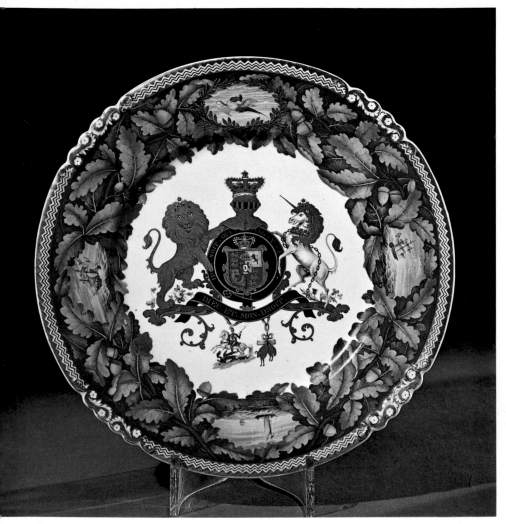

V. Royal specimen plate, decorated around the rim with a wreath of oak-leaves and acorns on a green ground and with vignettes of three seascapes and an exotic bird in flight, and painted in the centre with the Royal Arms (hung with the George and Golden Fleece). 9½ inches in diameter. Puce mark ("Rockingham Works, Brameld, Manufacturer to the King"). See pages 40-1.

long, is also illustrated (Plate 128). It is moulded with coloured flowers and finely painted with a named view: 'Norfolk Suspension Bridge, Shoreham'.

These baskets appear to belong to the puce-mark period only.

R.O.P. Colour Plate 7; Plates 45 and 47.

CIRCULAR BASKETS

As the name suggests, these are circular in design with entwined rustic handles. They appear encrusted and plain, sometimes with pierced covers. Seemingly confined to the puce-mark period, they were produced in varying sizes, e.g. $4\frac{1}{4}$ inches, $6\frac{1}{2}$ inches and $8\frac{1}{2}$ inches in diameter. A fine example is illustrated here (Plate 126) decorated with applied flowers and painted in the centre with a landscape.

R.O.P. Plates 48 and 49.

DEEP POT-POURRI BASKETS

Deep pot-pourri baskets with single rustic handles were produced in varying sizes, e.g. $2\frac{3}{8}$ inches, $3\frac{1}{4}$ inches, $4\frac{5}{8}$ inches and $6\frac{1}{4}$ inches in height. Encrusted examples are invariably from the puce-mark period; but on occasion, plain examples are found which generally bear the red mark.

A magnificent example, $6\frac{1}{4}$ inches high, encrusted with coloured flowers and painted around the body with a continuous chain of flowers against a background of puce and indigo, by or after the style of Edwin Steele, is illustrated in Colour Plate II.

Although covers were normal, specimens have been recorded where a lid was never supplied. In these instances, the baskets could not be regarded as dispensers of aromatic perfumes but must have been used for other purposes.

At least one other variety of pot-pourri is known to exist. Complete with cover and stand, it has entwined branch handles and a primrose-leaf pattern moulding. It carries the griffin mark in puce.

R.O.P. Plates 52 and 54.

HELMET-SHAPED BASKETS

These baskets, appearing in two sizes—$5\frac{1}{2}$ inches and 8 inches high respectively, are shaped as moulded leaves, splaying outwards at the ends. With their loop handle, they have the appearance of an upturned helmet. They stand on two acanthus-shape feet, and seem not to have been produced before 1831. A specimen in my possession is interesting for the rare puce ground with which it is decorated.

Examples are found both encrusted and plain.

R.O.P. Plates 50 and 51.

ROUND OCTAGONAL BASKETS

This type of basket is formed with eight equal sides and has a single rustic handle. A specimen, $5\frac{3}{4}$ inches across, encrusted with white flowers and decorated in the centre with a named view, 'Sprotbro' Hall', after a drawing by

F

J. P. Neale, engraved by J. B. Allen and published in Jones' *Views of the Seats, etc. of Noblemen, etc.*, 1st August 1829, is shown in Plate 129. Another example in my collecton, 3¾ inches across, is interesting for the fact that, in addition to the encrusted flowers in colour, it has in the centre the letter 'V' elaborately formed with roses and forget-me-nots, possibly commemorating the accession to the throne of Queen Victoria.

All the examples recorded to date have belonged to the puce-mark period.

SQUARE BASKETS WITH SHAPED SIDES

These baskets are square, either 3½ inches or 5⅜ inches across, with shaped and steeply sloping sides, and have a handle of the entwined rustic kind.

They seem not to have been produced before 1831.

R.O.P. Plates 53 and 55.

OBLONG BASKETS WITH SHAPED SIDES

An example of this shape—the only one recorded to date—is illustrated in Plate 130. It measures 5¾ inches long by 4½ inches wide, has an entwined rustic handle and is decorated with a white and grey ground, a gilt sea-weed pattern and a named view: 'Carisbrook Castle', after the drawing by H. Bartlett, engraved by T. Barber and published in Barber's *Picturesque Illustrations of the Isle of Wight* c. 1833.

It is printed with the griffin mark in puce.

SQUARE BASKETS WITH PROJECTING CORNERS

Only two examples of this shape are known. One is in the Yorkshire Museum. The other, which is in private ownership, is illustrated in Plate 131. It measures 8⅛ inches by 7⅝ inches, is encrusted with floral sprays in colour, and is painted in the centre with a named view: 'Salisbury Cathedral'.

The distinctive features of these baskets—which have an entwined rustic handle and belong to the puce-mark period—are the projecting corners, moulded with either one or two acanthus leaves according to the size.

PIN-TRAY BASKETS

These baskets consist of pin-trays as described later on page 67, with the addition of an entwined branch handle. One such, approximately 3⅝ inches square, belonging to a private collector, is decorated in the centre with painted shells and seaweed, and bears the puce mark.

Scent Bottles

Rockingham produced scent bottles in considerable variety and quantity. They seem to have belonged almost exclusively to the puce-mark period and appear both with and without applied flowers. The larger bottles could not

have been used to hold scent in its technical sense but were doubtless containers for lavender water or other toilet preparations. However, for convenience of terminology, they will be referred to here as scent bottles. Needless to say, every scent bottle had a matching stopper.

LONG-NECKED SCENT BOTTLES

These are perhaps the most common variety, sometimes appearing in sets. As their name suggests, they have long necks extending from a bun-shaped body. Generally, they are encrusted, their stopper being surmounted by a single flower; but the rarer, plain ones have a simple stopper that is flat and circular. Heights vary, recorded examples being 3 inches, $3\frac{7}{8}$ inches, $4\frac{7}{8}$ inches and $6\frac{3}{8}$ inches.

R.O.P. Plate 60.

CIRCULAR SCENT BOTTLES

Circular in shape, these bottles have short necks which taper towards their base. Examples are recorded 3 inches and $4\frac{1}{4}$ inches in diameter.

R.O.P. Plate 61.

BULBOUS SCENT BOTTLES

The distinctive features of this type of bottle are the spherical body and short neck, giving it an overall bulbous look. Two sizes are recorded, $4\frac{3}{4}$ inches and 6 inches high.

These bottles, which sometimes appear with small applied insects in colour, are accompanied by two distinctive kinds of stopper—namely, that supplied with the specimen illustrated in Plate 132 and that used on the bottles shown in *Rockingham Ornamental Porcelain, Plates 57 and 58*, where the applied flowers are built up into a kind of pyramid shape.

TAPERED SCENT BOTTLES

These bottles, which really stand half way between the long-necked and bulbous varieties, have an essentially bulbous body that tapers off into a somewhat elongated neck flaring outwards at the top. They are accompanied by a rather elaborate stopper.

One of a pair, marked in puce, of truly magnificent quality, 16 inches high, with applied flowers of exquisite delicacy, is illustrated in Colour Plate III. Similar vases in biscuit are to be found in the Rotherham Museum. Perhaps this was the shape Jewitt was referring to when, in speaking of the porcelain specimens then at Wentworth House, he mentions[1] 'a pair of fine biscuit scent bottles, sixteen inches high, decorated with exquisite raised flowers'.

Other examples of tapered scent bottles have been seen $11\frac{1}{4}$ inches and $4\frac{3}{4}$ inches in height.

R.O.P. Plate 56.

[1] *Ceramic Art in Great Britain*, Vol. i, p. 512.

HEXAGONAL SCENT BOTTLES

These six-sided scent bottles are rare. They appear encrusted and plain, and measure approximately 5 inches in height.

 R.O.P. Plate 62.

DIAMOND-SHAPED SCENT BOTTLES

Equally rare are the diamond-shaped scent bottles. They are rather like a cut diamond, with a short neck at the top and a flat base at the bottom. An interesting pair is shown in Plate 133, covered all over with applied floral heads in the 'Mayflower' pattern. Two different sizes are recorded, measuring 3 inches and 4 inches across respectively.

 R.O.P. Plate 59.

SCENT SPRINKLERS

Technically speaking, these are not bottles, but they can nevertheless be conveniently classified within this group. They are in the form of small modern coffee pots with the spout covered over and perforated. They measure some 4 inches high. Two examples, encrusted with flowers, are illustrated in *The Connoisseur Year Book*, 1962, page 145.

Articles of Illumination

During the days of the Rockingham factory, the normal method of lighting was by candle. Gaslight had not yet been developed for domestic use other than in the most exceptional of houses. Accordingly, it is only to be expected that Rockingham should have produced candlesticks and tapersticks, some of which are described below.

COLUMN OR PILLAR CANDLESTICKS

These are of two kinds. One, standing $7\frac{1}{2}$ inches high, has a hollow circular base and is moulded all over with a leaf design. The top is formed to take the candle and receive the dropping wax.

 R.O.P. Plate 65.

 The other variety is rather more elegant—based, it would seem, on silver models. It is tall and slender, with a moulded acanthus-leaf motif and with a shaped base in neo-rococo style. It presumably occurs without as well as with applied flowers. The upper portion, which holds the candle, was constructed in two different ways. In the one case the sconce is continuous with the body, in the other it is divided off from the main body by a low collar. One version, bearing the puce mark, is illustrated in *Rockingham Ornamental Porcelain, Plate 63*. The other appears in an advertisement in *The Connoisseur*, December 1912, page xxxii.

CHAMBER CANDLESTICKS

At least three different shapes of chamber candlesticks are recorded. Perhaps the most attractive is that formed like a leaf, measuring 4½ inches in length, with a simple candle-socket and a rustic handle. This basic shape occurs sometimes in a more elaborate guise, with a flower-encrustation in the centre and with a ring-type handle.

R.O.P. Plate 66.

A second type of candlestick has a body of the identical mould of the small pin-trays described later on page 67 and, except for differences in the handle and candle-socket, is almost indistinguishable from the Bloor Derby model as far as shape is concerned.

R.O.P. Plate 64.

A third style of candlestick has a saucer-shape platform, 4½ inches across, moulded around the rim with acanthus-leaves, and a handle scrolled rather than rustic in form.

R.O.P. Plate 73.

TAPERSTICKS

Miniature tapersticks with gilt ring-handles were also produced at Rockingham. They measure only 1⅞ inches high. Another variety without ring-handles, 2 inches high, is illustrated in Plate 139b.

Pastille-Burners

The reader will doubtless be familiar with the apparently limitless number of porcelain cottages and castles found in antique shops and auction rooms everywhere which are automatically credited with a Rockingham provenance. But the interesting fact is that there is not a shred of evidence that they have anything to do with the Rockingham factory whatsoever. These cottages and castles are invariably unmarked and are without any Rockingham characteristics. It is also significant that in the records of the closing-down sale in 1843—although many of the factory's products, both partly and fully decorated, were offered for disposal—no reference can be found to any cottage or castle. We can, without hesitation, reject as spurious all these pastille-burners, which have nothing to support their authenticity except unsubstantiated tradition.

Needless to say, this rejection does not imply—still less prove—that no cottages were made at Swinton. The existence of a few marked specimens from the contemporary factories of Spode, Flight, Barr & Barr, and Chamberlain's[1] suggest that perhaps Rockingham was also responsible for a small output. In due course, a marked specimen may well come to light—from

[1] Minton is known, from its surviving pattern books, to have produced cottages even though they are unmarked. See Geoffrey A. Godden's *Minton Pottery and Porcelain of the First Period, 1793–1850*, Plates 91 and 92.

which, incidentally, we will know the shape of any unmarked examples that may be extant. But to date, no genuine Rockingham cottages or castles have been recorded.

However, pastille-burners do not have to take the form of cottages. Indeed, Rockingham is known to have produced at least three different types of burners quite divorced from such a conception. One is in the form of an egg-shaped container terminating at the top in a gilt flame and, at the bottom, slotting into a stand made to take the pastilles.

R.O.P. Plate 67.

Another shape, for which a single example some $3\frac{1}{2}$ inches high is the only known evidence, is in the form of a Greek crater or circular vase, decorated around the rim with encrusted flowers in colour and standing on a circular column hung in the classical manner with applied floral chains.

R.O.P. Plate 68.

A further type of pastille-burner has been recorded in the form of a sea-shell.

Desk Pieces

INKSTANDS

Quite a variety of inkstands was produced at Rockingham. Perhaps the most common comprised a circular container, bulbous in shape, moulded with acanthus-leaves and fitted with three small holes to take quills; the inkwell itself; a cover—surmounted by a pointed finial when the decoration was plain but by a flower knob when it was encrusted; and a circular stand, again moulded with an acanthus-leaf motif.

R.O.P. Plate 74.

This particular style of inkstand is recorded in two sizes, $3\frac{3}{4}$ inches and 5 inches in diameter, and was sometimes made to fit on to a special tray. Such a tray, decorated with fruit, is illustrated in *Rockingham Ornamental Porcelain, Plate 70*. Measuring 14 inches by 10 inches, and encrusted with flowers along the edges, it is essentially rectangular in shape but has slightly canted edges and pierced rustic handles. In addition to the inkstand proper, it also holds a similarly shaped sand-container with a lid in the form of a taperstick.

A totally different type of inkstand, dating from the red-mark period, whose distinguishing features are its circular shape and two raised lion-masks at each end, is occasionally encountered. It has a simple cover, and measures about 2 inches in height. Whether there was ever a stand is unknown.

The red-mark period was also responsible for another form of inkstand, moulded essentially in the form of shells. It is small, measuring only $3\frac{1}{2}$ inches by $3\frac{1}{4}$ inches by $1\frac{1}{2}$ inches high; and the body, shaped as a cockleshell, rests on two shell feet. Besides the actual inkpot and cover, there are two winkleshells fashioned to hold quills.

Two larger varieties of inkstand, from the puce-mark period, have been recorded. One, painted with flowers and fruit, measuring 12 inches long by 8½ inches wide by 5¾ inches high, is in the Sheffield Museum. It rests on gilt paw feet and contains two small inkpots and covers, together with a taper-stick. The other, somewhat smaller—9 inches long by 7 inches wide by 4¼ inches high—with a serpentine body finely gilded and painted with flowers and with four gilt and white acanthus-leaf feet, is in my own collection.
R.O.P. Plates 71 and 69.

TOY INKSTANDS

Some of the most delightful inkstands produced at Rockingham were really toys. One variety is in the form of a shoe, 5 inches long, the inkpot portion being located in the heel.
R.O.P. Plate 91.
Another is in the form of an elephant and castle, 3⅝ inches high, standing on a shell-edged tray, 4¾ inches long by 3¾ inches wide.
R.O.P. Plate 125.
Examples of both kinds recorded to date have invariably belonged to the red-mark period.

QUILL-HOLDERS[1]

As one would expect, Rockingham produced quill-holders as well as ink-stands. Two types are recorded, although doubtless there were others. One, 10⅞ inches long, puce-marked, essentially rectangular in form but with shaped and rounded edges and resting on flanges, is illustrated in *Rockingham Ornamental Porcelain, Plate 74*.
The other variety, in its simplest form, is again essentially rectangular but has shaped and projecting ends moulded with a flower decoration. In its more sophisticated form, instead of resting on simple flanges it stands on paw feet—and in the case of an even more sophisticated version, there are lion-mask terminals at the point where the short legs to which the paw feet are attached meet the body of the holder.
R.O.P. Plate 72.

CARD RACKS

These are rectangular in form, 5 inches long by 3½ inches high, with shaped edges and moulded borders, their sides tapering somewhat from top to bottom. They stand on four scrolled feet, appear sometimes with applied flowers, and seem to belong exclusively to the puce-mark period. They were used as repositories for visiting cards or letters, and were often designed to go with trays.

[1] See Christie's Sale, 12th February 1830, Lots 56 and 61; 13th February 1830, Lots 29, 30 and 62 (Appendix F).

A large number of card racks are recorded with named views, including those of 'Victoria House', St. Leonards, where Princess (later Queen) Victoria lived with her mother for some two years, 'Newstead Abbey, Nottingham', engraved after Thomas Allom's original drawing and published in 1836, 'Windsor Castle, Berkshire', 'Howick Hall, Northumberland' and 'Wentworth House, Yorkshire'.

R.O.P. Plates 75 and 76.

Trays

Some of the finest work executed by the Rockingham factory is revealed in its trays. They prove invariably of high quality.

A really accomplished example is in the Rotherham Museum. Although smashed, it nevertheless shows off the excellence of the painting of Thomas Steel, by whom it is signed. Measuring 16 inches by 14 inches, it displays an excellent arrangement of fruit.

R.O.P. Plate 79.

Another tray of identical form is at Wentworth House. With a green, white and gold border, moulded with foliage, it is painted with a portrait of Earl Strafford dictating his defence to his secretary, after the portrait by Van Dyck —itself at Wentworth House. The tray is signed by G. Speight and, like the previously mentioned example, bears the red griffin mark. It is particularly interesting for the fact that Joseph Marryat in his *History of Pottery and Porcelain*, 1850, makes special mention of it, and equates it for quality with anything that Sèvres could offer. An even earlier reference to this particular piece can be found in *History, Gazetteer and Directory of the West Riding of Yorkshire*, 1838, by William White:[1]

> ... Mr. Thomas Brameld ... has also produced on porcelain tablets in enamel colours, many excellent copies of original paintings, one of which is the 'The Earl of Strafford dictating his defence to his Secretary', by Vandyke. This tablet [it was, in fact, a tray], now at Wentworth House, is said to be equal to the most admired productions of the far famed Sèvres Works.

After being originally at Wentworth House, it somehow vanished and later reappeared on the open market, being advertised with a full-page display in *The Connoisseur* of March 1913, page xiii. It was subsequently repurchased by the Fitzwilliam family.

Recently acquired by the Rotherham Museum is a red-marked tray, 19 inches by 13¼ inches, similar to the foregoing in shape except that it has handles and is pierced around the rims (Plate 135). Although damaged, it has been skilfully repaired. It is finely if somewhat heavily painted with a recumbent Cupid against a ruby-red cloth background. It is not signed, and the artist responsible cannot be identified with certainty.

[1] Vol. II, p. 215.

A totally different shape of tray, this time from the puce-mark period, can be seen in the Sheffield Museum. It measures 11½ inches over-all in length and 7⅝ inches in width, its most distinctive feature being its double twig handles at either end. This specimen is painted with a view of 'Newstead Abbey, Nottinghamshire', but another, in the collection of Mr. L. Godden, and illustrated in Geoffrey Godden's *An Illustrated Encyclopaedia of British Pottery and Porcelain, Colour Plate XI*, is decorated with a view of the 'Norfolk Suspension Bridge, Shoreham'.

Another variety of tray has already been described—that made to take ink-stands. But on occasion it was produced independently. An extremely fine example, from the puce-mark period, 14 inches long by 10⅜ inches wide, without flower encrustations and without pierced handles, is illustrated in *Rockingham Ornamental Porcelain, Plate 80*. It held a miniature tea service.

Finally, a further shape of tray, 15 inches by 13 inches, without handles, essentially oblong in form but with shaped corners, exists in a private collection. It is painted with a miscellany of birds, and carries the red mark.

Pieces for the Dressing Table

RING-HOLDERS

Illustrated in *Rockingham Ornamental Porcelain, Plate 94*, is a ring-holder, 3 inches high by 3¾ inches in diameter, finely gilded and decorated with a periwinkle-blue ground bordered with a wreath of pink roses. It bears the red mark, and was doubtless part of a lady's toilet-set.

PIN TRAYS

Rockingham produced at least two varieties of pin tray. One, which dates from the red-mark period, is identical with the base of the 'elephant ink-stand' described earlier on page 65, and has shell-shaped edges as its most distinctive feature. It measures 4½ inches long by 3½ inches wide.
R.O.P. Plate 90.

The other type of pin tray is essentially square, 3¾ inches across, with canted corners and shaped sides, the edges moulded with gadrooning and acanthus-leaves. It is found in both the red- and puce-mark periods, and appears plain—sometimes beautifully painted—or encrusted. When applied flowers are used, it is difficult to see how the piece can still be regarded as suitable for the receipt of pins. But the classification adopted here is convenient.
R.O.P. Plates 92 (a) and (c).

BUTTERFLY-SHAPED BOXES

Quite delightful accessories for a lady's dressing table are the butterfly-shaped boxes that are occasionally encountered. They measure 3¼ inches long, seem to belong exclusively to the puce-mark period, and appear both with

and without applied flowers. It is the cover that is shaped in the form of a butterfly (Plate 136).

R.O.P. Plate 87.

POMADE, POWDER, PATCH AND TRINKET BOXES

Apart from the butterfly-shaped examples mentioned above, other boxes made for ladies are recorded as Rockingham productions, including:

(i) A pomade box and lid, red marked, $1\frac{7}{8}$ inches high and $3\frac{1}{8}$ inches in diameter, decorated with a periwinkle-blue ground and painted all over with floral sprays.

(ii) A powder box, about $\frac{1}{2}$ inch in depth, with a screw-on lid, $3\frac{1}{2}$ inches in diameter. The cover is charmingly decorated with flowers and fruit, and inside it is printed with the red griffin. The base is covered with an apple-green ground. (A further example, in my own collection, is exquisitely painted with flowers in a basket on a table.)

(iii) A patch box, puce marked, with a maroon ground, $1\frac{1}{4}$ inches deep by $1\frac{1}{2}$ inches in diameter, its cover painted with shells and coral.

(iv) A trinket box and cover (loose), 3 inches by $2\frac{1}{2}$ inches by $\frac{3}{4}$ inch, encrusted with flowers on the top and marked in puce. Another variety is illustrated here (Plate 137), fitted with compartments, $8\frac{1}{4}$ inches long.

MODEL FLOWERS

Very occasionally, model flowers can be seen. They seem to belong to the puce-mark period, and were presumably intended to contain some form of cosmetic. A damaged specimen, shaped as an aster with green leaves for its base, is in the Rotherham Museum; but a finer example appeared at the Grosvenor House Fair of 1962, made in two parts and fashioned in the form of an open rose in white with five green leaves. A further specimen from a private collection is illustrated in Plate 138.

Toys

In common with other contemporary factories, Rockingham produced a number of toys, including tea services, baskets, buckets, basin and ewer sets, watering cans, shoes and slippers.

The delicacy and decoration of these quite delightful items—involving, as must have been the case, a very considerable original cost—are such that it is inconceivable that they could have been made for small children. They might have been produced for girls of twelve or so, but far more likely for ladies to display in their boudoirs.

TEA SERVICES

An extremely fine part tea service in miniature, from the puce-mark period, is illustrated in *Rockingham Ornamental Porcelain, Plate 82*, standing on its

matching tray described earlier on page 67. It consists of a teapot and cover, sucrier and cover, and cream jug, $2\frac{3}{4}$ inches, $2\frac{1}{2}$ inches and $1\frac{3}{4}$ inches in height respectively, together with three cups and saucers, $1\frac{9}{16}$ inches and $2\frac{1}{2}$ inches in diameter. Each item is decorated with a periwinkle-blue and yellow ground and some exquisitely painted flowers on a diminutive scale. In shape, the principal pieces are exact replicas of the full-size pieces belonging to the early neo-rococo tea services with twig finials and rustic handles described in Chapter III. The same shape teapot, sugar bowl and cream jug— though still toys—are sometimes found in a somewhat larger version. The cream jugs measure $2\frac{3}{4}$ inches in height, the sugar bowls 4 inches.

Sometimes these miniature tea services appear with applied flowers, and the cups and saucers, $1\frac{3}{4}$ inches and $2\frac{7}{8}$ inches in diameter respectively, are somewhat differently shaped, with edges slightly scalloped and handles that are angularly constructed rather than rustic in form. The matching plates are identical in shape with the saucers and measure $3\frac{3}{4}$ inches in diameter.

R.O.P. Plate 83.

Quite independent of the services described above are the individual toy teapots, $2\frac{3}{4}$ inches in height, that are occasionally encountered. Two from the puce-mark period are illustrated in *Rockingham Ornamental Porcelain, Plates 85 and 86*: one with a very rare lavender body—the colour permeating the paste through and through—on which white flowers are moulded in relief, the other made from the usual white porcelain but encrusted with flowers in colour.

BASIN AND EWER SETS, BUCKETS AND WATERING CANS

Apart from tea services, Rockingham produced, as toys, basin and ewer sets, $2\frac{1}{2}$ inches high in all, buckets 2 inches high with a dropped handle, and toy watering cans. An example of the last, in a private collection, is made of the same lavender paste described in connection with the miniature teapot.

R.O.P. Plates 88 and 92.

SHOES AND SLIPPERS

Rockingham produced toy shoes and slippers, the former of which have also been mentioned under the heading 'Inkstands'. The slippers, 4 inches in length, are moulded with the heel turned over, as though well worn, and the mark is normally on view within the slipper itself—not, as one might have expected, underneath it.

R.O.P. Plate 91.

VASES

Very rarely, the Rockingham factory turned out miniature vases. A garniture of three trumpet-shaped examples in toy form exist in my collection, and measure $1\frac{3}{4}$ inches, $3\frac{1}{2}$ inches and $1\frac{3}{4}$ inches respectively. They carry the

puce mark, and are decorated with front panels of painted flowers reserved on a maroon ground.

R.O.P. Plate 91.

A fine pair of miniatures of the same height as the two smallest of the foregoing, but this time in the form of overhanging-lip vases, is illustrated in Plate 117. The gilding and landscape painting are superb.

Violeteers

It is sometimes possible to come upon puce-marked objects in the form of teapots with a fixed pierced cover in place of the usual loose lid. These were designed to hold small flowers, such as violets. They measure 2¾ inches in length and 1¾ inches in height, and are frequently flower-encrusted (Plate 139a).

Cache Pots

Cache pots were manufactured at Swinton but are very rarely found. Tapering slightly from top to bottom, they stand 7 inches in height. A pair in a private collection are charmingly decorated in dove grey, royal blue and elaborate gilding, and are further ornamented with individual painted flowers.

Cabinet Service Pieces

PLATES

Cabinet plates were designed not for use but for display in a cabinet, or possibly as 'place' plates—i.e., plates laid out between courses before each guest in order to give the table a decorative effect (see also page 27). Various cabinet plates are illustrated in my *Rockingham Ornamental Porcelain* and are of truly magnificent quality. An example from the red-mark period, with a rare pink border and an exquisitely executed landscape in the centre, is shown in Plate 141. It is the companion to the outstanding specimens illustrated in *Colour Plate 8* of *Rockingham Ornamental Porcelain*. Although the stand shown in Plate 140 was undoubtedly made as part of a magnificent service and was intended for useful rather than ornamental purposes, its sheer quality elevates it to cabinet status. Measuring 9⅛ inches in diameter, the borders and cavetto are decorated with periwinkle-blue panels, reserved with a single rose, alternating with solid gilt panels relieved by a motif of anthemia. The centre is superbly painted with a naturalistic bird in a landscape setting.

Some cabinet plates are decorated with applied flowers. An example is illustrated in Plate 142. Though qualifying as a cabinet plate, it lacks finish and is but a pale shadow of the exceptional piece illustrated in *Colour Plate 10* of *Rockingham Ornamental Porcelain*.

R.O.P. Colour Plates 8, 9, 10 and 11; Plate 93.

TEA SERVICES

Of truly magnificent quality are the teapot and cover, 6½ inches by 9 inches wide, sucrier and cover, 5½ inches by 6¾ inches, and cream jug, 4 inches in height, reproduced in *Rockingham Ornamental Porcelain, Colour Plate 13*. They are brilliantly painted with floral bouquets and are decorated in green on the rustic handles, knobs and feet. Small encrusted floral heads have also been applied. Each piece, apart from the covers, is printed with the griffin mark in red. It is difficult to envisage that these were ever made for any other purpose than for cabinet display. They are some of the finest things Rockingham ever manufactured. Whether any matching cups and saucers were produced is doubtful.

It is interesting to note that in Jewitt's *Ceramic Art in Great Britain*,[1] an identically shaped teapot with cover is illustrated, this time painted with butterflies instead of flowers. Regretfully, its present whereabouts—if it is still in existence—is unknown.

CAUDLE CUPS

Caudle cups made at Rockingham are very rare. Together with their cover and stand, they assume a total height of approximately 5¼ inches. The cup is essentially bucket-shape, with twin entwined rustic handles either side of it. The cover has a similarly formed handle, and the stand is either completely circular or shaped around its rim like the scallop-edged saucers described on page 44.

R.O.P. *Colour Plate 15, and Plate 89.*

MISCELLANEOUS CUPS

From time to time, it is possible to come upon a Rockingham cabinet cup. An example—perhaps surprisingly, from the puce-mark period—4½ inches high, with a top diameter of 3⅝ inches and a separate circular stand 4½ inches across, is illustrated in *Rockingham Ornamental Porcelain, Colour Plate 14*. The scrolled handles rise above the rim and are richly gilded. Both the cup and the stand are painted with floral sprays. A 'loving-cup' some 5½ inches high (puce-marked) has recently been discovered. With twin scrolled handles it stands on a circular base, and is exquisitely painted with flowers on one side and gooseberries and other fruit on the reverse.

Another variety of cabinet cup and stand is in the form of shells. The stand, 5¼ inches wide, is moulded as a scallop-shell. The cup, 2¾ inches high by 3¾ inches wide, is constructed as a deeper shell with a loop handle normally coloured red in imitation of coral. Such a cup and stand exist in the Victoria and Albert Museum apart from several puce-marked sets in private collections. The shape is, in fact, illustrated by Jewitt in his *Ceramic Art in Great Britain*.[2]

[1] Vol. I, p. 511, Fig. 875. [2] Vol. I, p. 511, Fig. 876.

JUGS

Jugs were produced in both the red- and puce-mark periods in varying sizes, and often in pairs or sets of three or four. A fine pair of rococo shape, 6 inches high, is illustrated in Plate 143. They have a green ground, and are well painted with bouquets of flowers. The inscription 'Beagle' on the front of one and 'Vanish' on the front of the other suggests that they were originally owned by a dog-lover. Both jugs carry the mark in puce.

A more commonly found variety of jug—of a shape also found in green earthenware (see Plate 37)—has for its distinctive features moulded patterns of daisy-heads over its top half and primrose-leaves over its bottom half. The rising handle is rustic in form.

R.O.P. Plate 96.

Not quite so frequently found is a jug basically of the same form as the foregoing, except that the body is essentially smooth—i.e., without any moulded motif—and the handle, raised somewhat higher, is scrolled (see Plate 22 for the same shape of jug in earthenware).

R.O.P. Plate 97.

An extremely rare shape of jug is that illustrated in *Rockingham Ornamental Porcelain, Plate 95.* Measuring $7\frac{3}{4}$ inches in height, somewhat shallow in construction, with a long neck, bulbous body and loop handle, it is finely painted with floral groups on either side of it and is well gilded at its top. Marked in red, it has in addition a series of raised concentric rings identical with those generally found on the base of Rockingham hexagonal vases.

Another equally rare jug which is also in my own collection stands 7 inches high, with fluted sides, a bulbous body and an angular handle (Plate 134). It is finely gilded and magnificently painted with floral bouquets loosely arranged. It bears the red griffin mark. Two similar jugs are illustrated in Margaret Vivian's *Antique Collecting*, page 61, Figure 41.

COMMEMORATION MUGS AND BEAKERS

Commemoration mugs of cabinet quality were also produced at Rockingham. Their distinctive feature is their handle in the shape of a horse's hoof and tail—a motif more generally associated with the factory's cane-coloured earthenware jugs described on page 21.

A fine example, $3\frac{3}{4}$ inches high by $4\frac{1}{4}$ inches across, painted with floral sprays, is illustrated in Plate 144. Another of the same shape, illustrated in *The Connoisseur Year Book*, 1962, page 144, is decorated with a superb miniature of the Duke of Wellington, seemingly painted by William Corden after Sir Thomas Lawrence's portrait. Both examples carry the puce mark. Other specimens appear $2\frac{1}{4}$ inches in height.

It would seem that sometimes these mugs were made to accompany beakers.[1] Such a set exists in a private collection (Plate 145). Although, un-

[1] Beakers are very much in evidence at Christie's Sale, 13th February 1830. See Lots 14, 22, 38, 47, 56 and 65 (Appendix F).

fortunately, neither piece is marked, the shape of the mug—with its hoof and tail handle and distinctive Rockingham decoration—undoubtedly establishes its authenticity; and the piece bears the inscription 'Joshua Bower'. The companion beaker—the connection is demonstrated by the modelling and gilding alone—is inscribed 'Alice Bower'. Both pieces are painted with flowers, but by different hands.

PUNCH BOWLS[1]

A fine example of a Rockingham punch bowl from the red-mark period can be seen in the Sheffield Museum. It measures 10⅝ inches in diameter and is decorated with an elaborate gilt wheat-ear pattern on a dark blue ground and with painted floral bouquets.

R.O.P. Plate 99.

BASINS

Although these are similar to punch bowls, they differ inasmuch as they have shaped instead of smooth rims, and they stand on four scroll feet, between which are to be found moulded leaves attached to the underside of the basin. A good example, 9¾ inches in diameter, is illustrated in Plate 146a. It is finely decorated inside with a floral arrangement (Plate 146b).

Plaques

Plaques,[2] which are really highly finished paintings on porcelain, were often done by the artist at home in his own time, and were carried round by him as testimonials of his work whenever he sought employment. Accordingly, it is possible to find a plaque executed and signed by a Rockingham artist without the piece bearing the factory mark. The two marine plaques illustrated in Plates 147 and 148, showing named views of 'Sunset—view on the Welsh coast' and 'The Clyde from Erskine Ferry' respectively, carry the inscription 'W. W. Bailey pinxt' on the back. For the reasons discussed on page 84, this work must have been carried out on Rockingham porcelain and must almost certainly have been done by Bailey at home. With the aid of these plaques, we are able to identify other work of Bailey on marked but unsigned, pieces.

When Bailey was working in the firm's time the plaque doubtless carried the factory mark, and the name 'Bailey'—when he was allowed to sign his work—appeared without initials. This would seem to be supported by a plaque in my own collection. Depicting a dog in pursuit of game, seemingly

[1] See Christie's Sale, 12th February 1830, Lot 20: 13th February 1830, Lot 26 (Appendix F).
[2] It would appear that these were sometimes called tiles. See Christie's Sale, 12th February 1830, Lots 15, 40, 41 and 65; 13th February 1830, Lots 15, 31, 39 and 68 (Appendix F).

after an engraving by J. Scott, published in William B. Daniel's *Rural Sports*, it is signed 'Bailey pinxt' and bears the red griffin mark.

R.O.P. Plate 98.

Documentary plaques by George Speight are extant. A small but exquisitely executed scene of three children standing by a tomb in front of a church, entitled on the back 'The Mother's Grave, No. 13', is illustrated in *Rockingham Ornamental Porcelain, Colour Plate 12*. It measures $3\frac{1}{8}$ inches by $4\frac{1}{8}$ inches and is signed 'Speight pinx'. A bigger plaque, 7 inches by 5 inches, portraying the Madonna and Child, with predominant colours of blue and pink, is shown in Plate 149. Speight's signature, the mark in red, and the title of the painting—'Madonna'—are all inscribed on the reverse. A larger and important example of Speight's work, $12\frac{1}{2}$ inches by $10\frac{3}{8}$ inches, is illustrated in Colour Plate VII and consists of a landscape of Derwent Water after the drawing by Thomas Allom engraved by S. Lacey and published in the *Northern Tourist*, Vol. 1, by Fisher Son & Co., London, 1832. This piece bears the signature of George Speight but not the Rockingham mark. On the reverse, the following inscription is painted in green script:

> A very Fine Old Rockingham Picture
> on Porcelaine a Beautiful View of
> Derwent water
> by Speight

The style of lettering indicates if not a contemporary origin at least one dating well back into the nineteenth century. For the use of the French spelling of 'porcelain' in the nineteenth century, compare the reference to Welsh porcelain in *The Morning Chronicle* of 11th July 1816: 'Improvement in Porcelaine has succeeded in this country beyond the most sanguine expectations, a new manufactory has been established in Wales, the brilliancy of the white and transparency being equal to the celebrated Porcelaine of the Royal Sèvres manufactory.'

A documentary plaque of Thomas Steel is reproduced in Margaret Vivian's *Antique Collecting*, page 140, Figure 106. It belongs to the red-mark period and is, in fact, dated 1830. Measuring $6\frac{1}{2}$ inches by 5 inches, it depicts fruit.

Miscellaneous Items

Certain other items—such as bed-posts—which, though interesting, do not belong in any of the above categories, should be mentioned. In some cases, it is debatable whether they should be ascribed to ornamental or useful ware. According to Jewitt:[1]

> These bed-posts [two examples are in the Victoria & Albert Museum] and other similar things were made at the Rockingham Works, though never to any extent. They are now of very great rarity, but examples are

[1] *Ceramic Art in Great Britain*, Vol. 1, p. 506.

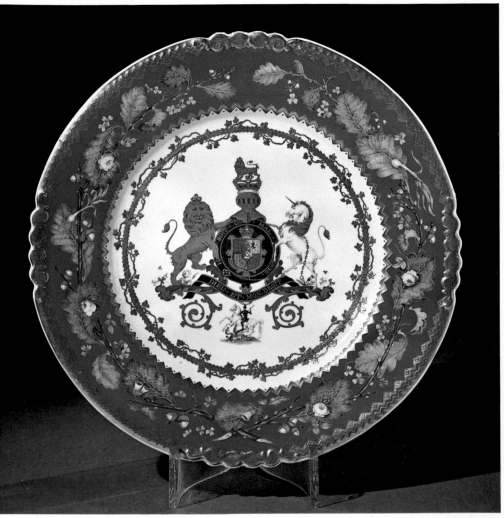

VI. Royal specimen plate, decorated with oak, leeks, shamrock, roses and thistles on a rare orange border, and painted in the centre with the Royal Arms (hung with the George) surrounded by a gilt circle of fruiting vine. 9½ inches in diameter. Puce mark ("Royal Rockᵐ Works, Brameld"). See pages 40-1.

in my own possession. The body is white, the prevailing colour being Rose-du-Barry, with yellow flowers, etc. Another of these interesting examples is white with an effective chintz pattern in colours; while others have small groups and sprigs of flowers, the outline in transfer printing, and filled in with colour. In my own possession, too, are several of the original drawings of designs for beds, window cornices, lamps,[1] candelabra, tables, etc., which are remarkable for their elegance and beauty. An elegant work-table of this description of ware, of simple but very effective design and excellent workmanship, is in the possession of Mr. Wilson of Sheffield. It is 2 feet 6 inches high and 1 foot 6 inches in diameter at the top. Among the designs to which I have alluded is one representing a small and remarkably elegant table of somewhat similar, but much more ornate character, on which is a fish-globe stand of corresponding design.

It cannot be too strongly stressed that the ornamental items listed here are in no way exhaustive. Many more will come to be discovered in the course of time. But it is quite impossible to exaggerate the danger of accepting unmarked pieces, whose authenticity cannot be established without reliance on unsupported tradition and trade practice, as genuine Rockingham.

[1] A pair of such lamps has recently been discovered, and is now in a private collection.

G

Chapter V

Figures

General

Genuine Rockingham figures are rare. On the evidence of the marks used on them, they were manufactured for only about four years—from 1826 to 1830. However, at least one bust—of Earl Fitzwilliam, unmarked and in the Yorkshire Museum—must have been produced after 1833. It is inscribed 'William Wentworth Fitzwilliam, Earl Fitzwilliam, etc., etc., etc. Born May 30, 1748. Died Feb. 8, 1833'. This particular model may, however, have been issued as a special memorial item without any necessary resumption of figure production generally.

While varying considerably in the skill employed in their modelling, Rockingham figures attain, on the whole, a high degree of excellence far surpassing all contemporary products for the quality of their glaze, paste, gilding and palette. They are patently distinguishable from the immense number of spurious specimens emanating from Staffordshire which ignorance alas, still all too prevalent where Rockingham is concerned—has graced with a Rockingham provenance. In particular, the collector should pay no heed to the innumerable poodles and sheep, with their fuzzy-textured wool, which unsubstantiated tradition has assigned to Rockingham. These come from Staffordshire and belong, for the most part, to the second half of the nineteenth century; in fact, long after the Swinton Works closed down in 1842.[1]

It is also important to be able to differentiate between Rockingham and Derby figures, for there would seem to have been a close connection between the two factories in their figure production.[2] Various points of difference can be mentioned. Notably, in the case of coloured models, the palette of Derby is harsher; the paste is less silky; the pigments do not sink in as well as in Rockingham porcelain; the gilding is less rich. And the lettering, where it occurs around the base, is in block form at Derby and in script at Rocking-

[1] The whole position is discussed fully in *Rockingham Ornamental Porcelain*, pp. 45–7. See also Appendix D.
[2] *R.O.P.*, pp. 48–54.

ham. But far and away the most important distinguishing element is that, except in the case of busts (which are invariably unnumbered), the figures produced at Rockingham—which generally have a solid base with a small circular hole—bear an incised number quite different from that used on an equivalent Derby piece.

Discovery of the Rockingham number is difficult by virtue of the scarcity of surviving figures. But once the secret is revealed, the number is in itself almost conclusive evidence of genuineness—no attempt having as yet been made to forge these numbers. The compilation of the list of numbers (which would seem to extend from 1 to 120) can only be achieved by hunting out marked specimens and ascertaining from them the correct Rockingham numeral. It is known that in some instances—for example, numbers 4, 23, 26, 28, 36, 44, 80, 108 and 110—the same number was applied to each of a pair. Naturally, no catalogue can be complete until all the factory's models are brought to light—in all probability, at this late stage, an impossible task. In consequence, the list is constantly being added to as new discoveries are made. Since the list in Appendix A of *Rockingham Ornamental Porcelain* was published, I have come upon nine new models and obtained the number of a group hitherto found only unnumbered. The list, in its revised form, with details of measurements is set out in Appendix A of this book with details of measurements and the authority for their attribution.

Different Classes of Figures

Rockingham figures can, for convenience, be classified under six heads: Busts and Personalities; Theatricals; Romantics; Animals; Continental Peasants; and Miscellaneous.

Busts and Personalities

Personalities normally take the form of busts. The only known exception, of which no extant specimen is recorded, is the model of Chantrey's full-length statue of Lady Russell referred to by Jewitt.[1] All Rockingham busts recorded to date are in biscuit, and most stand on a pedestal. Examples showing the head and shoulders of Wordsworth (after Chantrey's marble, $21\frac{1}{2}$ inches high, originally made in 1820 for Sir George Beaumont and now in the possession of Indiana University, U.S.A.), the Duke of York (in two versions, one of which is after Nollekens), George IV, and Earl Fitzwilliam are illustrated in *Rockingham Ornament Porcelain* (*Frontispiece, Colour Plates 16 and 17, and Plate 100*). It is certain that the Earl Fitzwilliam bust was—as presumably were the rest—modelled by William Eley, who is known to have remained with the factory until its close along with his sons John and William (his third eldest, Jonathan, also being apprenticed at the works).

The Swinton factory also produced busts of Wordsworth and Scott, as a pair and without a pedestal (Plate 151), and of Lord Brougham.

[1] *Ceramic Art in Great Britain*, Vol. 1, p. 514.

As busts never seem to bear an incised number, their identification in the absence of a mark is extremely hazardous. The similarity of the Rockingham biscuit to that produced at other factories is so remarkable that an attribution on this ground alone is very inconclusive. It is possible, however, to make a claim with reasonable confidence where certain pecularities of modelling appear on both a marked and an unmarked piece, even though they may depict different personages. It is on these grounds that the bust of William IV illustrated in Plate 150 is given a Rockingham provenance. The detailing of the drapery and the treatment of the band around the pedestal are so identically reproduced on the marked busts of the Duke of York and Lord Brougham that we are entitled to ascribe the work to Swinton even though there is no actual mark.

Theatricals

Some of the early models produced at Rockingham were of theatre personalities. They are of exceptionally high quality—well able to stand comparison with the products of the eighteenth-century factories. They would seem invariably to have been glazed and coloured, since no biscuit examples have as yet been recorded.

Madame Vestris (1797–1856) appears in Bavarian costume as a broom girl, No. 6 (Plate 152), in the performance of her famous song 'Buy a Broom', the first verse and refrain of which went as follows:

> From Deutschland I come with my light wares all laden,
> To dear happy England in summer's gay bloom;
> Then listen, fair lady, and young pretty maiden,
> O buy of the wandering Bavarian a broom.
> Buy of the wandering Bavarian a broom.
> Buy a broom! Buy a broom (*spoken*). Buy a broom!
> O buy of the wandering Bavarian a broom.

The fame of Vestris is evident from the frequent references to her in contemporary memoirs. The Marquise de Keroubec, in her diary for 21st April, 1802, quotes Talleyrand as saying: 'And my betrothal shall be celebrated by the grandest entertainment I have ever given. Vestris must perform her Russian steps and a gavotte.' And in J. T. Smith's *Nollekens and his Times* the sculptor's wife chides her husband with the words: 'A man like you who could obtain orders at any time for the Opera House where you could see Vestris.'

John Liston (1776–1846), the celebrated actor of farces, is represented in several of the parts he made famous. Thus he appears as Simon Pengander, No. 7 (*R.O.P. Colour Plate 20*); Billy Lackaday, No. 8 (Plate 153); Paul Pry, No. 9; Moll Flaggon, No. 10 (Colour Plate VIII); Lubin Log, No. 11 (Plate 154); and Tristram Sappy, which is not numbered. An advertisement in *The Connoisseur*, September 1912, page v, illustrates a figure described as

'Liston as Van Dander' and attributes it to Rockingham. Unfortunately, there is no specific mention of it being marked: but if it was, it might well have been model No. 12.

The figure illustrated in Plate 155, of Napoleon in his familiar stance, would seem to be a theatrical despite its somewhat late number of 42. The face looks strongly reminiscent not of Napoleon but of the actor John Warde. Certainly John Warde won a tremendous success in the part of Napoleon—bringing the house down with his dramatic portrayal of the emperor on horseback—in *Napoleon Buonaparte*, written by Rophino Lacy, which opened at the Covent Garden Theatre on 16th May, 1831.

Romantics

Various examples falling within this category, both in colour and in biscuit, are illustrated in *Rockingham Ornamental Porcelain*. Included are a shepherd and dog, and the matching shepherdess and sheep, No. 4 (*R.O.P. Colour Plate 18 and Plate 108*); a Swiss boy and the corresponding Swiss girl, No. 23 (*R.O.P. Plate 102*)—which could be classified as Continental Peasants but for the fact that the figures do not display a specific regional costume and do not, in any event, tone generally with the series; a boy clasping a pitcher, No. 26, together with the companion girl of the same incised number (*R.O.P. Plates 105 and 109*); a boy writing and, to correspond therewith, a girl sewing, No. 28 (*R.O.P. Plate 106*); Chantrey's sleeping child, No. 63, and waking child, No. 64, in biscuit (*R.O.P. Plates 104 and 103*); and a pair of kissing putti, No. 102 (*R.O.P. Plate 101*).

Another example of the shepherd and dog, No. 4, is illustrated in Plate 156. It is interesting for the depth of its colour, and it must have been an early production. A group comprising a girl clasping a sheep in one hand and a bowl in the other, No. 44, is also illustrated (Plate 160), together with a model of the Whistling Cobbler, No. 39 (Plate 167). The pair of figures in biscuit, No. 35 (Plate 165), comprising a girl with a sheep and a boy with a dog are identical to 'the models more frequently found at Derby'. They are presumably Cocker models.

Animals

Rockingham issued a fine range of animals, surpassing in quality all others produced elsewhere in the nineteenth century. Many of these, including dogs, cats, squirrels, rabbits, hares, deer and sheep, are illustrated in *Rockingham Ornamental Porcelain* (*Colour Plates 19–21 and Plates 110–117, 119–122*). In this book are illustrated an elephant, No. 69 (Plate 158); a pug dog, No. 76 (Plate 159); a cat-and-kittens group, No. 107 (Plate 161); a squirrel, No. 111 (Plate 163); and, for sheer quality, quite magnificent examples of a hare, No. 110 (Colour Plate VIII) and of a swan, No. 99 (Plate 157). Most of the surviving examples seem to be glazed.

It is of incidental interest to note that squirrel figures were decorated with

a collar, usually in gilt—a practice also adopted at Derby. The explanation for this is that in the late eighteenth and nineteenth century squirrels were kept as pets and, naturally enough, were fitted out with collars. Although they were usually given the freedom of the house, they were also confined in special cages with a revolving treadmill.

> Did you ever see a squirrel vent his tiny rage
> In turning round his tiny cage? (Matthew Arnold)

The owners' attachment to pet squirrels is illustrated by Lady Sarah Lennox's reaction to George III's marriage to another after hints that he had chosen her. According to her son, Henry Napier, 'My mother would probably have been vexed, but her favourite squirrel happened to die at the same time, and his loss was more felt than that of a crown.'

Closely connected with the animal classification are the silhouette figures with their distinctive flat-looking backs which are really slightly concave. They are extremely rare—and most of those wrongly attributed to Rockingham emanate, in fact, from Minton. A genuine example, however, in the form of a pair of greyhounds, is illustrated in Plate 162. Another example—'The Boxers', 3½ inches high by 3¼ inches long—can be seen in the Yorkshire Museum (see also Geoffrey Godden's *Illustrated Encyclopaedia of British Pottery and Porcelain*, *Plate 492*).

Not exactly animals but very similar in spirit are the fox-masks and hound-masks—in the form of rhyton cups, used by mounted huntsmen immediately before the hunt set off—that Rockingham occasionally produced. An example of each, illustrated in *Rockingham Ornamental Porcelain*, page 148, can be seen in the Yorkshire Museum. They both belong to the red-mark period. Such pieces were presumably issued in pairs, for an important pair in the form of hound-masks is in my own collection.

It is uncertain whether Rockingham ever did produce a poodle. The model has certainly not been recorded to date. If there are any examples extant, they will undoubtedly be finely modelled, almost positively without a fuzzy wool texture, and incomparably superior to the numerous Staffordshire productions with which, by tradition, the Rockingham factory has—to its infinite detriment—been credited.

Unfortunately, genuine Rockingham animals are so rare that their intrinsic quality—which puts them on a plane with similar products from the eighteenth-century factories—has not been so fully appreciated as undoubtedly would have been the case had their output been more extensive. Testimony to their rarity and quality has, however, been given in the salerooms in recent years by the quite exceptional prices they have commanded.

Continental Peasants

Rockingham produced a series of figures of peasants from different parts of the Continent wearing their local costume. They would seem to have been

based on engravings. Several examples are illustrated in *Rockingham Ornamental Porcelain*, including 'Paysanne de S. Angelo', No. 120 (*R.O.P. Colour Plate 21*) and, on pages 149–54, 'Femme de l'Andalousie', No. 119; 'Paysanne du Canton de Zurich', No. 18; 'Paysan Piemontais de la Vallee d'Aoste', No. 57; 'Paysanne de Sagran en Tirol', No. 22; 'Paysanne du Mongfall en Tirol', No. 15; 'Paysan du la Vallee de Ziller en Tirol', No. 50; 'Paysanne de Schlier en Tirol', No. 14; 'Paysan Basque des environs de Bayonne', No. 115; and 'Paysan du Canton de Zurich', No. 53.

Within this group can conveniently be included the Russian Wandering Pilgrim or Peasant No. 37 (*R.O.P. Plate 136*), bearded, leaning on a stick, with a knapsack on his back, and wearing straw boots. It would seem to be based on a slightly larger model produced by an expatriate Englishman, Francis Gardner, in a factory at Twer (now Kalinin) between Moscow and St. Petersburg.[1]

Opportunity has been taken to illustrate in this book (Plate 164) a further peasant figure—'Homme du Peuple à Valence', No. 113—which is in the possession of the Rotherham Museum.

The modelling of this series is extremely fine—even if the general conception is, as one would naturally expect from models based on engravings, somewhat stiffer on occasion than one would have liked.

Miscellaneous

Rockingham also produced a variety of figures which cannot be classified in any of the foregoing groups. Examples are the two drunken topers, No. 1 and No. 29, reproduced on a smaller scale and with somewhat different detailing at Derby and alleged to be based on the original models of a certain Dr. Douglas Fox, who employed his amateur talents as a modeller to illustrate to his patients the evils of over-indulgence. One of the topers—entitled around the base 'Steady Lads'—is illustrated in Plate 166. Although the subject can scarcely be said to be appealing, the quality of the figure is excellent.

It would seem that, in the tradition of the eighteenth-century factories, Rockingham produced a set of seasons. Certainly a Bacchus representing autumn, No. 32, was included among its output. An example of the model is illustrated in Plate 168.

In addition to the above, a figure in the form of a Turkish gentleman, No. 25, was turned out at Swinton. The model appears in two sizes, $2\frac{7}{8}$ inches and $3\frac{3}{4}$ inches in height (Plate 169).

[1] For a discussion of this, see *Rockingham Ornamental Porcelain*, p. 60.

Chapter VI

Artists

It is to be regretted that our knowledge of the artists employed at the Rockingham works is not extensive. Most of it depends on the writings of Llewellynn Jewitt and John Haslem and on a few signed plaques and other documentary pieces that have survived. However, it is to be hoped that much more information will eventually be brought to light with the discovery of more documentary specimens and the development of research generally.

It seems convenient at this point to give a general warning where landscapes are concerned. To try and attribute views to a particular artist on the basis of stylistic treatment of the subject depicted is a natural error for the inexperienced. This approach, though perfectly valid in the case of original paintings in oils or watercolour, is quite out of place where, as is usual with landscapes on porcelain, the view is a more or less exact reproduction of a contemporary engraving. The characteristics on which the inexperienced eye is focused are those of the original artist and not those of his ceramic copyist. Thus, the engraved works of T. H. Shepherd, A. C. Pugin and C. Fielding, H. E. Challon, John Preston Neale, and Thomas Allom are to be found reproduced on Rockingham pieces.

Specific examples are T. H. Shepherd's drawing 'Hanover Lodge, Regent's Park', published as an engraving by W. Tombleson, 10th August 1827 in Jones & Co.'s *Metropolitan Improvements in London in the 19th Century* and reproduced on a fine oblong octagonal basket in private hands; A. C. Pugin and C. Fielding's drawing 'The Pavilion, Brighton, West View', engraved in aquatint by T. Sutherland in 1824 and substantially reproduced on the magnificent oblong octagonal basket illustrated in *Rockingham Ornamental Porcelain (Colour Plate 7)*; H. E. Challon's drawing of a dog chasing game, engraved by J. Scott and included in William B. Daniel's *Rural Sports*, 1801, Vol. III, opposite page 260, substantially copied by Bailey on a plaque illustrated in *Rockingham Ornamental Porcelain (Plate 98)*; and John Preston Neale's drawings 'Eaton Hall', reproduced on the fine pot-pourri jar illustrated in *Rockingham Ornamental Porcelain (Plate 38a)*, and 'Sprotbro'

Hall' (Plate 129)—both published in Jones' *Views*, 1829, and engraved by W. Radclyffe and J. B. Allen respectively.

Thomas Allom is particularly strongly represented, the following of his views being especially in evidence: 'Newstead Abbey' (*Rockingham Ornamental Porcelain, Plates 76, 77 and 78*); 'Chatsworth' (Plate 120); 'Radford Folly' (Plate 120), published in *The Counties of Chester, Derby, Nottingham, Leicester, Rutland and Lincoln Illustrated* by Fisher Son & Co., 1836; 'Howick Hall'; 'Alnwick Castle' (*Rockingham Ornamental Porcelain, Colour Plate 6*); 'Derwent Water' (Colour Plate VII); 'Raby Castle'; 'Netherby'; 'Warkworth Castle'; and 'Ennerdale Water', published in the *Northern Tourist*, by Fisher Son & Co., 1832.

Therefore, although the palette used—and possibly the treatment of leaves and other details not absolutely essential to the engraving's reproduction— may furnish a clue to the identity of a particular painter at the Rockingham factory, the composition itself can afford no help at all. Neither, of course, can the brush strokes: they would have been lost in the firing when the pigments fused with the glaze.

Earthenware

COLLINSON

The only artist whose work can be identified with any confidence on earthenware is Collinson. Jewitt makes explicit reference to him as the best flower-painter employed at the Swinton Works[1] and adds that he decorated earthenware with naturalistic flowers whose Latin names were pencilled at the back. The *Dilwynia floribunda* painted on a round earthenware plate belonging to the Victoria and Albert Museum is an example of his work.

LLANDIG

The so-called 'blackberry pattern' attributed to Llandig (see also page 16) appears on earthenware as well as porcelain. To this extent, it can be claimed that the work of Llandig as well as Collinson has been identified on pottery.

Porcelain

ISAAC BAGULEY (1794–1855)

Isaac Baguley was at Swinton from about 1829 to the factory's closure in 1842.[2] Jewitt records that in 1829 'Mr. Baguley had charge of all the painting and gilding department in china and enamel earthenware'[3] having been

[1] *Ceramic Art in Great Britain*, Vol. 1, p. 509.
[2] From the records contained in the Census of 1841 (see *R.O.P.*, pp. 63–5).
[3] *Ceramic Art in Great Britain*, Vol. 1, p. 503.

'formerly employed at the famous Derby China Works'.[1] Moreover, Chaffers' *Marks and Monograms on Pottery and Porcelain*[2] tells us that 'Baguley was a painter of birds'. Unfortunately, no work of his has been identified, nor has a distinctive style of bird-painting appearing in both the red- and puce-mark periods come to light on which a tentative attribution could be based.

On the closure of the Rockingham works in 1842, Isaac Baguley continued there with his son Alfred—who had served his apprenticeship under the Bramelds—buying in pottery and porcelain pieces from outside factories and decorating them. According to Jewitt,[3] his speciality was the continuance of the old brown glaze of the Bramelds, which he richly gilded. However, it is probable that he decorated some of the remnants left over at Swinton from the original Rockingham production; and he may even have initially usurped the old puce mark of the Bramelds. His own individual marks are discussed on pages 108–9.

On Isaac Baguley's death in 1855, his son carried on the business— ultimately moving it to Mexborough in 1865 where he died on 7th March 1891, aged 69.

WILLIAM W. BAILEY

According to Jewitt,[4] Bailey 'was the principal butterfly painter . . . who also painted landscapes and crests'. From the red-mark period, the only documentary work of this artist so far recorded is a plaque with the red griffin mark which depicts a dog chasing game. It is illustrated in *Rockingham Ornamental Porcelain, Plate 98*. This specimen enables us to ascertain Bailey's style and palette during the early period. And it is on this evidence that I have been able to ascribe to his hand one of the plates from a particularly distinctive service now widely dispersed—frequently referred to by collectors as the Faversham Service—whose principal features are a claret ground colour and elaborate scenes of northern views. The plate in question is painted in the centre with a view of Rotherham (Plate 74) and is, at the time of writing, on loan to the Rotherham Museum. It is arguable from this that it would be reasonable to assume that all the other plates from this same service were decorated by Bailey.

As for the puce-mark period, I have in my possession a pair of unmarked plaques, painted with named marine views of 'The Clyde from Erskine Ferry' (Plate 148) and 'Sunset—view on the Welsh coast' (Plate 147) respectively, and both signed 'W. W. Bailey pinxt'. The paste, with its silky feel, brown staining and characteristic crazing, is undoubtedly that of the Swinton factory. But far more important, the hand on these two plaques can also be identified on many paintings executed on various *marked* pieces from the puce-mark period. Examples can be seen in *Colour Plate 6* and *Plates 41, 45 and 76* of *Rockingham Ornamental Porcelain*.

[1] *Ceramic Art in Great Britain*, Vol. 1, p. 506.
[2] Fourth Edition, 1874, p. 781.
[3] *Ceramic Art in Great Britain*, Vol. 1, pp. 506–7.
[4] Ibid, p. 515.

The prevalence of this hand is not surprising. The fact that Jewitt makes particular mention of Bailey whilst omitting others—such as William Corden, John Lucas, John Randall, Thomas Steel, and Edwin Steele—must indicate that he was a painter of importance during the life of the factory whose work would be expected to appear with reasonable frequency. Accordingly, it is possible to identify his landscape painting during both the red- and puce-mark periods. And it appears on ornamental and useful ware alike.

This last point is confirmed by an interesting dessert service sold by Christie's on 11th December 1951, Lot 133, which also gives further proof of W. W. Bailey's connection with the Rockingham works. The catalogue reads:

> An attractive Rockingham Dessert Service, the centres superbly painted with figures of children and lovers after paintings by Landseer and Witherington and adapted from Annuals such as The Book of Beauty 1834 and 1835 and The Keepsake of 1835, many of the pieces with long inscriptions on the reverse, comprising: Centre Dish on tall foot, two oval Dishes, two oblong Dishes, two square Dishes and twelve Plates (19).

A footnote is added as follows:

> Many of the pieces bear the inscription 'China Works, Wath', 'W. W. Bailey, Wath' and other variants. Wath is in Yorkshire not far from the Rockingham Works and a Bailey is recorded as 'a principal Butterfly painter'.

Now, a 'China Works, Wath' is unknown in ceramic literature. The cost of establishing a porcelain works was very considerable, involving a capital outlay far beyond that which a workman or artist could command. Moreover, once established, it would make an impact and would not easily be forgotten. It can safely be concluded that W. W. Bailey, in so far as he was claiming the existence of a porcelain factory, was guilty of a grandiose exaggeration. At best, he could have owned a firing kiln to enable him to decorate at home porcelain acquired elsewhere—presumably from Rockingham. Clearly, he could not have referred to work done at home as coming from the Rockingham works. What more likely, then, than that he invented a 'China Works' at Wath, presumably his own home, and gave his output this provenance? It is unfortunate that we do not know the shape of this dessert service, on the strength of which a conclusive attribution of the porcelain to the Swinton factory could have been made.

However, the service does help to establish W. W. Bailey's connection with Rockingham—and in addition, whilst the marked plaque referred to above proves his presence at Swinton before 1830, the adaptations on the service from The Book of Beauty, 1834 and 1835, and The Keepsake of 1835 suggest Bailey's presence at Wath, and presumably at Rockingham, late in the

factory's life. This length of stay at Swinton would be consonant with his acknowledged importance as a Rockingham artist. It is to be regretted that in the Census of 1841 his name does not appear among those living in the Swinton area at that date. Had this been the case, we might have been able to define more closely the period of his residence at the Rockingham works.

It is to be noted that whilst the marked plaque bears the signature 'Bailey' *simpliciter*, the two unmarked marine plaques add the initials 'W. W.'. This would suggest that in the former case he was an employed artist working at the factory, and in the latter he was painting at home on his own account. That he did have a private practice is supported by White's *Directory of Sheffield, etc.*, 1833. For he is listed there as 'Bailey Wm. Ornamental painter' along with other inhabitants including 'Brameld Thos. China mfr.'. The implication of the entry is that at that date, at any rate, he was not merely an employee of the Rockingham factory, although doubtless he spent most of his time there.

So much for Bailey's landscapes. But what of his butterflies? For Jewitt describes him as 'the principal butterfly painter'. To date, his butterflies have not been identified. But a particular style of butterfly, finely executed, is sometimes found on pieces from the red-mark period—when Bailey is known, by virtue of the marked plaque referred to above, to have been at Swinton. An example of such painting can be seen on a caudle cup, cover and stand and on the rim of a dessert plate illustrated in *Rockingham Ornamental Porcelain, Colour Plate 15* and *Plate 138* respectively. Was this the work of Bailey? Only later research can provide confirmation.

JOHN WAGER BRAMELD (1797–1851)

John Wager Brameld, the artist brother of the three partners in the Rockingham factory, was almost certainly responsible for the flower painting around the rim of the plate illustrated in *Colour Plate 11* of *Rockingham Ornamental Porcelain*. This conclusion is arrived at from a comparison of the style of painting displayed there with that appearing on a fine brown-glazed cup, cover and stand in the Victoria and Albert Museum which had been exhibited by J. W. Brameld in 1851 at the Great Exhibition. Almost certainly, the flower-painting on the latter piece must have been the work of J. W. Brameld. Consequently, so too must the floral chain on the plate referred to.

John Wager Brameld was also responsible for the decoration of the Rhinoceros Vase (Plate 171), formerly at Wentworth House and now in the Rotherham Museum (see Appendix B).

The best account of this artist is that given by Jewitt:[1]

> Mr. John Wager Brameld, like his brother, was a man of pure taste. He was an excellent artist, and some truly exquisite paintings on porcelain by him have come under my notice. He was a clever painter of flowers and of figures, and landscapes. In flowers Mr. Brameld went

[1] *Ceramic Art in Great Britain*, Vol. 1, p. 502.

to Nature herself, collecting specimens wherever he went, and reproducing their beauties on the choice wares of the works. At Lowestoft I remember seeing a set of three vases painted in flowers, which, it is said, Mr. Brameld gathered on the Dene, at that place, on one of his visits, and which vases he presented to the father of their present owner. In the same hands is an elegant snuff-box, bearing an exquisite painting of 'The Politician', with groups of flowers, and bearing the words, 'Brameld, Rockingham Works, near Rotherham', 'The Politician, J. W. Brameld'. This being a signed piece of John Wager Brameld's, is particularly interesting. Mr. Brameld's time was chiefly devoted, however, to travelling for the firm in the United Kingdom, and to the Management of the London house, so that his artistic productions did not make a feature in the goods generally made at the Works.

Unfortunately, the present whereabouts of the pieces mentioned above are not known.

John Wager Brameld travelled extensively on behalf of the factory, particularly to Scotland and the Norfolk area (see Appendix G). He also ran the London House, particulars of which are given in Appendix E.

THOMAS BRENTNALL (c. 1799–1869)[1]

Jewitt is the authority for Thomas Brentnall's employment at Swinton. He refers to him as 'a clever flower-painter'.[2] Moreover, the fact that Jewitt makes specific mention of him, when he is silent about other well-known artists, would seem to indicate that Brentnall's stay at Rockingham was of some significant duration. It is interesting to note that in the Census of 1851, his son Alfred, who was then 15 years old, is described as having been born in Yorkshire. Accordingly, it is a reasonable inference to suppose that Thomas was in any event at Swinton in 1836. More concrete still is the insertion in White's *Directory of Sheffield, etc.*, 1833, of his name among a list of inhabitants of Swinton including Thomas Brameld himself. He is referred to as a 'flower-painter'. The special mention accorded him suggests that he was an important artist and that he may have had a private practice.

Unfortunately, we can get no help from Haslem's *The Old Derby China Factory*. For although Thomas Brentnall is also referred to there, and his dismissal from Derby in 1821 specifically cited, Haslem mentions only Coalport[3] and 'several manufactories in Staffordshire' (Messrs. Ridgeway, of Cauldon Place, for the latter part of his time) as his subsequent places of employment.[4] No reference is made to Swinton.

No signed work of Thomas Brentnall seems to have survived and, as yet, we are unable to identify his hand.

[1] i.e., according to John Haslem's *The Old Derby China Factory*, p. 111. However, in the 1851 Census he is described as being 48 years old.
[2] *Ceramic Art in Great Britain*, Vol. 1, p. 515.
[3] See *Coalport and Coalbrookdale Porcelains*, G. A. Godden, p. 105.
[4] *The Old Derby China Factory*, pp. 110, 111.

WILLIAM CORDEN (1797–1867)

This artist, according to Haslem,[1] 'was apprenticed at the Derby works, where he learnt to paint landscapes in an agreeable manner. While at the works he turned his attention to the painting of portraits and figure subjects. About 1820 he left the china works, and devoted himself to portrait painting . . . About 1831 Corden was engaged to paint some of the subjects on the largest pieces of a magnificent service which was manufactured at Swinton for William IV.' It is to be presumed that his brush can be seen on this particular production. His painting can also be found on certain ornamental pieces made at Rockingham, an example of which can be seen in *Colour Plate 3* of *Rockingham Ornamental Porcelain*. The duration of his stay at Swinton was approximately from 1831 to 1832.[2]

It is interesting to note that after William Corden left Derby, in about 1820, he was employed for a while at Coalport. A plaque signed by him and dated 1822, which was offered for sale at Sotheby's on 1st August 1967, Lot 186— it depicted Jebediah Strutt seated in a cane-backed chair, wearing a yellow coat—bore the incised mark *J. Rose & Co., Coalport*.

Whether the various unmarked plaques signed by William Corden and dated between 1823 and 1824, which tradition ascribes to the Derby Factory— see Sotheby's sale of 30th May 1967, Lots 177 and 178—do in fact have this provenance, is, in the light of the foregoing, perhaps doubtful. A Coalport attribution might be more accurate.

William Corden was a sufficiently distinguished portrait painter to secure a place in the *Dictionary of National Biography*, to which the reader is referred for further details of his career.

JOHN CRESSWELL

All that is known of this artist is what Jewitt has said of him,[3] viz:

> In 1826 (Nov. 17) Messrs. Brameld & Co. secured the services of an excellent painter, 'Mr. John Cresswell, painter on china', and articles of agreement (in my own possession) were drawn up by which Cresswell engaged himself to them for five years at 7s. 6d. a day for the first three years, 9s. 3d. a day for the fourth year, and 10s. 6d. a day for the fifth year.

Although none of his work has been identified, it is interesting to reflect on whether he could possibly have been responsible for the flower decoration on the pair of plates illustrated in Plate 69. These plates carry not merely the red mark but also one of the lowest recorded pattern number—namely, 417. Clearly, the artist responsible for the decoration must have been at Rockingham in 1826. In addition, he was also responsible for the flower painting

[1] *The Old Derby China Factory*, pp. 113, 114.
[2] See the discussion in *Rockingham Ornamental Porcelain*, p. 70.
[3] *Ceramic Art in Great Britain*, Vol. 1, pp. 503, 504.

carried out on two red-marked plates bearing the low pattern number 425. As for ornamental pieces, the hexagonal vase shown in Plate 119, the similarly shaped piece illustrated in *Colour Plate 2* of *Rockingham Ornamental Porcelain*, the loop-handled jug shown on page 136 of that book and the rare jug illustrated in Plate 134 were also painted by the same artist; and all the items belong to the red-mark period. In fact, no work of his has so far been seen on a piece dating from after 1830.

It is, perhaps, not without significance that the articles of agreement cover the years 1826–31—which would correspond ideally with the period when the pieces referred to were manufactured. Although it must be emphasised that there is no positive proof that the artist in question was John Cresswell, there is at least some slight circumstantial evidence.

HAIGH HIRSTWOOD (1778–1854) and WILLIAM LEYLAND (Died 1853)

Haigh Hirstwood was employed by the Bramelds for upwards of forty years, leaving them in 1838—along with his sons Joseph and William, and son-in-law William Leyland, also Rockingham artists—to found his own manufactory at York. According to Jewitt,[1] he 'was a clever painter of flowers, etc., and was considered the best fly painter at the Rockingham works. In 1826 he copied for use in the decoration of the Rockingham china, upwards of five-hundred insects at Wentworth House, which had been arranged by Lady Milton, the daughter-in-law of Earl Fitzwilliam. He and his sons Joseph and William (who were brought up at the Rockingham works) were engaged upon the chef-d'œvres of that manufactory, the services for King William IV and for the Duchess of Cumberland.'

Apart from these services, is there any other ware on which his talents were exercised? A possibility lies in the flowers and insects painted on the red-marked cream jug illustrated in *Rockingham Ornamental Porcelain*, *Plate 140*. However, to confirm this attribution we would have to find evidence of this same style of painting on a piece from the puce-mark period: for Hirstwood's employment at Swinton spanned both the red- and puce-mark periods.

As for William Leyland, Jewitt says of him:[2]

> Mr. William Leyland, also from the Rockingham works, who became [Hirstwood's] managing partner . . . was a clever painter, gilder and enameller, and understood well all the practical details of the potter's art.

After dissolution of his partnership with Haigh Hirstwood through disagreement, Leyland went to London, where he took to painting and decorating lamps. He died in 1853.

Illustrated in *Yorkshire Potteries, Pots and Potters* by Oxley Grabham, on page 110 of the *Annual Report* for 1915 of the Yorkshire Philosophical Society,

[1] *Ceramic Art in Great Britain*, Vol. 1, p. 462.
[2] Ibid, Vol. 1, p. 462.

are two plaques alleged to have been painted by William Leyland and Joseph Hirstwood respectively. Whether or not they were executed at Swinton is problematical.

JOHN LUCAS (c. 1811–1833)

Our authority for John Lucas's residence at Swinton is Haslem, who in his book *The Old Derby China Factory* writes of him on page 122 as follows:

> Daniel Lucas had three sons, all of whom were apprenticed at the Derby works. John, the eldest, learned landscape painting under his father, but left Derby shortly after he was out of his apprenticeship, and worked at Swinton until his death in May 1833. He painted somewhat after the manner of his father, but his execution was more refined. In the Derby Exhibition of 1870 were two plaques by him—No. 542 'The Plains of Waterloo', and No. 547 'View of Chatsworth'. These were painted on Rockingham china, and were the property of the late Mr. John Woolley, of Derby.

Although the present whereabouts of these plaques are unknown they were certainly in existence in 1912, for in the Register Section of the December issue of *The Connoisseur* for that year, on page xxxiv, the following advert appears:

> For Sale—Pair of Rockingham Plaques, floral china frames. Views, Chatsworth House and Plains of Waterloo, by Lucas.

These are the only works known to have been executed by John Lucas at Swinton.

As for the date at which Lucas arrived at the Rockingham factory, exactitude is impossible. But it is known that his name appears, along with that of his father Daniel, on the Derby subscription list compiled shortly after the passing of the Reform Act of June 1832. It would seem, then, that the extent of the artist's stay at Rockingham was from late in 1832 to the time of his death in May 1833.

Confirmation of John Lucas's presence at Swinton is given in White's *Directory of Sheffield, etc.*, 1833. His name is listed there along with other Rockingham artists.

JOSEPH MANSFIELD (Born c. 1803)

Jewitt refers to Mansfield as 'the principal embosser and chaser in gold'[1] at Rockingham but unfortunately does not enlarge on this bare statement.

However, in the 1851 Census for Shelton, where Joseph Mansfield is

[1] *Ceramic Art in Great Britain*, Vol. 1, p. 515.

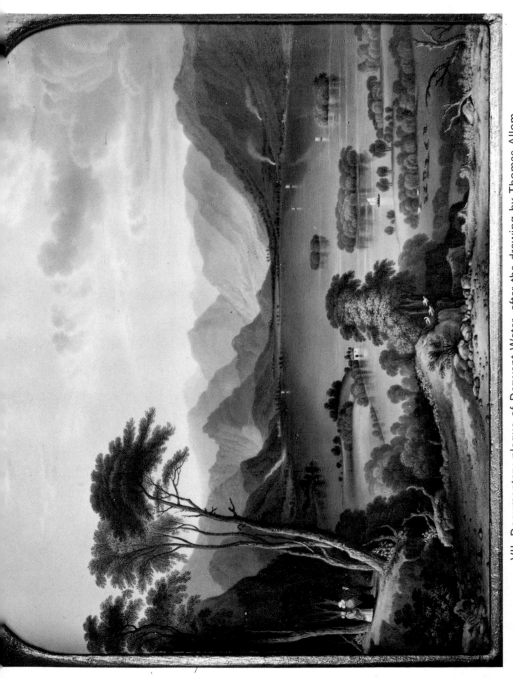

VII. Documentary plaque of Derwent Water, after the drawing by Thomas Allom. Signed on the front "G. Speight pinx'". 12½ inches by 10⅜ inches. See page 74.

described as forty-eight years old, the following additional information appears in respect of his children:

Name	Age	Born at
Henry	22	Swinton
Elizabeth	18	Wath-upon-Dearne
George	14	,, ,, ,,
Jane	10	Burslem

Accordingly, in view of the birthplaces of Henry, Elizabeth and George, it is reasonable to assume that Mansfield was at Rockingham from at least 1829 to 1837. From the fact that Jane was born at Burslem in 1841, we can also conclude that he had left Swinton by then; and this is further confirmed by the absence of his name from the 1841 Census for the area.

Apart from the 1851 Census statement, an important reference is made to Joseph Mansfield in the *History, Gazetteer and Directory of the West Riding of Yorkshire*, by William White, 1838 Vol. 11, where, under the heading 'Swinton', he is grouped with such local commercial concerns as Brameld & Co. and Samuel Barker (Don Pottery) and is described as 'chaser and gilder'. This citation establishes that Mansfield was at Swinton as late as 1838 and that at that date he was presumably trading on his own account. Indeed, he may have been an independent contractor for a considerable period prior to this, being employed by the Bramelds on a contract basis from time to time for their most important work. This theory gains some support from the inclusion of his name in White's *Directory of Sheffield, etc.*, 1833, along with other inhabitants of Swinton including Thomas Brameld. He is described as 'gilder and chaser', and the implication would seem to be that even at this time he had a private practice as well as being employed by the factory.

In any event, it is clear that Mansfield was present at Swinton during a great part of the factory's life as a porcelain producer. Indeed, he may have worked there almost throughout its entirety.

In the light of Jewitt's remark, we can assume that his work can be seen on the most richly gilded pieces of the factory's output.

JOHN RANDALL (1810–1910)

John Randall was a most remarkable man. He lived to be a centenarian, spanning the last decade of George III's reign, the Regency, and the rule of George IV, William IV, Queen Victoria and Edward VII. To have been born when George III was still on the throne and to have died in the reign of George V was to have seen an almost unbelievable transformation of the world. But Randall is even more remarkable for the fact that he remained *mentis compos* throughout his long life and was able to give an interview to W. Turner at the age of ninety-eight, the gist of which is recorded in *The Connoisseur*, December 1908, under the title *Madeley Porcelain*.

Most of his working life was spent at Coalport (1835–1881), where he excelled at bird-painting, particularly of the exotic type; and it was to this flair that he owed his distinguished position in the ceramic world. Long before his retirement from Coalport, as a result of failing eyesight, he took to writing, the following being among his more important publications: *History of Madeley*, *The Clay Industries on the Banks of the Severn* and *The Severn Valley*.

Jewitt, after referring to John Randall's uncle, T. M. Randall, goes on to add, perhaps somewhat patronisingly:[1]

> . . . a nephew, who is the author of pleasant little volumes on the '*Severn Valley*' and '*The Willey Country*', is still employed at the Coalport Works, principally on birds.

It is noteworthy that Randall's literary productions, full of scholarship and facility of expression, were published while he was still employed at Coalport. And it is salutary to remember that a ceramic artist could accomplish something far more than would have been expected of a mere artisan. Perhaps Randall, in his later years, was more of a freelance artist with wider interests but permanently on retainer to exercise his skill on some of the factory's finest specimens.

At the conclusion of the second edition of his *The Severn Valley*, 1882, it is interesting to observe the following advertisement:

> PRICE £22, a Collection of Carboniferous and Silurian Fossils, the result of many years' labour and research. Suitable for a Private Collection or a Public Museum. J. Randall, Post Office, Madeley, Salop.

He was always a keen collector of fossils, being elected an honorary Fellow of the Geological Society in 1863. His collection, after being displayed at the 1851 Exhibition, was subsequently acquired for the nation.

Despite John Randall's long life and the facility for self-expression which, unlike many ceramic artists, he clearly had at his command, very little of his working life has been recorded and his importance as a ceramic painter has not been fully appreciated. Still less has it been generally known that he spent a short part of his early working life at the Rockingham factory.

Turner records in his account of his interview with John Randall[2] that:

> He began to paint under his uncle's tuition at Madeley in 1828. After a few years he went to Rockingham, thence to the Potteries, and in 1835 to Coalport, where he decorated some of the productions of that famous factory for forty-five years.

The exact duration of Randall's stay at Swinton is not clear from the above passage. But it would be reasonable to assume that his apprenticeship

[1] *Ceramic Art in Great Britain*, Vol. 1, p. 273.
[2] *The Connoisseur*, December 1908, p. 252.

finished in all probability when he was twenty-one, i.e., in 1831, and that it was about that time that he moved to Rockingham. Certainly no work of his has, as yet, been identified on pieces carrying the red mark which covers the period 1826–30. However, there is some evidence to suggest that he was at Swinton in 1830. For his hand is clearly in evidence on one of the specimen plates submitted with eleven others, in competition with other leading manufacturers, for the order for the Royal Service commissioned by William IV. One of Randall's famous birds is clearly visible on the Royal specimen plates illustrated in Colour Plate V. On the rim of this same plate, incidentally, are three other vignettes depicting sea scenes and seemingly executed by the same hand as was responsible for the exotic bird. Accordingly, one must assume that Randall was equally capable of painting seascapes and views generally. As the order for the Royal Service was received in 1830 and drawings of the principal pieces had already be enprepared by Thomas Brameld by November 1830—they were once in the possession of Llewellynn Jewitt[1]—it would seem that John Randall had arrived at Swinton by 1830 rather than 1831.

The exact date of his departure is likewise obscure. He cannot have remained long, as he had to go to the Potteries and then on to Coalport—all before 1835. Perhaps a date of 1833 might prove as reasonable a conjecture as any, and this finds remarkable confirmation in White's *Directory of Sheffield, etc.*, 1833, for his name is listed there along with other Rockingham artists.

But how do we identify Randall's work at Rockingham, particularly as no signed example has so far come to light? Fortunately, the problem admits of solution by virtue of his long employment at Coalport. For throughout the years a distinctive style of bird-painting can easily be traced, running contemporaneously with the period 1835 to 1881, and the matter is put beyond dispute by comparison of this style with certain plaques actually signed by John Randall in the 1870s. In this latter period, Coalport appears to have relaxed its strict rule of anonymity and permitted signatures by individual artists. A documentary plaque painted with three finely executed birds, illustrated in Geoffrey Godden's *Victorian Porcelain* on page 208, is particularly important in this respect. One or more of these appears again in virtually identical form on a pair of Coalport vases and covers, 17 inches high, shown at the Exhibition of 1871, and on a further pair of the same size—the rear panels this time painted with flowers by William Cooke —in the Godden Collection. Several examples of Randall's bird painting are featured in Geoffrey Godden's *Coalport and Coalbrookdale Porcelains*, 1970.

Accordingly, no great difficulty attends the identification of Randall's work on Rockingham porcelain, and the absence of signed work does not constitute a serious impediment. His style is distinctive. The palette he employs is bright and full of colours, the plumage of his birds characterised by yellow, orange, blue and red. Although Randall was famous at Coalport for his exotic

[1] *Ceramic Art in Great Britain*, Vol. 1, p. 505.

birds and they sometimes appear on Rockingham porcelain (*R.O.P., Plate 32*), as far as his output at Swinton is concerned they usually took what can conveniently be called a tropical form, excellent examples of which can be seen on the dessert plate and dishes illustrated in Plates 78–81.[1] It is interesting to note that it is to this type of bird that he returned in his later years at Coalport and that the signed plaques at that factory reveal bird-painting of this style. Occasionally, Randall reproduced naturalistic birds native to Britain. The specimen on the eagle-handled vase shown in *Rockingham Ornamental Porcelain, Colour Plate 4*, is finely executed without that stylised treatment so typical of naturalistic reproduction, which probably stems from mechanical copying of engravings.

But perhaps the most distinctive feature of John Randall's style is his stippled background, grey-green in colour, faintly outlining trees and foliage. This, seemingly more than any other characteristic, is indicative of his work.

Whatever the exact length of Randall's stay at Rockingham, it cannot have been long and we would expect little of his output to survive. The fact that it is found on Rockingham porcelain rather more frequently than we would perhaps have envisaged—being well represented in both public and private collections—is possibly a more fitting testimony than any other to its vigour and excellence. The sheer quality of his workmanship is a natural explanation of the assiduity with which collectors throughout the years have safeguarded his work from destruction.

GEORGE SPEIGHT (Born c. 1809)

The year of Speight's birth is deduced from the statement in the 1851 Census at Shelton that he was then forty-two years old. It is fortunate for the identification of George Speight's style that he did, on occasion, sign his work. A plaque depicting three children standing in front of a grave and entitled on the reverse 'The Mother's Grave', illustrated in *Rockingham Ornamental Porcelain, Colour Plate 12*, provides a clear means of attributing other, unsigned work to his brush. Thus, with reasonable confidence, we can ascribe to him the two magnificent plates illustrated in *Colour Plates 8 and 9* of *Rockingham Ornamental Porcelain*. In addition, he is stated by Jewitt[2] to have been responsible for the heraldic decorations on the Royal Service. Accordingly, his work can again be seen on the three specimen plates illustrated in Colour Plates IV, V and VI in this book and on two other specimen plates now belonging to the Victoria and Albert Museum. The flower decoration intermingled with the heraldic design is also by his hand. Another plate, in a private collection, painted with a scene of nymphs bathing and entitled 'The Enchanted Stream', is a further documentary piece of this artist.

A totally different subject-matter is the 'Madonna and Child' plaque illustrated in Plate 149. It is quite magnificently executed, the palette being pre-

[1] See also *R.O.P. Plates 26, 31* and *35*.
[2] *Ceramic Art in Great Britain*, Vol. 1, p. 515.

dominantly a deep blue and pink. It is entitled on the reverse 'Madonna' and bears both the griffin mark in red and the artist's signature.

Another subject executed by George Speight in a totally different idiom is his copy of Van Dyck's 'Earl Strafford occupied in dictating his defence to his secretary', which appears on a fine tray at Wentworth House (see also page 66). This piece is likewise printed with the red mark and signed.

A really important plaque depicting Derwent Water, after Thomas Allom, and bearing George Speight's signature on the front is illustrated in *Colour Plate VII*. It has already been described in detail under Plaques (see page 74).

George Speight continued at the factory from at least 1826 to shortly before its close. He was certainly still there on 10th April 1839, as is apparent from the birth certificate of his son Arthur George. Thereafter, his name appears in the records of the Ridgeway factory on watermarked paper of the year 1841. In or before 1857, he returned to Swinton to set up in business on his own account, decorating pieces bought in from other factories, for his name and occupation are recorded in connection with the district in the *Post Office Directory of Yorkshire* for 1857. He may have carried on a private practice at Swinton as early as 1833 since his name appears in White's *Directory of Sheffield, etc.*, 1833, along with other noteworthy people living in Swinton, including Thomas Brameld. He is described as an 'ornamental painter'. Whether or not he operated on his own at that time, he was without doubt employed regularly by the Rockingham factory on some of its finest work.

A superb example of his independent work can be seen in a beautifully gilded plate in my own collection. The centre of the plate is magnificently painted with the same view of 'The Mother's Grave' as appears on the plaque already referred to.

The name of George Speight appears in numerous Directories relating to Swinton between 1857 and 1865.

THOMAS STEEL (1772–1850)

We are indebted for a great deal of our information on Thomas Steel—more frequently but apparently inaccurately spelled 'Steele'—to Haslem, who summarises the artist's career as follows:[1]

> Thomas Steele, whose fruit painting on china has never been surpassed, was a native of the Staffordshire Potteries, where he first learned his art. He worked at the Derby factory from 1815 until within a few years of its close. On leaving he was engaged for a short time at Swinton, in Yorkshire; afterwards he returned to the Potteries, and worked, during the rest of his days, for the late Mr. Herbert Minton, by whom his talents were highly valued.

This passage clearly establishes that Thomas Steel worked at the Rockingham factory. Indeed, signed work of his appears on porcelain bearing the red

[1] *The Old Derby China Factory*, p. 119.

griffin mark. It is fortunate for us that he was apt to sign the finer examples of his skill. In fact, Haslem goes out of his way to make this point. 'The elder Steele usually put his name on his paintings of fruit on china plaques.'[1]

But the above biography given by Haslem cannot be accurate in its reference to Thomas's residence at Derby from 1815 'until within a few years of its close'. The life of the Derby factory expired in 1848, and it is clear from other evidence that the elder Steel left before 1830. Proof positive lies in the fine signed tray belonging to the Rotherham Museum, described fully on page 66, and in a documentary plaque illustrated in Margaret Vivian's *Antique Collecting*, page 140, Figure 106—both of which carry the griffin mark in red. The plaque also bears the date 1830. Accordingly, there can be no doubt that Thomas Steel appeared at Rockingham in or before 1830. How long he stayed is not known for certain. But the passage quoted from Haslem tells us that he moved on to Minton, and the researches of Geoffrey A. Godden into the records of the Minton factory reveal that Thomas Steel's name appears on the wages list for the week March 17th, 1831. Therefore, he cannot have left Rockingham later than that date. It follows from this that he can have decorated very little, if any, porcelain from the puce-mark period, and any attribution to Thomas Steel of fruit painting carried out on a puce-marked piece should be treated with the very greatest caution.

As for the technique of Thomas Steel, it is perhaps worth quoting the appraisal of him by Haslem:[2]

> The fault of Steele's roses is that they are sometimes left too white in the lights, the outline cutting hard against a dark background. This was never the case with his fruit.
>
> Steele painted both flowers and insects well, but as a painter of fruit on china he had no superior, if, indeed, he had any equal in his day. His colour is remarkably pleasing, being rich and transparent, and his large fruit pieces are painted with real force. His grouping is harmonious, the light and shade well managed, each piece of fruit is well rounded, and the outline softened and blended into the one next it, each partaking of the reflected colour from the other, a matter not always attended to by either china or other painters. Many of Steele's effects were cleverly produced by carefully dabbing on the colour, while wet, with his finger, thus blending the various tints well into each other, and giving great softness and delicacy, with an appearance of high finish, as if by elaborate stippling.
>
> Although Steele was at times an ardent worshipper at the shrine of Bacchus, he had attained his 79th year at the time of his death, which took place at Stoke-upon-Trent in 1850. Nor did his occasional indulgence impair his execution, as his later productions are equal to those of his best days.

It is interesting to note that in referring to Steel's work on display at the Derby Exhibition of 1871 Haslem cites 'a bunch of white grapes, painted from

[1] *The Old Derby China Factory*, p. 111. [2] Ibid, p. 120.

one grown in the hothouse of Earl Fitzwilliam, at Wentworth' as being 'probably the best specimen of his work'.[1]

EDWIN STEELE (1804–1871)

In contrast to his father, Edwin seems to have signed his name with the additional 'e'.

> Edwin, the eldest son [of Thomas Steel], worked at Swinton for a time after he left Derby. In the South Kensington Museum is a large vase, with cover, three feet two inches in height, which was manufactured at that place, and painted with groups of flowers by Edwin Steele. They are highly finished . . .
> Edwin [was] chiefly employed in the Staffordshire Potteries after leaving Derby . . . at Messrs. Minton's and at some other of the best manufactories. He died in 1871 in his 68th year.

So Haslem describes the career of Edwin Steele.[2] Unfortunately, he tells us nothing of Edwin's connection with the Rockingham factory except that he stayed there for a while after leaving Derby and that he was responsible for decorating the Rhinoceros Vase now in the Victoria and Albert Museum (see Appendix B). However, from these bare statements—assuming that they are accurate—it is possible to learn something more of Edwin's residence at Swinton.

To begin with, the hand that was responsible for the decoration of the Rhinoceros Vase is seen again on two flower-painted plates moulded with primrose-leaf borders in the Victoria and Albert Museum—one of them illustrated in Plate 71—both of which carry the red mark. Moreover, Mrs. Margaret Jarvis informs me that a pair of overhanging-lip vases painted with fruit in baskets on a shelf and bearing both the red mark and the signature 'E. Steele' have passed through her hands. We can conclude from this that Edwin arrived at Rockingham, possibly with his father, in or before 1830.

This same hand is seen again on certain pieces from the puce-mark period —notably, a garniture of three spill vases and an eagle-handled base (illustrated in *Rockingham Ornamental Porcelain, Plates 22 and 40* respectively). It follows, therefore, that Edwin Steele must have continued at Swinton into the puce-mark period for probably a year or two. We might thus put forward as tentative dates of residence 1828 to, say, 1832.

Although Haslem refers to Edwin's going to Minton, his name does not appear in the Minton wages list for the period 1831–36. There is therefore no need to assume any natural connection between the time of his father's transfer to Minton in about March 1831 and the date of his own departure from the Rockingham factory.

One piece of information culled from the 1851 Staffordshire Census returns lends some support to the tentative dates of residence at Swinton

[1] *The Old Derby China Factory*, p. 119. [2] Ibid, pp. 120–1.

postulated above. It is clear from the particulars relating to Edwin Steele in this Census that two children were born to his wife *at Derby* in 1827 and 1833. Edwin's name does not appear in the Derby Subscription List of 1832, so he is unlikely to have returned to Derby before 1833. However, assuming that he was with his wife at the time these two children were born, the dates would suggest that he left Derby in about 1828 and possibly returned for a short period in about 1833. Admittedly, Haslem makes no reference to a return to Derby: but there would be nothing to stop Edwin going back for a short while—or even for his wife, Charlotte, returning in 1833 to her home in Derby, where presumably her family and friends still resided, to have the child, pending a change in the location of her husband's employment. The point is purely speculative. But a stay at Swinton on the part of Edwin Steele for a period from 1828 to 1832 is probably not wildly inaccurate.

Edwin Steele was apt to sign his finest work, and familiarity with his style can be acquired from examining the various works executed at other factories.

OTHER ARTISTS

Artists other than those already mentioned are known to us as having worked at Swinton, among them being Sylvanus Ball, William Hopkins, and Edward Wood—to whom I have made reference in *Rockingham Ornamental Porcelain*.

Apart from professional artists, ladies of fashion are known to have painted on china by way of a cultural accomplishment. For example, a saucer painted with a floral spray in the centre—sold at Christie's on 22nd July 1969, Lot 44—is inscribed on the reverse 'Mary Wentworth Fitzwilliam Oct. 6th 1827'.

But to revert to the professionals, Jewitt makes mention,[1] *inter alios*, of Llandig as 'a charming fruit and flower painter', of Tilbury as one 'who painted landscapes and figures', of William Cowen as 'an artist of much repute' who 'for many years enjoyed the patronage of the Fitzwilliam family', and of Ashton as a clever modeller of flowers. However, their work has not as yet been identified.

As for William Cowen, it is interesting to note that he studied in Italy and that he published his *Views of Corsica* in 1843. He was a sufficiently distinguished artist—a regular contributor to the Royal Academy—to earn a place in the *Dictionary of National Biography*.

Finally, at some time a further artist, Benjamin Woolf, must have been at Rockingham, for his name appears in the *Directory of Sheffield etc.*, 1833[2]. Nothing is known of this china painter other than the fact that he is placed in company with other distinguished artists, which must indicate his importance. The list reads as follows:

Bailey, Wm.	Ornamental painter
Brentnall	Flower painter

[1] *Ceramic Art in Great Britain*, Vol. 1, p. 515.
[2] I acknowledge my indebtedness to Mr. John D. Griffin for bringing this particular local directory to my attention.

Lucas	Landscape painter
Mansfield, Jph.	Gilder & chaser
Randall, John	China painter
Speight, George	Ornamental painter
Woolf, Benj.	China painter

Chapter VII

Marks

On Pottery

There are only two basic earthenware marks—apart from certain rare exceptions mentioned later—for whose authenticity indisputable evidence exists. They consist of the word BRAMELD or ROCKINGHAM in varying forms.

The first mark appears sometimes alone and sometimes with a + sign followed by a number, often indecipherable. The numbers set out below have come to my attention, but there are doubtless many others:

0, 1, 2, 4, 5, 6, 7, 8, 10, 11, 12, and 16.

The indistinct impression of some of the numbers occasionally gives rise to error. Thus it has been claimed that a Greek delta sometimes followed the + sign after BRAMELD. Close examination, however, will reveal that this is merely a badly impressed 4.

BRAMELD is written in capital letters, normally large but occasionally small, and the mark is usually impressed. However, sometimes the name BRAMELD is raised on an applied oval plaquette within a wreath of roses, shamrock and thistles in such colours as cane, white, light or dark blue, chocolate, or olive green, depending on the colour of the applied decoration employed on the piece in question. For example, two of the three jugs illustrated in Plate 40 are marked in this fashion. The same design of mark without the outer rim also appears in an impressed form under the glaze. The dish and two plates with the Castle of Rochefort pattern illustrated in Plate 17 are stamped with this variant.

Where BRAMELD is used in its impressed form, although it is usually followed by a + sign and a numeral, it is occasionally followed by a single + or two + signs, or by a + sign and a dot, or by two asterisks. However, other variations also occur, as on some of the pieces of the blue and white dinner service described on pages 16–17. The following are recorded:

(i) BRAMELD + 1 in small capitals, beneath which are two six-pointed stars separated by two dots—one round, one square—all impressed.

(ii) BRAMELD + 1 in large capitals, above and below which is an eight-pointed star impressed.

(iii) BRAMELD + 4 in large capitals, in front of which, above and below, are two eight-pointed stars impressed.

(iv) BRAMELD + 1 in small capitals, beneath which are a six-pointed star, a club and a further six-pointed star impressed.

(v) BRAMELD + 0 in large capitals, above which are a six-pointed star, a dot and a further six-pointed star impressed.

(vi) A six-pointed star, a dot and a further six-pointed star impressed, without the word BRAMELD.

(vii) A six-pointed star followed by a dot impressed, without the word BRAMELD.

In addition, there appears on a green-glazed Cadogan pot in the Victoria and Albert Museum (Plate 33) an impressed BRAMELD & CO.

Some rare instances have been recorded where the BRAMELD mark was printed instead of impressed. It occurs on the magnificent cream ware jug referred to on page 23, where the mark takes the form of BRAMELD & CO. SWINTON POTTERY in capitals; and it appears again in another form on the spill vase illustrated in Plate 52b.

Except in the case of certain plates whose moulding is suggestive of porcelain (Plate 50), where the mark is in the form of a griffin followed by the words 'Rockingham Works, Brameld' printed in red and the word KAOLIN impressed, the ROCKINGHAM mark is always impressed. It is usually in capitals, large or small, but in rare instances it appears in script form—a piece bearing this type of mark being illustrated in Plate 6.

The printed 'Cl' mark is sometimes found on pottery, though far less frequently than on ornamental porcelain. The brown-glazed Cadogan pot in Plate 2 and the coffee pot illustrated in Plate 5a have 'Cl 2' written in gold on their base.

Mortlock's of Oxford Street, the London dealers, gave frequent orders for Rockingham ware and often required their own name to be impressed on the goods. Hence, we occasionally find the mark

MORTLOCK'S		MORTLOCK'S
CADOGAN	or	ROYAL
		ROCKINGHAM

Jewitt also cites MORTLOCK *simpliciter*. NORFOLK impressed is also claimed by some as a genuine mark. Undoubtedly the Bramelds did a great deal of business in the Norfolk area, so it may well be that this statement is correct.

In addition, the following extract from Oxley Grabham's *Yorkshire*

Potteries, Pots and Potters (published in the Annual Report for 1915 of the Yorkshire Philosophical Society, page 91) is worth citing:

> Mr. T. Boynton tells me that he has seen an early piece of Rockingham or Swinton Ware marked BINGLEY.

Not strictly speaking factory marks but of value in ascribing a Swinton provenance are the printed trade marks occasionally found on earthenware, seemingly peculiar to the factory and indicating the particular pattern employed, e.g., the words 'Indian Flowers' within a floral design; a parroquet over the words 'Parroquet Fine Stone B'; the words FLOWER GROUPS GRANITE CHINA surrounding a floral motif; the words 'Don Quixote' within a shield; the words 'Castle of Rochefort, South of France' inset in a blue irregular floral garland; a Chinese figure standing over a slab inscribed INDIA STONE CHINA; and the words 'Paris Stripe' within a cartouche.

On the closure of the factory, John Thomas Brameld—second son of Thomas Brameld—traded as a china dealer from 3 Titchborne Street (which he preferred to call 232 Piccadilly), London, and used his own mark in various forms on both pottery and porcelain pieces bought in from unknown sources. The mark is illustrated and discussed by Terence A. Lockett in his article 'The Bramelds in London', published in *The Connoisseur*, June 1967, page 102.

Another late mark, used on a non-Rockingham pottery plate bearing the date 1842, is in the form of BRAMELD & BECKITT impressed (see also page 130).

It is interesting to speculate whether, in view of the wide span of time during which earthenware was produced at Swinton, the date of manufacture of particular pieces can be narrowed by reference to the mark. There is no direct evidence on the point, but it is surely a reasonable assumption to infer that all pieces impressed with the ROCKINGHAM mark were made after 1826. For it was not until that date that the Swinton factory assumed the title Rockingham Works. A corollary to this is that all pieces marked with BRAMELD in its various forms were made prior to 1826. However, this is really a *non sequitur* in that there would have been nothing to prevent the factory employing the old mark in the later period. Nevertheless, one would have thought that the factory would have preferred to use its new styling, and it is perhaps reasonable to assume that most items with the BRAMELD mark are early examples.

If the theory is correct—that pieces with the BRAMELD mark were for the most part made before 1826, but those impressed with the word ROCK-INGHAM were produced after that date—certain interesting conclusions follow. For the fact that the mark on all dinner and dessert pieces I have so far seen has been in the form of BRAMELD and not ROCKINGHAM impressed, and conversely that most brown-glazed pieces recorded to date—the majority of Cadogans form the exceptions—have had, where marked, the 'Rockingham' version, must surely suggest that most services had ceased to

be manufactured at Swinton after 1826 but that brown-glazed ware did not really get under way until that date: in which event, the latter was produced contemporaneously with the porcelain.

Common sense would seem to support the above conclusions. After porcelain began to be produced, and *a fortiori* when the order for the Royal Service had been received, it is difficult to see why the factory should have wanted to continue manufacturing earthenware services. And it would be reasonable to expect their virtual discontinuance. But as for brown-glazed ware, why should its manufacture, so far from being halted in 1826, actually find its real momentum from that date onwards? A difficult question to answer. This much, however, is clear. Brown-glazed ware proved extremely popular— so popular, in fact, that the name Rockingham became associated with it even when it was produced throughout the nineteenth century by other factories. Moreover, it was often finely gilded, particularly with chinoiserie figures, or painted with enamel colours in the cloisonné style. It became a celebrated speciality of the Rockingham works; and despite the immense standing of the factory as a consequence of its porcelain production, the brown-glazed ware was presumably deemed sufficiently important to be continued and, in fact, increased throughout the golden period of the factory's existence.

In view of the continued manufacture of brown-glazed ware, it is perhaps surprising to find that the factory's cane-coloured ware—along with the plain blue and white and the more sophisticated green-glazed—seems to have ceased to be made after 1826. For all the marked pieces of this type of ware appear so far to have carried the name BRAMELD, usually though not invariably raised on an oval plaquette. The 'Rockingham' version has never

BRAMELD
Raised on an applied oval plaquette. Occurs
on cane-coloured ware, and very rarely on
porcelain.

been seen. Why this excellent ware should have been discontinued, if this was in fact the case, is a mystery. Perhaps competition was intense, particularly from Wedgwood, and the Bramelds decided to concentrate their competitive energies on porcelain production.

On Porcelain

The manufacture of porcelain at Rockingham can be divided into two periods—1826–30 and 1831–42. Although the factory did not finally close

till 1842, bankruptcy proceedings were instituted in December 1841, so we can safely assume that nothing of consequence was produced during the final year. Prior to 1831 the usual mark consisted of the griffin in red,

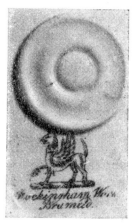

(Griffin)
Rockingham Works
Brameld
In red. The normal mark of the period
1826–30, together with the raised concentric
rings often found on the base of hexagonal
vases.

beneath which was written in two lines in red script 'Rockingham Works, Brameld'. Hence, these years are known as the red-mark period. A variant mark is occasionally encountered where the griffin no longer raises his front

Rockingham Works
(Griffin)
Brameld
In red. The rare mark of the period 1826–30.
Note that the front right paw of the griffin
is not raised. Note also the Cl mark in its
unextended form.

leg and 'Rockingham Works' is written in circular form over the griffin while 'Brameld' is written underneath. Sometimes, both marks are found on different pieces of a single service.

In the case of biscuit figures, the normal mark—which was always impressed—consists of the words ROCKINGHAM WORKS, BRAMELD, usually though not invariably accompanied by the griffin. Sometimes the mark was not properly applied, so that the words ROCKINGHAM WORKS alone appear, or the single word BRAMELD. Moreover, A. H. Church states in his book *English Porcelain*, 1904, page 103, that the Willett Collection contained two biscuit groups (No. 44) marked with the griffin and the words ROCKINGHAM

(Griffin)
Rockingham Works
Brameld
Impressed. The usual mark on figures. The position of the griffin in relation to the words varies. Note the form of the incised number and the general construction of the base.

WORKS BRAMELD & CO. If this is a correct observation, we have a variant of the normal mark. Where figures are glazed, the mark is generally impressed; but sometimes, on the early models, it is printed in red script.

Three early marks of great rarity are also recorded: BRAMELD set in a cartouche in relief, a mark often found on cane-coloured earthenware; the name 'Brameld' written in red script (according to the Catalogue of the Boynton Collection); and 'Rockingham China Works, Swinton 1826' in script on a cup in the Rotherham Museum.

After 1831, the colour of the mark was changed to puce and the phrase

'Manufacturer to the King' was added, the whole caption being written in three lines in puce script under a puce griffin. More rarely, 'Manufacturer to the King' was omitted and the factory was described as 'Royal' instead.

(Griffin)
Rockingham Works
Brameld
Manufacturer to the King
In puce. The usual mark of the period
1831–42.

(Griffin)
Royal Rockm Works
Brameld
In puce. A less usual mark of the period
1831–42.

(Griffin)
Royal Rockingham
Brameld
In puce. A less usual mark of the period
1831–42.

Two variants are found—one in the form of 'Royal Rockingham Brameld' and the other written as 'Royal Rockm Works, Brameld'.

Whether it is possible by virtue of the mark alone to divide the years 1831–42—which, for convenience, are referred to as the puce-mark period—

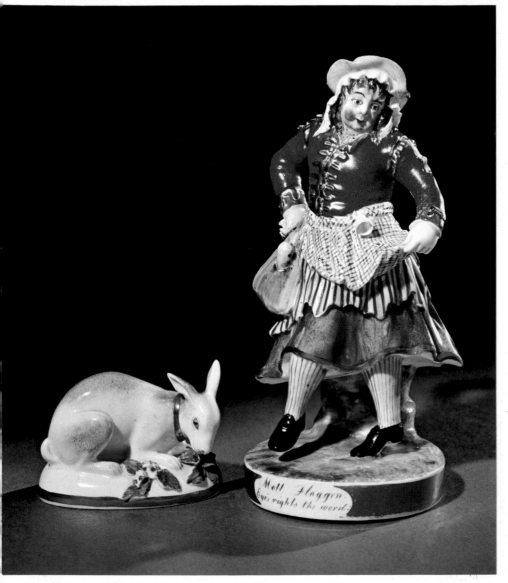

VIII. Figure, glazed and coloured, of John Liston as "Moll Flaggon". Inscribed around the base in script "Moll Flaggon. Eye's rights the word". 6¼ inches high. Incised No. 10. Red mark. See page 78.
Figure of a Hare, glazed and coloured. 2¾ inches long. Incised No. 110. Cl. 3. Impressed mark. See page 79.

into late Regency and early Victorian is debatable. Queen Victoria came to the throne in 1837, and it is difficult to see how the factory could continue to call itself 'Manufacturer to the King'. The word 'Royal', however, was conveniently equivocal. The whole problem is discussed in *Rockingham Ornamental Porcelain*, pages 83–5; but on the evidence so far, no firm conclusion can be arrived at. However, the view sometimes expressed that pieces with the caption that includes 'Manufacturer to the King' should be confined to the reign of William IV cannot be supported. The converse proposition—that pieces bearing the 'Royal' mark should be assigned to the period after Queen Victoria's accession—has an attraction: but although there is some evidence in its favour, it is unproven.

A blue mark may occasionally be encountered. This will be found only on pieces where the decoration is in underglaze blue. Clearly, the factory found it easier in these cases to apply the mark as well as the decoration in underglaze blue to save the bother of an extra firing. The exact terminology of the caption will depend on the period in which the piece was produced.

A seemingly unique mark is that found on the specimen royal plate illustrated in Colour Plate IV: for although the caption beneath the griffin reads 'Rockingham Works, Brameld', the whole mark is in puce, not red.

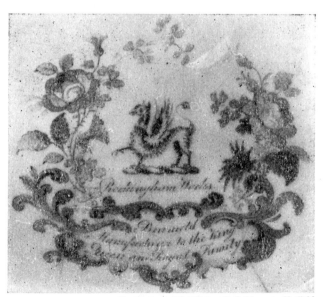

By courtesy of the Weston Park Museum, Sheffield

(Griffin)
Rockingham Works
Brameld
Manufacturer to the King, Queen and Royal
Family (in a wreath)
In puce. Rare mark of the 1831–42 period;
particularly used on pieces made for royalty.

Other specimen royal plates have the puce mark in its normal forms—see the two examples illustrated in Colour Plates V and VI, and the two specimens in the Victoria and Albert Museum. (Did this mean that the factory already enjoyed royal patronage before the famous order for the dessert service was awarded?) As for the various royal plates which were of the design chosen but were factory 'overs', some are found unmarked (see the specimen in the Rotherham Museum, illustrated in Plate 55) and one at least has the elaborate mark with the extended description 'Manufacturer to the King, Queen and Royal Family' set within a wreath of roses, shamrock and thistles.[1] This latter form is sometimes found on comports of the finest services, like the specimen in the Sheffield Museum illustrated in Plate 57.

The Baguley Mark

After the closure of the factory in 1842, Isaac Baguley and his son Alfred continued decorating porcelain (Plate 14) and pottery ware bought in from other factories, their speciality being the application of the fine brown glaze originally produced by the Bramelds. Isaac died in 1855; but the business was

(Griffin)
Rockingham Works
Manufacturer to the Queen
In red. An early Baguley mark. Pieces so marked were decorated after the closure of the factory and normally are not of Rockingham manufacture.

ROCKINGHAM WORKS MEXBRO'
In a garland encircling BAGULEY
Very late Baguley mark, post 1865. Pieces so marked have nothing to do with Rockingham.

[1] *Old English China*, Mrs. W. Hodgson, 1913, facing p. 122.

continued at the Rockingham Works by his son until 1865, when he removed it to Mexborough. Prior to this date, the usual mark consisted of a griffin (slightly different in form from that adopted by the Bramelds) with the caption 'Rockingham Works, Manufacturer to the Queen' written underneath, all in red script. After 1865 the mark normally took the form of a garland inset with the words ROCKINGHAM WORKS MEXBRO' encircling the name BAGULEY, the griffin being abandoned altogether. But it is said that where items were made for the Fitzwilliam family the Baguley griffin was adopted together with the caption 'Baguley Rockingham Works' in script, all in red.

At some date, possibly early on, the Baguleys occasionally used a further variety of mark—namely, the griffin with the words 'Royal Rockingham Works, Baguley' in red script.

The Cl Mark

Although not strictly speaking a mark, there is frequently to be seen on ornamental but not useful porcelain, and on some pottery, the letter 'C' or, more often, the letters 'Cl', followed by a figure—from 1 to at least 17— in red, gold, puce, orange or even deep mauve. This is discussed fully in *Rockingham Ornamental Porcelain*, pages 87–8.

Rockingham Works
Brameld
In red. The normal mark of the period 1826–
30, together with the Cl mark in its extended
form.

Occasionally, this quasi-mark is seen in an extended form, e.g., C. Cl. 11 N. 9. The exact significance of the letters 'C' and 'Cl' is unknown. But they are peculiar to Rockingham, and their presence is as indicative of a Swinton origin as the griffin mark itself.

Another quasi-mark is in the form of a series of raised concentric rings. It is frequently found on the base of hexagonal vases.

Forgeries

There is no evidence to date of the Cl mark, as it has come to be called, ever having been forged. Unfortunately, this is not true of the griffin mark. Samson of Paris is known to have reproduced this mark—but in a dirty brown colour, with lettering of a different style from the genuine. The pieces

themselves cannot deceive the experienced as they are completely alien in shape and decoration. And even the inexperienced will quickly see that the fakes are of hard paste with none of the softness of true Rockingham.

Greater problems confront the collector when genuine soft paste items emanating from other English factories are discovered bearing a Rockingham mark. At least three instances have been recorded of Coalport dishes being found marked in this way. Fortunately, the occurrences are rare.

Pattern Numbers

Generally speaking, Rockingham porcelain services were numbered with a figure—normally painted in red or gold—indicative of their place in the original pattern books. These numbers usually appear on most and sometimes all of the constituent parts of a service, exclusive of covers. And they are, on occasion, a negative means of identifying genuine Rockingham porcelain. For where numbers appear higher than the maximum that can conceivably be credited to the factory, rejection is both simple and necessary. This does not obtain, of course, where a pattern number falls within the figure range acceptable for Rockingham china. Such a contingency is still consistent with the service being the product of another factory employing the same range of pattern numbers. Thus, a service with the number 2000 or more or with a fractional number (except for $\frac{2}{1}$ to about $\frac{2}{100}$ in respect of tea and coffee services) cannot possibly be of Rockingham origin. (I have, however, seen a small puce-marked basin, clearly of late origin, decorated with a green ground and painted with floral bouquets, which bore the number $\frac{2}{143}$.) On the other hand, a service bearing, say, 750 might or might not be Rockingham. In this instance the number is equivocal. Other factors must be taken into account.

But what is the range of numbers employed by the Rockingham factory? As far as dessert services are concerned, the numbering is known to start from about 416 and continue to at least 829. Tea and coffee services begin at approximately 430, extend to 1563 or more, and then become a second series expressed fractionally as $\frac{2}{1}$ to $\frac{2}{96}$ or beyond. This information has been elicited from a careful examination of numerous service pieces still in existence.

The whole question of the numbering of Rockingham porcelain services could perhaps be settled beyond dispute by reference to the original pattern books. For it is one of the miracles of the history of ceramics that although the Rockingham works went into liquidation through insolvency and its documents were presumably destroyed—there being no re-emergent factory to continue its tradition and maintain intact its records—Thomas Brameld's own original master pattern books do, in fact, survive today. I understand that these pattern books came into the hands of descendants of the Baguley family (presumably Isaac took over the books in 1842 to enable him to carry out replacements to services, etc.), that they are now divided between different ownerships, and that they are not available for public inspection. Nevertheless, Arthur A. Eaglestone and Terence A. Lockett were fortunate

enough to examine, albeit cursorily, three out of four of them, from which certain interesting information was elicited.[1] But in the main, we must once again rely on surviving specimens rather than documentary evidence for our knowledge of the factory.

In considering pattern numbers, it must not be forgotten that their significance is limited. All that they indicate is the particular form of decoration used—not the *shape* of the piece on which it was employed. Thus number 578, which comprises a gilt chain pattern around the rim and a named botanical flower painted in the centre, is found on the scallop-edged cup and saucer illustrated in Plate 105c and also on the two circular-shaped saucers illustrated in Plate 95. And again, although the surviving pattern books are said to contain notations to the effect that flowers etc., were by a particular painter, the mere finding of examples bearing the relevant pattern numbers does not prove that these pieces were in fact decorated by the artist in question. Artists often moved on, and the designs were reproduced by their successors. Therefore, the importance of pattern numbers must not be exaggerated.

However, examination of such numbers can sometimes reveal, even in the absence of a red or puce mark, the period within which a particular service was made. For it is possible to determine the approximate pattern number which divides the earlier from the later period. In the case of tea and coffee services the number would appear to be somewhere between 742 and 796, and between 600 and 608 in the case of dessert services. Pieces bearing a later number cannot possibly belong to the red-mark period: but the converse does not apply. For service pieces with an early number might well have been ordered during the puce-mark era in that designs originating before 1831 were continued until the factory's closure in 1842. The classification of patterns into either the red- or puce-mark periods can, however, be a negative help in identifying genuine Rockingham. Where a service piece carries an early number but its style is quite out of keeping with the known shapes of the red-mark period—early patterns were invariably confined to early shapes—rejection is automatically justifiable. And similarly, where a piece bears a late number but the style is in no way consonant with the changed forms of the puce-mark period, a Rockingham attribution cannot be entertained.

Unmarked Ware and the London Retailers

Although it would seem that most of the surviving Rockingham ornamental porcelain is marked, this does not necessarily mean that most porcelain was marked at the time the factory was in operation. It may well be that an artificial situation exists today due to the preservation by generations of collectors of the marked examples and the neglect, and eventual loss, of the unmarked specimens. If this did in fact happen, we are left with a distorted impression of the extent of marking.

But be that as it may, many pieces were undoubtedly issued from the

[1] *The Rockingham Pottery*, p. 55.

factory without the griffin imprint, though some still had the Cl. mark—whatever the letters may really stand for. Far more interesting is the fact that some of the *finest* of the factory's productions do not carry the griffin mark. It is virtually impossible to believe that such a situation arose from accident or the haphazard practice of those responsible for applying the mark. The situation must surely have been deliberately created by the management itself. The Bramelds must have purposely prevented the mark being applied to certain pieces. But why?

Perhaps the clue to the problem is given by Geoffrey A. Godden in his extremely interesting and enlightening *Minton Pottery and Porcelain of the First Period*, 1793–1850. In his citation of the correspondence relating to the Minton factory, he reveals the trepidation felt by porcelain manufacturers towards the large London retail houses and the latter's reluctance to allow the manufacturer's mark to appear on goods they were offering for sale on their premises. Doubtless, they feared that their customers would tend to contact the manufacturers direct and dispense with their own services. Indeed, some retailers went so far as to insist on their own names being printed on the goods.

The extent to which manufacturers stood in fear of the London retailers is graphically illustrated in a passage from Sir Henry Cole's *Fifty Years of Public Work*, 1884.

> Having recently become acquainted with Mr. Minton I persuaded him, with difficulty, to send in a design for a beer jug to the Royal Society of Arts Competition of 1845. He dreaded the retailers of London who, at that time, ruled manufacturers with a rod of iron, but at last he gave way in terror . . . It was a condition of the Society of Arts that the manufacturer's name should be given and attached to any object rewarded. Mr. Minton feared he would be ruined if he gave his! . . .

Geoffrey Godden suggests that this abject fear of the London retailers was responsible for the fact that scarcely any Minton ware produced between 1824 and 1850 was marked.

Although an immense amount—possibly the major part—of the Rockingham output was marked, could the explanation for the non-marking of some of the finest pieces lie in the Bramelds' wish to market them through the London retailers and in their respect for the latter's extreme sensitivity to the employment of manufacturers' marks? If this were the case, it is easy to see why some of the finest productions, which would almost automatically be sold through London, should not carry the griffin mark.

The Bramelds appear never to have placed on their porcelain the mark of any retailer—though on brown-glazed pottery the impressed name of Mortlock's, the well-known London dealers, is found—and would seem therefore, not to have been so overawed by the retailers as Herbert Minton clearly was. They also had the advantage of possessing their own London House and, by virtue of their order for the Royal Service for William IV,

could presumably afford to be reasonably independent. However, there would be no commercial sense in being unduly provocative, and they may well have made a concession to economic reality by ensuring that goods destined for sale in London, other than through their own premises, should go out unmarked.

Appendix A

List of Rockingham Figures

Those in capitals are illustrated in this work; those in italics are reproduced in *Rockingham Ornamental Porcelain.*

Unless otherwise stated, the impressed mark consists of the words ROCKINGHAM WORKS BRAMELD usually, though not invariably, accompanied by the griffin impressed.

Height	Length	Width	Model No.	Description	Authority
$5\frac{1}{2}''$			1	A TOPER ('STEADY LADS').	Red Mark
$7\frac{1}{4}''$			2	A girl with wide-brimmed hat, carrying a milk-pail in her right hand.	Red Mark
$8\frac{1}{4}''$			4	A SHEPHERD AND DOG.	Red Mark and Impressed Mark
$6\frac{3}{4}''$			4	*A Shepherdess and Sheep.*	Red Mark and Impressed Mark
$6''$			6	MADAME VESTRIS SINGING 'BUY A BROOM'.	Red Mark
$6\frac{7}{8}''$			7	*John Liston as 'Simon Pengander'.*	Red Mark
$6''$			8	JOHN LISTON AS 'BILLY LACKADAY'.	Red Mark
$5\frac{3}{4}''$			9	John Liston as 'Paul Pry'.	Red Mark
$6\frac{1}{4}''$			10	JOHN LISTON AS 'MOLL FLAGGON'.	Red Mark
$6\frac{3}{4}''$			11	*JOHN LISTON AS 'LUBIN LOG'.*	Red Mark and Impressed Mark
$7\frac{3}{4}''$			14	*'Paysanne de Schlier en Tirol'.*	Impressed Mark
$7\frac{1}{4}''$			15	*'Paysanne du Mongfall en Tirol'.*	Impressed Mark
$7\frac{1}{4}''$			18	*'Paysanne du Canton de Zurich'.*	Impressed Mark
			21	'Paysanne des environs de Bilbao'.	Impressed Mark
$7\frac{1}{4}''$			22	*'Paysanne de Sagran en Tirol'.*	Impressed Mark

Height	Length	Width	Model No.	Description	Authority
$8\frac{1}{4}''$			23	*Swiss boy.*	Impressed Mark
$7\frac{7}{8}''$			23	*Swiss girl.*	Impressed Mark
$2\frac{7}{8}''$ and $3\frac{5}{8}''$			25	A TURK	Impressed Mark
$5\frac{1}{2}''$			26	*A leaning boy holding a pitcher.*	Impressed Mark
$5\frac{1}{2}''$			26	*A girl holding a sheep and pitcher at a well.*	Impressed Mark
$5''$			28	*A boy seated writing.*	Impressed Mark
$5''$			28	*A girl seated sewing.*	Impressed Mark
$3\frac{3}{4}''$			29	A toper.	Impressed Mark
$8\frac{3}{4}''$			31	A girl holding a basket of flowers over her head.	Impressed Mark
$5\frac{3}{4}''$			32	BACCHUS	Impressed Mark
$5\frac{3}{4}''$			35	GIRL HOLDING A SHEEP	Impressed Mark
$5\frac{3}{4}''$			35	BOY HOLDING A DOG	Impressed Mark
$5''$			36	Beggar boy.	Impressed Mark
$5''$			36	Beggar girl.	Impressed Mark
$6\frac{1}{2}''$			37	*A Russian peasant.*	Impressed Mark
$5\frac{1}{2}''$			39	THE WHISTLING COBBLER	C. 3 Mark
$7\frac{7}{8}''$			42	NAPOLEON.	Cl. 2 Mark
$5\frac{1}{2}''$			44	A kneeling boy feeding a rabbit.	Impressed Mark
$3\frac{3}{4}''$			44	A GIRL CLASPING A SHEEP IN ONE HAND, A BOWL IN THE OTHER	Impressed Mark
			49	'Chef du Tartares Noguars'.	Impressed Mark
$7\frac{1}{2}''$			50	'Paysan du la Vallee de Ziller en Tirol'.	Impressed Mark
$8''$			53	'Paysan du Canton de Zurich'.	Impressed Mark
$8''$			57	'Paysan Piemontais de la Vallee d'Aoste'.	Impressed Mark
$7\frac{3}{4}''$			58	Shepherd leaning on a crook with a dog and sheep.	Impressed Mark
$2\frac{1}{4}''$	$4\frac{3}{4}''$	$2\frac{1}{2}''$	63	*Chantrey's sleeping child*	Impressed Mark
$2\frac{1}{4}''$	$4\frac{3}{4}''$	$2\frac{1}{2}''$	64	*Chantrey's awakening child.*	Impressed Mark
$1\frac{1}{2}''$	$1\frac{7}{8}''$	$1\frac{1}{4}''$	69	AN ELEPHANT.	Cl. 2 Mark
$\frac{7}{8}''$	$1\frac{7}{8}''$	$1\frac{3}{8}''$	70	*A toy group of rabbit and young.*	Paste, style, decoration and glaze
$1\frac{1}{8}''$			71	*A toy dog sitting.*	Cl. 1 Mark
$\frac{1}{2}''$	$\frac{7}{8}''$	$\frac{9}{16}''$	72	*A toy rabbit.*	Paste, style, decoration and glaze
$2''$			73	*A toy squirrel.*	Cl. 1 Mark
$1\frac{3}{8}''$			74	*A toy dog sitting*	Cl. 1 Mark
			76	A PUG DOG.	
$2\frac{5}{8}''$				FIRST SIZE.	Impressed Mark
$2\frac{1}{8}''$				Second Size	Impressed Mark
			77	*A cat sitting on a tasselled cushion:*	
$2\frac{3}{8}''$				*First Size*	Impressed Mark
$2\frac{1}{8}''$				*Second Size*	ROCKINGHAM WORKS impressed

Height	Length	Width	Model No.	Description	Authority
$1\frac{3}{4}''$				*Third Size*	Impressed Mark
				A cat sitting on an oval base:	
$2\frac{1}{4}''$				*First Size*	BRAMELD impressed
$1\frac{3}{4}''$				*Second Size*	Cl. 1 Mark
	$2\frac{3}{4}''$	$1\frac{7}{8}''$	80	*A stag lying down.*	Cl. 2 Mark
	$3\frac{1}{4}''$	$1\frac{7}{8}''$	80	*A doe lying down.*	Pair to the above
$2\frac{7}{8}''$	$3\frac{1}{4}''$		83	A dog running.	Impressed Mark
$2\frac{5}{8}''$	$3\frac{3}{4}''$	$2\frac{3}{8}''$	87	*A smooth-coated dog lying down with head raised.*	Impressed Mark
$3\frac{1}{4}''$	$3\frac{1}{2}''$	$2\frac{1}{4}''$	89	A dog standing watching a mouse.	Impressed Mark
$1\frac{1}{8}''$	$2\frac{5}{8}''$	$1\frac{5}{8}''$	91	*A small long-haired dog lying curled up.*	Impressed Mark
$2\frac{1}{4}''$	$3\frac{3}{4}''$	$2\frac{1}{2}''$	92	Hound lying down with head raised.	Impressed Mark
$2''$	$4\frac{1}{4}''$	$2\frac{1}{4}''$	94	*A long-haired dog lying down with head raised.*	Impressed Mark
$2\frac{1}{4}''$	$2\frac{7}{8}''$		99	A SWAN.	Cl. 2 Mark
$2\frac{3}{8}''$	$3''$		100	A sheep sitting down.	Impressed Mark
$3''$			101	A dog sitting with head raised.	Impressed Mark
	$6\frac{3}{8}''$	$4''$	102	*Kissing putti.*	Impressed Mark
$1\frac{3}{4}''$	$2\frac{1}{4}''$	$1\frac{1}{4}''$	104	*A cat lying down with head raised.*	Impressed Mark
$1\frac{5}{8}''$	$2\frac{3}{8}''$	$1\frac{1}{2}''$	106	A crouching rabbit on an oval base.	Impressed Mark
$1\frac{3}{4}''$	$3\frac{7}{8}''$	$1\frac{3}{4}''$	107⎱	A GROUP COMPRISING A CAT AND THREE KITTENS.	Impressed Mark
$2''$	$4\frac{1}{4}''$	$2''$	⎰		
$1\frac{3}{4}''$	$2\frac{1}{4}''$	$1\frac{3}{4}''$	108	*A ram lying down.*	Impressed Mark
$1\frac{3}{4}''$	$2\frac{1}{4}''$	$1\frac{3}{4}''$		*A ewe lying down.*	Impressed Mark
$1\frac{1}{8}''$	$1\frac{3}{4}''$	$1\frac{1}{2}''$	109	A small sheep on an oval base.	Cl. 2 Mark
$2''$	$2\frac{3}{4}''$	$1\frac{3}{4}''$	110	A CROUCHING HARE.	Impressed Mark
$2\frac{1}{4}''$			111	A SQUIRREL.	Cl. 2 Mark
$7\frac{1}{2}''$			113	HOMME DU PEUPLE À VALENCE.	Impressed Mark
$8\frac{3}{4}''$			114	'Paysanne Basque des environs de Bayonne'.	Impressed Mark
$8''$			115	*'Paysan Basque des environs de Bayonne'.*	Impressed Mark
$7\frac{1}{2}''$			119	*'Femme de l'Andalousie'.*	Impressed Mark
$7\frac{1}{2}''$			120	*'Paysanne de S. Angelo'.*	Impressed Mark
$2\frac{1}{2}''$			none	*Pug bitch sitting on oval base.*	Red Mark
$2\frac{5}{8}''$			none	*Pug dog sitting on oval base.*	Cl. 2 Mark
$2\frac{1}{2}''$			none	*Cat sitting on oval base.*	Red Mark
$7\frac{3}{8}''$			none	'Tristram Sappy'.	C. 3 Mark

PERSONALITIES

Height				Description	Authority
$6\frac{3}{4}''$			Bust	Lord Brougham	Impressed Mark
$8''$ and $10\frac{1}{4}''$			Bust	*MR. WORDSWORTH*	Impressed Mark

Height	Length	Width	Model No.	Description	Authority
$7\frac{3}{4}''$			Bust	SIR WALTER SCOTT	Impressed Mark
$7\frac{1}{2}''$			Bust	*George IV* ⎫ pair	Impressed Mark
$7\frac{1}{2}''$			Bust	*Duke of York* ⎭	
$6\frac{1}{2}''$			Bust	*Duke of York*	Impressed Mark
$12''$ ⎫					Jewitt and
$13\frac{1}{2}''$ ⎬			Bust	*Earl Fitzwilliam*	historical
$15''$ ⎭					connection
$7''$			Bust	WILLIAM IV	See page 78
			Full Length	Lady Russell	Jewitt

The Rhinoceros Vases

Rockingham was responsible for the two extremely large vases in the neo-rococo style commonly known as the Rhinoceros Vases—so titled by virtue of the finely executed model of a rhinoceros which surmounts their cover. It is to the factory's great disadvantage that these vases have continually been cited in ceramic literature as typifying the true Rockingham style. This assertion is quite unjustified, the factory's products being far more restrained—particularly those manufactured in the red-mark period. These two Rhinoceros Vases, although apparently highly regarded at the time they were made and throughout most of the nineteenth century, have been universally condemned by modern writers; and it must be admitted that they do not conform to modern canons of taste. However, it must be remembered that they were special pieces, meant to demonstrate the factory's remarkable technical skill; and although they are clearly out of keeping with modern households, who are we to say that in the setting in which they were intended to be placed they necessarily struck a discordant note?

The earlier example (Plate 171), painted by John Wager Brameld, dated 1826 and marked with the red griffin, was made originally for Wentworth House. It suffered some damage there—the result, it is said, of an impromptu game of rugger in its immediate vicinity—and now, rather badly repaired, it rests in the Rotherham Museum. It measures 3 feet 9 inches in height and is alleged to have been the largest china vase in the country ever to have been produced up to that date as one single piece. An excellent description of it is given by Ebenezer Rhodes, who visited the factory in 1826.

> At the time I visited these works, Messrs. Bramheld [sic] & Co., had just finished a large specimen of porcelain ware of the finest quality and the most exquisite workmanship. It is a scent jar forty-four inches in height and nearly a hundred pounds in weight, exclusive of the cover, being all fired and completed in one piece.[1]
>
> The base or plinth is triangular, with circular projections at the corners from which three paws of the lion rise angularly with curtains between them to support the body of the jar which is globular. The neck is beautifully perforated with hexagonal honey-comb openings for the perfume to escape. Three rustic handles of knotted oak divide the jar into compartments; branches of oak foliage, intermixed with acorns, rising from the plinth spread tastefully

[1] It was naturally formed in different parts. The handles, for example, were formed, or moulded, separately.

over the curtains and lion's legs, and continue entwined with the handles to the neck, the base of which they encircle. The cover is ornamented with oak branches and foliage to correspond, the whole being surmounted by a beautiful model of a rhinoceros or unicorn of Holy Writ. The three compartments into which the jar is divided are enriched with highly finished paintings by Mr. J. Brameld from the adventures of Don Quixote. These comprise the knight's attack on the army of sheep—his meeting Dulcinea enchanted in the form of a country wench—and the dejected mood in which he travelled on with Sancho after the interview—all from designs by Stothard. The circular corners of the pedestal and cover are adorned with six subjects of rare botanical plants accurately drawn and coloured from the originals in the gardens at Wentworth; painted in compartments on a delicate blue ground, intermixed with rich burnished and chased gold ornamental work. The whole of the foliage is burnished or chased gold, and the handles are tastefully formed and relieved with gold.

The only points that need be added are that three raised bees are applied to the honeycomb openings and that the underside of the cover is painted with small landscapes alternating with subjects from Bewick's tail-pieces. Inside the cover can be seen the mark in red and the date 1826.

The other Rhinoceros Vase (Plate 170), which is in the Victoria and Albert Museum, is somewhat smaller and was presumably modelled on the earlier Wentworth example. According to John Haslem,[1] it was painted by Edwin Steele—on the strength of which, this particular artist's work is identified on other Rockingham pieces. The ground colour is essentially puce and indigo, giving the vase a somewhat dark appearance. It is decorated with flowers instead of 'Don Quixote' scenes, together with certain architectural features as well, the underside of the lid being left unpainted. The base is maroon.

The history of the latter vase, which is unmarked, is obscure. All that is known for certain is that it was acquired by the Victoria and Albert Museum from the china dealer Mortlock's of Oxford Street for the sum of 100 guineas. It is interesting to note that the source from which it was obtained is consistent with the piece being unmarked. As explained on page 112, the London retailers preferred the goods they dealt in to bear their own name or to be unmarked. Mortlock's are known to have handled a great deal of the Rockingham factory's output in the early days—they were, in fact, at one time their London agent[2]—and indeed their name appears on Rockingham brown-glaze earthenware. It is therefore not the least surprising that they should have had in their possession—doubtless bought speculatively—a duplicate of the Wentworth Vase and that it should have been unmarked.[3]

[1] *The Old Derby China Factory*, p. 121.
[2] *Ceramic Art in Great Britain*, Vol. 1, p. 219.
[3] For a recent discussion of the Rhinoceros Vases (and also the Dragon Vase) see *The Connoisseur*, April 1970, pp. 238–43.

Appendix C

The Practice of taking Tea and Coffee during the first half of the Nineteenth Century

There is no better way of assimilating the mystique and ceremony associated with the drinking to tea or coffee during the period in which the Rockingham factory operated than by studying contemporary letters and diaries that bear directly on the subject. In this respect, American writers have proved particularly helpful. Whereas a native of this country would never bother to comment on every-day activities, this attitude would not necessarily hold with a foreigner.

Thus, Mrs. Sallie Coles Stevenson, wife of the American Minister at the Court of St. James between 1836 and 1841, in a letter written home to her sister on 13th July 1836, highlights the whole ceremony:

> Everything here is so different from what it is with us . . . the manner of serving tea is very disagreeable to us, the servants, generally the butler, and James the footman bring in the waiter with the things on it, and the urn hissing is sat before the lady of the house. She draws towards her a little table, or stand, containing tea, sugar, etc., unlocks it, and makes the tea, when the gentleman of the house, or any familiar friend present, hands to each person a cup, sugared and creamed, or each individual may approach the table and help himself, and it is the same thing with coffee after dinner—and at breakfast the servants also retire, but at dinner you must be looked at by a dozen if there is as many in the house each one with napkins over their right thumb.

In a later letter written from Fonthill, Wiltshire in September 1836, Mrs. Stephenson adds further details of the English eating habits of this period:

> The breakfast consists of a variety of cold bread—dry toast—and excellent butter, with eggs on the breakfast table—on the side table, is every variety of cold meats, to which the gentlemen help themselves, and the ladies, who wish for any. The servants disappear after bringing in the urn and coffee, and everybody helps themselves . . . Coffee is handed after dinner, and is followed almost immediately after by tea . . .

And again, in a letter dated 20th November 1838, the same lady, after describing a dinner at Raby Castle, goes on to add:

> When the ladies retired they amused themselves with coffee—tea—and chit chat . . . but when the gentlemen entered the scene changed. After they had

taken their coffee and tea the Duke sat down to cards, and those who liked music went into the next apartment.

The same routine was adopted at Warwick Castle where, according to the memoirs of the Duchesse de Dino (10th February 1834):

> On leaving table a long time before the men we went to the great drawing-room . . . I have never seen anything more chilling and depressing than this drawing-room . . . I kept thinking that the portrait of Charles the First and the bust of the Black Prince would come and join us at coffee before the fire. At last the men came, and after them the tea, and at ten o'clock a sort of supper.

Of particular interest are the observations of Richard Rush, the American Minister at St. James from 1817 to 1825. Writing in 1818, he remarks:

> Going through the streets, and stopping a moment, an incident arrested my attention. A woman stood at the door of a house where cheap refreshments were sold. Some labouring people passing along, she called out to ask if they would take *tea*. It was about one o'clock. Houses of this kind I understood were not uncommon in London. I had myself observed tea sold in the streets, near Charing Cross, by huckster women, who obtained the boiling water by means of coals in a pan, or a lamp. In a country where the light wines are not produced, the first step into temperance is small beer; the next, tea. The national schools in England have done much towards meliorating the condition of her people. The use of tea has co-operated, by doing more of later years, probably, than any other physical cause, towards lessening the appetite for ardent spirits. It acts not so much by reclaiming old drunkards, as diminishing the stock of new. What a sight, to see this woman beckoning labouring men to tea, instead of drams! The use of tea in England, is universal. It is the breakfast of the wealthy as of the poorer classes. On passing to the drawing room from the sumptuous dinner table the cordial cup of Mocha coffee is first brought in; but after an interval, black tea is also served. A general in the Duke of Wellington's army told me, that when worn down with fatigue, there was nothing for which the officers in the Peninsular War used to call so eagerly, as tea. Servants in London take it twice a day, sometimes oftener, and the occurrence at Greenwich shows the taste for it to be spreading among labouring classes at all hours. (*Memoranda of a Residence at the Court of London*, 1833, pages 163, 164).

The use of tea by the poorer classes, referred to above, appears to date from the middle of the eighteenth century, even though a pound of tea then cost a sum equivalent to a third of a skilled worker's total weekly earnings. A complaint had been heard as early as 1742 that, in Scotland, 'the meanest families, even of labouring people, made their morning meal of tea' instead of ale. Arthur Young, in riding through the countryside in 1767, had comments on 'labourers losing their time to come and go to the tea table; nay farmer's servants even demanding tea for their breakfast, with the maids'. Testimony to the social popularity of tea-drinking by all classes is also amply borne out by the springing up of the famous tea-gardens at Vauxhall, Ranelagh, Cuper's, Marylebone and elsewhere.

In a later passage in his *Memoranda* (on page 288) Richard Rush, in speaking of a dinner given by the Marquis of Stafford, observes:

> Leaving the table, we were an hour in the drawing rooms, always an agreeable close to English dinners. On entering them, the cup of Mocha coffee is handed; to which, after a short interval, tea succeeds. Ladies make part of these dinners,

heightening their attractiveness; they leave the table first, the gentlemen soon following and rising altogether; on no occasion have I observed any one leave the table, until all rise.

Another contemporary reference to taking tea can be found in J. T. Smith's *Nollekens and his Times*:

The ladies at last retired [i.e., after dinner] and Bronze soon declared tea to be ready; upon which the gentlemen went to the drawing-room.

Indeed, the taking of tea and coffee during the first half of the nineteenth century was, for all classes, an invariable pleasure and often something of a ritual.

Although the foregoing quotations seem to refer to tea taken at breakfast or after dinner, it must be remembered that from about 1820 onwards—that is, during the entire Rockingham porcelain period—the peculiarly English institution of 'afternoon tea', served with bread and butter etc. from around four to five o'clock, had established itself. During the eighteenth century, the time for dinner—the one main meal, after which tea was served at home or abroad in response to formal social visiting—advanced progressively from around three or four o'clock in the afternoon to, in the early nineteenth century, about seven in the evening. It is reputed that the wife of the seventh Duke of Bedford, not being able to contain the pangs of hunger caused by the delayed commencement of dinner, chose to invite a few friends to drink tea and eat bread and butter informally with her in her private rooms. Whether or not this was, in fact, the origin of the institution, the rationale underlying its establishment is perfectly comprehensible. But once inaugurated, it has remained a peculiar feature of English life—and Rockingham service ware must, in the early days, have played a significant part.

It may not be generally realised that the tea served would have come from China, not India. Although Indian and Ceylon leaf has a virtual monopoly of the market in the United Kingdom today, in the days of the Rockingham factory China was the only source of supply. A small experimental consignment of eight chests of tea grown in Assam at Government instigation was shipped to this country in 1839; but no commercial output from India was realised until 1852—long after the Rockingham works had ceased to function.

It is also interesting to note that in the days of the Rockingham factory green tea and black tea were sold in approximately equal quantities.

K

Appendix D

Origin of the Pseudo-Rockingham Figures:
A possible explanation

Although, on the evidence as it now stands, no serious scholar can accept as genuine the countless crudely modelled figures that tradition has ascribed to Rockingham, it is yet intriguing to contemplate how it was that this misconception came into existence. Needless to say, no difficulty confronts our understanding of how the mistake, once made, came to be perpetuated. The moment a convention surrounds the provenance of a particular ceramic production, little can arise to disturb it in the absence of the application of proper scholarship. Collectors crave for attributions to specific factories; and dealers and auctioneers, who are essentially men of business, are hardly likely to decline to indulge this whim.

But how was the original error in ascribing to Swinton these crudely made models ever perpetrated? One thing seems reasonably clear. The misattribution goes back to the last century. Thus, in *The Collector*, published in 1903 (reproducing in book form articles previously appearing in *The Queen*), Volume 1, page 35, the following assertion is made:

> The factory also turned out very handsome figures, but as they were seldom marked, they are not often assigned to Rockingham.

In Volume 2, published a year later, the following passage appears on page 28:

> Rockingham figures have always been in great request, and only on rare occasions do they bear any mark.

(By way of illustration a photograph is there reproduced showing two rustic figures, a poodle and a pair of bears. None of them has the slightest connection with Rockingham.)

If it does not herald the misconception, this reference to Rockingham figures not being generally marked at least confirms it.

In later years, nothing arose to inhibit the wholesale attribution of these figures to Rockingham. Indeed, until recently, any unmarked porcelain figure of the nineteenth century was liable to be assigned to Swinton. Nothing served to check the dealer, auctioneer or collector except his own arbitrary rules of classification—rules which, fallacious as they were, did not have the merit of universal application in accordance with systematic principles.

The writer of the articles in *The Collector* was presumably only stating the convictions of collectors at the turn of the century. So we can confidently trace the

error back to the nineteenth century, when interest in pottery and porcelain—Lady Schreiber and a few other enthusiasts excepted—was minimal. Such interest as did exist was directed principally to the productions of the eighteenth century; and when once a wrong attribution in respect of a particular range of nineteenth-century ware had taken root, the requisite scholarship was not available to disturb it. But how far back in the nineteenth century did the error originate? A clue lies in the first catalogue (published in 1885) of the Schreiber Collection which had been donated to the South Kensington Museum (now the Victoria and Albert Museum) the previous year and had in fact been commenced in 1865. For item 793 reads: 'Small Group of Two Greyhounds and a Dead Hare on green base, painted in natural colours. Rockingham. L.4⅔".' This piece does not enjoy a Rockingham origin but is typical of the group of figures spuriously attributed to the factory. It would seem, then, that by 1885—if not considerably earlier—the misconception had taken a firm hold.

But what of the views of the one great ceramic scholar of this period, namely Llewellynn Jewitt? In his monumental work *Ceramic Art in Great Britain*, published in 1878, he writes of the Rockingham factory at some length and, as later research has shown, with remarkable accuracy; but he says nothing that would support the genuineness of the type of figures under discussion. Nor does he trouble to reject their authenticity. What are we to deduce from this? Either that the mis-attribution had not occurred at the time he was writing or that it was current locally, i.e., in the Yorkshire area, among collectors but, naturally enough, by virtue of the more sound and reliable sources from which Jewitt drew his information, had not actually come to his ears.

Although Jewitt is tantalisingly equivocal as far as the Rockingham section of his book is concerned, it is nevertheless submitted that he may have given us the clue to the problem in his discussion of the York China Manufactory on pages 461–2 of Volume 1 of his work. The vital passages are quoted below, the italics being mine:

> In 1838, Mr. Haigh Hirstwood, formerly of the Rockingham China Works, established a china manufactory in York . . . The works were established in Lowther Street Groves, and were continued until about 1850, when the concern was wound up. Mr. Haigh Hirstwood . . . learnt the art of china making and decorating under the Bramelds at the Rockingham Works, as did also afterwards his sons and son-in-law. He continued at the Rockingham Works upwards of forty years leaving them only towards their close, when he removed to York and commenced business as a china dealer. In 1839 . . . he erected kilns, etc. at York, and *commenced business in the decorating and finishing departments, buying his china in the white from Sampson Bridgewood & Co., of Longton, and from others.* In this business he was assisted by his son-in-law, Mr. William Leyland, also from the Rockingham Works, who became his managing partner . . . Mr. Leyland was a clever painter, *gilder*, and enameller, and understood well all the practical details of the potter's art. Mr. Hirstwood was a clever painter of flowers, etc. and was considered the best fly painter at the Rockingham Works . . . *No mark was used.*
>
> The goods principally produced were dinner, tea, dessert and other services, vases, *figures*, etc. *The style of decoration was, as is natural to expect, closely assimilated to that of Rockingham china, indeed, so closely as in some instances scarcely to be distinguished from them.* Some of the flowers are beautifully painted, as are also the butterflies and other natural objects, and the *gilding* is remarkably good. *The figures are usually of good character.*

It is clear from the foregoing that the York products (i) were painted and gilded in a way indistinguishable from Rockingham; (ii) never bore a mark; (iii) included figures of good quality; (iv) were turned out between 1839 and 1850; and (v), being

bought in from Sampson Bridgewood & Co. and elsewhere, assumed forms alien to true Rockingham pieces. It is uncertain whether Hirstwood applied the Rockingham glaze. The phrase 'buying his china in the white' suggested that the items purchased were already glazed and not left in biscuit. If he did apply the glaze, doubtless by virtue of his long experience at Rockingham, it would probably be virtually indistinguishable from that used at Swinton. If the pieces came already glazed, the similarity in formula then current among factories of that period might make differentiation difficult.

Of great significance is the emphasis given by Jewitt to figure output at York when in his discussion of Rockingham he hardly refers to figures as being manufactured there at all. Indeed, the only reference is to biscuit figures. This approach is, of course, quite compatible with the facts of Rockingham production. For it would seem that figures were manufactured there for only about four years and formed a comparatively insignificant part of the factory's total output, terminating long before the works' own demise. But as far as York was concerned, Jewitt implied that its figure output was considerable. Moreover, according to him, the York figures were of good character and, presumably, although quite alien to Rockingham in modelling, were nevertheless identical in gilding and decoration.

Could it be, then, that here lay the origin of the misattribution? Was it these York figures—presumably reasonably plentiful at first in the immediate environs of York—that induced collectors in Yorkshire in, say, the 1860s to succumb to the confusion that thereafter prevailed? Of course, the actual York figures must be extremely rare nowadays, and the vast majority of pseudo-Rockingham figures will have a Staffordshire origin. But if the hypothesis put forward here were true—that the York figures, which had the same Rockingham decoration and similar or possibly the same glaze (except where they were bought in unglazed) but completely different modelling, were wrongly assigned to Swinton—it is but an easy step to make the same misattribution in respect of other figures with modelling similar to that of the York figures but with dissimilar colouring and gilding. And once we have reached this point of error in identification, where neither the modelling nor the decoration has any relationship to Rockingham, it is natural for the floodgates to be opened up and the whole concourse of Staffordshire figures to be admitted as genuine Rockingham products.

However, it cannot be too strongly emphasised that the suggested explanation put forward here of how the crudely modelled Staffordshire figures came to be associated with Rockingham is only a theory. It should not be accepted as proven until, at any rate, further substantiating evidence is discovered.

Appendix E

The London House and its Location

Establishing the exact location of the London House has excited the interest of collectors,[1] but to date it has proved extremely difficult to pronounce on the matter with any degree of finality. I have made a careful examination of the various contemporary Directories and of the Rate Books deposited in the archives of the City of Westminster Public Libraries. Combining these basic sources with certain other subsidiary evidence, I have set out what would appear to be a reasonably authoritative account of the various premises from time to time occupied by the Bramelds in London.

Vauxhall Bridge Road

The first entry relating to the Bramelds in the Post Office Directories is to be found in the issue for 1830. The reference reads as follows:

> Brameld & Co. Rockingham China, Glass and Earthenware Rooms, Vauxhall Road, Westminster.

These premises are mentioned by Thomas Brameld in his letter dated 28th August 1832 addressed to William Newman, Earl Fitzwilliam's agent, where he observes:

> The London wholesale place in Vauxhall Bridge Road lost money at first: but it is now become so far established as to do enough to pay its way.

The implication is that the premises had been in existence for some while prior to 1832; but to what extent, Thomas Brameld gives no clue whatsoever. However, in the factory's balance sheet drawn to 3rd April 1830, there is a hint that the Vauxhall Road property may have been occupied before 1830. For the accounts reveal an item 'China not charged in the Invoices to London Warehouse prior to April 3rd . . . £200'. The date 3rd April is not far into the year, and somehow there is a ring about the phrase used in the balance sheet suggesting that the London Warehouse had been established some little while.

However, the issue is resolved the moment the Rate Books are examined. For in the years from 1828 onwards, Thomas Brameld & Co. appear as the ratepayer in respect of premises in Vauxhall Road and, from 1829 onwards, in respect of property in Dorset Street as well. These hereditaments are more fully described in later

[1] See *The Bramelds in London*, by Terence A. Lockett, in *The Connoisseur*, June 1967, pp. 102–3.

years of the Rate Books as 'House, Yard and Building' and '3 Cottages' respectively. In the Rate Book for 1828, the fact that the name 'Thos. Brameld & Co.' is written in pencil, the ink entry 'Henry Westmacott' having been struck through, strongly confirms that the Bramelds had only arrived in London that year. In any event, no entry can be found for them in respect of earlier years. The Rate Books establish that the Bramelds continued in occupation of the premises in Vauxhall Road (or, to give it its full address, 13 Vauxhall Bridge Road)[1] and those in Dorset Street until 1839—for their name disappears from the Rate Books only from 1839 onwards.

174 Piccadilly

In the Post Office London Directories for 1832, 1833 and 1834, over and above the usual reference to Vauxhall Road, Brameld & Co. are credited with a further address at 174 Piccadilly—an address which does not appear in the Directory of the following year. Recourse to the Rate Books fails to provide confirmation, for the ratepayer recorded in respect of 174 Piccadilly during this period (and for many years after) was Jeffery Ludlam. This discovery in no way undermines the accuracy of the Directories. It merely proves that the Bramelds were not the owners of the property and were therefore not liable for the rates. Assuming, then, the correctness of the statement in the Directories, the Bramelds must have held a lease of 174 Piccadilly or, more accurately, a part of it: for the Directories also reveal the occupant of 174 Piccadilly to be 'Ludlam Jeffery & Co. hosiers'. Clearly, the owners, Jeffery Ludlam & Co., who carried on the business of hosiers, shared their premises with Brameld & Co. during the period 1832 to 1834.

It would seem that the shop at 174 Piccadilly was not satisfactory. For in his letter dated 28th August 1832, referred to above, Thomas Brameld has this to say of it:

> The retale part of the London Trade is gradually on the increase—altho' it has not yet done much good—for the want, perhaps of a good *shop*. The stock in it . . . does not probably exceed 1,000 £ because it is fed regularly from the Warehouse—and on that account can be kept low.

It is not surprising, then, to find the Bramelds vacating these premises after 1834.

3 Titchborne Street and 56 Great Windmill Street

During 1835 and 1836 the Bramelds had no establishments in London other than that in Vauxhall Bridge Road and the three cottages in Dorset Street. This fact is confirmed by the Directories for these two years. But in 1837 they acquired 3 Titchborne Street and 56 Great Windmill Street, previously owned by William Jenkinson and Charles Weeks, successors in title to Thomas Weeks. Number 3 Titchborne Street (presumably together with 56 Great Windmill Street) had previously housed the Weeks Museum, famous for its mechanical curiosities. The relationship of 56 Great Windmill Street to 3 Titchborne Street is somewhat obscure, but I suggest the possibility that these two premises, though facing different roads, might in fact have been joined at their rear. Thus, they might really have constituted one single property with two different entrances, the main one being 3 Titchborne Street. They seemed to have been continually in the same ownership for many years and during the period 1849 to 1852 they were rated together as one property when they were picturesquely described as 'Warehouse over Stabling in Black Horse or George Yard and House and Premises 56 Gt. Windmill St.'

The conclusive authority for the acquisition by Brameld & Co. of 3 Titchborne

[1] Pigot's *London Directory*, 1836.

Street and 56 Great Windmill Street are, again, the Rate Books. These showed the premises to have been empty during 1836 but to have been occupied jointly by John Wager Brameld and Thomas Brameld in the following year and thereafter till 1842 when John Thomas Brameld took over—with J. D. Beckitt as a partner for one period (see also page 130)—up to 1851.

The occupancy of premises at 3 Titchborne Street by the Bramelds receives confirmation from three interesting sources. First, in Tallis's *Street Views of London*, c. 1835–40, 3 Titchborne Street is actually illustrated, with a large resplendent griffin over the portals and with the words 'BRAMELD & CO., Rock^m China, Glass and Pottery Warehouse' written above. Secondly, on the birth certificate of his son Charles Wager (12th June 1838), John Wager Brameld's address is given as 3 Titchborne Street. The third confirmation is provided by John Timbs in his *Curiosities of London* (published in 1855, with a second edition in 1885). In his reference to 3 Titchborne Street as the former home of the Weeks Museum, he adds that it subsequently became the showrooms of the Rockingham Works and that, in 1837, the Royal Service was put on display there. The implication is that the Bramelds took over the premises in 1837, which accords perfectly with the Rate Books.

But what do the Directories have to say? Unfortunately, I have been unable to obtain sight of an issue for 1837. But the *Post Office Directory* for 1838 and Pigot's *London Directory* for 1838, apart from referring to the premises at Vauxhall Bridge Road, also credit the Bramelds with the further address of 3 Titchborne Street. No mention is made of 56 Great Windmill Street. Robinson's *London Directory*, 1838, has a somewhat different entry: 'Griffin Warehouse Piccadilly and Vauxhall Bridge Road'. Clearly, in view of the illustration in Tallis's *Street Views of London*, the 'Griffin Warehouse' must refer to 3 Titchborne Street. Moreover, the issue is put beyond all dispute when reference is made to Kelly's *Post Office London Directory*, 1842—for under 'China, Glass and Earthenware Dealers' John Thomas Brameld & Co. (which had succeeded Thomas Brameld & Co.) appears with an address at '3 Titchborne Street', and under 'China, Glass and Earthenware Manufacturers and Wholesale Glass Dealers' the same firm is credited with premises at '(The Griffin) Piccadilly, top of the Haymarket'.

Hodge & Beaumont

In the following two years, Kelly's *Post Office London Directory* confirms the Bramelds' occupancy of 3 Titchborne Street: in 1839 specifically ('3 Titchborne Street, Haymarket') and in 1840 indirectly ('the Griffin, Piccadilly, top of the Haymarket'). It is only when we turn to Pigot's *National Directory* for these two years that a complication arises: for there we read the following startling entry under China and Earthenware Manufacturers and Dealers:

> Hodge & Beaumont, successors to Brameld & Co. (to the Queen), 3 Titchborne Street and Vauxhall Bridge Road; Manufactory, Rockingham Works, near Rotherham, Yorkshire.

Clearly, this statement cannot be accurate—at any rate, in its entirety. It is indisputable that the Bramelds continued trading until 1842; therefore, Hodge & Beaumont could not correctly be described as successors to their entire business. But does the statement contain a partial truth? The answer to the problem would seem to lie in an analysis of three separate entries in Kelly's *Post Office London Directory*, 1840. They are as follows:

> Brameld & Co., manufacturers, Rockingham china, glass and pottery warehouse, the Griffin, Piccadilly, top of the Haymarket, the works near Rotherham.

Hodge & Beaumont, wholesale dealers in china, earthenware, etc., Rockingham Warehouse, Vauxhall Bridge Road, Westminster.

Kewell Barton, wholesale china, glass and earthenware warehouse, 13 and 14 Vauxhall Bridge Road; opposite Regent Street, Westminster.

Clearly, then, Hodge & Beaumont were china dealers who had succeeded not to the whole Brameld business, as the statement in Pigot's *National Directories* for 1839 and 1840 would suggest, but merely to their original London premises at Vauxhall Bridge Road. In fact, 3 Titchborne Street was not vacated by Thomas Brameld until the premises were taken over in 1842 by his son John Thomas.

A complication would seem to lie in the occupancy by Barton Kewell of 13 and 14 Vauxhall Bridge Road: for we know from Pigot's *London Directory*, 1836, that 13 Vauxhall Bridge Road was the full address of the Brameld's premises. The explanation must be that Barton Kewell and Hodge & Beaumont shared the warehouse once owned by the Bramelds.

John Thomas Brameld (1819–92)

n 1842, John Thomas Brameld took over 3 Titchborne Street and 56 Great Windmill Street from his father Thomas. John Wager Brameld would appear to have vacated the premises in around 1840. In the Rate Books for that year, his name is struck through in pencil. And in 1841 Thomas was the sole ratepayer. In an interesting letter to Earl Fitzwilliam, dated 29th November 1842, Thomas Brameld makes direct reference to his son and his activities:[1]

> . . . at Piccadilly we could always sell our own Tea, Bkfast and Dessert china, much more readily than we had from 4 or 5 other manufactories.—My son finds it the case now—and is distressed because we cannot supply him with the articles so much wanted.

In 1843, John Thomas Brameld took into partnership J. D. Beckitt—the name is spelt John Ducker Beckitt in the Post Office Directories but John Duckett Beckett in the Rate Books—and traded under the name Brameld & Beckitt. Indeed, a pottery plate bearing their impressed mark has been discovered. According to the Directories and Rate Books, the partnership lasted until 1848–9—when John Thomas once again resumed operations on his own account. Pieces bearing his mark are occasionally found, and some are interesting for the fact that the address incorporated in the mark is '232 Piccadilly'. Terence A. Lockett has suggested[2] that, since Piccadilly ends at number 229, John Thomas Brameld may have treated Titchborne Street as an extension of Piccadilly and added three to 229 to arrive at 232 in order to obtain a more fashionable address. This conjecture is eminently reasonable and must surely be right.

John Thomas Brameld discontinued trading in 1851 when Henry Robin, the conjuror, took over and refitted-out 3 Titchborne Street and 56 Great Windmill Street[3]. He is known to have entered St. Bees Theological College and to have been ordained as a priest in the Church of England in 1855. In the following year he was appointed assistant curate of Falkingham, Lincolnshire, and by 1858 he was incumbent of St. John's, Mansfield, Nottinghamshire.

Incidentally, Titchborne Street (or Tichborne Street, as it was sometimes spelt)

[1] See the Wentworth correspondence, Appendix G.
[2] *The Connoisseur*, June 1967, p. 103.
[3] See the Rate Books and John Timbs' *Curiosities of London*, 1885, p. 606.

has long since disappeared, its separate identity lost when Shaftesbury Avenue was created and Piccadilly Circus enlarged.

Postscript to John Wager Brameld (1797–1851)

As has been stated above, John Wager Brameld would seem to have left 3 Titchborne Street in 1840. But where did he go? To another address in London or, perhaps, back to Swinton? Tradition has it that John Wager continued in London manufacturing porcelain—or, at any rate, decorating it. Undoubtedly, he entered several items in the Great Exhibition of 1851,[1] and presumably it was on the strength of this that he was regarded as having continued in the china business after the Rockingham factory closed down in 1842.

However, if this were so, why did he leave 3 Titchborne Street in 1840? Surely, the obvious thing for him to have done would have been to go into partnership with his nephew John Thomas. Instead, Kelly's *Post Office London Directory*, 1846, tells us he took up residence at 7 Cobourg Place, Bayswater (the previous year the occupant was stated to be James William Bramer), where he is described as 'Brameld John W. esq.'. The use of the title 'esq.' would suggest that John Wager was living the life of a gentleman and not that of a trader. In the Directory for 1848, he is given the address of 6 Cobourg Place, Bayswater—number 7 not appearing at all. The address ascribed to John Wager Brameld in the Catalogue of the Great Exhibition of 1851 is 7 Coburg (an alternative spelling to 'Cobourg') Place, Bayswater; but in the Post Office London Directory for 1851, no reference at all is made to him anywhere under Coburg Place.

There need be little mystery on this last point. John Wager Brameld died in 1851. In all probability he entered in the 1851 Exhibition, just for the fun of it, genuine Rockingham pieces produced at the factory in its heyday and doubtless decorated by him either long ago, when the works were still in existence, or more recently as a special project for the Exhibition. In any event, it is doubtful whether it can be maintained that John Wager Brameld ever carried on business in the commercial sense after about 1840. Indeed, no mark of his has as yet been discovered. A porcelain jug in the Godden Collection alleged to bear his mark is, in fact, printed with that of John Thomas Brameld.

[1] For details see *Rockingham Ornamental Porcelain*, p. 67. In the Catalogue, he is described as a 'Manufacturer'.

Christie's Sale of Rockingham,
12th and 13th February 1830

A

CATALOGUE OF A SINGULARLY
ELEGANT ASSEMBLAGE OF
MODERN PORCELAIN
BEING THE LAST
SEASON'S STOCK
OF
ROCKINGHAM CHINA

which the Proprietors have resolved to dispose of, to make room for a fresh Selection now preparing at the Works in Yorkshire; consisting of beautiful and massive Dinner, Dessert, Breakfast, Tea and Coffee Services; Vases, Beakers, and Ornaments, in Patterns of well painted Fruit, Flowers, Landscapes, etc. on various coloured Grounds, tastefully finished with the richest burnished Gold.

which will be sold by auction
by Mr. Christie
at his great room
in King Street, St. James's Square,
on Friday, the 12th of February, 1830
and the following day,
at one o'clock precisely.

12th February, 1830

Reserve

Lot 1. A set of two large Grecian pitchers, two small ditto, and one candlestick of fine figured ware. 8/–
Lot 2. A set of ditto
Lot 3. A set of ditto
Lot 4. A set of ditto
Lot 5. A set of ditto
Lot 6. A set of ditto
Lot 7. A set of ditto
Lot 8. A tea and coffee service of twelve cups and saucers, twelve coffee cups, a tea-pot and stand, sugar box,

Reserve

cream ewer, slop basin, and two plates, painted with
flowers. £2

Lot 9. A set of three small vases 12/6

Lot 10. A tea and coffee service, consisting of twelve cups and
saucers, twelve coffee cups, tea-pot and stand, sugar
box, cream ewer, slop basin, and two plates 4½ gns.

Lot 11. A dessert service, rose colour with landscapes, con-
sisting of centre, two cream bowls and stands, eight
fruit dishes and twenty-three plates. £6

Lot 12. A breakfast and coffee service, consisting of twelve
breakfast and twelve tea-cups and saucers, fourteen
plates, a tea-pot and stand, two slop basins, a sugar
box, six egg cups, a cream ewer, and a milk jug. £5

Lot 13. A set of three vases, painted with flowers. 35/-

Lot 14. A set of ditto. 28/-

Lot 15. A tile for framing, painted with flowers. 18/-
 (Sold for 18/-)

Lot 16. A dessert service, painted with flowers, gilt, consisting
of a centre, two cream bowls, two stands, twelve fruit
dishes and twenty-four plates. £11
 (Sold for £10)

Lot 17. A breakfast and coffee service, white and gold, con-
sisting of twelve breakfast and twelve coffee cups and
saucers, sixteen plates, two muffin ditto and covers,
six egg cups, a slop basin, butter tub and stand, a
sugar box, twelve toast plates and milk ewer. £6
 (Sold for £6)

Lot 18. A set of three vases, painted with flowers and views. 39/-

Lot 19. A tea and coffee service, painted with flowers and
ornaments in gold, consisting of twelve tea-cups and
saucers, twelve coffee cups, tea-pot and stand, sugar
box, cream ewer, and two bread and butter plates. £3½

Lot 20. A large punch bowl, richly painted with flowers. £5

Lot 21. A tea and coffee service, painted with flowers, con-
sisting of 45 pieces. £2½

Lot 22. A dessert service, painted with flowers, consisting of
a centre, two cream bowls, two stands, twelve fruit
dishes and twenty-four plates. £11

Lot 23. A set of three vases, painted with flowers. 45/-

Lot 24. A set of ditto, jars and covers, blue and gold. 55/-

Lot 25. A breakfast and coffee service, painted with flowers
and plants, consisting of twelve breakfast and twelve
coffee cups and saucers, sixteen plates, a butter tub
and stand, a honey pot and stand, two muffin plates
and covers, a slop basin, a milk and cream ewer. 14 gns.

Lot 26. A very handsome dessert service, painted with views
in Yorkshire, with rose-coloured borders, consisting
of a cream bowl and stand, eight fruit dishes, and
twelve plates. 20 gns.

Lot 27. A set of three vases, painted with flowers. 69/-

Lot 28. A set of three ditto vases. 31/6

Lot 29. A breakfast and coffee service, consisting of eleven
breakfast and twelve tea-cups and saucers, twelve
coffee cups, sixteen plates, two slop basins, two muffin

Reserve

plates and covers, a sugar box, a milk and cream ewer,
tea-pot and stand, and honey pot and stand. £10

Lot 30. A dinner service, painted with rose, thistle and sham-
rock, consisting of two soup turennes and covers, four
sauce ditto, covers and stands, a salad bowl, four
vegetable dishes and covers, thirteen dishes, seventy
table and seventeen soup plates. £14

Lot 31. A ditto dessert service, consisting of centre, two cream
bowls and stands, twelve fruit dishes and twenty-four
plates. £5

Lot 32. A set of three vases, painted with flowers. 1 gn.
 (Sold for 1 gn.)

Lot 33. A tea and coffee service, painted with flowers, con-
sisting of forty-fivepieces. £5

Lot 34. A dessert service, painted with flowers, consisting of
centre, two cream bowls and stands, twelve fruit
dishes, and twenty-four plates. 18 gns.

Lot 35. Three vases, painted with flowers. 29/-
 (Sold for 29/-)

Lot 36. A tea and coffee service, painted with flowers, con-
sisting of twelve cups and saucers, twelve coffee cups,
tea-pot, stand, sugar box, cream ewer, slop basin, and
two bread and butter plates. 4 gns.

Lot 37. A set of three small vases.

Lot 38. A tea and coffee service, Brunswick blue, consisting of
twelve cups and saucers, twelve coffee cups, sugar box,
cream ewer, slop basin, and two bread and butter plates. £5

Lot 39. A set of three vases, with landscapes. 31/6

Lot 40. A tile for framing, painted with a view of Ullswater. 25/-

Lot 41. A ditto, with a subject from Shakespeare. 38/-

Lot 42. A dessert service, consisting of four high stands, two
bowls and stands, eight fruit dishes, and thirty-six
plates, beautifully painted with bouquets differently
designed, and with green borders. £29

Lot 43. A pair of ice pails to correspond. £9

Lot 44. A vase, painted with fruit and a pair of figures. 29/-

Lot 45. A tea and coffee service, painted with flowers, con-
sisting of twelve cups and saucers, twelve coffee cups,
a tea-pot and stand, sugar box, cream ewer, slop basin,
and two plates. 35/-

Lot 46. A ditto, only forty-one pieces, with flowers on
crimson ground. £7

Lot 47. A dessert service, painted with flowers, with borders of
green and gold, consisting of a centre, two cream bowls
and stands, ten fruit dishes and twenty-four plates. £11
 (Sold for £11)

Lot 48. A breakfast service, consisting of twelve breakfast and
twelve tea cups and saucers, twelve coffee cups, tea-
pot and stand, sugar box, cream ewer, slop basin and
two plates. 5½ gns.

Lot 49. A set of three small ornamental vases. 24/-

Lot 50. A tea and coffee service, plain round shape, consist-
ing of 12 tea cups and saucers, 12 coffee cups, sugar
box, cream ewer, slop basin and 2 plates—42 pieces. £3½

Lot 51. A set of three ornamental vases, painted with flowers. 35/–
Lot 52. A set of ditto.
Lot 53. A tea and coffee service, painted with flowers, consisting of twelve tea-cups and saucers, twelve coffee ditto, tea-pot and stand, sugar box, cream ewer, slop basin and two plates. £7
Lot 54. A pair of ornamental vases, and a jar painted with fruit. 29/–
Lot 55. A set of ditto vases. 25/–
Lot 56. Two pen trays. 29/–
Lot 57. A tea service, painted with flowers, consisting of twelve tea cups and saucers and twelve coffee cups, sugar box, cream ewer, slop basin, and two plates.

£6
(Sold for £6)

Lot 58. A dinner service, painted with roses, consisting of seventy-three plates, twelve soup ditto, eighteen dishes, four ditto and covers, four sauce turennes, covers and stands, two soup turennes covers and stands and salad bowl; in all 134 pieces. £33
Lot 59. A dessert service, beautifully painted with groups of fruit and crimson borders, consisting of centre and two ends, two cream bowls and stands, 8 fruit dishes and twenty plates. £29
Lot 60. Two cream bowls painted with fruit. 3 gns.
Lot 61. Two pen trays painted with flowers. 29/–
(Sold for 29/–)
Lot 62. A vase and a pair of rustic groups, one imperfect 78/-
Lot 63. A tea and coffee service, consisting of 12 tea-cups and saucers, and 12 coffee cups, tea-pot and stand, sugar box, slop basin, cream ewer, and 2 plates painted with flowers.

£3½
(Sold for 3½ gns.)
(Lot crossed out)

Lot 64. A ditto, painted with wild flowers.
Lot 65. A pair of tiles for framing, painted with views of Conisbro and Athelstane Castles. 48/–
Lot 66. An elegant dessert service, painted with groups of fruits, consisting of centre, 2 cream bowls and stands, 12 fruit dishes and 24 plates. £27
Lot 67. A pair of handsom vases, painted with marine views and crimson ground. 12 gns.
Lot 68. A set of three very elegant vases, painted with groups of flowers. 11 gns.
Lot 69. A breakfast and coffee service consisting of 12 breakfast cups and saucers, 12 coffee ditto and saucers, 16 plates, butter tub, honey pot and stand, sugar box, muffin plate, an egg stand and 6 cups, a roll tray, cream ewer and milk jug and 3 dishes pencilled with flowers. 11 gns.
Lot 70. A set of 2 large Grecian pitchers, two small ditto, and a candlestick of fine figured ware. 8/–
Lot 71. A set of ditto. 8/–
Lot 72. A set of ditto. 8/–
Lot 73. A set of ditto. 8/–
Lot 74. A set of ditto. 8/–
Lot 75. A set of ditto. 8/–

13th February, 1830
[Note: there are no reserve prices entered]

Lot 1. A set of two Grecian Pitchers, two smaller ditto, and a mug with figures in relief.
Lot 2. A set of ditto.
Lot 3. ,,
Lot 4. ,,
Lot 5. ,,
Lot 6. ,,
Lot 7. A breakfast and coffee service, light blue and gold, consisting of twelve breakfast cups and saucers, six coffee cups and two muffin plates and covers.
Lot 8. A dessert service of Oriental pattern, consisting of two cream bowls, eight fruit dishes and ten plates.
Lot 9. A set of three ornamental vases.
Lot 10. A set of ditto.
Lot 11. A breakfast and coffee service, white and gold, consisting of six breakfast cups and saucers, six coffee cups, a butter tub and stand, an egg stand with four cups, a milk ewer and two plates.
Lot 12. A dessert service, with rose-coloured borders, painted with flowers, consisting of a centre and stand, two cream bowls and stands, twelve fruit dishes and twenty-four plates.
Lot 13. A tea and coffee service, white and gold, consisting of twelve tea and twelve coffee cups and twelve saucers, a tea-pot and stand, sugar box, cream and slop basins, and two plates.
Lot 14. A pair of handsome beakers.
Lot 15. A tile for framing, painted with fruits, highly finished.
Lot 16. A set of three vases with rose handles.
Lot 17. A dessert service, with centre and stand, two cream bowls and stands, twelve fruit dishes and twenty-three plates painted with groups
(Sold with Lot 52 for £37).
Lot 18. A tea and coffee service, with twelve cups, twelve coffee ditto and twelve saucers, tea-pot and stand, sugar box, cream ewer, two plates and slop basin.
Lot 19. A set of three vases.
Lot 20. A vase, beautifully painted with a wreath of flowers, imperfect.
Lot 21. A tea and coffee service, with twelve tea and twelve coffee cups and twelve saucers, a tea-pot and stand, sugar box, cream-pot, two plates and slop basin.
Lot 22. Two beakers, painted with historical subjects.
Lot 23. A dessert service, with centre and stand, two cream bowls, twelve fruit dishes and twenty-four plates.
Lot 24. A tea-service, with twelve tea cups and saucers, twelve coffee cups, tea-pot and stand, sugar box, cream ewer, two plates and slop basin.
Lot 25. A ditto, with only eight coffee cups.
Lot 26. A large punch bowl, painted with flowers.
Lot 27. Two vases.
Lot 28. Three vases.
Lot 29. Two pen-trays.
Lot 30. Two ditto.
Lot 31. A tile, painted with a marine view.
Lot 32. A dinner service, consisting of fifty table plates, seventeen soup plates, fourteen dishes, four dishes and covers, four sauce turennes and stands, two soup turennes, a fish drainer and a salad bowl.
Lot 33. A dessert service, consisting of centre and stand, two cream bowls and stands, twelve fruit dishes, and twenty-three plates.
Lot 34. Eighteen ice plates, painted with groups of flowers.

Lot 35. A tea service, with twelve tea cups and saucers, eleven coffee cups, sugar box, cream and slop basin, and two plates, painted with flowers and crimson and gold.

Lot 36. A ditto, forty-five pieces.

Lot 37. A dessert service, consisting of a centre and stand, two high ends and stands, two cream bowls and stands, eight fruit dishes and twenty-four plates.

Lot 38. A set of three ornamental vases and beaker.

Lot 39. Three tiles for framing with views of Finlareg Castle, Virginia Water and Aysgarth Force.

Lot 40. A tea and coffee service, consisting of eleven tea cups and saucers, twelve coffee cups, tea-pot and stand, sugar-box, cream ewer, slop basin and two plates; forty-three pieces.

Lot 41. A ditto, light blue and gold, with six plates, forty-seven pieces.

Lot 42. A set of three ornamental vases.

Lot 43. A set of ditto.

Lot 44. A dessert service, painted with views, consisting of a centre and stand, 2 high ends and stands, 2 cream bowls and stands, 8 fruit dishes and 24 plates.

Lot 45. A tea and coffee service, consisting of 11 tea cups and saucers, twelve coffee cups, tea-pot and stand, sugar box, cream ewer, slop basin, and 2 plates; 43 pieces.

Lot 46. A tea service; 33 pieces.

Lot 47. A set of three beakers.

Lot 48. A pair of ornamental vases, painted with flowers, and a small figure.

Lot 49. A pair of ditto and ditto.

Lot 50. A tea and coffee service, plain round shape, consisting of 12 tea cups and saucers, 12 coffee cups, sugar box, cream ewer, slop basin and 2 plates— 42 pieces.

Lot 51. A ditto, 42 pieces.

Lot 52. A dinner service, consisting of 71 plates, 17 soup ditto, 15 dishes, 4 ditto and covers, 4 gravy turennes, stands and covers, 2 soup ditto and covers, and a salad bowl—128 pieces.

(Sold for £37 with Lot 17)

Lot 53. A dessert service, painted with flowers, consisting of a centre, 2 high ends and stands, 2 cream bowls and stands, 8 fruit dishes and 24 plates.

Lot 54. A tea and coffee service, painted with flowers and crimson borders, consisting of 12 tea-cups and saucers, 12 coffee cups, tea-pot and stand, sugar box, cream ewer, slop basin and 2 plates.

Lot 55. A ditto, white and gold (no tea-pot), 42 pieces.

Lot 56. A set of five beakers.

Lot 57. A pair of vases.

Lot 58. A dessert service, painted with flowers, consisting of a centre and stand, 2 high ends and stands, 2 cream bowls and stands, 8 fruit dishes and 24 plates.

(Sold for 14 gns.)

Lot 59. A tea and coffee service, 12 tea-cups and saucers, 12 coffee cups, slop basin and 2 plates.

Lot 60. A vase, beautifully painted with figures.

Lot 61. A set of three ornamental vases.

Lot 62. Two pen-trays.

Lot 63. A dessert service, with painted border, 44 pieces.

Lot 64. A tea service of bucket shape, 45 pieces.

Lot 65. A jar, and a pair of beakers, with flowers in gold on a green ground.

Lot 66. A ditto, and a pair of small vases.

Lot 67. A dessert service, painted with garden scenes and crimson borders, consisting of a centre and stand, 2 high ends and stands, 8 fruit dishes and 24 plates.

Lot 68. A tile for framing, painted with a garden scene.

Lot 69. A set of three ornamental vases, painted with figures.

Lot 70. A set of two Grecian pitchers, two smaller ditto and a mug, with figures in relief.

Lot 71. A set of ditto.

Lot 72. ,,

Lot 73. ,,

Lot 74. ,,

Lot 75. ,,

Lot 76. [Hand-written] Tea Service. Sold for £2.

Lot 77. [Hand-written] Breakfast service. Sold for £4 10s. od.

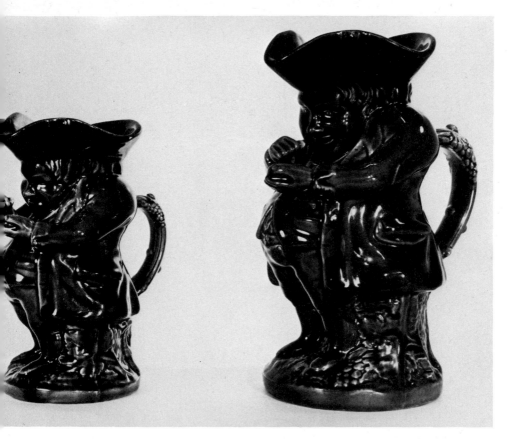

1. Two brown-glazed Toby jugs of the 'Snuff-taker'. 7 and 9 inches high respectively. Both impressed ROCKINGHAM. See page 13.

Brown-glazed
gan pot,
rated with
g. 6¼ inches
Cl. 2 in
Impressed
ELD. See
s 10–11.

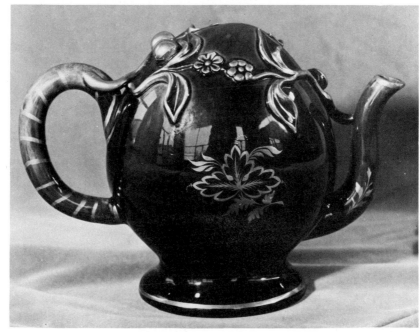

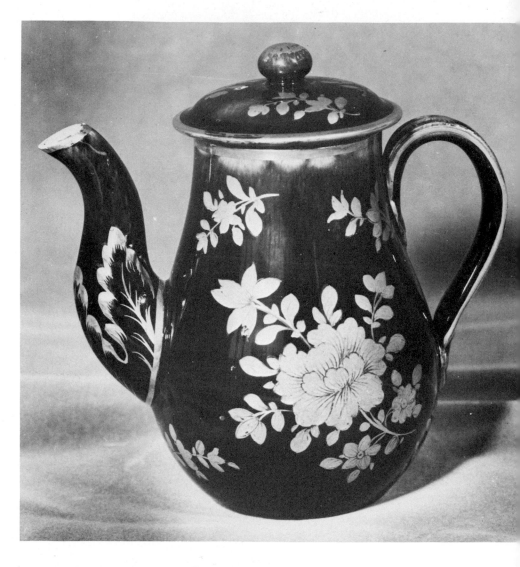

3. Brown-glazed coffee pot and cover, finely gilded with flowers. $5\frac{1}{4}$ inches high. Impressed ROCKINGHAM. See page 12.

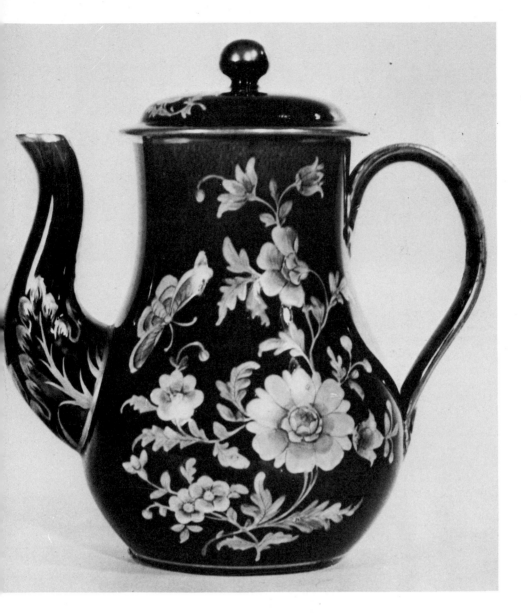

4. Brown-glazed coffee pot and cover, decorated with gilding and with butterflies and flowers in enamel colours. $6\frac{3}{4}$ inches high. Impressed ROCKINGHAM. See page 12.

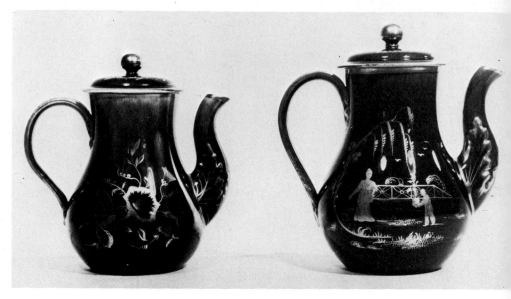

5. Brown-glazed coffee pots and covers. See page 12.

(a) Gilded with pansies on one side and with morning glories on the other. $6\frac{3}{4}$ inches high. Cl. 2 in red. Impressed ROCKINGHAM.

(b) Gilded both sides with Chinese figures and scenes. $7\frac{1}{4}$ inches high. Impressed ROCKINGHAM.

6. Brown-glazed coffee pot with high domed cover and pointed finial. 6 inch high. Impressed 'Rockingham' in script. See page 12

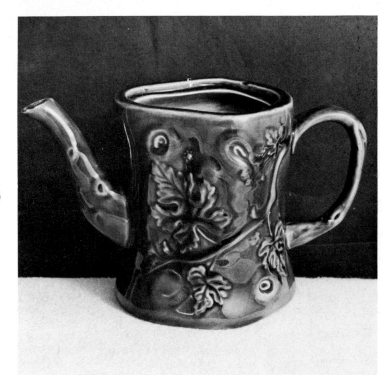

7. Brown-glazed tea-
pot (without the cover)
in the form of a tree
trunk. 4⅛ inches high.
Impressed
ROCKINGHAM. See
page 12. *By courtesy
of Mr. and Mrs. John
D. Griffin.*

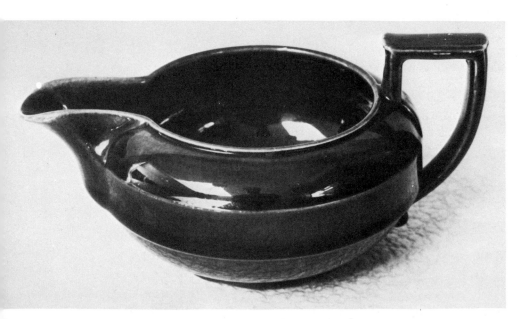

8. Low circular brown-glazed jug with arc handle. 2¼ inches high,
3¼ inches in diameter. Impressed ROCKINGHAM in large capitals. See
page 13. *By courtesy of the Weston Park Museum, Sheffield.*

9. Circular brown-glazed teapot and cover with arc handle, elaborately gilded. 9⅛ inches long. Impressed ROCKINGHAM. See page 12. *By courtesy of the Victoria and Albert Museum.*

10a. Brown-glazed teapot and cover of melon shape, with rustic handle and conical finial. 8 inches long by 3¾ inches high. Impressed ROCKINGHAM in large capitals. See page 12.

10b. Matching coffee pot and cover, with slightly fluted body. 6½ inches high. Impressed ROCKINGHAM. See page 12.

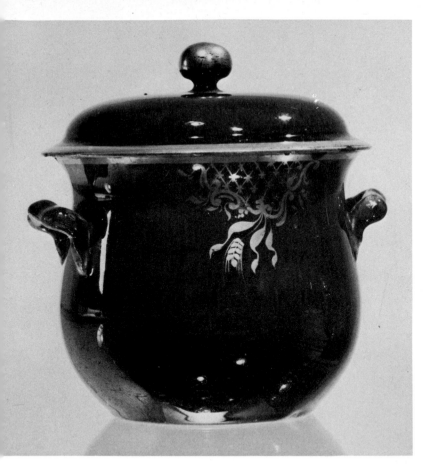

11. Brown-glazed broth bowl and cover, gilded. 5½ inches high. Impressed ROCKINGHAM. See page 13.

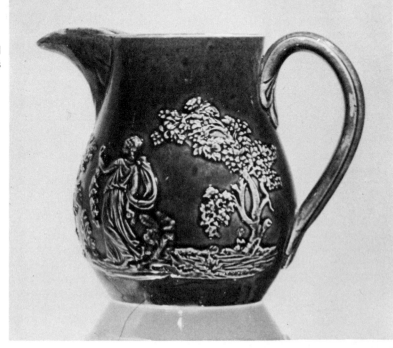

2. Brown-glazed cream jug, decorated with classical figures in relief. 3¾ inches high. Impressed ROCKINGHAM. See page 13.

13. Brown-glazed coffee pot and cover, gilded; by Alfred Baguley. 8½ inches high. Mexborough mark. See page 9.

14. Brown-glazed dish, cover and stand in porcelain, decorated with gilding; by Baguley. 5¾, 6 and 7 inches in diameter respectively. Red griffin without caption under the dish alone. See page 9.

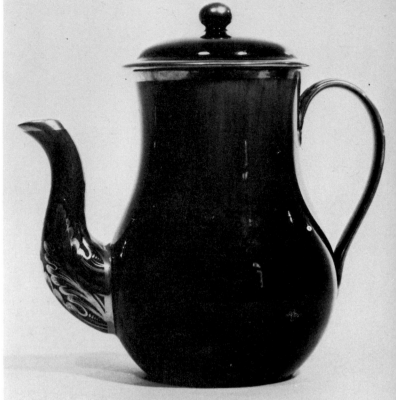

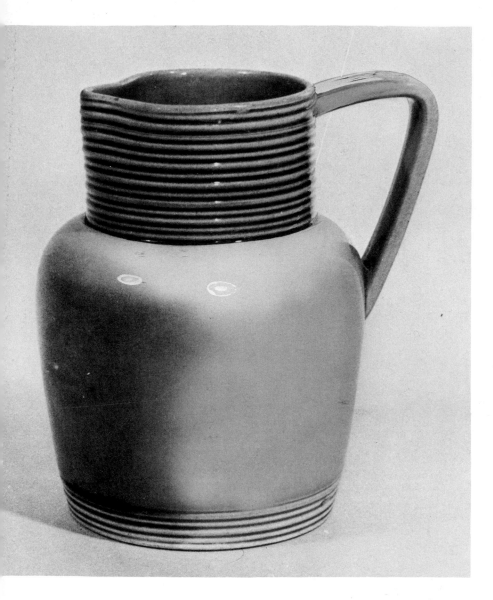

15. Cream jug of terracotta colouring, with angular handle and raised
concentric rings around the neck and base. 5 inches high. Impressed 12
and ROCKINGHAM. See page 13.

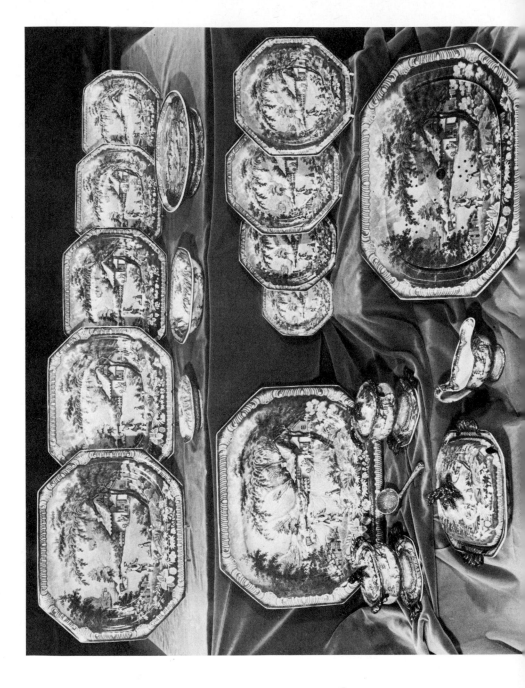

16. Specimen pieces from a large dinner service printed with the 'Returning Woodman' pattern in underglaze blue. For measurements and marks see pages 16–17.

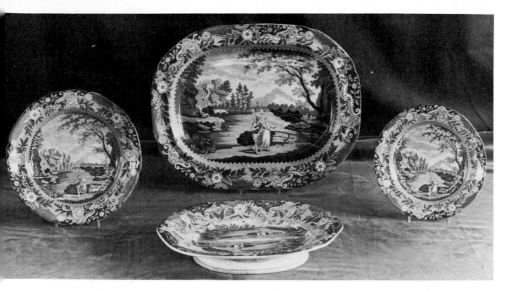

17. Meat dish (16½ inches long), dessert stand, dinner plate (9⅞ inches in diameter) and dessert plate (8⅜ inches in diameter), printed in underglaze blue with the 'Castle of Rochefort' pattern. Each piece impressed BRAMELD within a cartouche under the glaze. See pages 14 and 18.

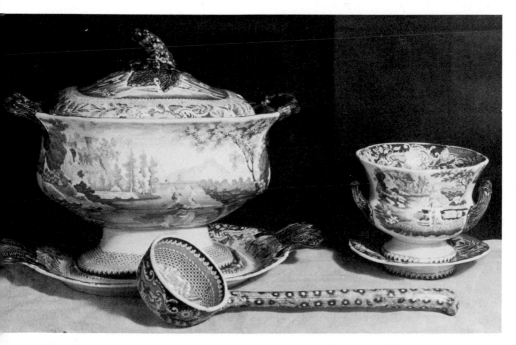

18. Tureen, cover and stand (11 inches high in all), a ladle (12½ inches long) and broth bowl and stand (5¼ inches high), printed in underglaze blue with the 'Castle of Rochefort' pattern. Tureen impressed BRAMELD + 1; stand impressed BRAMELD + ?. See pages 14 and 17–18. *By courtesy of Mr. and Mrs. John D. Griffin.*

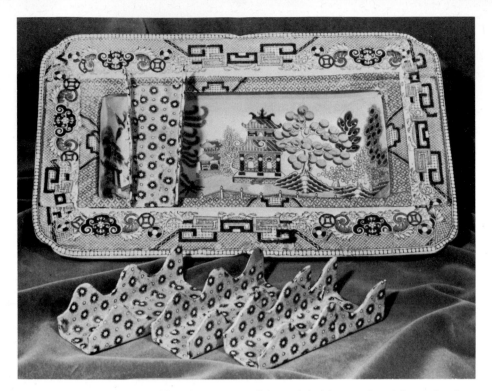

19. Asparagus dish and holders, printed in underglaze blue with the 'Willow' pattern. 14½ by 8¾ inches. Impressed BRAMELD. See pages 14 and 18.

20. Tureen and cover, with gadrooned edging, printed in underglaze blue with the 'Flower Groups' pattern. 14¼ inches long, 11½ inches high. See pages 15 and 18. *By courtesy of Mr. and Mrs. John D. Griffin.*

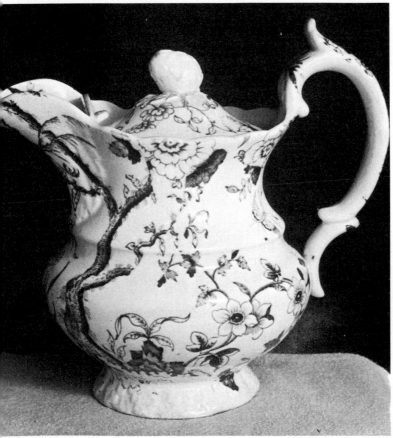

21. Meat dish with gadrooned edging, printed in underglaze blue with the 'Parroquet' pattern. $21\frac{1}{2}$ inches long. Impressed BRAMELD + 1. See page 15. *By courtesy of Mr. and Mrs. J. G. Evans.*

22. Jug and cover, with strawberry finial, and scrolled handle, printed in underglaze blue with the 'Twisted Tree' pattern. 8 inches high. See page 18. *By courtesy of Mr. and Mrs. John D. Griffin.*

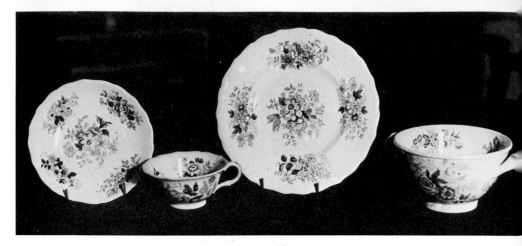

23. Tea cup and saucer, side plate ($7\frac{13}{16}$ inches in diameter) and bowl, printed with a floral pattern in underglaze green. Plate impressed BRAMELD. See page 18. *By courtesy of Mr. and Mrs. J. G. Evans.*

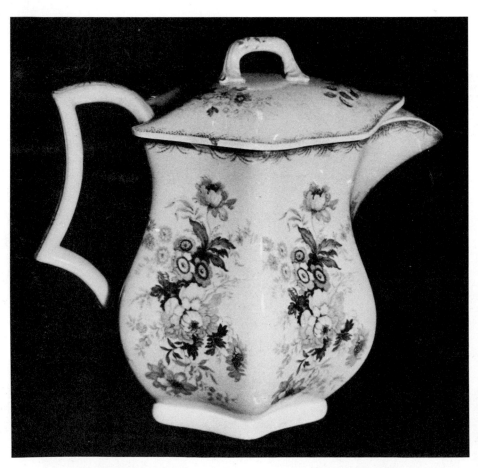

24. Jug and cover, printed in underglaze blue with the 'Flower Groups' pattern. 10 inches high. Impressed BRAMELD + ?. See page 15. *By courtesy of Mr. and Mrs. J. G. Evans.*

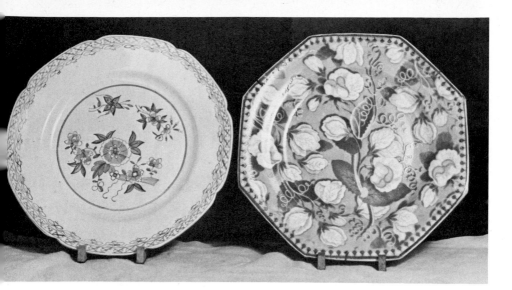

25a. Essentially circular plate, 9¾ inches in diameter, painted in underglaze blue with the 'Sprays of Stylised Flowers' pattern. Impressed BRAMELD within a cartouche.

25b. Octagonal plate, 9¾ inches across, printed in underglaze blue with the 'Sweet Peas' pattern. Impressed BRAMELD within a cartouche.

See page 15. *By courtesy of Mr. and Mrs. John D. Griffin.*

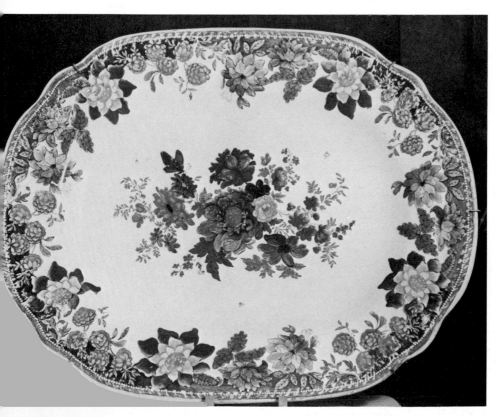

26. Meat dish, 17 by 13½ inches, decorated in underglaze blue with the 'Flower Border' pattern, painted over the glaze in polychrome colours. Impressed BRAMELD+1. See page 15. *By courtesy of Mr. and Mrs. John D. Griffin.*

27. Specimen pieces from a 'Don Quixote' dinner service in underglaze green with raised 'C' scroll and acanthus-leaf motif. See page 19. *By courtesy of Dr. G. A. Cox.*

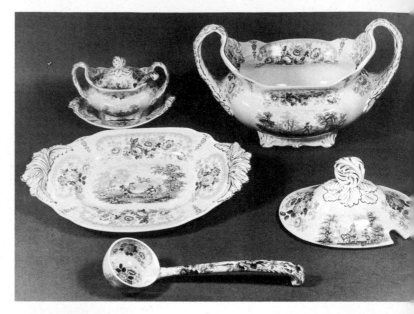

27a. Large soup tureen, cover and stand, with acanthus-leaf handle and floral finials, $11\frac{3}{4}$ inches in height; and ladle, $12\frac{3}{4}$ inches long. Impressed BRAMELD+1 on the stand. Small sauce tureen, cover and stand, $6\frac{1}{4}$ inches high. Impressed BRAMELD+1 on the tureen's base.

27b. Dinner plate, $10\frac{1}{4}$ inches in diameter; soup plate, 10 inches in diameter; dessert plate, 9 inches in diameter; and side plate, $6\frac{3}{4}$ inches in diameter. Impressed BRAMELD+1.

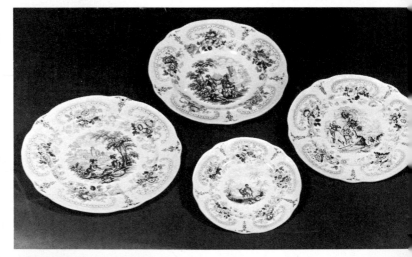

27c. Pair of sauce-boats, 8 inches long, and stands, $4\frac{1}{2}$ inches high. Impressed on the boats BRAMELD+12 and on the stands BRAMELD+5.

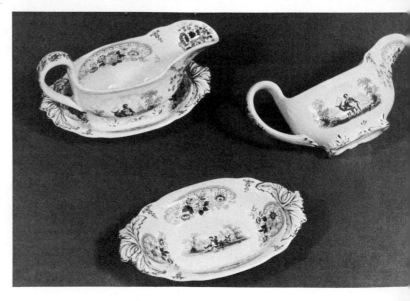

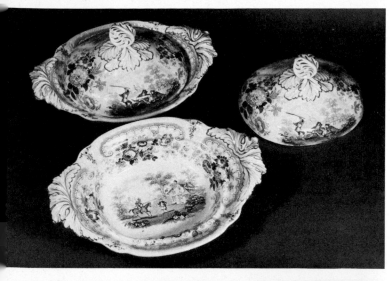

27 (*continued*). Specimen pieces from a 'Don Quixote' dinner service in underglaze green with raised 'C' scroll and acanthus-leaf motif. See page 19. *By courtesy of Dr. G. A. Cox.*

27d. Pair of vegetable dishes, 14 inches long, and covers, 7 inches high. Impressed BRAMELD + 1.

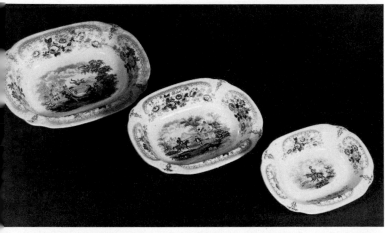

27e. Three pie dishes, $13\frac{1}{2}$, $10\frac{1}{2}$ and 8 inches in length respectively. Impressed BRAMELD + 1.

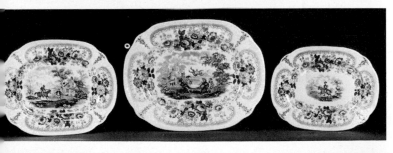

27f. Three meat dishes, 11, 13 and $9\frac{3}{4}$ inches in length respectively. Impressed BRAMELD + 1.

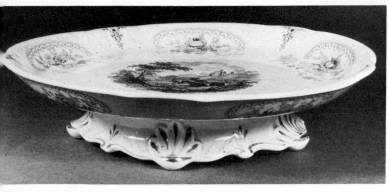

27g. Cheese stand, $12\frac{1}{2}$ inches in diameter and 3 inches high.

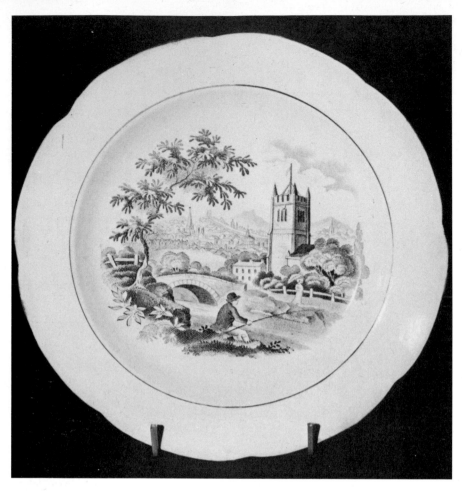

28. Circular plate,
7¼ inches in diameter,
decorated in underglaze
black with a compre-
hensive town-and-
country view.
Impressed
BRAMELD +10. See
page 19. *By courtesy
of Mr. and Mrs. J. G.
Evans.*

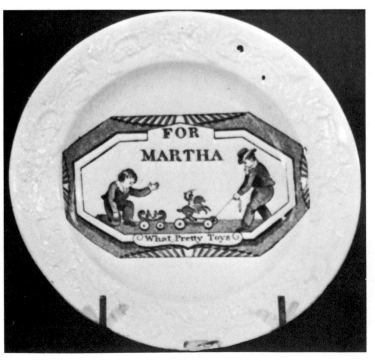

29. Child's plate,
5¼ inches in diameter,
moulded with a floral
pattern around the
border and painted in
underglaze black with
children playing.
Impressed BRAMELD +.
See page 19.

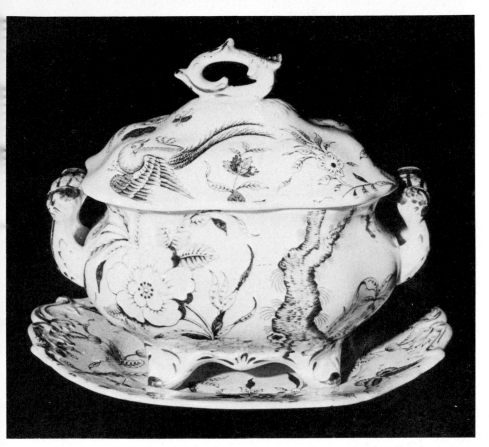

30. Sauce tureen, cover and stand, 6½ inches high, decorated with the 'Twisted Tree' pattern in underglaze green. Impressed BRAMELD. See page 14. *By courtesy of Mr. and Mrs. J. G. Evans.*

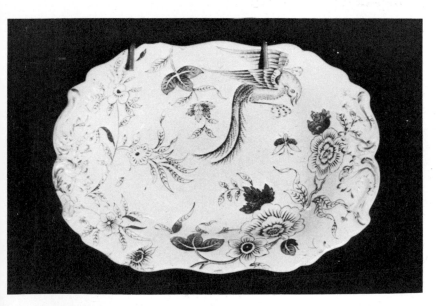

31. Sweetmeat dish, decorated with the 'Twisted Tree' pattern in underglaze green. 6½ inches long. See page 14. *By courtesy of Mr. and Mrs. J. G. Evans.*

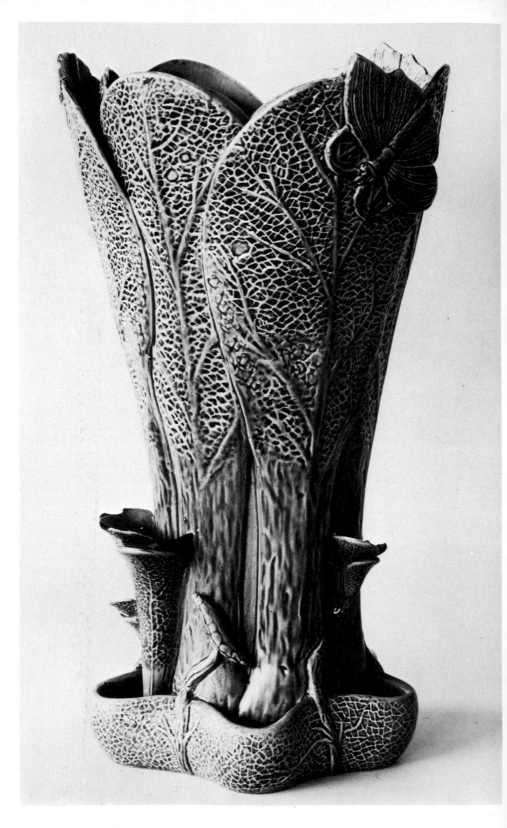

32. Green-glazed 'Lotus Vase'. 12½ inches high. See pages 20–1. *By courtesy of the Victoria and Albert Museum.*

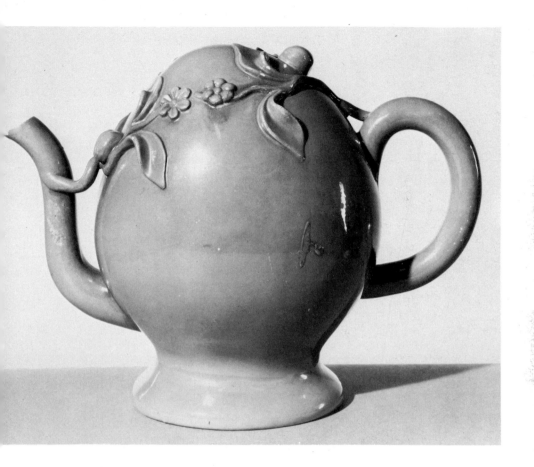

33. Green-glazed Cadogan pot. 7$\frac{1}{8}$ inches high. Impressed BRAMELD & CO.
See pages 11 and 21. *By courtesy of the Victoria and Albert Museum.*

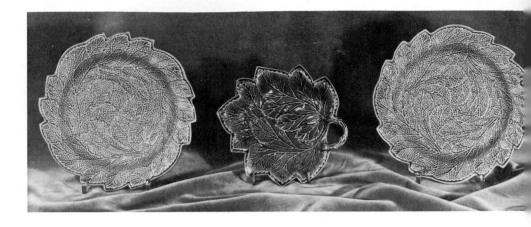

34. Pair of green-glazed serrated plates, $7\frac{1}{2}$ inches in diameter, impressed BRAMELD +1; and a green-glazed leaf-shaped pickle dish, $6\frac{3}{8}$ inches long, impressed BRAMELD, moulded with an all-over leaf motif. See page 20.

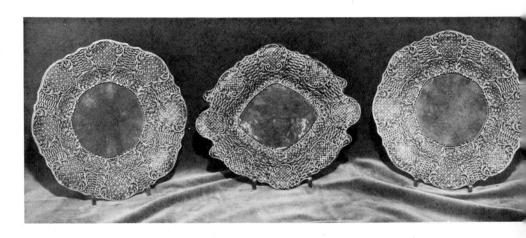

35. Pair of green-glazed plates, $8\frac{11}{16}$ inches in diameter; and diamond-shaped dish, $9\frac{1}{4}$ inches long, with intricate basket-weave pattern around the border. Impressed BRAMELD +4 and BRAMELD +11 respectively. See page 20.

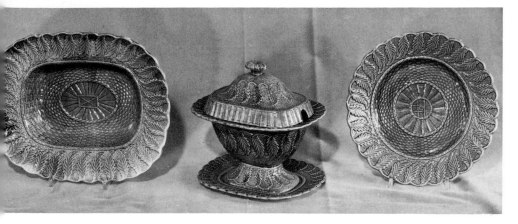

36. Green-glazed dish, 10¼ inches long, impressed BRAMELD +4, moulded with basket-weave centre and foliate rim, together with matching tureen, cover and stand, 7 inches high, impressed BRAMELD +8, and plate, 8¼ inches in diameter. See page 20.

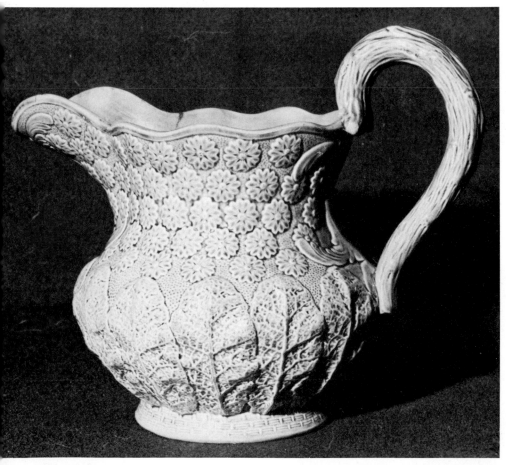

37. Green-glazed jug, moulded with daisy-heads and primrose-leaves. 7⅝ inches high. See page 20. *By courtesy of Mr. and Mrs. J. G. Evans.*

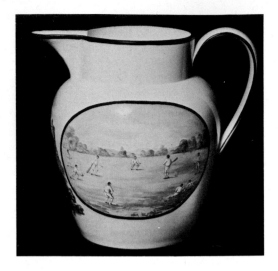

38. Large and magnificent cream-
coloured jug, beautifully painted on the
front with a picture of a castle and on
either side with two early cricketing
scenes, and printed underneath with the
words BRAMELD & CO SWINTON POTTERY.
9½ inches high. See page 23. *By courtesy
of Messrs. B. & T. Thorn & Son.*

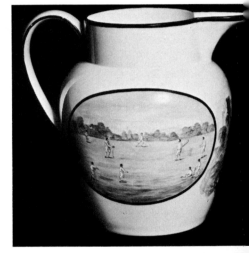

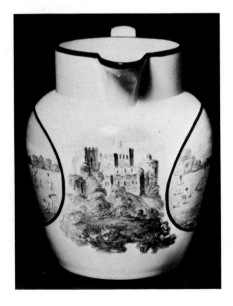

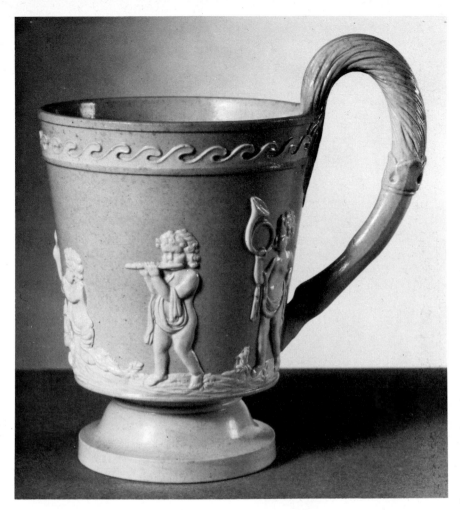

39. Cane-coloured mug with applied classical figures in white and with hoof-and-mane handle. 4 inches high. BRAMELD on a raised oval plaquette. See page 22. *By courtesy of the Victoria and Albert Museum.*

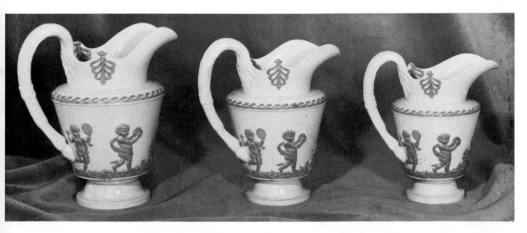

40. Set of three cane-coloured jugs, $7\frac{1}{2}$, $6\frac{7}{8}$ and $6\frac{1}{4}$ inches in height respectively, with applied classical figures in dark blue and with hoof-and-mane handles. BRAMELD on a raised oval plaquette (on the two largest). See page 21.

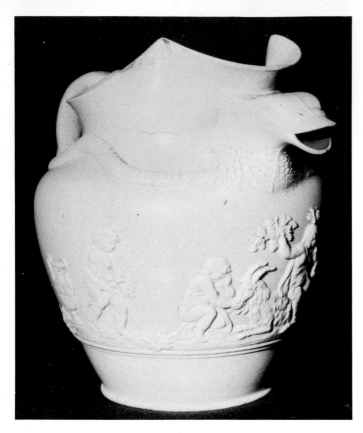

41. Cane-coloured jug with a false snake spout and serpent handle, decorated with applied classical figures in cane-colours. 7 inches high. BRAMELD on a raised oval plaquette. See page 21. *By courtesy of Mrs. K. Stacey.*

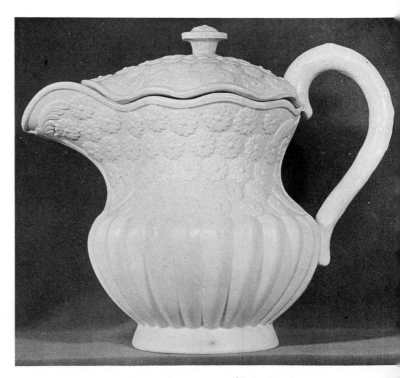

42. Cane-coloured jug and cover moulded with daisy-heads over the upper portion and fluted below. 7½ inches high. Impressed BRAMELD+4. See page 21. *By courtesy of Bryan Bowden, Esq.*

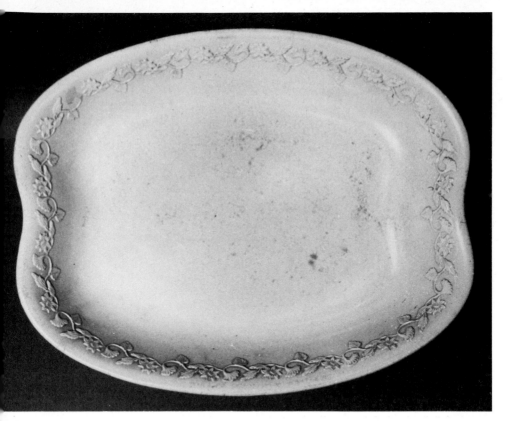

43. Cane-coloured rectangular dish with shaped sides, decorated with applied foliage. 11 inches long. Impressed BRAMELD+7. See page 22. *By courtesy of the Weston Park Museum, Sheffield.*

44a. Cane-coloured square dish with shaped sides, decorated with applied foliage. $7\frac{1}{4}$ inches across. Impressed BRAMELD +7. See page 22. *By courtesy of Mr. and Mrs. John D. Griffin.*

44b. Reverse of dish in Plate 44a. See page 22.

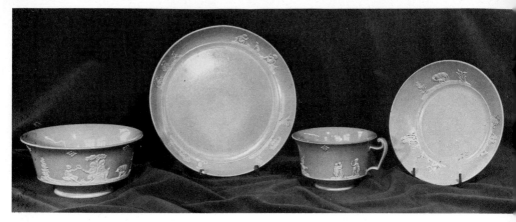

45. Specimen pieces from a cane-coloured tea service comprising slop basin, $6\frac{1}{4}$ inches in diameter, impressed BRAMELD+7; saucer dish, $8\frac{1}{2}$ inches in diameter, impressed BRAMELD+16; and tea cup and saucer, $4\frac{3}{8}$ and $6\frac{1}{2}$ inches in diameter respectively, impressed BRAMELD+7 and BRAMELD respectively, decorated with classical rustic scenes in light blue. See page 22.

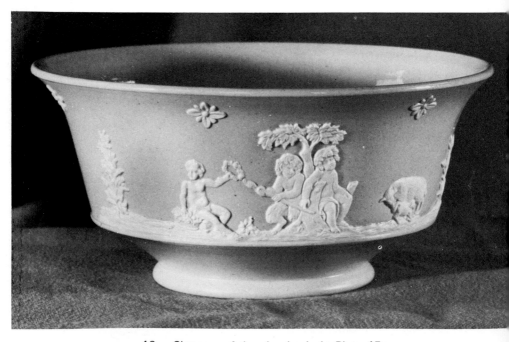

46. Close-up of the slop basin in Plate 45.

47. Set of five plates (soup, dinner, dessert recessed, desert flat, and side), 10, 10, $8\frac{3}{4}$, $8\frac{3}{4}$ and $6\frac{1}{2}$ inches in diameter respectively, painted over the glaze with foliage in green. Impressed BRAMELD. See page 20.

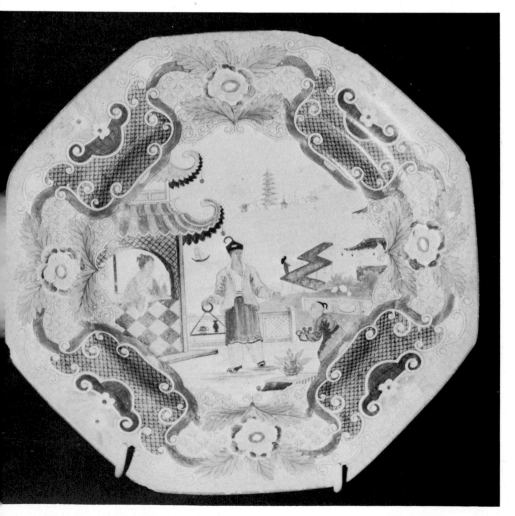

48. Octagonal plate, 10 inches across, decorated with a chinoiserie pattern in underglaze fawn and overpainted in bright colours. Impressed BRAMELD. See page 20. *By courtesy of Mrs. K. Stacey.*

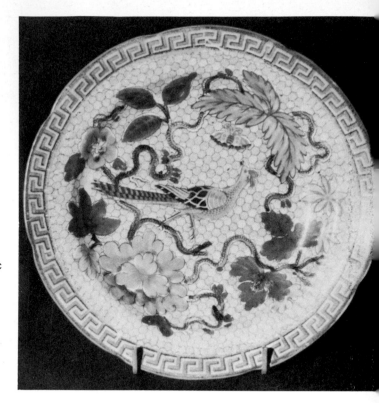

49. Circular plate, $7\frac{1}{4}$ inches in diameter, painted with an exotic bird and elaborate foliage. Impressed BRAMELD +10. See page 20. *By courtesy of Mr. and Mrs. J. G. Evans.*

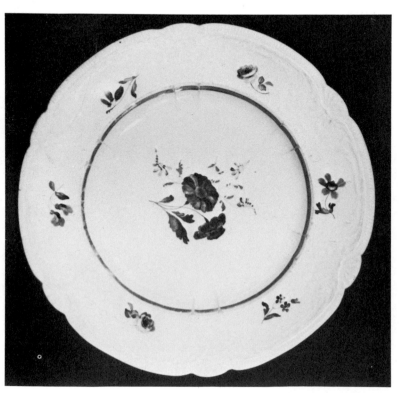

50. Circular plat with moulded 'C' scrolls, painted w' flowers, $8\frac{7}{8}$ inches diameter. Printed the griffin in red, 'Rockingham Wor Brameld 567', an impressed KAOLIN. page 20. *By cour of the Weston Pa Museum, Sheffiel*

51. Rare yellow-glazed jug and cover, with pineapple moulding, decorated with blue painted lines and with red stars. Impressed BRAMELD. See page 24. *By courtesy of Jack L. Leon, Esq., and the Smithsonian Institution, Washington, D.C.*

52a. Spill vase, 4 inches high, painted with flowers and leaves. See page 25.

52b. Base of vase in Plate 52a showing rare mark.

By courtesy of Mr. and Mrs. John D. Griffin.

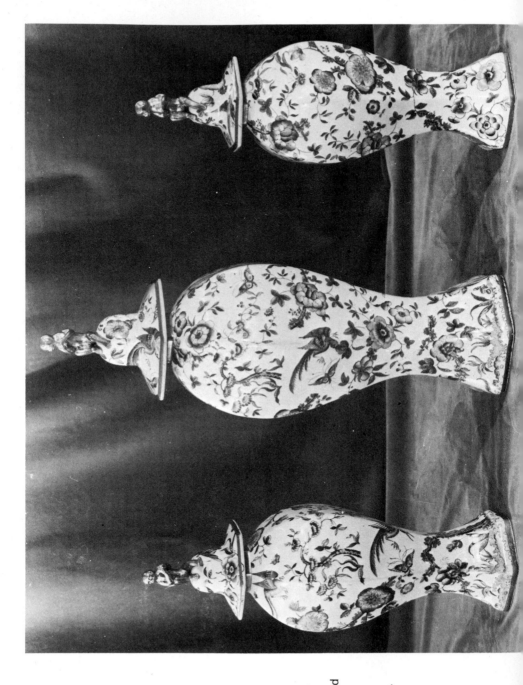

53. Important garniture of three hexagonal vases and covers, with gilt monkey finials, decorated with the 'Twisted Tree' pattern, overpainted in polychrome colours. $17\frac{1}{4}$, $21\frac{1}{2}$ and $17\frac{1}{4}$ inches in height respectively. See pages 14, 19 and 25.

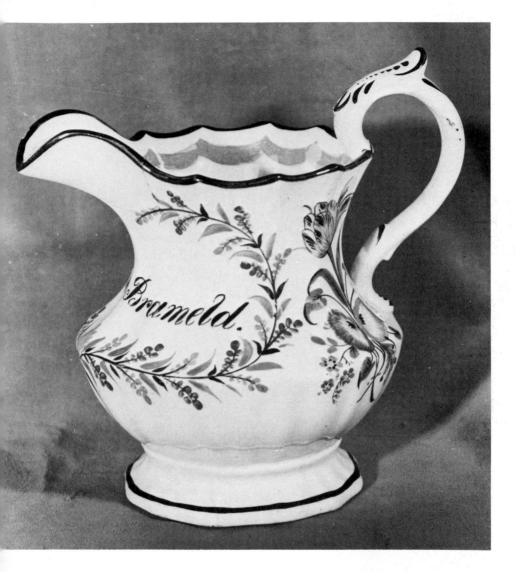

54. Jug, painted with flowers and foliage, and inscribed in black with
 the name 'John Brameld'. 7½ inches high. See page 26.

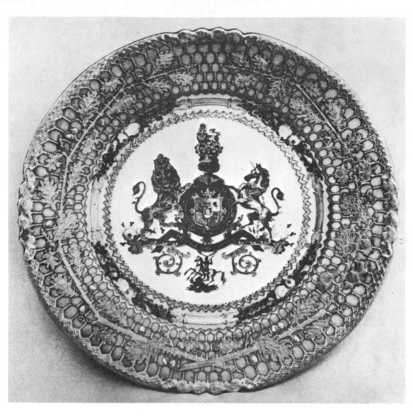

55. Dessert plate of the pattern supplied to the Royal order, decorated with a light blue border, ornamented with raised oak borders in gilt over a laced design also in raised gold, and painted in the centre with the Royal Arms. 9½ inches in diameter. See page 41. *By courtesy of the Clifton Park Museum, Rotherham.*

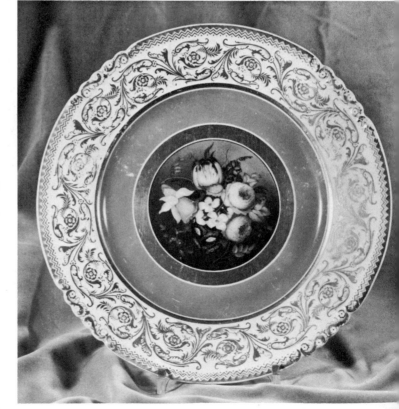

56. Dessert plate with shark's teeth and 'S' scroll moulding—the border gilded with an intricate pattern, the centre finely painted with a flower group surrounded with a gold band and a pink border. 9¼ inches in diameter. Pattern number 416. Red mark. See page 28.

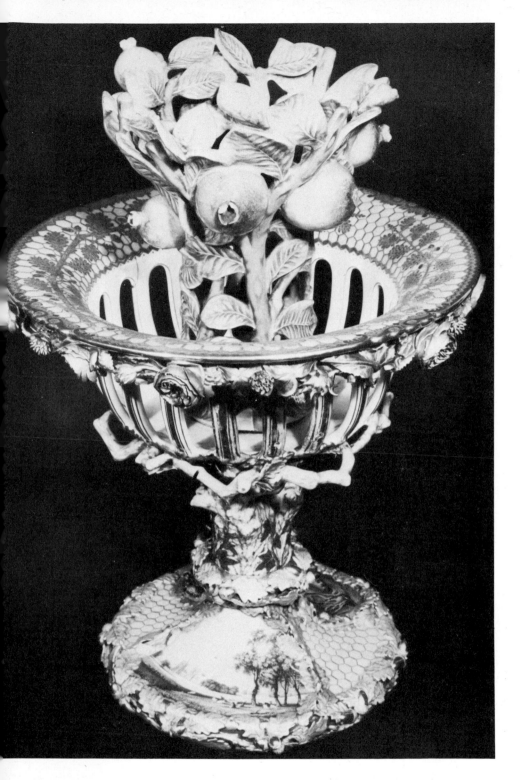

57. Dessert comport, of the style supplied with the Royal Service, with pierced bowl, holding guava fruit, supported on a stem of naturally coloured oak branches, the flower-encrusted rim of the bowl decorated with raised gilt oak-leaves and the base with raised gilt trellis and named views of 'Raby Castle, Durham' and 'Netherby, Cumberland'. 16 inches high. Puce mark (elaborate version with the caption 'Manufacturer to the King, Queen and Royal Family'). See page 42. *By courtesy of the Weston Park Museum, Sheffield.*

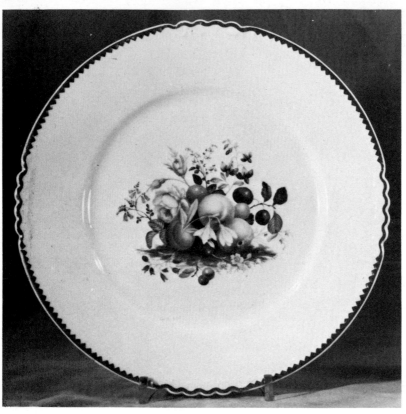

58. Dessert plate with shark teeth and 'S' scroll moulding, painted with fru and flowers. 9 inches in diameter. Puce mark. See page 28.

59. Dessert plate with shark's teeth and 'S' scroll moulding, painted in the centre with fruit and flowers, and decorated with a periwinkle-blue border edged with gilding. 9¼ inches in diameter. Puce mark. See page 28.

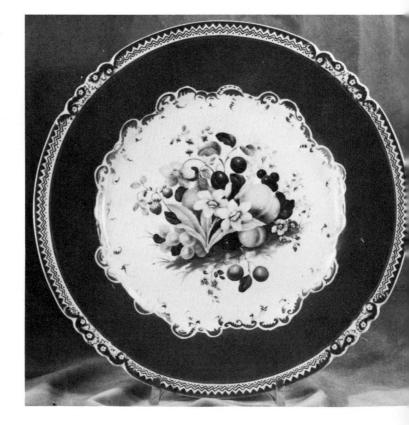

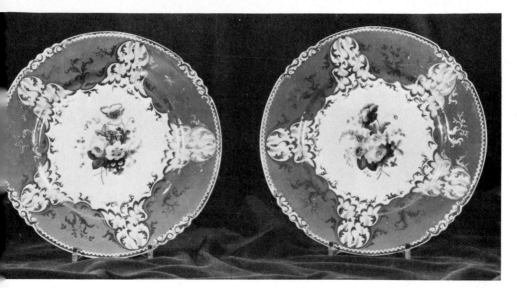

Pair of dessert plates (from a surviving set of twelve) with shark's
[teet]h and 'S' scroll moulding, decorated with a green and yellow border
[and] painted in the centre with floral groups. 9 inches in diameter. Pattern
[num]ber 626. Puce mark. See page 28.

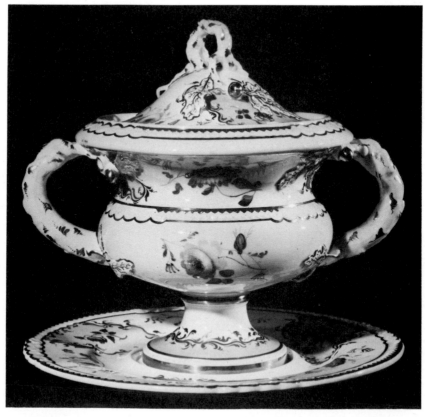

61. One of a pair of tureens, covers and stands, with shark's teeth
and 'S' scroll moulding, with rustic handles and finials, and with
moulded and applied oak-leaves and gilt acorns in high relief; decorated
with a rare apricot ground and with painted flowers. 8 inches high by
$8\frac{1}{2}$ inches wide. Pattern number 564. See page 28.

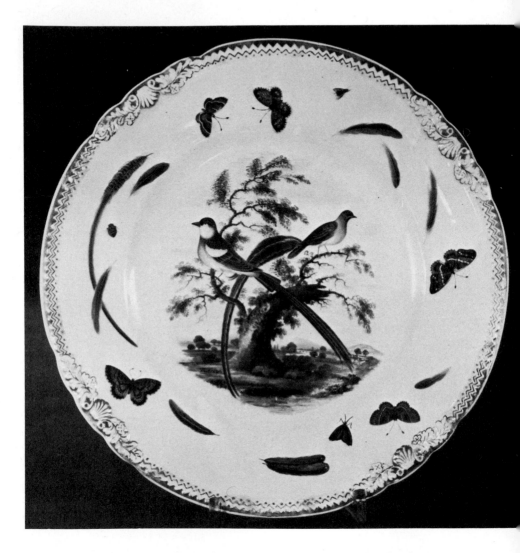

62. Dessert plate with shark's teeth and acanthus-leaf/shell moulding, painted in the centre with named birds and around the border with butterflies and feathers. $9\frac{3}{4}$ inches in diameter. Red mark. See pages 28–9.

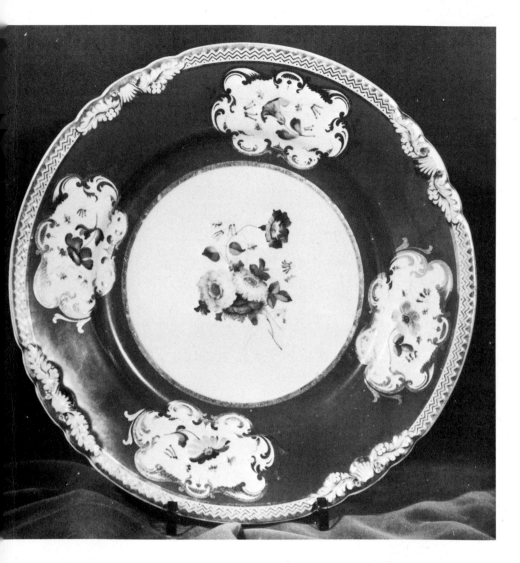

63. Dessert plate with shark's teeth and acanthus-leaf/shell moulding, decorated with a floral group in the centre and with single flowers in reserves edged with gilt on a green border. Pattern number 552. $9\frac{5}{8}$ inches in diameter. Red mark. See page 28.

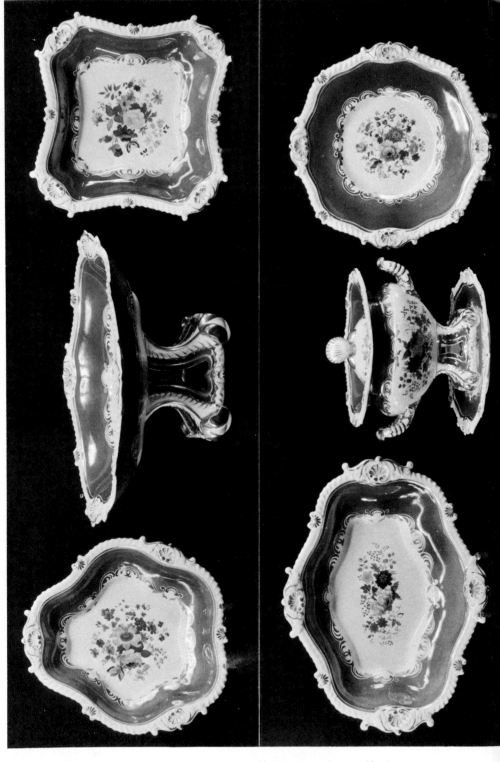

64. Specimen pieces from a complete dessert service with gadrooning and shell moulding, decorated with transfer-printed flower groups overpainted and with a rich claret ground colour. Red mark. See page 29. *By courtesy of Messrs. Moss Harris & Sons.*

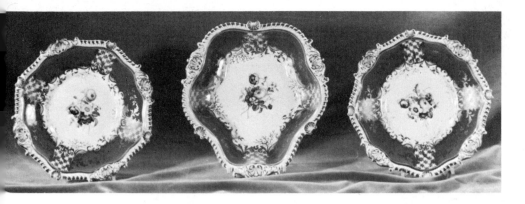

65. Pair of octagonal dessert plates, 9 inches across, and shell-shaped dish, $9\frac{5}{8}$ inches long, moulded with gadrooning and shells, decorated with a periwinkle-blue and yellow border, and with floral groups in the centre. Pattern number 599. Puce mark. See page 29.

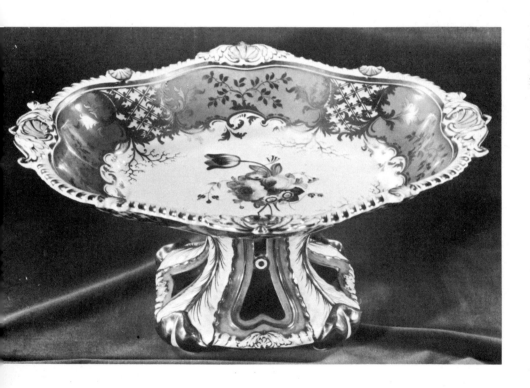

66. Centre-piece matching the items in Plate 65. 7 inches high by $14\frac{1}{4}$ inches long. See page 29.

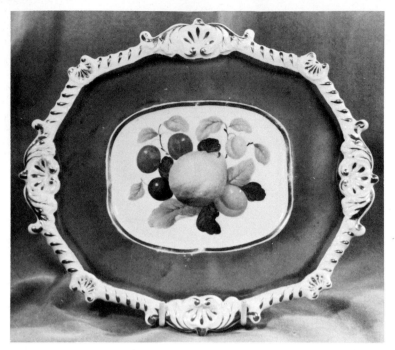

67. Octagonal
stand with
gadrooning and
shell moulding,
decorated with a
periwinkle-blue
border, and finely
painted in the
centre with fruit.
8 inches long by
7 inches wide. See
page 29.

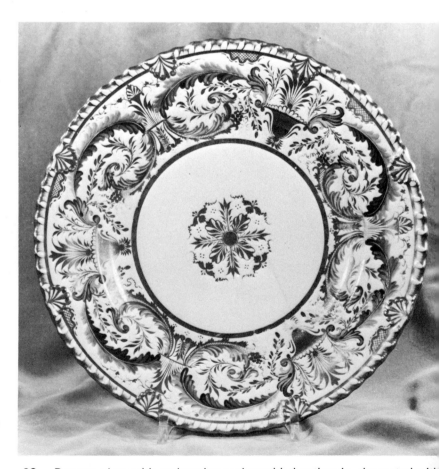

68. Dessert plate with gadrooning and moulded anthemia, decorated with
a leaf motif (in the Derby style) in mauve, orange and green. $9\frac{1}{4}$ inches in
diameter. Pattern number 425. Red mark. See page 29.

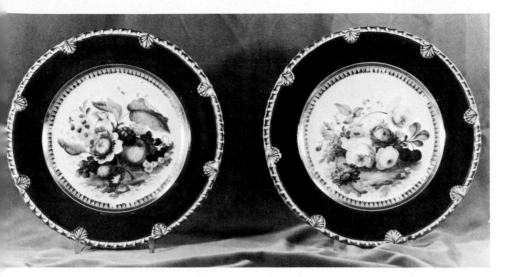

69. Pair of dessert plates with gadrooning and moulded anthemia, decorated with a maroon border, and painted in the centre with loosely arranged flowers. $9\frac{1}{8}$ inches in diameter. Pattern number 417. Red mark. See pages 29 and 88.

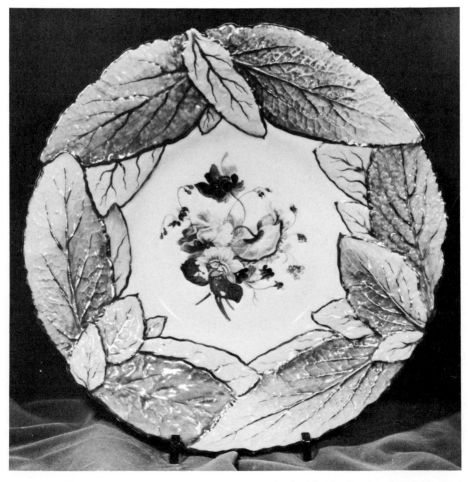

70. Dessert plate with primrose-leaf moulding—the border decorated with two tones of grey, the centre painted with floral bouquets. 10 inches in diameter. Puce mark. See page 30.

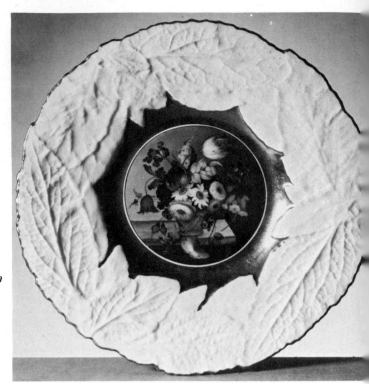

71. Dessert plate with primrose-leaf moulding, painted in the centre with a floral arrangement (attributed to Edwin Steele) in a basket on a table. $9\frac{3}{4}$ inches in diameter. Red mark. See pages 30 and 97.
By courtesy of the Victoria and Albert Museum.

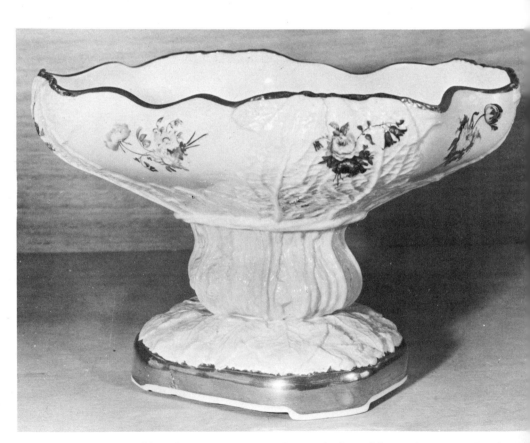

72. Centre-piece with primrose-leaf moulding, painted with floral spra $12\frac{1}{4}$ inches long by $8\frac{3}{8}$ inches high. See page 30.

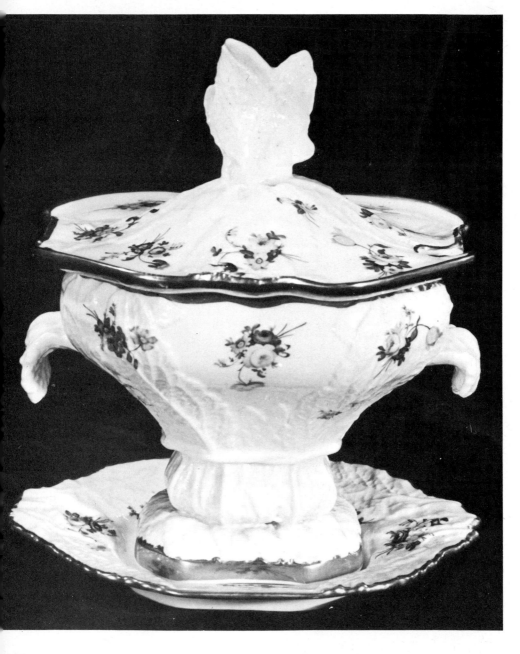

Tureen, cover and stand, with primrose-leaf moulding, painted with
al sprays. $10\frac{3}{4}$ inches high. See page 30.

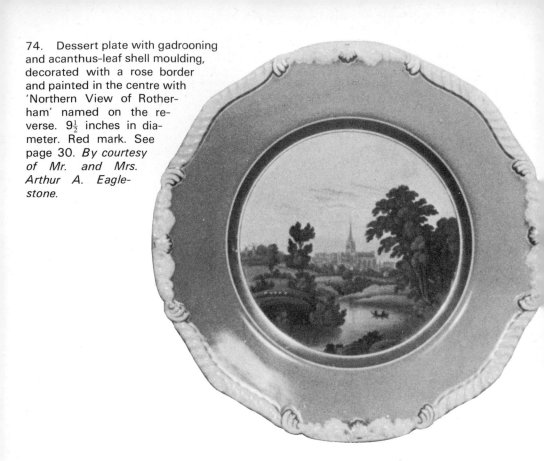

74. Dessert plate with gadrooning and acanthus-leaf shell moulding, decorated with a rose border and painted in the centre with 'Northern View of Rotherham' named on the reverse. 9½ inches in diameter. Red mark. See page 30. *By courtesy of Mr. and Mrs. Arthur A. Eaglestone.*

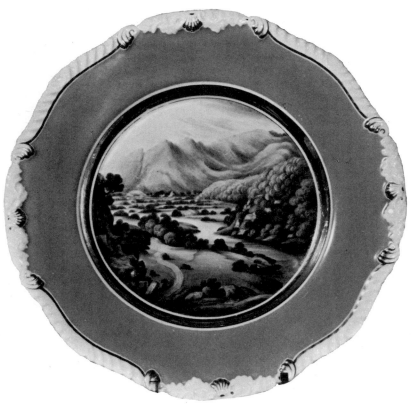

75. Dessert plate similar to that in Plate 74 but with a named view of 'Borrowdale'. 9½ inches in diameter. Red mark. See page 30. *By courtesy of Major G. N. Dawnay.*

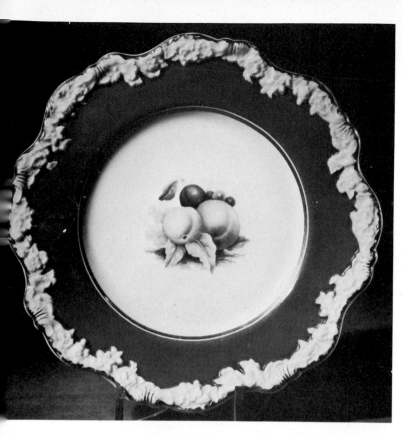

76. Dessert plate, with shaped edge, the maroon border moulded with white floral heads in high relief and the centre finely painted with fruit (possibly by Thomas Steel). $9\frac{5}{8}$ inches in diameter. Red mark. See page 30.

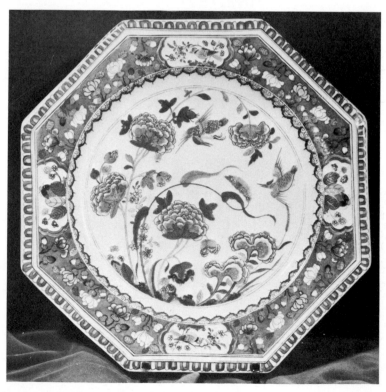

77. Octagonal dinner plate with Chinese decoration in famille verte colours. $9\frac{1}{2}$ inches across. Puce mark. ('Royal Rockm Works, Brameld'.) See page 31.

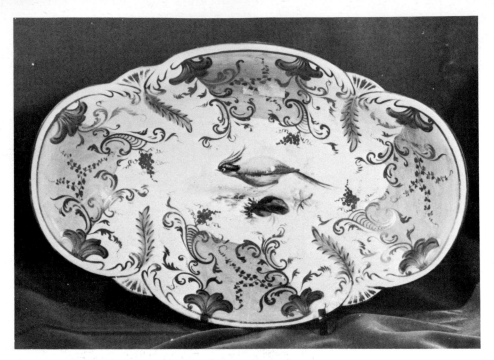

78. Lozenge-shaped dish of raised 'C' scroll design, elaborately gilded and painted in the centre with a tropical bird by John Randall. $11\frac{3}{8}$ inches long. Pattern number 700. See page 31.

79. Dessert plate of raised 'C' scroll design, elaborately gilded and painted in the centre with a tropical bird by John Randall. 9 inches in diameter. Pattern number 700. Puce mark. See page 31.

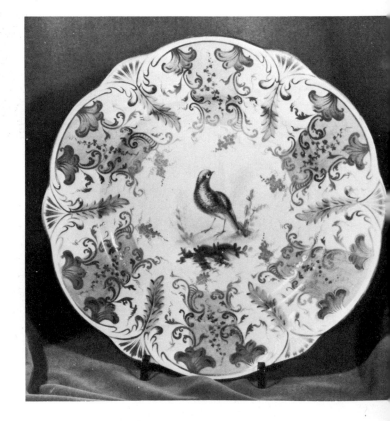

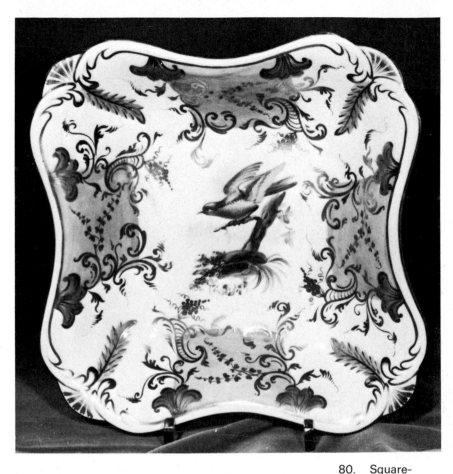

80. Square-shaped dish of raised 'C' scroll design, elaborately gilded and painted in the centre with a tropical bird by John Randall. 8½ inches across. Pattern number 700. See page 31.

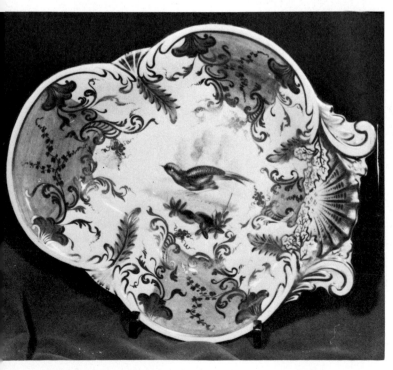

81. Shell-shaped dish of raised 'C' scroll design, elaborately gilded and painted in the centre with a tropical bird by John Randall. 9¼ inches across. Pattern number 700. See page 31.

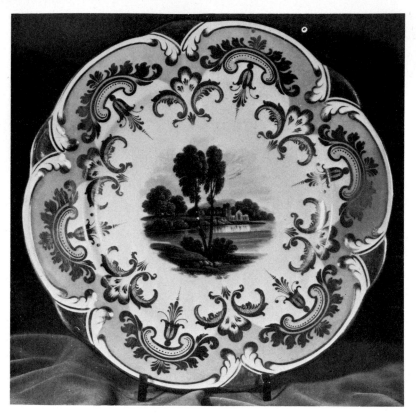

82. Dessert p
of raised 'C' scr
design, elaborat
gilded and pain
in the centre wi
view of ruins be
a lake. 9¼ inche
diameter. Puce
mark. See page

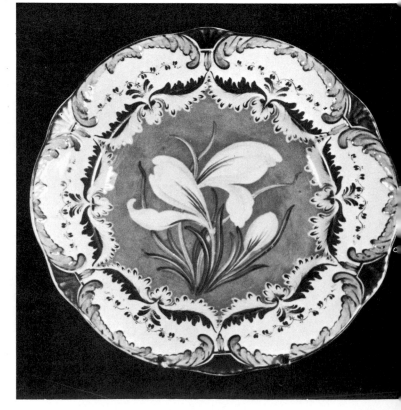

83. Dessert
plate of raised
'C' scroll design,
elaborately gilded
and painted with
a lily in botanical
style. 9⅜ inches
in diameter.
Pattern number
750. Puce mark.
See page 31.

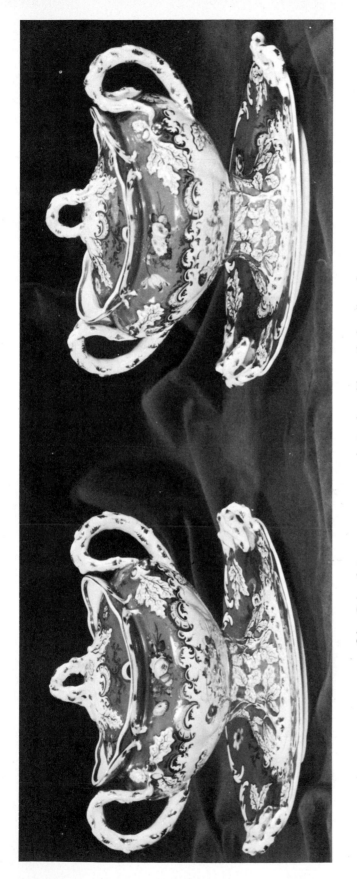

84. Pair of tureens, covers and stands, with rustic handles, from a dessert service of the raised 'C' scroll design, finely painted with floral bouquets on a rich green ground and further ornamented with raised acorns in gold. 7 inches high by 10 inches wide. Pattern number 627.
See page 32.

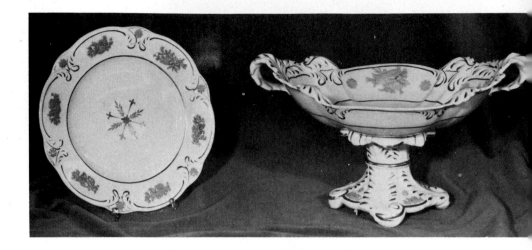

85. Dessert plate, $9\frac{1}{4}$ inches in diameter, and matching centre-piece, of raised 'C' scroll design, encrusted with a shell motif in blue. See page 32.

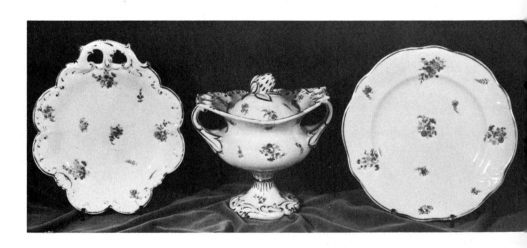

86. Dish with pierced handle, 9 inches long; tureen and cover with strawberry finial, $7\frac{1}{2}$ inches high; and dessert plate of raised 'C' scroll design, $9\frac{1}{8}$ inches in diameter, painted with floral bouquets. Puce mark. *Note:* The dish and tureen and cover were probably bought in from another factory but decorated at Rockingham. See page 32.

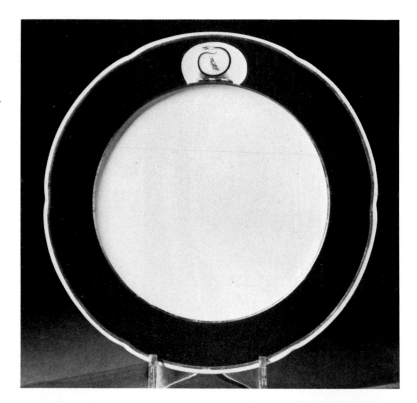

87. Dessert Plate without raised 'C' scrolls, decorated with a dark blue border reserved with a crest in the form of a snake on a bar encircling a bird. $9\frac{3}{16}$ inches in diameter. Puce mark. See page 33.

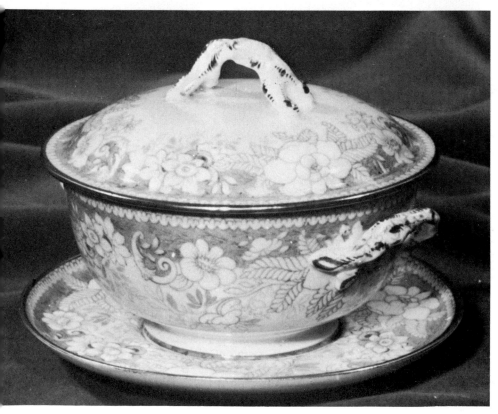

88. Broth bowl, cover and stand, with rustic handles, decorated with a floral pattern in underglaze blue. 6 inches in diameter. Puce mark. See page 37.

93. Pair of circular-shaped tea cups and saucers, 4 and 6 inches in diameter respectively, decorated with a rare apricot ground and painted with floral bouquets. Pattern number 732. Red mark. See page 45.

94. Early circular-shaped tea cup and saucer, 4 and 6 inches in diameter respectively, painted with floral sprays. Pattern number 454. Red mark. See page 45.

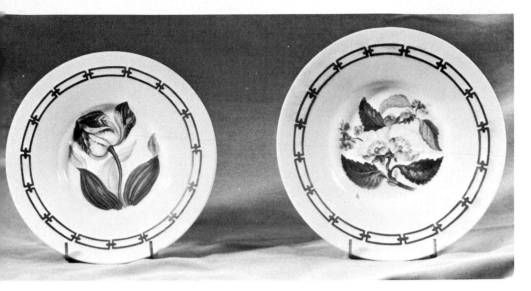

95. Two circular-shaped saucers with chain-link decoration in gilt, one
($6\frac{5}{8}$ inches in diameter) painted with a named tulip, the other ($7\frac{1}{4}$ inches
in diameter) painted with a named apple-blossom. Pattern number 578.
Puce mark. See page 45.

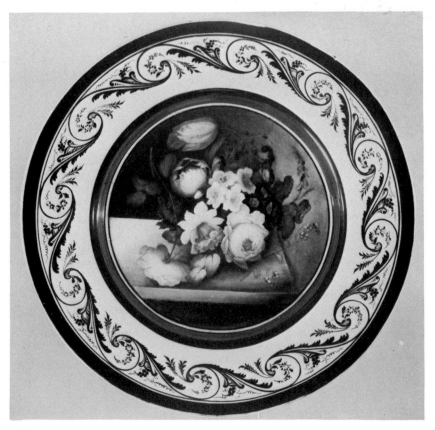

96. Circular shaped saucer, finely painted in the centre with a flower
arrangement set on a table. $7\frac{1}{4}$ inches in diameter. Red mark. See page 45.
By courtesy of the British Museum.

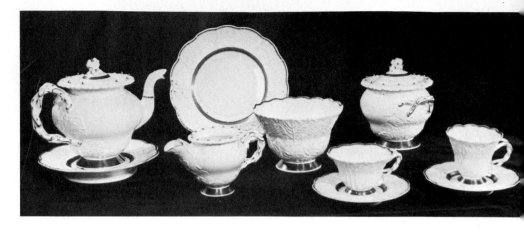

97. Specimen pieces from a primrose-leaf patterned tea and coffee service in white and gilt. Pattern number 655. Red mark. For measurements see page 46.

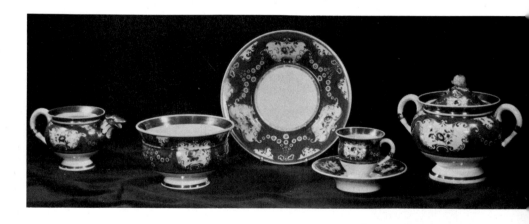

98. Cream jug, slop basin, bread and butter plate, coffee cup and saucer, and sucrier and cover, decorated with painted floral groups reserved on a green ground, from an Empire-style tea and coffee service. Pattern number 643. Red mark. For measurements see page 46.

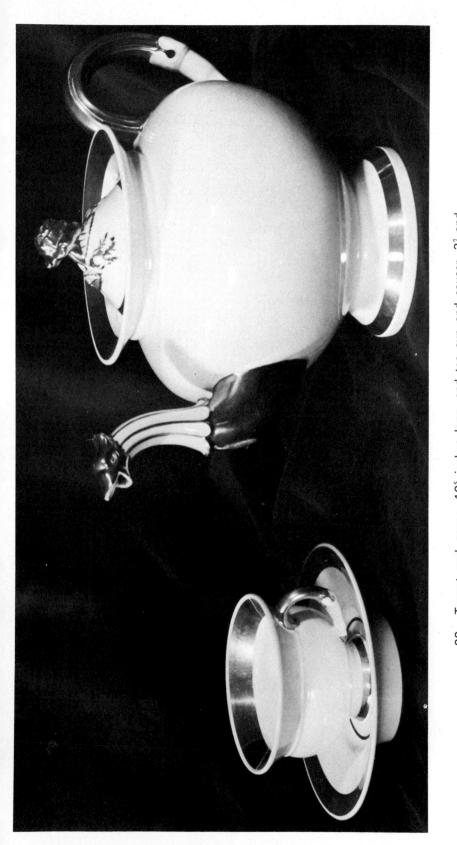

99. Teapot and cover, $10\frac{5}{8}$ inches long, and tea cup and saucer, $3\frac{7}{8}$ and 6 inches in diameter respectively, in white and gilt from an Empire-style tea and coffee service. Pattern number 680. Red mark. See page 45.

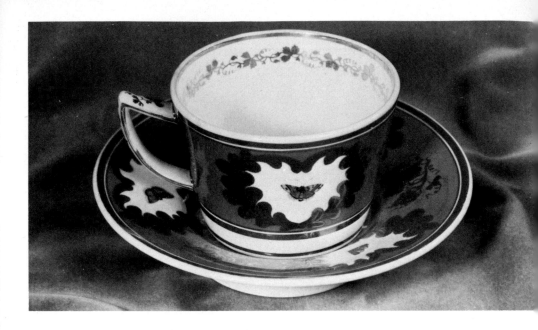

100. Bucket-shaped tea cup and saucer, decorated with butterflies reserved on a rare puce ground. $3\frac{5}{8}$ and 6 inches in diameter respectively. Pattern number 676. Red mark. See page 47.

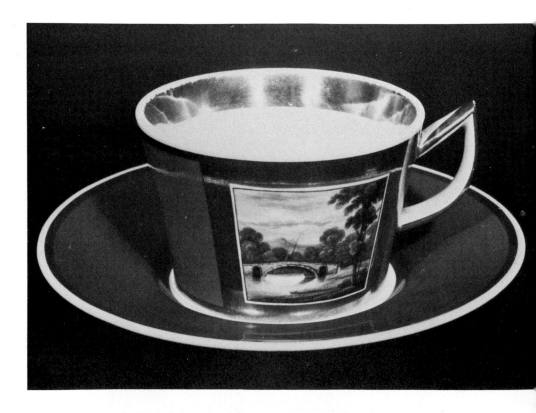

101. Bucket-shaped tea cup and saucer, decorated with a green ground and painted with a view. $3\frac{1}{2}$ and $6\frac{1}{8}$ inches in diameter respectively. Pattern number 714. Puce mark. See page 47. *By courtesy of the Weston Park Museum, Sheffield.*

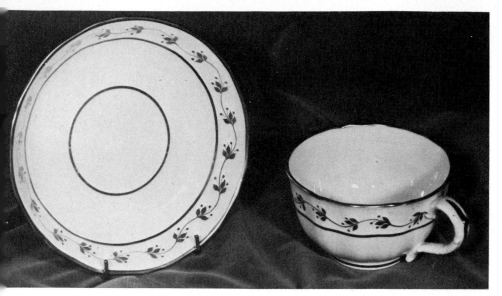

102. Breakfast cup and saucer of fluted design, decorated with a leaf motif in gilt. $4\frac{1}{2}$ and $6\frac{3}{4}$ inches in diameter. Puce mark. See page 47.

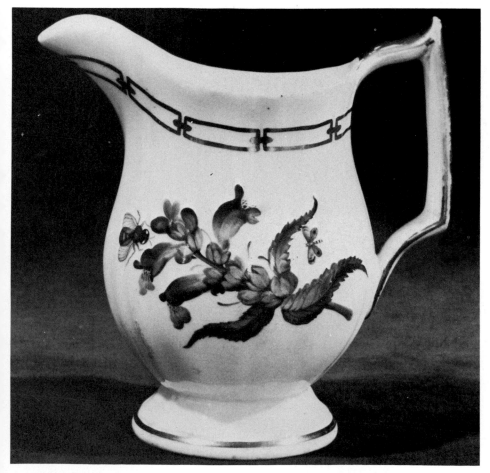

103. Cream jug of fluted design, decorated with flowers and insects, and with a chain-link pattern in gilt. $4\frac{1}{4}$ inches high. Pattern number 695. Red mark. See page 47.

104. Specimen pieces from a neo-rococo-style tea and coffee service with three-spur handles. Covers with coronet finials. Decorated with a gilt seaweed pattern and a grey ground. Pattern number 1139. Puce mark. *Note the unusual coffee pot.* See pages 48–9.

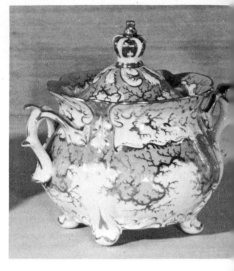

104a. Sucrier and cover, $6\frac{1}{2}$ inches high.

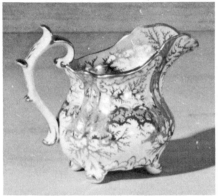

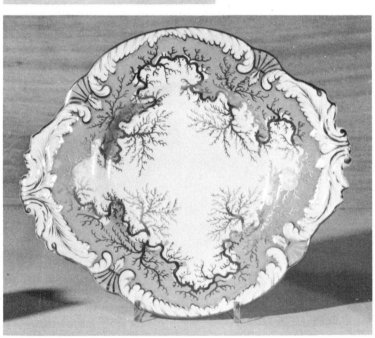

104b. Two different cream jugs, 4 and $4\frac{3}{?}$ inches high respectively, and bread and butter plate, $10\frac{1}{2}$ inches long.

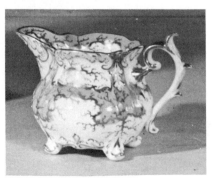

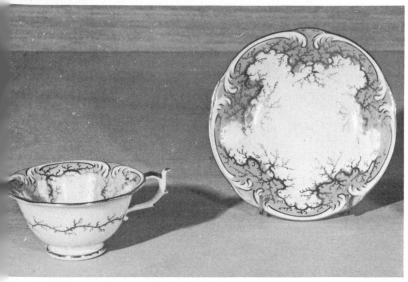

104c. Tea cup, saucer, coffee cup and slop basin, $4\frac{1}{8}$, $5\frac{7}{8}$, $3\frac{7}{16}$ and $7\frac{1}{4}$ inches in diameter respectively.

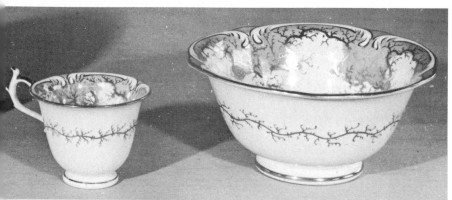

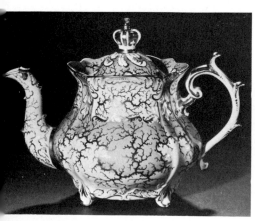

04d. Teapot and cover, $7\frac{1}{2}$ inches igh.

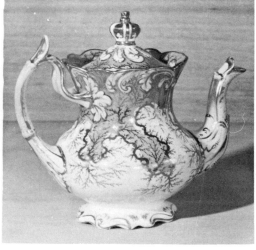

104e. Coffee pot and cover, $8\frac{1}{2}$ inches high. *Note:* This has a single-spur handle.

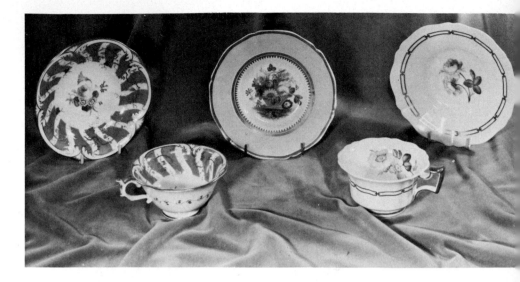

105a. Three-spur tea cup and saucer, with raised 'C' scrolls decorated with painted floral sprays in the centre and with a striped underglaze grey ground around the body, $4\frac{1}{8}$ and $5\frac{3}{4}$ inches in diameter respectively. Pattern number $\frac{2}{21}$. Puce mark. See page 49.

105b. Scallop-edged saucer, finely painted with a floral arrangement in the centre and decorated with a rare turquoise border. 6 inches in diameter. Pattern number 574. Red mark. See page 44.

105c. Scallop-edged tea cup and saucer, decorated with a chain-link pattern in gilt and painted with yellow and pink flowers, $3\frac{7}{8}$ and 6 inches in diameter respectively. Pattern number 578. Red mark. See page 44.

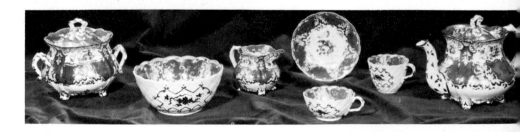

106. Specimen pieces from a neo-rococo style of tea and coffee service, with twig finials and basket-weave cups and saucers, finely painted with floral groups and decorated with a green and yellow ground. Pattern number 806. Puce mark. Sucrier and cover, $5\frac{1}{2}$ inches high; slop basin, $6\frac{1}{2}$ inches in diameter; cream jug, $3\frac{1}{2}$ inches high; saucer, $5\frac{1}{2}$ inches in diameter; tea cup, $3\frac{5}{8}$ inches in diameter; coffee cup, $3\frac{1}{16}$ inches in diameter; and teapot and cover, 6 inches high. See page 49.

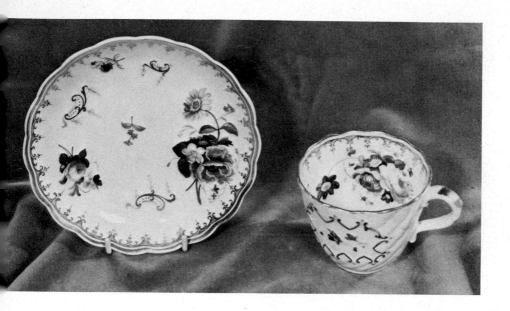

107. Basket-weave coffee cup and saucer, finely painted with floral groups, 3⅛ and 5½ inches in diameter respectively. Puce mark. See page 49.

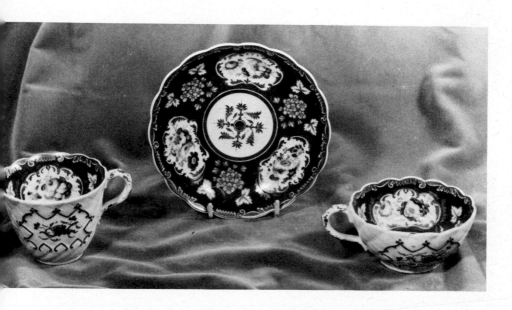

108. Basket-weave coffee cup, saucer and tea cup, finely painted with floral groups reserved on a crimson ground, 3, 5½ and 3½ inches in diameter respectively. Pattern number 797. Puce mark. See page 49.

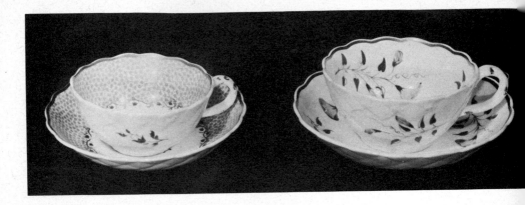

109a. Basket-weave tea cup and saucer painted in the centre with floral bouquets and decorated around the border with Llandig's blackberry pattern in green, $3\frac{3}{4}$ and $5\frac{1}{2}$ inches in diameter respectively. Pattern number 880. Puce mark. See page 49.

109b. Basket-weave breakfast cup and saucer painted with morning glories, 4 and 6 inches in diameter respectively. Pattern number 859. Puce mark. See page 49.

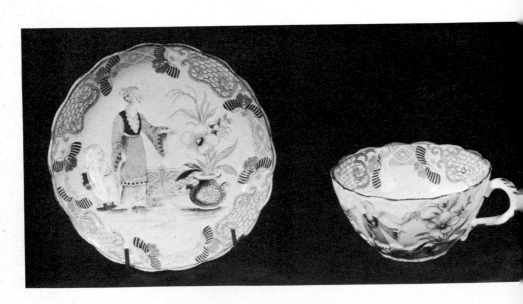

110. Basket-weave tea cup and saucer, decorated with a chinoiserie transfer pattern in underglaze green, $3\frac{5}{8}$ and $5\frac{3}{8}$ inches in diameter respectively. Pattern number 1151. Puce mark. See page 49.

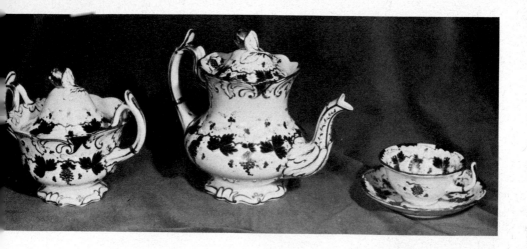

111. Sucrier and cover, 6¼ inches high; teapot and cover, 7¾ inches high; and tea cup and saucer, 3⅞ and 5⅞ inches in diameter respectively, from a neo-rococo tea service with single-spur handles, decorated with leaves in underglaze dark blue and with a gilt grape motif. Pattern number $\frac{2}{66}$. Puce mark. See page 50.

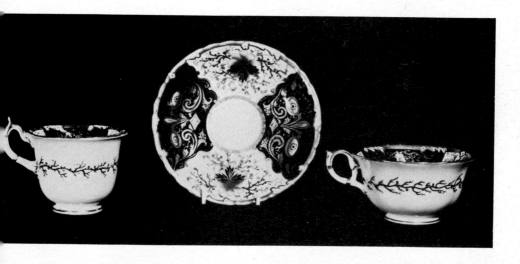

112. Single-spur coffee cup, saucer and tea cup, 3¼, 5¹³⁄₁₆ and 3⅞ inches in diameter respectively, decorated with a Japan-pattern. Pattern number 1460. Puce mark. *Note:* The handle of the tea cup is alien to Rockingham and suggestive of an import from another factory. See page 50.

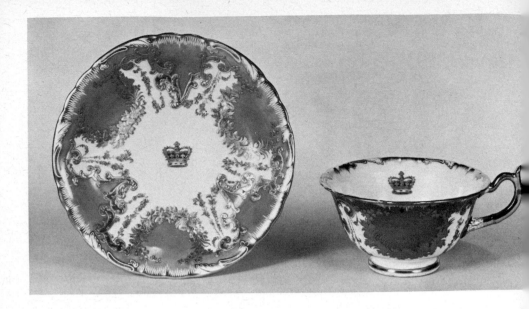

113. Single-spur tea cup and saucer, decorated with a green ground and raised gilding and painted with a coronet, $4\frac{1}{8}$ and $5\frac{7}{8}$ inches in diameter respectively. Puce mark. See page 50. *By courtesy of the Victoria and Albert Museum.*

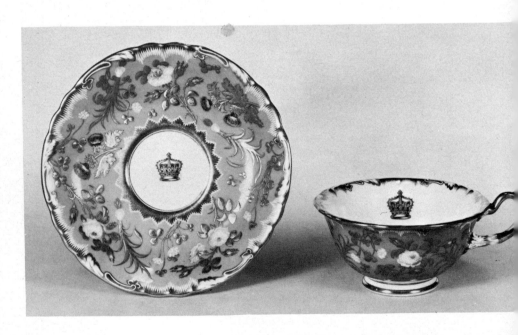

114. Single-spur tea cup and saucer, decorated with raised gildin a coronet, and with painted roses, thistles, leeks and shamrock on ground, $4\frac{1}{8}$ and $5\frac{7}{8}$ inches in diameter respectively. Puce mark. Se 50. *By courtesy of the Victoria and Albert Museum.*

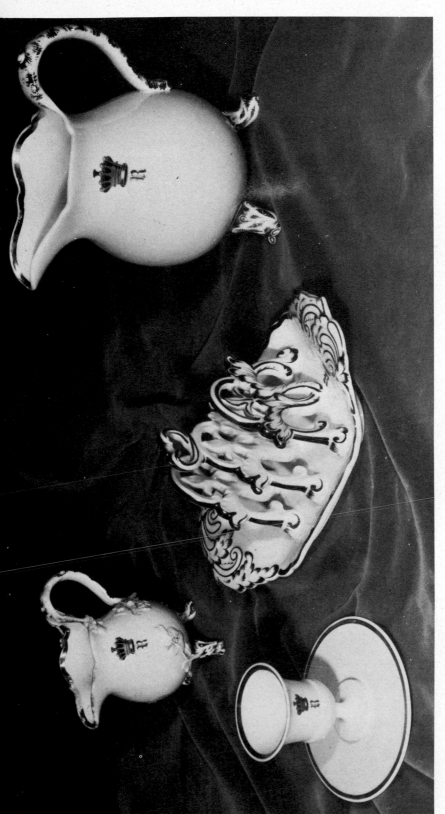

115. Egg cup and attached stand, $2\frac{7}{8}$ inches high; cream jug, $4\frac{3}{8}$ inches high; toast rack, 8 inches long; and milk jug, $6\frac{1}{2}$ inches high, white and gilt, with earl's coronet surmounting the letter 'R'. Puce mark (except for cream jug). See pages 47 and 51.

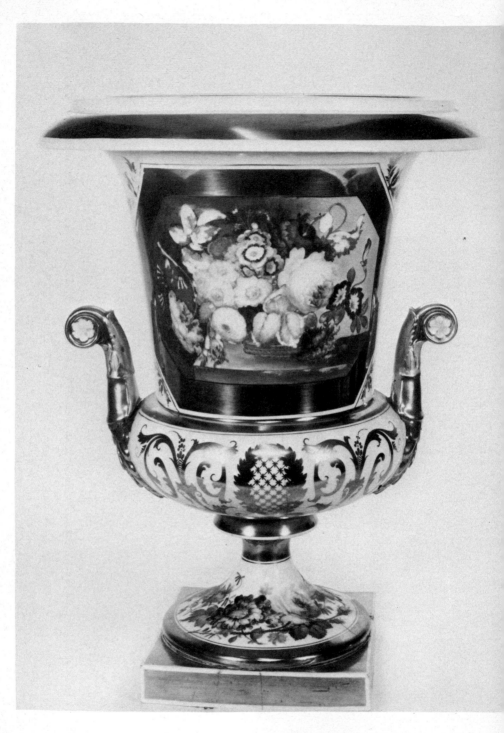

116. Empire-style vase of urn shape, the front panel finely painted with
a basket of flowers on a marbled table, richly gilded, and decorated on
the base with flowers. 14¼ inches high. Red mark. See page 53. *By
courtesy of Messrs. Sotheby & Co.*

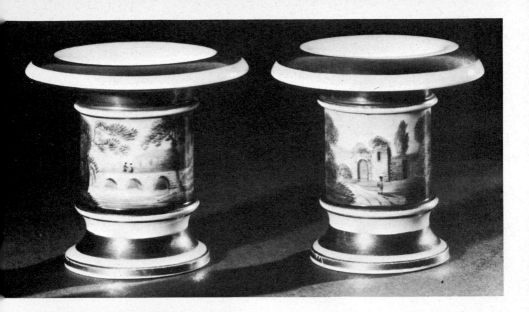

117. Pair of miniature overhanging-lip vases, finely painted with a continuous landscape and richly gilded. $1\frac{3}{4}$ inches high. Cl. 17. Red mark. See pages 54 and 70.

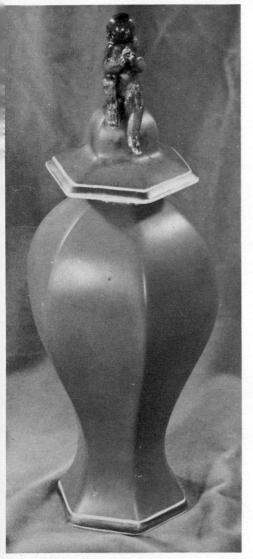

118. Hexagonal vase with cover surmounted by a monkey in grey, decorated with a periwinkle-blue ground. $12\frac{1}{4}$ inches high. Raised concentric rings. Red mark. See page 54.

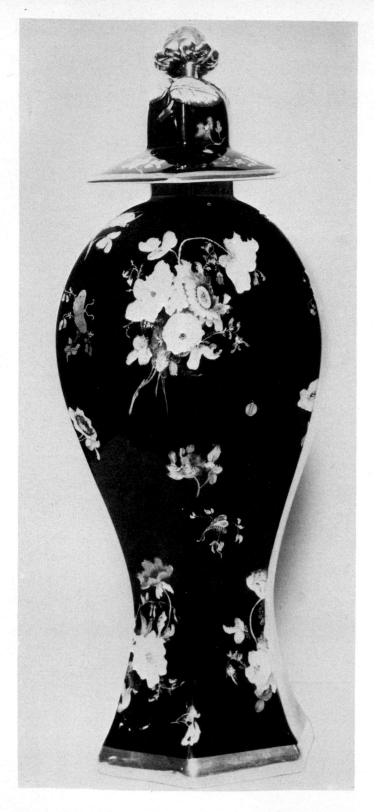

119. Hexagonal vase, with cover surmounted by a rose, decorated with well-executed floral groups on a rich royal blue ground. 18 inches high. Cl. 12. Raised concentric rings. See pages 54 and 89.

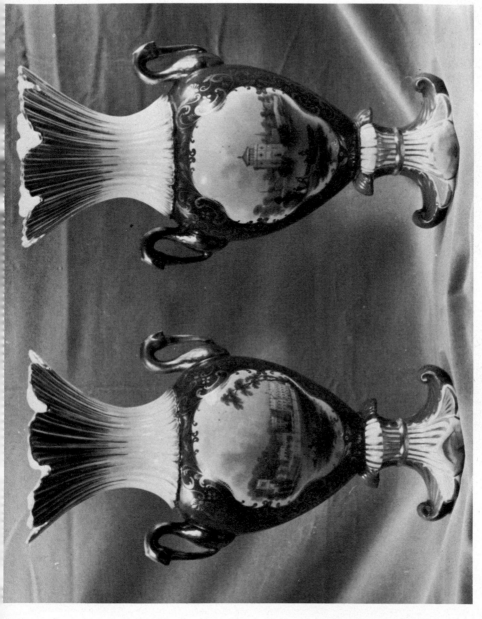

120. Pair of stork-handled vases, the front panel of each, reserved on a periwinkle-blue ground, painted with views of 'Radford Folly' and 'Chatsworth' respectively. 13½ inches high. See page 55.

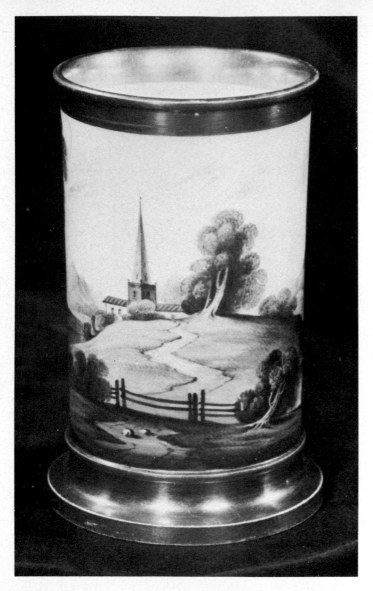

121. Spill vase painted with a continuous landscape and thickly gilded. $4\frac{5}{8}$ inches high. C. 8. Red mark. See page 55.

122. Unusual variant of the spill vase, painted with a continuous landscape around the body. $3\frac{1}{4}$ inches high. Cl. 14. Red mark. See page 55. *By courtesy of T. A. Willis, Esq.*

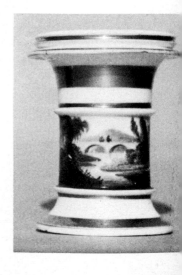

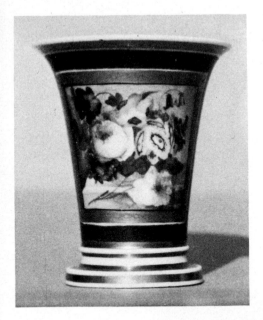

123. Trumpet-shaped vase, with unusual sharply tapering body, finely painted with flowers in a basket on a ledge, surrounded with a gilt chased border and reserved on a claret ground. $3\frac{7}{8}$ inches high. Cl. 6. Red mark. See page 54. *By courtesy of T. A. Willis, Esq.*

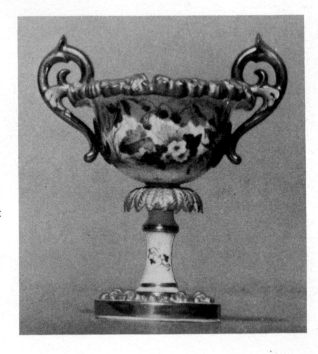

124. Pot-pourri vase of goblet-shape (without cover), with twin rising handles and with an overhanging rim deeply embossed with solid matt gilded flowers, mounted on a stem and round flat base, and painted around the body with a continuous band of wild flowers. 4 inches high. Cl. 9. Red mark. See page 56. *By courtesy of T. A. Willis, Esq.*

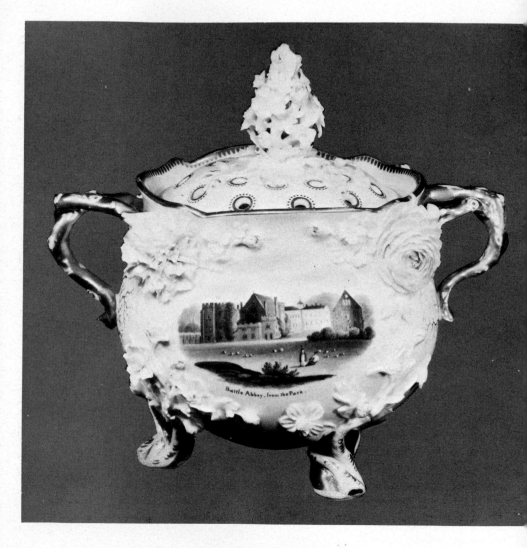

125a. Pot-pourri jar and cover, with entwined rustic handle, encrusted
with flowers in white and painted with a named view of 'Battle Abbey
from the Park'. 7½ inches high. Puce mark. See page 57. *By courtesy of
Messrs. Sotheby & Co.*

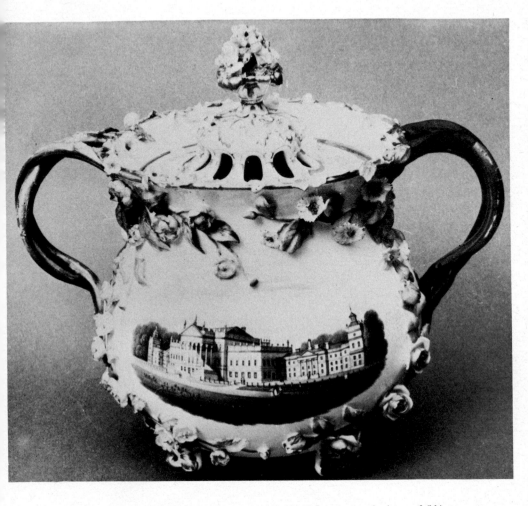

125b. Pot-pourri jar and cover, painted with a named view of 'Went-
worth House, Yorkshire, The Seat of Earl Fitzwilliam'. 9½ inches high.
Puce mark. See page 56. *By courtesy of the Weston Park Museum,
Sheffield.*

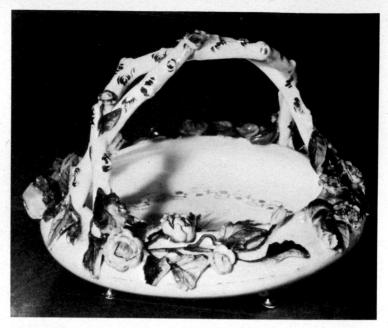

126. Circular basket with entwined rustic handle, encrusted with flowers in colour and decorated with a view. 6½ inches in diameter. Cl. 3. Puce mark. See page 59.

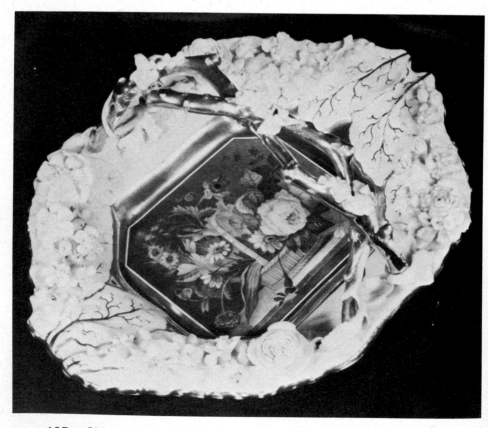

127. Oblong octagonal basket with gilt entwined handle, encrusted with white flowers, and finely painted in the centre with an arrangement of flowers in a basket on a table. 9 by 6½ inches. Puce mark. See page 58.

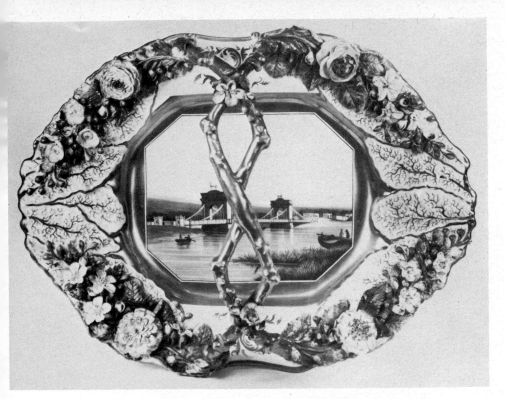

128. Oblong octagonal basket with gilt entwined handle, encrusted with flowers in colour, and finely painted in the centre with a named view of the 'Norfolk Suspension Bridge, Shoreham'. 13½ by 10 inches. Puce mark. See page 59. *By courtesy of Messrs. Sotheby & Co.*

129. Round octagonal basket with branch handle, encrusted with white flowers, and decorated in the centre with a named view of 'Sprotbro' Hall, Yorks'. 5¾ inches across. Puce mark. See pages 59–60.

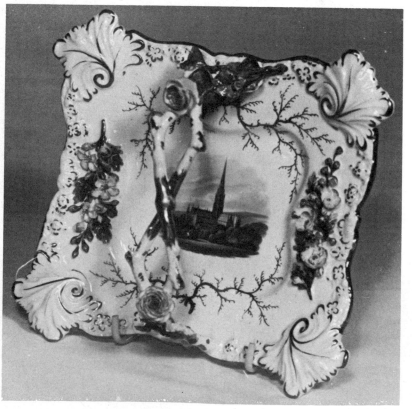

130. Oblong basket with shap[ed] sides with entwi[ned] rustic handle, decorated with a white and grey ground, a gilt seaweed pattern and a named vie[w] of 'Carisbrook [si[c]] Castle'. $5\frac{3}{4}$ by $4\frac{1}{2}$ inches. Puce ma[rk]. See page 60.

131. Square basket with projecting corner[s] encrusted with floral sprays in colour, and painte[d] in the centre with a named view of 'Salisbury Cathedral'. $8\frac{1}{8}$ by $7\frac{5}{8}$ inches. Puce mark. See page 6[0].
By courtesy of T. A. Willis, Esq.

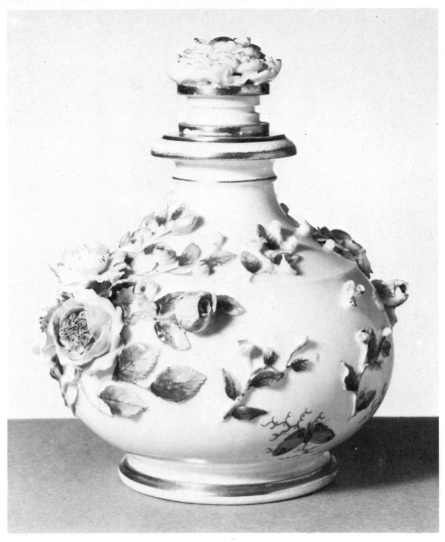

132. Bulbous scent bottle and stopper, encrusted with flowers in colour. 6 inches high. Puce mark. See page 61. *By courtesy of the Victoria and Albert Museum.*

133. Rare pair of diamond-shaped scent bottles and stoppers, encrusted all over with floral heads in the 'Mayflower' pattern. 4 inches across. Puce mark. See page 62. *By courtesy of E. Thompson, Esq.*

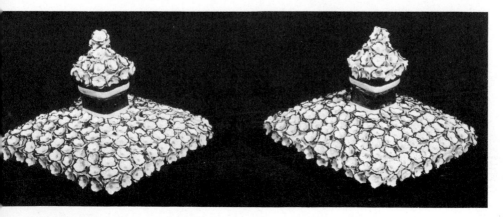

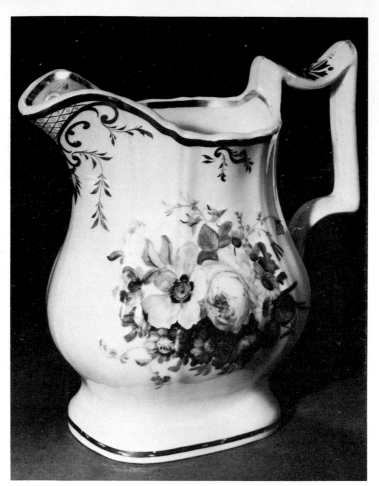

134. Jug, with bulbous body and angular handle, finely painted on both sides with loosely arranged flowers. 7 inches high. Red mark. See pages 72 and 89.

135. Large tray with handles, pierced around the rim and painted with a recumbent Cupid against a ruby-red cloth background. 19 by 13¼ inches. Red mark. See page 66. *By courtesy of the Clifton Park Museum, Rotherham.*

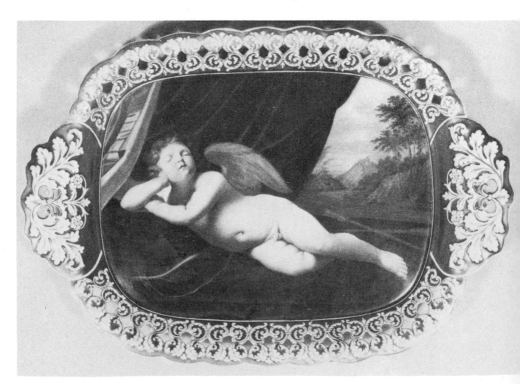

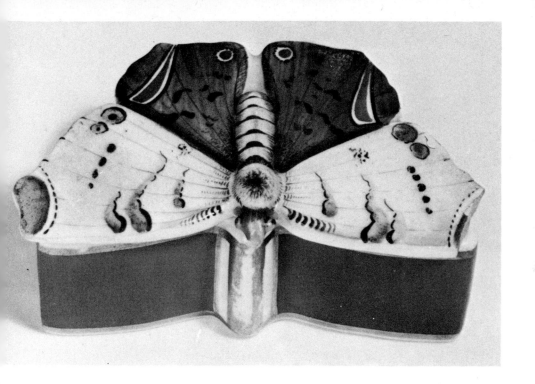

6. Box, in green, with cover shaped as a butterfly and painted with
low and orange upper wings and green and gold lower wings.
inches long. C. 2. Puce mark. See pages 67–8. *By courtesy of*
essrs. Sotheby & Co.

7. Shaped box and cover, with compartments, painted with
wers. 8¼ inches long. See page 68. *By courtesy of Mr. and Mrs.*
D. Griffin.

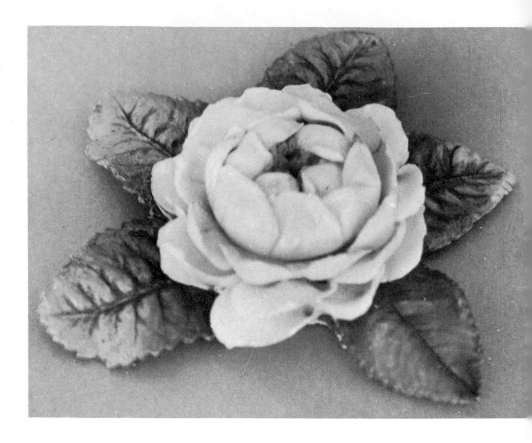

138. Model flower in the form of a white rose. 6 inches wide. C. Puce mark. See page 68. *By courtesy of T. A. Willis, Esq.*

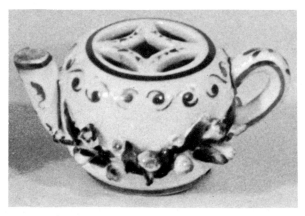

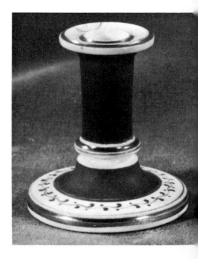

139a. Violeteer, encrusted with coloured flowers. $1\frac{5}{8}$ inches high. Cl. 2. Puce mark. See page 70. *By courtesy of T. A. Willis, Esq.*

139b. Miniature tapestick decorated with a peri-winkle-blue ground. 2 inches high. Cl. 2. Puce mark. See page 63.

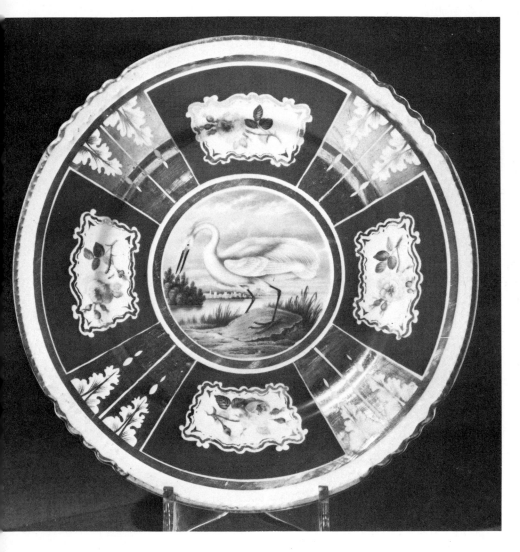

). Stand with shark's teeth and 'S' scroll moulding, decorated
und the border and cavetto with periwinkle-blue panels (reserved with
ingle rose) alternating with solid gilt panels (relieved by a motif of
hemia), and superbly painted in the centre with a naturalistic bird in
ndscape setting. $9\frac{1}{8}$ inches in diameter. See page 70.

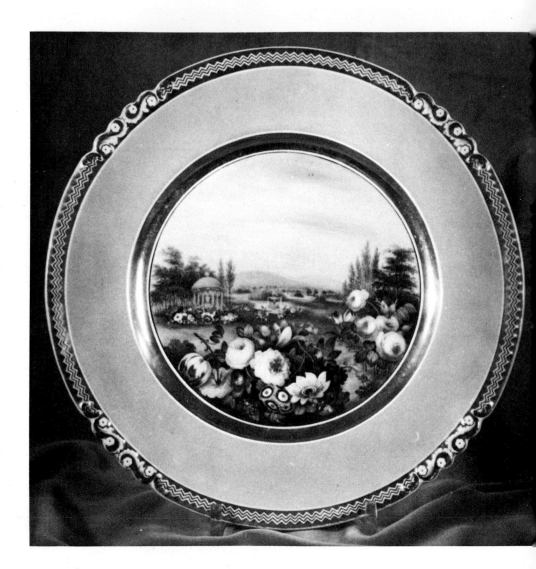

141. Cabinet plate with shark's teeth and 'S' scroll moulding, decorated
with a rare pink ground and superbly painted in the centre with a land-
scape. 9½ inches in diameter. Red mark. See page 70.

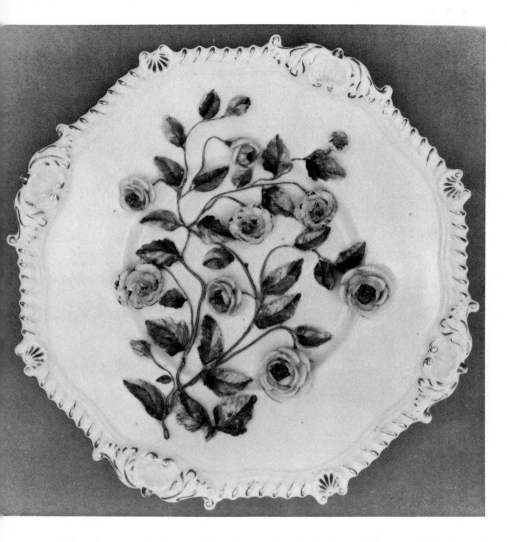

142. Octagonal plate with gadrooned and shell moulding, encrusted with flowers in colour. $9\frac{7}{8}$ inches across. Puce mark. See page 70. *By courtesy of Messrs. Sotheby & Co.*

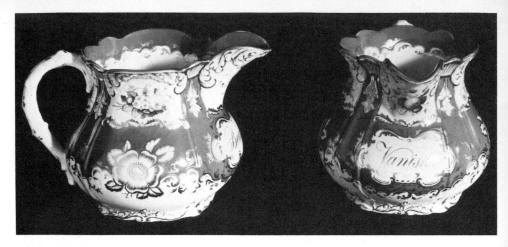

143. Pair of jugs decorated with a green ground, painted with floral bouquets, and inscribed 'Beagle' and 'Vanish' on the front of each respectively. 6 inches high. Puce mark. See page 72. *By courtesy of Major G. N. Dawnay.*

144. Commemoration mug, with hoof-and-tail handle, painted with floral sprays. $3\frac{3}{4}$ inches high. Cl. 2. Puce mark. See page 72.

145. Mug, $2\frac{1}{4}$ inches high, and beaker, with hoof-and-tail handle, painted with flowers and inscribed 'Joshua Bower' and 'Alice Bower' respectively. See page 73. *By courtesy of T. A. Willis, Esq.*

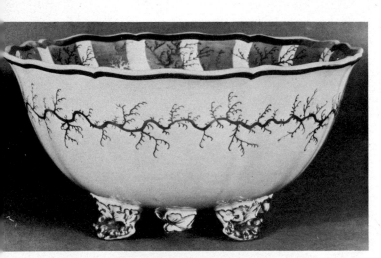

146. Basin, with shaped rim and four scroll feet, painted with floral bouquets. $9\frac{3}{4}$ inches in diameter. Puce mark. (a) Outside. (b) Inside. See page 73. *By courtesy of Messrs. Sotheby & Co.*

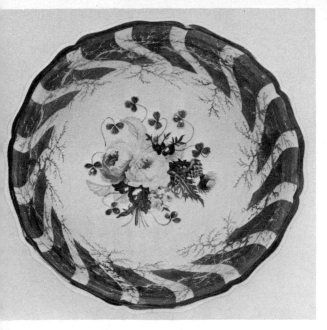

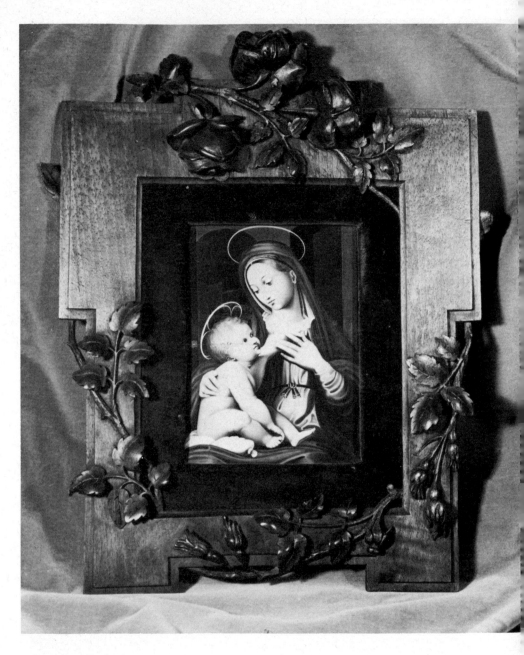

149. Plaque of the Madonna and Child, with predominant colours of blue and pink, inscribed on the reverse 'Madonna' and 'Speight pinx'. 7 by 5 inches. Red mark. See pages 74 and 94–5.

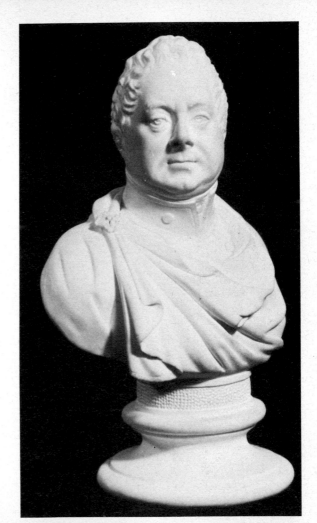

0. Bust of William IV in biscuit.
ches high. See page 78.

1. Pair of busts in biscuit
Sir Walter Scott and
lliam Wordsworth, $7\frac{3}{4}$ and
inches high respectively.
pressed mark. See page
. *By courtesy of Messrs.*
M. & P. Manheim.

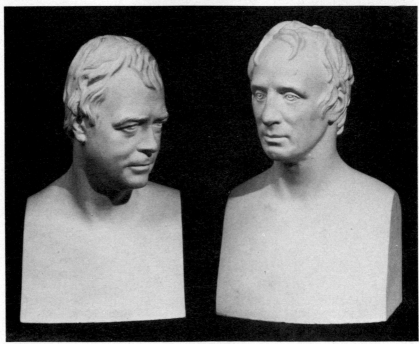

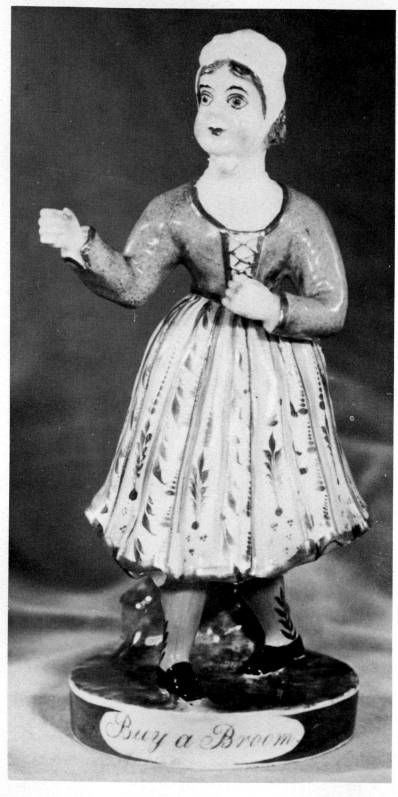

152. Madame Vestris singing 'Buy a Broom'. 6 inches high. Incised
No. 6. Red mark. See page 78.

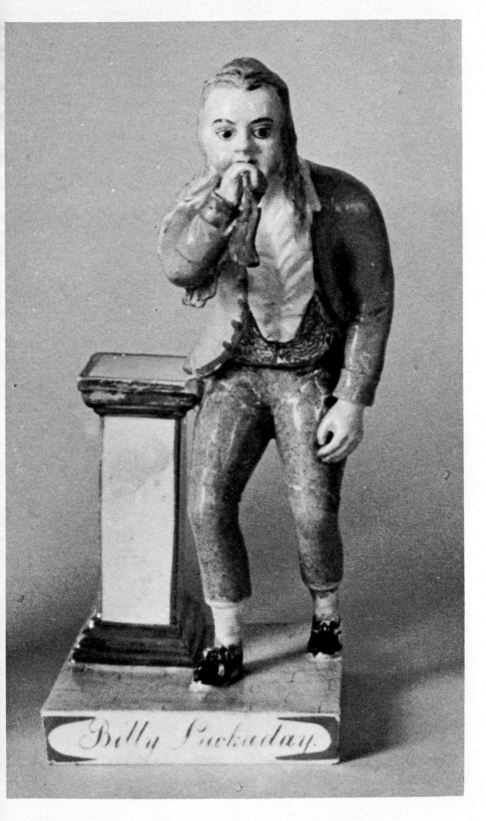

153. John Liston as 'Billy Lackaday', inscribed around the base. 6 inches high. Incised No. 8. Red mark. See page 78. *By courtesy of the Clifton Park Museum, Rotherham.*

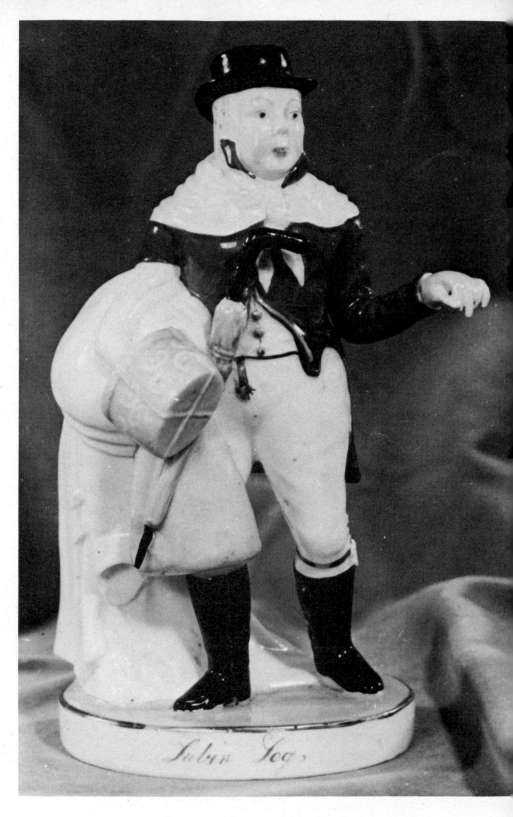

154. John Liston as 'Lubin Log', inscribed around the base. 6¾ inches high. Incised No. 11. Impressed mark. See page 78.

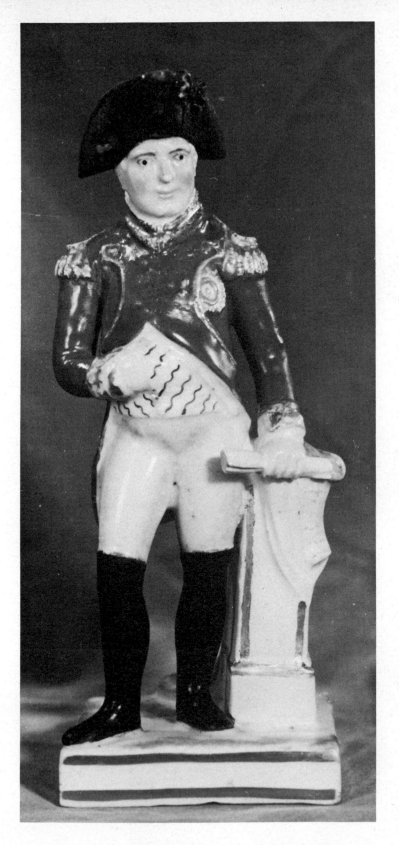

155. Napoleon. $7\frac{7}{8}$ inches high. Incised No. 42.
Cl. 2. See page 79.

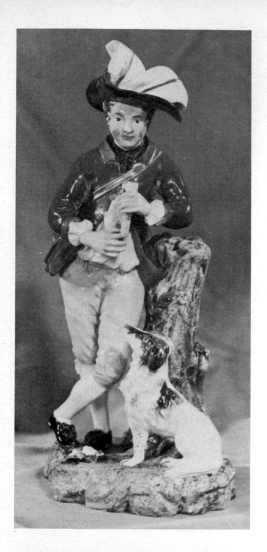

156. Shepherd and dog, decorated in strong colours, the shepherd with a black hat, a green jacket and blue breeches. 8¼ inches high. Incised No. 4. See page 79.

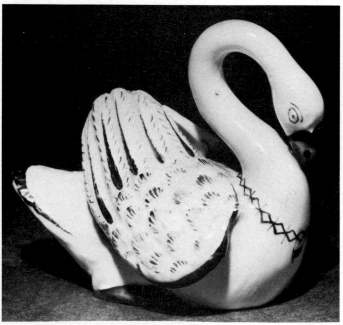

157. Swan, with gilt bell around its neck. 2⅞ inches long. Incised No. 99. Cl. 2. See page 79.

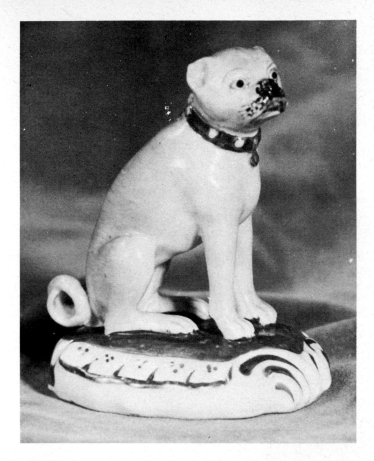

). Pug dog, 2⅝ inches
h. Incised No. 76.
2. Impressed mark.
e page 79.

3. Elephant. 1⅝ inches high. Incised No.
Cl. 2. See page 79.

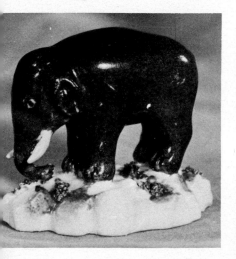

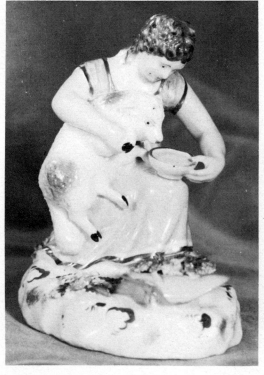

). Girl clasping a sheep in one hand, a
vl in the other. 3¾ inches high. Incised
44. Cl. 2. See page 79.

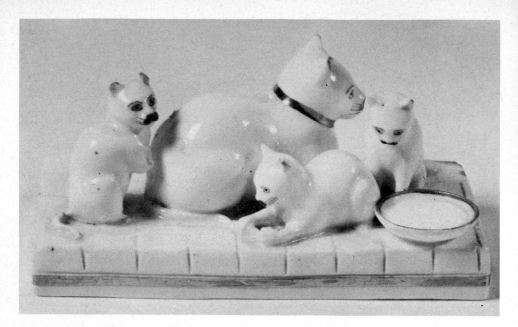

161. A group comprising a cat and three kittens. 4¼ inches long. Incised No. 107. Cl. 1. *Note:* This group was sometimes produced without the saucer of milk. See page 79. *By courtesy of Messrs. Sotheby & Co.*

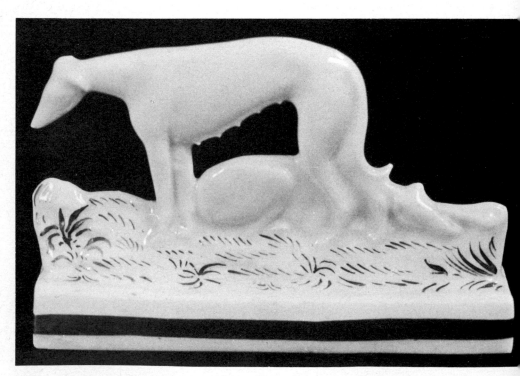

162. Silhouette group of two greyhounds, white and gilt. 2¹³⁄₁₆ inches long. C. 1. Red mark. See page 80.

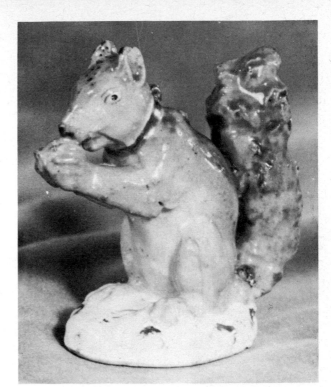

3. Squirrel, decorated in brown.
inches high. Incised No. 111.
2. See page 79.

164. Continental peasant in biscuit, inscribed around the base 'Homme du peuple à Valence'. 7½ inches high. Incised No. 113. Impressed mark. See page 81. *By courtesy of the Clifton Park Museum, Rotherham.*

165. Boy with dog and girl with sheep in biscuit. 5¾ inches high. Incised No. 35. Impressed mark. See page 79.

166. Toper, inscribed around the base 'Stea-dy La-ds'. 5½ inches high. Incised No. 1. Rare red circular mark. See page 81.

167. Cobbler whistling to his starling, after Cyffle's model produced in Lorraine. 5½ inches high. Incised No. 39. See page 79.

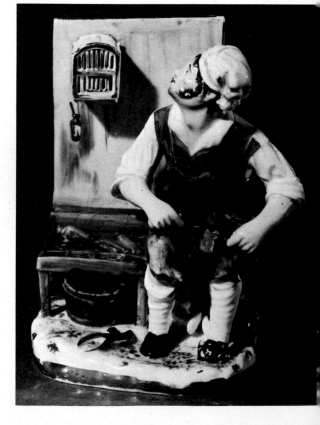

168. Bacchus. $5\frac{3}{4}$ inches high. Incised No. 32. Impressed mark. See page 81.

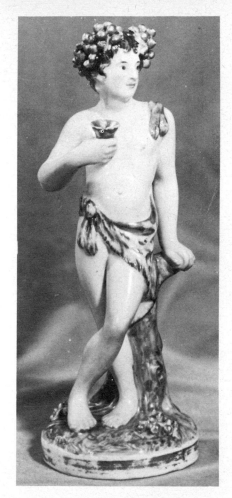

169. Turk, side by side with the more common Derby version. $3\frac{5}{8}$ inches high. Incised No. 25. Impressed mark. See page 81. *By courtesy of T. A. Willis, Esq.*

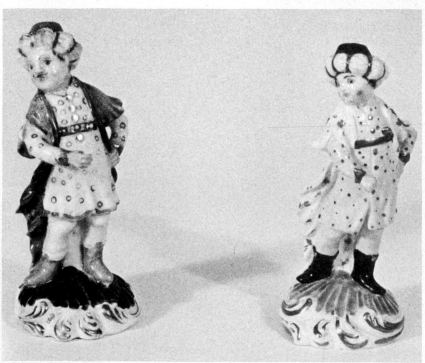

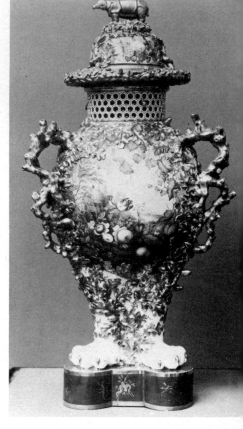

170. The Rhinoceros Vase in the Victoria and Albert Museum, painted by E. Steele. 38 inches high. See Appendix B. *By courtesy of the Victoria and Albert Museum.*

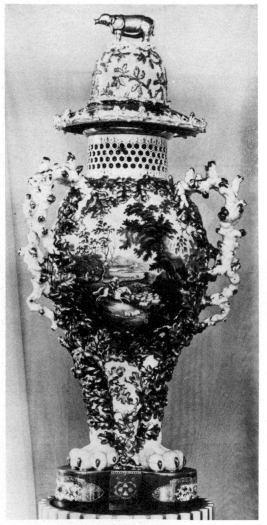

171. The Wentworth Rhinoceros Vas painted by John Wager Brameld. 45 inche high. Rare red circular mark. See Appendix I *By courtesy of the Clifton Park Museur Rotherham.*

Appendix G

The Wentworth Correspondence

By courtesy of Earl Fitzwilliam and Earl Fitzwilliam's Wentworth Estate's Company, the correspondence from the Wentworth Woodhouse Muniments (papers numbered F 106 (c) and G.47) relating to the Pottery is published below.

The last two letters, from William Green and John Green respectively, relate to the Don Pottery and not the factory at Swinton, but they are included out of general interest.

As a general rule, the original spelling, punctuation and underlining have been retained.

(COPY)

The following proposals are offer'd to Messrs. John & William Brameld by Mr. Thos. Bingley on the part of himself, and Mr. William Hartley & Jas. Winter Butterworth on the part of the Leeds Pottery Company—

FIRST They are willing to sell unto the said John & William Brameld and their Friends their Interest in the Swinton Pottery and its dependencies upon the following terms, that is to say, that the whole shall be valued by two indifferent persons one chosen by each party, and in case the said two persons so chosen cannot agree on the said valuation on or before the 1st day of March 1806, then a third person shall be chosen by the said two; whose valuation shall be final, and to be made on or before the 1st day of April 1806.

2NDLY That the value of the respective Shares of Mr. Thos. Bingley and the Leeds Pottery Company, shall be paid for in the following manner— one fourth part on the 1st day of May 1806, one fourth part on the 1st day of Jany. 1807, one fourth part on the first day of Jany. 1808 and one fourth part on the first day of Jany. 1809,—the three last Instalments to bear Interest after the rate of 5 Pounds pr.Ct: p.ann: from the 1st day of May 1806, until the time the respective principals shall be paid—and that Messrs. John & William Brameld do find good and sufficient security for the payment of such sum or sums as the said Thos. Bingley and the said Leeds Pottery Company Shares shall amount to at the respective times as before agreed upon.

THIRDLY That the Leeds Pottery Company shall be refunded the Monies that they are in advance (or may be hereafter in advance during or after the Existence of the present Copartnership) out of the outstanding Debts, and that the remaining outstanding Debts shall be plac'd in the hands of

'person' 'Signed' { Thos. Bingley
Wm. Hartley
Jas. Winter Butterworth

Swinton Pottery
30th Dec, 1805

Swinton Jany. 1st 1806

My Lord,

It is not without a considerable degree of pain that I feel myself under the necessity of intruding upon your Lordship's Attention a second time on the Swinton Pottery Affairs—to a Person of your Lordship's eminent Rank and Dignity the private Affairs of Individuals must indeed be trifling and nothing but the peculiar hardships of my situation together with a sense of your Lordships feeling compassion for your Fellow Creatures could have emboldened me to address you in this manner—upwards of 50 years of my life have been spent in anxious and persevering Industry and in which I am now grown grey, every branch of my Family (a Wife and Children) have too as their years enabled them, contributed their share towards that Fund of Earnings and Economy by which we hoped to raise ourselves to a decent degree of respectability and usefulness in the World, but alas! these Exertions have been counter-balanced by placing our little Property and our Confidence in the Power of Men whose system has prevented its acquiring those fair and considerable Profits which commercial Capital in general does acquire, nay has even confined and cramped it so that is has not kept pace with the accumulation of common Interest—as a Proof of this and a very simple yet convincing Proof it is both of my former and present Statement—The Capital advanced and the Interest thereon being 5 pr.Cent annually to the 1st Jany. 1801 amounted to £827 Per Share, so on after and in consequence of the ill usage we experienced from our Partners we offered them (Mr. Bowns doing us the favour to negotiate) our Shares at £600 each being less by £227. than they cost in this way, but yet they refused to purchase, neither at that time would they sell or comply with any Mode proposed for establishing a free Partnership, it is probable they feared that under the management of Men unconnected with any other Work of the Sort Swinton Pottery might establish a free Trade and become a formidable rival to their favourite and more fortunate Works at Leeds—The Proposals made by Mr. Bowns on our part in 1801 being uniformly rejected by our Partners—we had no other alternative than to leave our Property in that helpless situation and wait until the Expiration of the Term in 1806—My two sons the elder of whom had been in the Business since 1786 and the younger since 1795 were during the greater part of the time since 1801 out of Employment, repeated Applications were made in Staffordshire for a Situation but without Effect, we would not attempt to conceal the Truth and what Manufacturer would take into his Bosom a Youth whose Family was engaged in a similar Trade to their own? thus unfortunately did we find ourselves situated and have so remained while at the same time to gratify their Prejudices our Partners placed at the Head of the Concern A Person (as Agent) who was an entire Stranger to the Business—but I shall tire your Lordship with Complaints and it is the less necessary for me to trouble you with particulars since our Partners have not

141

presumed so far on the goodness of their Cause as to lay it before you (nor yet before W. Bowns) altho' they mentioned to us that they knew we had had the favour of an Interview with you—They refused to buy our Shares but they have at length consented to dispose of theirs, which they are now pleased to say they think the best Mode for all Parties as they wish to terminate the Partnership amicably—On Monday they attended a Meeting & made to us in writing the Proposals of which we trouble your Lordship with a Copy enclosed herein,—they at the same time shewed an extreme urgency for an immediate, or at least a very early Answer—We replied that as it was out of our Power to purchase, so it depended on our Friends to enable us to Answer they however would insist on expecting an Answer in a Week or 10 Days because they must deliver up the Land and the Colliery on the 2nd of February.—To purchase their Shares and carry on the Work will require not less than 12 or 15,000£ and had the Concern been carried on for the last 20 years as it might have been we should have been able, or nearly so, to accomplish this—but as it is, we have now no Funds at all, nothing but the Property which has so long lain dead in the Pottery—so that after all, our Hands are fast behind us—to endeavour to remedy this we have applied to some Gentlemen of Property and Respectability (we would not apply to any other) to join us as Partners and make the Purchase, but they have all pleaded an inability to furnish the Money or prior Engagements in other Undertakings, and they have consulted their Friends but find the Allegation so general that they give us very little hopes of success in extending our Applications.—If we are not enabled to purchase, we fear no other alternative will remain but the breaking up the Concern and selling off the Stock, which I fear will be attended with a loss of one half the value of the Property, besides the injury sustained by the dismissal and dispersion of the Work People who are now employed, and the breaking off the Connections and Correspondencies now in existence—all of which might be continued by a Purchase and Continuation of the Concern—For your Lordship's information I ought to mention one deficiency in the Premises at Swinton Pottery (viz) the want of a Flint Mill—it has hitherto been supplied with its Ground Flint and Glazes from the Leeds Company's Mill at Thorp Arch—and probably for a Season might be supplied from thence or from the Sprotbro Mill near Doncaster, but all Supplies of this kind would be precarious, such Mills belong to other Potteries and of course their own wants must be supplied with the first and best, besides the Profit they will charge on their Commodities and these form a considerable part of the Materials requisite in a Pottery.—The great Mr. Wedgewood has at his Works a Steam Mill and I think no place more suitable for one than Swinton Pottery so near to Coal—I do not know the Cost but probably might be £2000 or upwards, it would make the Works very complete and add to that Great Consumption of your Lordship's Coal which the Pottery full worked would make.—Indeed nearly the whole Consumption of a Pottery is in British Raw Materials and many of these surround the Work in the midst of your Lordship's Estate at Swinton—When I contemplate the Situation of that Work—the Place where I and several of my Family have toiled many long years—yet hitherto without avail—and when I consider that the Hopes which have hitherto supported our Spirits are likely to vanish and their expected Advantages be wrested from us—with the loss of one half of that which our Labours have hardly earned,—I can scarcely support the Idea—May some Friend step in and avert the Calamity! It is only support we want, it is only Money, we do not want Skill nor Industry, our Experience has furnished us with one and our natural Habits impel us to the other—We feel confident we could (after a reasonable time to establish a Trade)

make the Concern repay the reasonable Expectations of any Friend who might join us—even in the Face of this extraordinary War—I can perceive one Mode, and at present only one, by which to escape the loss and evils of breaking up the Concern, but I could not have brought myself to mention it, were I not encouraged by the paternal Interest your Lordship has seemed to take in my welfare—that mode is for your Lordship to purchase the 18 Shares which the other Partners offer and which I think they would sell on very moderate terms rather than break up these Shares you might hold without appearing to do so as the whole might stand in the name of my Family—but this might be ordered as most agreeable to you—for really my Lord I cannot see any impropriety in your Lordship carrying on your own Pottery in the midst of your Estate and working up the Raw Materials which it produces into a manufactured Article universally useful and which now makes a considerable figure in the Commerce and adds to the riches of the Country—I believe there are instances of Noblemen concerned in carrying on Works of various kinds on their own Estates—Indeed the working of a Colliery is in some respects allied to a Pottery—

If this is not too disagreeable an Undertaking to your Lordship, it would indeed be to me an Act of the greatest kindness, as it would effectually remove the difficulties I labour under—If on the contrary your sentiments run Counter to my wishes I must entreat your Lordship's Pardon for the Liberty I have taken in suggesting it—There would be yet one more way in which your Lordship could assist us, and only you, as we could not give sufficient Security to any other Person, nor would it be prudent to engage in that way except under the Protection of one whom we could safely put ourselves into the power of—but as I have already trespassed so much on your Patience, I forbear to say more and must now conclude—with hoping to be favoured with your Answer as early as you can make it convenient—to enable me to reply to my Partners' proposals for which they are so very urgent—I hope that your Lordship's Health continues to improve and that the Country may continue to be benefitted by your Lordship's living to enjoy many happy new years is the sincere prayer of one who remains

My Lord
Your Lordships already obliged
and faithful hble Servt.
John Brameld

* Will you Lordship have the goodness to address me
'to be left at the Post Office Doncaster'

COPY

Sir,

Lord Fitzwilliam is so peculiarly circumstanced this morning that he cannot get time to write but being unwilling that your letter should remain another post unanswered, he has instructed me to say that though he can see the hardship of your case to the fullest extent, and every point upon which it bears, still his Lordship has to regret his inability to meet your wishes, either in respect to purchasing the Shares, or in advancing you a sufficient sum to enable you to become the Sole Proprietor of the concern—however as far as any preference can be given in point of Tenancy to this Pottery at the expiration of the Term, I believe that I may say with great safety, that it would be decidedly in your favor: and that you have his Lordships hearty good wishes that you may get through this business to your satisfaction, to which (tho' a stranger) I beg leave to add my own sincere wishes also, and to assure you that I know his Lordships money engagements, in consequence of purchases which I have engaged him in, as well as inclosures are got to such an extent as to preclude all hope of his being able to assist you.

> With esteem and respect I am Sir
> Your most obedient humble servant
> Henry Cole
> Agent to Earl Fitzwilliam.

If you see Mr. Bowns pray
make my best respects to him—and
if you think proper you may shew
him this letter.

My Lord,

Being informed that some of the Gentn. of the Leeds Pottery intend to wait upon yourself and as they appear much dissatisfied and particularly with me, I hope your Lordship will pardon me for troubling you with a full statement of what has passed between me and them—relative to the pottery business, and which I conceive will be necessary for your Lordship to be apprised of in order to judge of the propriety of the Claim intended to be made.

11th May 1785 Hartley Greens & Co. made the proposals—sent herewith, and on the 11th Sept. following Terms were agreed upon with them, as by Mr. Fentons Memorandum which accompanies the proposals—the Buildings were erected and your Lordship found Timber according to the contract, and additional ones have likewise been made and wood also—found by your Lordship, but I think it probable that some Erections may have been made for which Timber was not allowed, and that I may have refused it, not thinking it proper to give wood for every Building they might erect for their own convenience.

During Mr. Fentons life the Lease was not drawn, but after his death I prepared one and delivered the Draft of it to the Lessees, but they never returned it to be engrossed, which I apprehend was owing to the differences which frequently took place amongst the Copartners.

In August last, in consequence of the 21 years expiring at Candlemas and May day 1806, and the conditions of the Contract having been as fully performed by both parties as if the Lease had been actually executed, now also knowing that the term of the Copartnership expired at the same time (as I had been employed to prepare the Articles, but which were never executed) I conceived it necessary on the part of your Lordship to come to a new agreement, in order to which, and as the only legal preparatory measure, I delivered a regular Notice to Quit, to the Swinton Pottery Compy. which consisted of fifteen persons, and told Messrs. Brameld in Septemr. and also Mr. Bingley at the Rent day in November following, that my reason for so doing, was on account of the expiration of the 21 years, and for the purpose of coming to a new Agreement, which I fully expected the Lessees would have applied for, but I heard nothing from them until the 29th Jany. when Mr. Prince one of the Leeds Company's Agents called upon me respecting the quantity of Coal got on Swinton Comon; and upon my mentioning, that I understood the Company were preparing to quit and had no intention of continuing the pottery, he told me 'that the Leeds Gentlemen thought themselves extremely ill and disrespectfully treated, by my giving them so rigid a Notice to quit, that I should have written a civil letter to them as Gentlemen; but they were determined to obey the Notice and apply to your Lordship for a compensation towards the loss they would sustain by being turned out.—that they conceived any application to take the premises again, would be fruitless on account of the partiality which your Lordship and I had shewn to Messrs. Brameld, by whom they had been told that unless they, Messrs. Brameld, were reinstated to the management of the pottery,

again, the Leeds Gentlemen would not be treated with, therefore they thought it high time to give up, if your Lordship and I were to dictate to them who should manage their Concerns' he also said that the Leeds Gentlemen after receiving 'such a Notice to quit would never submit to go Cap in hand to apply for the premises again'.—In consequence of this unexpected great offence which I had innocently and unintentionally given to these Leeds Gentlemen by giving them a formal Notice (which I am now convinced was absolutely necessary and that a civil letter to fifteen parties would have completely broke up the Trade at Swinton Pottery) and as they professed to be preparing to quit under erroneous ideas and mistaken principles, I was determined that they should not have any just grounds to assert that they would not be treated with, therefore immediately wrote to the Leeds Gentlemen the Letter No. 1.

Not receiving any reply to that Letter, I addressed another to the Swinton Pottery Compy. on the 10th Feby—See No. 2—On the 26 Feby. Mr. Prince called upon me again in consequence of a Letter which the Leeds Gentn. had written to those at Swinton, of which he allowed me to take a Copy See No. 3—and in reply to that Letter, I sent one to the Swinton Pottery Com. See No. 4 on the 27 Febry. from which time my correspondence with them as a Company has ceased.

A few days since Messrs. Brameld acquainted me that the Company were arranging a Division of their Stock—Utensils etc. part of which they, Messrs. Brameld, wished to purchase, in case your Lordship would please to accept them for Tenants in future to the Pottery, to which, my reply was, that I could not agree with any part of the present Company, until such time as the other part of them had declined to treat, or their Term was expired and the whole of the premises given up, but that upon a dissolution of the Copartnership and a separation of the Company, they were to have the preference.

Yesterday Mr. Brameld acquainted me that in consequence of the promised preference I had given them, they were treating with the Leeds Gentn. for the purchase of Stock, Implements etc. and hoped they would be able to come to an amicable conclusion, notwithstanding which, and the Letters I had written, the Leeds Gentn. thought fit among their other orders and resolutions to make that No. 5— which has induced me to trouble your Lordship with this faithful statement of Facts, in addition to which I beg leave to assure your Lordship, that I have never given the least reason for any one to suppose that the Leeds Gentn. would not be treated with, if they chose, but I have very strong reason to belive it never was their intention to continue the Swinton Pottery if it was, the Notice would not have prevented their application; but its having been given, they make it a pretext, in order to obtain a remuneration for the loss they may sustain on giving up, but if the Notice had not been given, I am fully persuaded, that as a dissolution of the Copartnership must have taken place on account of the expiration of it, the Leeds Gentn. would have held over the premises another year; to the ruin of the old Tenants and the Pottery Trade on your Lordships Estate.—If in any one instance they think proper to reflect on my conduct, I rest assured your Lordship will allow me the opportunity of vindicating it, and have the honor of being

My Lord
Your Lordships most obedt. and
faithful Servant.
Chas. Bowns.

Darley Hall
16 March 1806.

No. 1.

To the Leeds Pottery Company 29th Jany. 1806

Gentlemen,

Mr. Prince has this day informed me that he presumes the reason you have not applied to continue Tenants to Swinton Pottery is because you have been informed by Messrs. Brameld that unless they are to be reinstated in the management of it, you would not be treated with or to that effect; in consequence of which I think it necessary to say that if Messrs. Brameld have given you such information, they have not my authority for it; I told them that the pottery would not be let to a company, of whom some of the partners were interested in different connections in the same Trade, and I am still of opinion that it will not be advisable to do it if it can be avoided. When Mr. Bingley applied to us to know the reason of the Notice to quit I told him it was a step I thought necessary to take in consequence of the expiration of the Term contracted for, in order to come to new conditions, and I now beg leave to add, that if you have any propositions or representations to make respecting the premises, due attention will be paid to them; and also that if you wish to continue the Engine and Implements belonging theColliery upon the premises, or to work the same as an accommodation to the Pottery until May day or for any shorter period, there will not be any objection to it.

<div style="text-align: right">

I am Gentn.
Yr. etc etc
C. Bowns.

</div>

No. 2.

To the Swinton Pottery Company 18 Feby. 1806

Gentlemen,

The letter which I addressed to the Leeds Pottery Company informed them that the Notice given you to quit the premises you hold under Earl Fitzwilliam was, in consequence of the expiration of the Term contracted for and in order to come to new Terms, but as I have not received any reply from them or application from you to take the premises again, and wishing to give you that preference which old Tenants are entitled to, I take the liberty of requesting you will please to inform me whether it be your intention to treat again for the Pottery and other premises or not, as I cannot treat with any other persons for them until I am favored with your determination which I shall be glad to have within the space of Ten days, and beg leave to add, that if I don't receive any answer from you within that time, I shall conclude from your silence that you decline the offer I now make you of treating again for the premises, and consequently that they will be at liberty to be let to whom Lord Fitzwilliam may think proper.

<div style="text-align: right">

I am Gentlemen,
Your most obedt. Servt.
C. Bowns.

</div>

No. 3.

To the Swinton Pottery Company from the Leeds Pottery 24 Feb. 1806

Messrs. Green Bingley & Co.,
Gentlemen,
 Your favor of the 20th is before us, in reply to which we wish Mr. Prince to wait
upon Mr. Bowns and inform him that agreeable to his notice we shall prepare to
quit the Swinton pottery premises by the time allowed us, as from his letters it
appears that we are not thought eligible Tenants, or at least that he is not satisfied
with us as Tenants, at the same time we would have him inform Mr. Bowns that
six months notice to quit such a concern is certainly too little in reason, and tho'
every exertion will be made to quit at the time specified in the notice, yet it may
happen that we cannot entirely get all our Articles away, in this case we should be
obliged by his giving us a little longer indulgence.—We also wish Mr. B. to be in-
formed that as we are under the necessity of sacrificing a great deal of money laid
out on Lord Fitzwilliams Premises, we shall reserve to ourselves the opportunity
of requesting from his Lordship some remuneration, as we are discharged from the
premises.

No. 4.

To the Swinton Pottery Company 27th Febry. 1806

Gentlemen,
 Mr. Prince having shewn me a letter of the 24th inst. from the Leeds Pottery
Company addressed to Greens Bingley & Co., I think it necessary to trouble you
again on the subject of that letter in which Mr. Prince is directed to inform me
'that agreeable to my notice you will prepare to quit the Swinton Pottery Premises
by the time allowed you, as from my letters it appears that you are not thought
eligible Tenants, or at least that I am dissatisfied with you as Tenants'. In reply to
which I have only to say, that I cannot consider such information, otherwise than
as a positive refusal on your part to treat again for the premises, and consequently
an answer to the offer made you in my letter of the 18th inst; and likewise that my
letter to the Leeds Pottery Company will shew in what respect and to what extent
I thought you ineligible Tenants. Upon Mr. Princes informing me that it was
impossible for the Leeds and Swinton Pottery Company's to be united in one
joint concern, I was induced to wave the objection I had made on account of their
being at present in different interests and connections, therefore made the offer of
treaty to you, without any condition of that kind, which preference I considered
you entitled to, as well as a proof that I neither thought you ineligible Tenants
or was dissatisfied with you and which I now repeat; as also, that I am still ready
and willing to treat with you, if you think proper, or in case of a dissolution of the
present Copartnership, with such of the Copartners as shall be desirous of contin-
uing the premises, in preference to letting them to a new Tenant.
 The letter also states 'that six months notice is too little in reason to quit such a

concern' in reply to which, you will please to observe, that you have had Nine Months for the Pottery, and that, as it is your intention to Quit the premises, I don't conceive myself, at present, authorised to extend the time mentioned in the notice, as that might tend to set it aside, but if at the expiration of that period, and upon your delivering up the Possession of the premises, you should have any articles thereupon, I have not a doubt but you will then experience every reasonable indulgence of time to remove them.

The letter likewise states that you wish me to be informed 'that as you are under the necessity of sacrificing a great deal of money laid out on Lord Fitzwilliams premises, you will reserve to yourselves the opportunity of requesting from his Lordship some remuneration, as you are discharged from the premises',—in consequence of which I beg leave to observe that I can't have the least objection to any application you may think proper to make to his Lordship, and that after the explanation you have received of the reason of the Notice, and the offer that has been made to you of treating, which you have not signified a wish to do, but on the contrary inform me of your determination to quit; in my humble opinion it may justly be said, that you abandon the premises and his Lordship must therefore judge upon the equity of your claim to a remuneration, to which, you might have been better entitled, had you been dismissed contrary to your own approbation, and without having had the opportunity of treating again, at the expiration of your lease.

<div style="text-align: right">

I am Gentlemen
Your most dvdt. Servt.
C. Bowns.

</div>

No. 5.

Copy Resolution of the Swinton Pottery Company

'That the Partners in the Swinton Pottery think themselves very much injured by the manner in which they have been treated, and discharged from the premises at or near Swinton, from which discharge they are under the necessity of discontinuing their works, and they propose to lay the whole of the circumstances before Lord Fitzwilliam, not doubting but that his Lordship's equitable disposition will induce him to allow some remuneration for the very great sums that have been laid out upon the premises'.

N.B. Looking upon the Transactions alluded to in this Resolution in a different light, we think it needful to state that we take no part in making it, but dissent from the opinion it contains.

<div style="text-align: right">

John Brameld
Wm. Brameld

</div>

The Company holding Swinton Pottery having repeatedly manifested their determination not to retake the Premises—J. & W. Brameld have digested a Plan for carrying on (with the approbation of The Right Honble. Earl Fitzwilliam) that work themselves, on a reduced scale so as only to supply the British Trade, but yet so as to consume about 2000 Tons of his Lordships Coal annually.—To effect this it will require from £4000 to £5000 more than their shares of the present Capital, and his Lordship's former beneficent intimations encourage them to look with confidence to his kind and protecting support in furnishing them with this sum, or such part of it as they may stand in need of, when his Lordship may have it in his power to put them in possession of the Premises.

The Majority of the Company have not only treated Mr. Bowns's various offers with equivocation and disrespect, but they have refused to deliver up the Premises at the time required in his notice; and one great aim of theirs seems to be to ruin the Trade and Connexions of this place and Transfer them to Leeds Pottery; by holding it shut up in the manner now doing they will be able to effect it, even in the short space of 6 months unless some plan be devised and put in execution to prevent them.

There are two plans that present themselves for this purpose: one is, to supply the Customers with Goods purchased at various other Manufactories in Yorkshire and Staffordshire, the other, and a much better plan, is to take a work for a short period of time on a Rent—and just now a most favourable opportunity seems to present itself for that purpose—At Mexbro' near Swinton is a small work built and carried on by some Gentlemen who are ignorant of the Business and completely tired of it, therefore will be glad to let the Work and Fixtures at a rent even for the short period of 2 or 3 years, and to dispose of the loose Stock of Goods and Materials on moderate terms—by taking this Place the Trade hitherto carried on at Swinton may be transferred thither and preserved until these Premises are liberated—when it can be transferred back again and probably improved by the addition of the present Mexbro' Trade—The Workmen employed at Mexbro' are chiefly what have been driven from Swinton by the late events,—and several other valuable old Servants have been lately dismissed and are in want of employment—these may be employed and kept together on this plan and taken back to Swinton when that work is ready for them, which will be a great advantage to the work as well as to the men. In doing this there will be no injustice to the Mexbro' Proprietors, because they have made an indirect offer of their work for this purpose. This Work at Mexbro' would in the mean time be supplied with Coals from Elsecar being upon the Banks of the River Don.

The only obstacle is the want of funds, but it is humbly hoped his Lordship's goodness will obviate this by advancing part of the sum above mentioned, of which about £2000 will be sufficient at present; and with this kind help from his Lordship will J. & W. Brameld be enabled to counteract the nefarious designs of the Rulers of Leeds Pottery, and in some measure to repair those injuries, and avert those various evils which they have heaped, and are proceeding to heap, on Swinton Pottery.

Swinton May 1806.

[Addressed to 'Viscount Milton']

My Lord,

I take the liberty of requesting that your Lordship will please to acquaint Lord Fitzwilliam that by the last post I remitted 3000£ to his account at Snow's, and 1000£ on the 9th of this Month—Mr. Fenton having paid his Rent up to Lady Day 1805 I have been enabled to discharge a Years Property Tax, and also the Fine of £972 15 to the dean and Chap^t. of Christs Church Oxford on the Renewal of the Lease of Wath Rectory, amounting together to upwards of 2500£—I am sorry to inform your Lordship that the Leeds Pottery Comp^y. refuse to deliver up the premises at Swinton—they have ceased working, and I don't learn that they have any other motive for withholding the possession than that of taking away the Trade, and injuring that pottery as much as in their power—I must of course deliver Ejectments to the Tenants in possession, to which I expect they will appear, which will bring the matter before a Jury at the next Assizes, where I trust a verdict will be obtained, as I am not aware of any defect either in the Title or the Notice to Quit, but in that case a writ of possession cannot be obtained before Miclemas Term—I have some reason to think that as the Pottery Works are erected upon the Waste, the Comp^y. are encouraged to try your Lordships Title to them, and that such advice originates at Newhill—this being the case I must trouble your Lordship to return the Minutes of Agreement and proposals of the Leeds Pottery Comp^y. on their entry to the premises, which I sent to Lord Fitzwilliam, when I wrote to him on the subject—the Rents were as well paid as usual—We have fine growing weather and a great prospect of a plentiful Crop of Hay.

I have the honor to be
My Lord Your Lordships
most obedt. and faithful Servant
Cha. Bowns.

Darley Hall
19 May 1806.

to advance Brameld 2000£

My Lord,

Your Lordship has certainly been misinformed at Snows, respecting the remittance of 3000£ which I sent at the time mentioned in my letter to Lord Milton, and received an acknowledgment for it (copied on the other side) in due course; otherwise, I should not have let this time elapse without having made the necessary inquiry after it.

I saw Mr. W. Brameld previous to his journey to Town, when he informed me of the plan they wished to adopt for carrying on the Trade, and keeping their present customers, at Swinton Pottery; which I thought feasible.—I then understood from him, that they might ultimately require a loan of three or four thousand pounds, but thought that about 2000£ would enable them to take the Mexbro' Works.—I am not sufficiently acquainted with the finances of Messrs. Brameld to judge whether or not 2000£ will be enough to enable them to carry on the Trade, but if they don't ask for a larger sum, I hope it will; and if they succeed in geting the Mexbro' Works, I think they will have a fair prospect of keeping their present customers, and carrying on the Trade to advantage at Swinton Pottery when possession of it is got, but should not be surprised if a further loan should be requisite at a future period, and if that should be the case I trust that the Trade will be an ample security for the Sum that may be necessary to borrow enable to Messrs. Brameld to carry it on, to the extent proposed, which is, to the Country Trade only.—I have great confidence in their managing the Business with the utmost caution and prudence, and that they will not attempt to push it beyond their means; which was the misfortune of the Copartners on their first entering into the Pottery Trade.

I have the honor to be
My Lord Your Lordships most obedient
and faithful
Cha. Bowns.

Darley Hall.
2 June 1806.

My Lord,

Mr. Faber and I have gone through the examination of the Books and accounts of the Swinton Pottery, and under another cover, marked No. 2., I forward to your Lordship the Result of the Investigation, with the Copy of a Report (which we deemed it necessary to make for the Information of the Creditors) of the causes which have led to the Messrs. Bramelds Embarrassments.—Had it not been for the foreign Losses, and for the great annual Expenditure on keeping up a fictitious capital to supply the void occasioned by the Loss of real Capital abroad, the concern would now have been in a very flourishing State.

A numerous Meeting of the Creditors took place this week at Brampton Bull Head, and I requested Mr. Maude would accompany me to it, which he did—altho' it was the unanimous opinion of the Meeting that the Bankruptcy could not be avoided, yet it was gratifying to see that all present, even those who were the greatest Sufferers from the Event, would willingly have adopted any Expedient, and would have given any Indulgence, which might have been found available to keep the Concern going.

Every one present would gladly have accepted 10/- in the £, and would have taken it by instalments in six and twelve months, could such a dividend have been guaranteed;—but, to whom (they observed) could they look for such a guarantee, except to your Lordship.—To this suggestion I felt it my duty to state, that I could not possibly think of your Lordships incurring any such Responsibility.

It was then suggested, that it was of Importance to your Lordships Interests, and to the Estate generally that the Works should be continued, and that this might be done, were your Lordship to purchase the Stock etc, and allow the Messrs. Bramelds to manage the concern, as your Lordships Servants, placing them under proper Controll and superintendance, and that the money to be given for such Stock should be divided amongst the creditors (including your Lordship) in the Ratio of the respective debts. This, I could not but state to be objectionable, inasmuch as it would in Effect, make your Lordship a Trader, independent of the objection arising from the large advance of capital which would be necessary.

It was then argued, that inasmuch as the Stock in Trade (which as a going concern is worth 15,000£) would not, if the works were broken up, fetch more than 7000£, or very probably not so much, it might be to your Lordships Interests to take it at 2/3ds. of its value (say 10,000£) and allow Messrs. Bramelds to go on, your Lordship taking a Security upon all the Effects, and taking all the profits as they arise, except what would be absolutely necessary for the Support of the Partners, in Liquidation of the debt.

This, tho' the least so, is still an objectionable Plan, inasmuch as it might be a doubt whether the future advantage to arise from the continuance of the Works, would counterbalance the Risk and Inconvenience of the present advance of Capital.

Mr. Faber who views these matters with the Eye of a Man of Business, is decidedly of opinion that if the Messrs. Bramelds were once relieved from the Burden which now weighs them down, 'that in a few years with Industry and Care, and by keeping to the Home Trade, the works would clear themselves and become a permanent source of Emolument to your Lordship, and of Employment and advantage to this Neighbourhood.

At present the affairs of the Pottery stand thus:—The Company are declared Bankrupts, Mr. Maude and Mr. Hugh Parker being the Commissioners, and Mr. Faber the provisional assignee.

The Works are intended to be carried on for a while by the assignees for the Benefit of the Creditors, till the debts are proved, and the outstanding accounts are got in; and thus time will be obtained for further Considerations, and for any ulterior arrangement.

On Monday next I shall go to Halifax, as settled by Mr. Maude, to view the Property of Messrs. B—, and finally to settle the Business with them.

> I have the Honor to remain
> Your Lordships very obliged
> and obedient Servt.
> Wm. Newman.

Darley Hall
21st Jan. 1826.

[Addressed to 'The Earl Fitzwilliam,
Milton,
Peterboro' ']

My Lord,

The Statement which I sent to your Lordship was rather intended by me as a Report of what passed at the meeting of the Creditors, than as the Communication of a direct proposal soliciting your Lordship's aid.—

Mr. Maude thought it best that I should communicate what had passed, in order that your Lordship might in some degree be prepared for the application which might probably be hereafter made to your Lordship. The first meeting under the Bankruptcy will be on the 3rd of February (tomorrow Week) when something of a more definite nature may occur, and when I shall be better prepared to see your Lordship on the Subject, if that Step should be thought adviseable, and when both Mr. Maude and myself shall have had better opportunities of forming a more matured opinion. I am sorry to say that my appointments are such that I could not be absent from this part of the Country for the next ten days, but after the 4th I can put myself into one of the Coaches which daily pass my House, and be in London as expeditiously as I could go to Milton.

<div align="center">I have the Honor to be

Your Lordships very obedient St.

Wm. Newman.</div>

26th Jan. 26

My Lord,

I have just received your Lordship's Letter, and I have written to Mr. Hill requesting his Services which I think may be useful in his Neighbourhood, and I have written to General Wharton to apprize him of my having done so.

I hope my Lord Fitzwilliam will not (in the Event of an application being made to him on Bramelds Affairs) accede to the measure of the Guarantee, as I see it very objectionable to secure to the Creditors any definite Sum in the £.—The debts may turn out greater than we are at present aware of, and the Sums due to the concern may be attended to with Difficulty and Loss in the Collection—for in the present state of the Commercial World it is impossible to pronounce any debt, or any person, safe.

The Proposition therefore of taking to the Effects at a reduced Value, (but which reduced Value it is quite fair under the circumstances of the Risk for anyone to offer) is the one which I quite agree with your Lordship in thinking the most proper to accept, if it be deemed prudent even to do that.

My Letter to Lord Fitzwilliam of Thursday would point out that there is no occasion to come to any immediate decision, as the Works were going on in a partial degree, and after the next Meetings on the 3rd and 4th of Feb. all parties will have better data to act upon.

I deemed it prudent to acquaint your Lordships of all that had passed, in order that your Lordships might not be unprepared on the Subject, in case Mr. Faber or some other principal Creditor had thought proper to write your Lordships personally.

I remain,
Your Lordships very faithful
and obedient Servt.
Wm. Newman.

28th Jan. 26.

PS. As Mr. Faber is at present only the provisional assignee, his appointment is liable to be superseded at the Meeting on the 4th when the choice rests with the Creditors—as he is the most likely person I know for the office. I enclose, in another cover a Power of Attorney to be signed and sealed by Lord Fitzwilliam empowering me to vote. I will thank your Lordship to return it as soon as possible.

PS. Since I wrote the within, I have learnt that Mr. Faber has proceeded to Milton on the Subject of the future Conduct of the Works—Your Lordships' answer to Mr. Faber's Proposition will, I trust, have been of a general Nature, or that they will be taken into further Consideration, as I am pursuaded the best Conclusion will be come to, when the whole debts are known, and the parties have passed their final Examination before the Commissioners.

[Addressed to 'The Earl Fitzwilliam,
Grosvenor Square,
London']

My Lord,

I had made every arrangement for setting off to London by this morning's Coach, and should have done so, had not the occurrences at the meeting of Brameld's Creditors on Saturday, rendered my Journey at present, in Mr. Maude's opinion as well as my own, premature.

I should feel exceedingly distressed, if in postponing my Journey for a short time longer, I act contrary to your Lordship's Wishes, but Mr. Maude concurs with me in opinion that your Lordship's Interests will be best served by the delay, and he was kind enough to say that he would so state it, in a Letter he proposed writing to your Lordship yesterday.

Mr. Faber, who, in my opinion, would have brought Messrs. Brameld's Affairs to the best and most satisfactory Conclusion, has declined altogether the office of assignee.—He was induced to take this step, in a great measure by the Probability of his time being wholly ingrossed as one of the assignees of Messrs. Wentworth & Co. at Wakefield—

The assignees now chosen by the Creditors are Mr. Wm. Carr and Mr. Johnson of Wath, and at present I am not prepared to state whether they have any proposition to submit to your Lordships Consideration or not—Whatever is proposed must originate with them, rather than with your Lordship, or any one on your Lordship's behalf.

The usual Meeting will take place in the Course of a Week or ten days for the Creditors to give their Sanction to the assignees to dispose of all the Effects by private Contract, and then I apprehend I shall receive some proposition of a definite Nature. I will then lose no time in waiting upon your Lordship. I cannot but think also, that it will have a salutary Effect upon Messrs. Bramelds themselves, to feel that it requires some time, and much Consideration on the part of your Lordship, how far it would be prudent in your Lordship to accede to the Suggestion Communicated by Mr. Faber, which I learn from him was in Effect, that your Lordship should take the Stock at a reduced Valuation, and once more trust to them.—I have no reason, certainly, to doubt the Integrity or the Industry of the Messrs. Bramelds, but their dispositions are too sanguine a Nature.—

On the Subject of the Affairs of the County I find from Letters from different Quarters, that the Co-alition between Mr. Wilson and Mr. Duncombe, is all but avowed. The agents for both, are making arrangements for Mutual Co-operation—

I have the Honor to remain
Your Lordships very faithful and
obedt. Servt.
Wm. Newman.

6th Feb. 26.

TO THE
RIGHT HONOURABLE EARL FITZWILLIAM

My Lord,

It is usual in approaching a Nobleman of your Lordships Rank to set out with high pretensions, but we trust you will give us credit when we say that being your Lordships Neighbours and many of us your tenants we know your character too well to think it necessary.

We deeply regret the occasion of our memorial by the failure of our neighbours, your Lordships Tenants at the Swinton Pottery:— for the causes of which we cannot do better than beg your reference to the Report laid before us at Brampton, drawn up by the Provisional Assignee and your Lordships principal Agent.

It is not our business here to discuss the character of the parties,—but this much we think it proper to say, that however unfortunately their late affairs have turned up for your Lordship themselves and us we feel satisfied their past experience has rather qualified them to steer a safer course in future than a second time to strike upon those rocks now too well known to them.

The Pottery gave direct employment to about Two Hundred and Seventy Individuals and upon these some Hundreds more depended as well as a necessary weekly expenditure of Cash, which, taken in the aggregate, amounted to about 10,000£ annually flowing into circulation amongst the Shopkeepers, Farmers Colliers and Mechanics on your Lordships Wentworth Estate.

The sudden (tho' not hitherto total) suspension of the works has thrown many of these poor people upon the neighbouring Parishes; and much misery and distress is occasioned by it, which we do not wish to press upon your Lordships attention and give unnecessary pain to your feelings.

But we would willingly turn to a brighter part of the subject, and we humbly but earnestly entreat your Lordship to step forward on this occasion and with your accustomed beneficence lend a saving hand to preserve this old established Manufactory from ruin. We are willing and anxious (and do hereby wish the Assignees to make an offer to your Lordship to sell the Tenants right entire as a going concern at a reasonable price and unless you listen to our request, and kindly become the purchaser, we see no alternative but the breaking up the whole concern which would be a great sacrifice of Property and seriously injure us by the smallness to which it would reduce our Dividend and indeed much injure the property itself by exposing its best workmen and most valuable customers to the temptations which,— in such a state of things,—would be held out to them by rival Manufactories with avidity.

We venture therefore my Lord! to hope you will add one more act of kindness to those already showered upon your neighbours in Yorkshire who would receive this blessing at your hands with gratitude as a great part of the inhabitants are affected directly or indirectly, in the prosperity of a Manufactory now brought

into a very improved state in the quality of its productions, and which must depend upon your Lordships liberality for its future existence.

We are my Lord! with sincere veneration and respect

Your Lordships obliged
and faithful servants

Names	Amount of Debts			Names	Amount of Debts		
William Musgrave	200	0	0	J. T. Wilde			
William Stables	156	5	0	[?.] Naylor	35	11	10
Nathl. Shaw	70	10	11	Wm. Barlaw	30	0	0
Benjn. Law	905	8	9	Richard Sailes	100	0	0
Joseph Hyworth	37	0	0	William Jackson	400	0	0
Benjn. Twigg	21	15	3½	John Story	13	6	0
Joseph Will Brailsford	14	13	10	Jos. Sailes.	60	0	0
John Brooke	50	0	0				
Wm. Myers	159	5	9				
William Hargreave							
Wm. Mawson							
Frank Garfit	520	5	0				
John Braithwaite	250	0	0				

[Written on the reverse of this document are the words
'13th April 1826
Petition presented by Messrs. Bramelds
Creditors to Lord Fitzwilliam—']

COPY

Upon the examination of the Books & Accounts of Messrs. Brameld the annex'd Statement appears to us, as nearly correct, as we have been able to ascertain.—

In tracing the causes of Messrs. Brameld's present difficulties to their source we have satisfaction in being able to assure the Crs. that we find no reason whatever to impute to them any design to take undue advantage of their Creditors—their Embarrassments have arisen mainly from the following causes—The great depression in the home Trade after the ratification of the Peace in 1815, and their wish notwithstanding to employ their works to the full extent (supposing thereby to render them more profitable) drove them into the foreign market—their first returns from thence gave them the most flattering promise of further advantage, they were led to make greater consignments; till at length a positive loss of 22,000£ was the result, as has been clearly made appear to us in this investigation.

The withdrawing of so great a capital from their concern drove them to the delusive expedient of supplying that deficiency by drawing Bills of accommodation and to raise money for the payment of currt. Wages and expenses by giving their Bills in exchange for Cash Notes obtained from Shopkeepers and others—and which Bills they received from time to time at an enormous expense of commission, Interest, Stamps etc.—In fact they appear for the last 5 years to have been working upon this system of false capital borrowed at a rate of interest of from 12 to 15 pr.Cent p.annum.—We feel satisfied that had it not been for the before mentioned losses and disadvantages their manufactory would now have been carried on so as to leave a considerable profit.—If these works are now broken up, and the Wares, Fixtures and Utensils disposed of to the best immediate advantage we cannot but feel assured that they are of such a nature they will not fetch one half of the value at which they are here estimated.

Under this conviction it became with us a material point to consider if by any possibility they could be carried on—on behalf of the Creditors—This we found impracticable without an immediate advance of from 10 to 15,000£ an advance which under existing circumstances it would be utterly hopeless to look for. We therefore see no probable means of avoiding a Bankruptcy.

<div style="text-align: right">(Signed) C. D. Faber.
Wm. Newman</div>

Copy of Mr. Faber's Report referred to in
the Petition of Messrs. Bramelds Creditors.—

Petition presented by Messrs. Bramelds 13th Ap. 1826
Assignees to Lord Fitzwilliam.

<div align="center">To the Right Honourable Earl Fitzwilliam</div>

My Lord,
 In consequence of a Memorial signed by many of your Tenants, and other Persons resident in and about Swinton, entreating your aid in order that the Pottery may be carried on, for the good of the neighbourhood, we as Assignees of Messrs. Brameld beg leave to state our particular wish to sell to your Lordship with that view, all the Tenants Property on the most reasonable terms.
 We also take the Liberty, to express our sincere concurrence in the prayer of the Memorial, and our belief and testimony as to the facts stated, but especially our Conviction that the Discontinuance of the Works will be very severely felt, by many of the Inhabitants of Swinton and surrounding Country, and will in truth be a great public misfortune.
 Altho' we cannot state ourselves to be perfectly disinterested, (as our Dividend will certainly be increased by your Lordship's Compliance with our wishes and those of the Memorialists) yet we trust you will do us the Justice to believe that our principal motive in thus troubling you, is the desire of obtaining your help as a Boon of very great value to many of our Neighbours of the Class of Labourers and smaller Tradesmen, who really stand greatly in need of your kindest consideration, and on whose account more than our own your Lordship's Compliance will be considered as a favor and remembered with gratitude by us.
 We have the honor to be with very great respect
Your Lordship's most obdt. Humble Servts.

<div align="right">Willm. Carr
Saml. Johnson.</div>

Wath upon Dearne April 12th 1826.

<div align="center">[Written on the reverse of this document are the words
'13th April 1826
Petition presented by Messrs. Bramelds
Assignees to Lord Fitzwilliam']</div>

Minutes of a Conference at Wentworth House the 14th April 1826
between Mr. Maude, Mr. Newman and Messrs. Bramelds.

It is calculated that the Capital necessary to carry on the Works at
Swinton Pottery as a Porcelain and Earthen Ware Manufactory is
as follows—viz

	£	s.	d.
Fixtures, Moulds, Utensils, Copper Plates and other articles of that nature ..	4500		
Stock of Porcelain and Earthen Ware which would be necessary to be kept on hand in the Warehouses, for the supply of customers coming to the Works and in order to execute orders, where the goods are wanted without delay............................	4500		
Money necessary for payment of wages and current expenses and for the purchase of materials etc.	5000		
Money necessary to enter to and stock a Farm of 100 acres of land (which should go with the Pottery) and to provide Horses, Wagons, Carts, Implements of Husbandry etc.	1000		
	£15000		

Messrs. Brameld feel confident that the Pottery would produce an annual Income
of 3000£ and they have no doubt of being able to pay thereout to Lord Fitzwilliam
the following sums annually viz.

	£	s.	d.
For Rent of the Pottery	800		
For Rent of 100 acres of land	200		
	1000		
For Int. of 15000£ Capital	750		
	£1750		

The assignees propose to sell to Earl Fitzwilliam upon reasonable Terms, the
following articles viz.

	£	s.	d.
The Fixtures at the Pottery, Moulds, Utensils, Copper Plates, and other articles of that nature, which have been valued at......	6612		
The Earthen Ware and Stock in Trade in the Warehouses, taken at the present worth, and deducting 20 pr.Cent...............	7200		
	£13812		

N.B. There is reason to believe that the assignees would accept 2/3rds of the
above sum for them, viz. 9208£; but in round numbers—say £9000

If Lord Fitzwilliam and Lord Milton should upon consideration (and it is a

subject which requires very serious consideration) deem it expedient to allow the Works to be carried on rather than be abandoned altogether as a Pottery, an advance of money would be necessary to the following amount viz.

Fixtures and Stock in Trade to be purchased of the assignees as

above...	9000
The Farm valuation	1000
In Money, (or by a Guarantee to Bankers).................	5000
	£15000

But if instead of Money, a Guarantee were given to Messrs. Walker & Co., or Messrs. Sealham Jew & Co, either of whom it is presumed would make the advances upon Messrs. Brameld keeping their account with them; the sum to be actually advanced would be reduced to 10,000

And out of this sum Lord Fitzwilliam would have to receive
back from the assignees for one years Rent 1036
And a dividend of 5/– in the £ upon 14,425£ the debt
proved 3606

 4642

Leaving to be actually advanced the sum of 5358

N.B. It is here to be observed that Lrd Fitzwm. has already received from the Bankrupts Estate, the House and Land which were in Mortgage, and which have been valued by two indifferent persons to be worth 2950£—

And altho' a Dividend of 5/– in the £ is only reckoned, there is every reason to believe that 6/8 will be ultimately paid, which will produce a further sum of 1200£ to be paid to Lord Fitzwilliam by the assignees.

If, however, it be deemed preferable to advance the 5000£ in money, rather than give a Guarantee to the Bankers, or if the Bankers should not agree to make the advance upon such Guarantee, then the sum to be advanced would amount to 10,358£ instead of 5358£.

The Securety which Messrs. Brameld propose to give (after they have obtained their Certificate, which there is every reason to believe they will do without delay) is an assignment of all the Stock in Trade and Effects, by way of Mortgage—a joint Bond, with a Warrant of Attorney, upon which judgment shall be signed, so as to give the immediate Power of seizing at any time, all that they possess—

They also engage never to draw or accept a Bill of accommodation for the purpose of raising money or obtaining credit, and never to enter upon any foreign connection.

They also engage to take Stock annually, and to make a Return thereof, and a Balance sheet of their Debts and Credits, to Mr. Maude or Mr. Newman, and to allow their Books, accounts and Bankers account to be inspected by them whenever they think proper.

My Lord,

On Saturday the Rent days at Wentworth closed, and yesterday I was engaged in adding up the Receipts. I am glad to say that so far as respects the Farm Rents, they have been very well paid; but I have been disappointed with respect to the Mineral Rents.

Messrs. Booth and Co. who ought to have paid 3160£ paid nothing, nor did Messrs. Hartop & Co. from whom 1400£ was due.—Mr. Darwin contrived to pay his Ironstone account, but he paid nothing to Mr. Biram for Coals. I have very strenuously urged them all to fulfil their Engagements, and they profess themselves very anxious to do so, but they urge in Excuse the very great difficulties they meet with in getting in their own accounts.—The Total amount of my Receipt for Rents was 11,700£, out of which I paid to Mr. Biram — 4500

To Messrs. Sykes & Jallding	400
For Interest, and other incidental payments	1900
	£6800

which sum being deducted from the gross Receipts only leaves in my Hands 4900£.

Of this Sum I shall be enabled in the Course of a fortnight (as soon I have converted it into Bills payable in London) to place 3000 to your Lordships account at Messrs. Snows; and as soon as Messrs. Booth & Co, Mr. Hartop and Mr. Fenton pay their accounts I shall be able to make a further Remittance.

Besides the 4500£ just now given to Mr. Biram, I have since Christmas supplied him with Cash to the amount of no less than 5700£.

I am now looking forward in the Hope of seeing your Lordship and Lord Milton shortly at Wentworth. It appears generally believed in the Country, that Parliament will be prorogued about the 30th; but that the dissolution will not take Place till the Autumn. I hope this may prove correct, as if the present fine weather continue the Election would interfere with the Hay-Harvest.—There have been partial Rains, but the Hay-crops in general are very deficient; and I fear the Wheat also will, in consequence of the late Drought and cold North-easterly Winds, be much below an average crop.

I have the Honor to remain
Your Lordships very faithful and obliged
Servant
Wm. Newman.

Darley Hall
23rd May 1826.

Swinton Pottery

Account of Stock manufactured from Xmas 1825 to July 1826.

Gross amount of Earthenware drawn out of the kilns since
the Valuation was taken at Xmas last 5088£
 allow for deficiency in the Biscuit Stock $\frac{ch}{w}$ is perhaps
 reduced— 88 £ s. d.

 5000 0 0
Deduct for Discounts etc etc 20% 1000 0 0

 £4000 0 0
Amount of Goods sold to Journey customers on credit £
(including some China) nett 1222
Sold for Ready money 936 2158 0 0

 1842 0 0
Materials paid for by the £
Assignees (E/Ware & China) 666
Earthenware Wages paid 1841
China Wages paid 742
 3249
*{ 3249 spent in producing the ear of 4000
 { and the China—say— 2000

 6000
Materials sold by the assignees for Ready Money 176£
exclusive of the E/Ware sold.

 [* Note: These words appear to have been inserted by an alien hand.]

[Addressed to 'The Right Hon. Viscount Milton M.P.
Wentworth House,
Rotherham'
Letter bears the postmark 'York Aug. 14 1826']

Etridges—Monday morning

My lord,

I satisfied the Claimant from Leeds, whose letter your Lordship forwarded to me, by giving him two Guineas, and which I desired him to consider rather as an act of Charity from your Lordship (he being in distress with a large Family) than as in discharge of any legitimate demand.

I found it necessary to have another personal conference with the Partners in the Doncaster Bank, on the subject of Messrs. Bramelds affairs, as they still wished to be guaranteed to a greater extent than I could agree to on behalf of your Lordship; viz., to the extent of 5000£ to be advanced in Notes, and of all Bills of Exchanges which might pass thro' their hands. However, upon my representation that the Indemnity could not possibly extend beyond 5000£, they ultimately agreed to the measure, with this modification. All Bills presented to them by Messrs. Bramelds either or not by regular Bankers, or bearing Indorsement of regular Bankers, they will discount as a matter of course.—There is a class of Bills which would pass thro' Messrs. Bramelds hands in the regular course of business, upon which there would be a greater risk, namely such Bills as they are obliged to draw upon their customers in discharge of their accounts and which are accepted by their customers and honor'd by them as they become due.—But if from circumstances these Bills should not be honor'd by their customers, they would be returned to the Doncaster Bank, and they would have no one to resort to for payment but Messrs. Bramelds—I find on application to Messrs. Brameld that the Bills of this description which they would have occasion to get discounted at the Bank would not at any one time amount to more than 1000£. The Bank has therefore agreed, that instead of advancing 5000 in Notes on your Lordships Guaranty, they will advance 4000£ in Notes and will discount Bills of the above description to the amount of 1000£.

This to the Bank, and to your Lordship will make no difference; but the Effect to Messrs. Brameld is, that it diminishes their means of carrying on the Works, by the sum of 1000£.—I have since seen them, and they say that they will exert themselves to the utmost to carry on the concern upon the plan we proposed.

If upon mature consideration your Lordship feels disposed to make Trial of them, your Lordship would perhaps have the goodness to favor me with a few lines at this place (where I shall be till the post comes in on Saturday morning) as I expect the assignees will be calling upon me on behalf of themselves and the Creditors as soon as I return home.

Mr. [?] S and I have just commenced our Duties here—Mr. Strickland will be here on Thursday, and Mr. Dealtry on Wednesday—Sir F. Wood is in Wales.

I have the Honor to be
Your Lordships very obliged
and obt. Servt.
Wm. Newman.

ROCKINGHAM WORKS DECR. 31ST 1827

DR.

	£	s.	d.
To Earl Fitzwilliam for money advanced for the Purchase of Stock at the Pottery and Farm with Fixtures, Utensils Materials etc.	10,500	0	0
To Dᵒ due for Rent and Interest	1,610	10	0
To Cooke Foljambe & Co. due to them	5,233	3	4
To Sundry Creditors in great Ledger	1,226	17	3
To A: small debts owing not in Great Ledger 104 1 3			
Balance due to Workmen 263 4 8	367	5	11
To 15 Pr.Cent on 5300 £ Amount of Journey Accounts being for Discount and collecting	795	0	0
To balance	1,537	17	3
	£21,270	13	9

CR.

			£	s.	d.
By Amount of Debts owing in Great Ledger			6,342	0	7½
By—do—do in Sub: Ledger			617	15	1½
By—do. of Utensils Materials Farm etc. Pr. Valuation of Mr. Eyre and ors.	8310				
—do—of Earthenware China etc	9138	18			
—do—of Dᵒ. York or Scarboro'	1348				
—do outstanding. Debts & Furniture at York.	150				
—do—do—Doncaster & Leeds	80				
—do—of Stock at Leeds	116				
	19135	18			
Deduct as before	4825				
			14,310	18	0
			£21,270	13	9
By Balance from Contra			1,537	17	3
Amount of bad or dubious debts			£152		

	£	s.	d.		£	s.	d.
To Earl Fitzwilliam for money advanced for the purchase of Stock etc.	10,500	0	0				
To do due for Rent and Interests	2,184	0	8				
To Cooke Toljambe & Co. due to them	5,157	16	4				
To Sundry Creditors in Great Ledger	1,598	2	11½				
To Sundry small debts owing not in do 297 6 3							
due to Workmen 90 12 2½	387	18	5½				
To 15 pr.Cent on £4858 amount of Journey Debts for the expense of collecting	728	14	0				
To Balance	2,581	10	5				

£23,138 2 10

	£	s.	d.	£	s.	d.
By Amount of Debts owing in Great Ledger	6724	0	3½			
Deduct recᵈ. on account from the Traveller	526	12	6	6197	7	9½
Amount of Debts owing in Sub Ledger				1036	19	4½
Do of Bad and dubious debts	549	7	5			
By Amount of Materials Utensils Farm etc.	8245	13	6			
Do Earthenware China etc.	9618	0	0			
Do Do York including Book Debts	2301	14	4			
Do Do at Doncaster Do	463	7	10			
Do Do at Leeds	100	0	0			
	20728	15	8			
Deduct as before	4825	0	0	15903	15	8

£23138 2 10

	£	s.	d.	
	2581	10	5	Gain in 1827
	1537	17	3	Gain in 1828
	£1043	13	2	

ROCKINGHAM WORKS APRIL 3RD 1830

DRS.

	£	s.	d.
To Earl Fitzwilliam for Money advanced for the purchase of the Stock at Pottery and Farm with Fixtures Utensils Materials etc.	10500	0	0
To Do for Rents and Interest	3497	11	10
N.B. Two Sums viz. 260 18 6 and 310£ making together 570 18 6 paid May 26th on acct. of the above Rents			
To Cooke Foljambe & Co. due to them	5098	19	1
To Sundry Crs. in Great Ledger	2311	0	8½
To Sundry Debts owing not in Great Ledger — 239 13 7			
Arrears due to Workmen — 460 0 0	699	13	7
To 15 pr.Cent on 3137£ Amount of Journey debts for Discount collecting etc.	470	11	0
To balance	3702	18	7
	£26280	14	9½

£	s.	d.	
3702	18	7	1827 and 1828
2581	10	5	(1829)
£11121	8	2	

CRS

	£	s.	d.
By Amount of Debts due to the concern in Great Ledger	10205	1	1½
Do Do in Sub Ledger	703	17	1
Amount of bad and dubious Debts not included in the above	871	6	7½
Amount of Utensils Materials Farm etc. pr Mr. Eyre etc.	8097	19	3
Do Earthenware & China	9189	3	7
China not charged in the Invoices to London Warehouse prior to April 3rd	200	0	0
Amount of Stock at York etc. etc. including Book Debts	2206	4	10
Do Do at Doncaster	444	9	2
Do Do at Leeds	58	19	9
	20196	16	7
Deduct as before	4825	0	0
	15371	16	7
	£26280	14	9½
By Balance (net Estate)	3702	18	7

DR. ROCKINGHAM WORKS OCTOBER 8 1831 CR.

DR.	£	s.	d.		£	s.	d.	CR.	£	s.	d.
To Earl Fitzwilliam for money advanced for the Purchase of Stocks etc.	10500	0	0	By Amount of Debts in Great Ledger					11897	5	9½
To Do D due for Rents and Interest	5383	18	4	—Do—Do—in Sub-Ledger					421	2	1
To Cooke Foljambe & Co. due to them	5472	6	1	Amount of bad Debts—	1085	15	3½				
To Sundry Crs. in Great Ledger	2122	16	4½	By Amount of Utensils and Materials	9538	19	10				
To Sundry Debts owing not in Great Ledger 573 18 11				of Earthenware & China	8488	13	8				
Workmen due to them 456 0 0	1029	18	11	York Warehouse	1854	14	6				
To 15 pr.Cent on 3074 19 0 amount of Journey Debts	461	5	0	Doncaster	273	15	3				
To Balance	2706	15	11	Leeds	27	9	6				
					2155	19	3				
					20183	12	9				
				Deduct as before	4825	0	0				
	£27677	0	7½		15358	12	9				
									£27677	0	7½
				By Balance					2706	15	11

Rockingham Works 28th Aug. 1832

Wm. Newman Esq.,

Sir,

We were favor'd with your Letter of the 22nd and exceedingly regret that we are not able to pay as we ought to do. We assure you that everything is done that we possibly can by every means in our power, but such has been the dreadful state of everything connected with business for the last 18 months—from political agitation; and the effects of the awful Malady now raging, & so severely too—in many places and parts where our business lays—as London, the Eastern coast generally, York etc and the whole of Scotland—that all efforts and plans have failed to produce sufficient current means.

In such circumstances we are under the necessity—and it is indeed **truly painful** to us—of saying, that we find the amount of Capital is not adequate for the Welfare of the concern and that, as the struggles we have been making to produce the desired effect have only tended to be injurious we think it better to ask your kind permission for our T. Brameld to solicit the favor of an interview with my Lord Milton—that he may himself explain our case to His Lordship. Altho' we cannot do good, as we ought to do, from not having as much disposable means as our rivals in the business—yet, we are very confident that the concern has not lost anything. Even the loss which appeared at last balance was only the consequence of sacrifices made on a part of the old and bad Stock: a good deal of which yet remains—for it had been hopeless to expect to dispose of it.—The way we have been working the last 2 years, is, however, so calculated for safety that all we have the means of getting up is available in the market—and there is no doubt whatever of a profitable result henceforth—if we can go on so as to fully employ the works: hitherto we have seldom done more than about half—and never more than two-thirds not having had the means in our power of going beyond it.—We ought to manufacture to the extent of 400£ a week—or 20,000£ a year—and we believe the proper Interests of the Works here cannot be secured without the Capital employed is equal to the annual production of Goods.—Our shop at York (with the exception of the present suspension of business from the Pestilence) is a very good concern, and furnishes us with great help in the weekly receipt of ready money:—but, it takes an extra Capital of about 2000£.—

The London wholesale place in Vauxhall Bridge Road lost money at first; but it is now become so far established as to do enough to pay its way (except of late from the two great and important causes of stagnation) and we are quite sure that it is capable of being a lucrative concern now, indeed had it not been for the Goods vended by it—the Works would not—in Earthenware, have been more than one quarter employed; for the Country Journies which used to amount to 8, 9, or 10,000£ a year, have not of late reached more than about 3,000 to 4,000£, and the ready money sales at home, which used to be about 40£ per week—have lately not been 5£ per week. The London concern requires a Capital of 6 to 7000£—but,

that is not all extra on the general Capital—as a portion—say half of it is supplied from the Stock here:—which is, by the supplies to London—constantly kept lower than it would otherwise be.—The retale part of the London Trade is gradually on the increase—altho' it has not yet done much good—for want, perhaps of a good Shop. The Stock in it is part of the above 6 to 7000£ and does not probably exceed 1000£ because it is fed regularly from the Warehouse—and on that account can be kept low.

It appears to us that Goods now are, and are likely to be—more wanted—and as our present new patterns are very good—our J. W. Brameld—who is now in Scotland, is obtaining better orders. Those also on the English Journeys are better than this time last year, so that if we could pay wages etc. regularly between now and the end of current year we can pledge ourselves to make you Monthly payments —commencing in January next of One Hundred and Fifty Pounds each.

There are also to pay the amounts due to Messrs. Cooke & Co.—about 750£ to the assignees about 500£—and Coal accounts to Newparkgate & Law wood about 250£. What we otherwise owe, and all current expenses for Materials etc.—will be fully covered by the Income between now and the end of the year so that if we are favored by my Lord Milton with the means of paying as above—the concern will be free from all other debt at the end of the year, and we shall have the means of keeping it so, and of paying our way regularly; as we know very well that we can manufacture as good an article for the Market, as any other House, and by the means of reduced expenditure in every way we can afford to sell at Market prices, and ensure business.

The Service we are preparing for the King will now be compleated with an outlay of from 5 to 700£—and when we are paid for it we can pay you an extra sum of 2000£.

When this Service—and that for the Duchess of Cumberland are delivered—we very confidently anticipate a considerable increase to our retale trade, in general, and particularly in London.

We are aware that this is an important communication to make to you,—and the writer's feelings have been excessively harassed before he could make resolution to set about it: but, the nature of circumstances requires us to do it; and we can only trust to the kind indulgence of my Lord Milton and yourself to allow it the most favorable attention and to afford us an opportunity of explanation on whatever points His Lordship may wish.

We have written more at length—because the nervous anxiety of the writer is so great—that he could not express himself personally. Yet he trusts if my Lord Milton kindly allows him a private interview—he can give him any explanation he may require—and which he is anxious to have the opportunity of doing.

We are, Sir,
Very respectfully,
Your mo. obliged Servts.
For Self & Brothers
Thomas Brameld.

Rockingham Works 8th Sept. 1832.

My Lord!

From a letter I have received this morning from Mr. Newman my grief and distress is very great in learning that your Lordship feels unwilling to afford us assistance.

It is true that we ought to have no need of it now, after all the help and the kindness we have experienced from your Lordship; but, there are circumstances, my Lord, besides the important and very oppressive ones I mentioned in my letter to Mr. Newman which have been the main cause of producing our difficulties; and the present untoward state of business has compleated the measure of them, and set us so fast that we really do not know what is best to be done for want of present means. These points, I will endeavour, as well as I can, to explain to your Lordship if you will be so good as favor me with an Interview for an hour; and when your Lordship has heard my explanation, if you can have confidence in us so far as kindly to assist us with the Loan of 2000.£* until we can finish, and get paid for His Majesty's Service—we will then re-pay it and I have full confidence in being able, ultimately, to satisfy your Lordship's wishes; for every Letter I receive from my brother Wager from Scotland is more favorable in orders—and in proof of the ground our Goods are gaining in character as well as some proof of amendment in the Times.

I purpose going to Wentworth on Monday Morning with this Letter—and there wait your Lordship's leisure for allowing me the honor of an interview.

<div style="text-align:right">
I have the honor to be

My Lord, your Lordship's

very grateful & obedt. Servant

Thomas Brameld.
</div>

* In weekly sums of £125 each for Wages
 the next 16 weeks from this time,—

To The Rt. Hon. Visc. Milton.

Sir!

I am sorry I have not been able sooner to furnish you with the accounts of the Scotch Journey etc etc I have now received—from my brother Wager from Glasgow—the separate calculation of each customer's order—as taken—and the difference is seen between the two Journies to be nearly 3 to 1 in favor of the present—& probably would have been full 4—if not 5—to 1. had not Glasgow, and the neighbourhood also, been so severely injured, and again this is not the season for the most orders. The Spring Journies (if all is in regular course) are generally full one third better than these for orders.—I am not able to give the separate names and amounts of the Norfolk Journey but the Spring was £766. and the present is 650£. This we consider is an improvement. We hardly hoped for more than 400 to 450£.—In some Towns (as Chatteris) the Cholera was so severe—not one order was taken. The young man who travels for us in Norfolk etc. says in his letter that he thinks the Shopkeepers and people generally are in better spirits—and hope to do more largely next spring. The extreme deficiency of circulating medium keeps them constantly so fast that they dare not order as much as they would otherwise. The Norfolk Journey used to be 2 @ 3000£ a few years ago on the same ground as above—during the late War and a few years after—it was about 4000£. We do not despair of seeing it improved now to something like what it was.

I am Sir—Very respectfully
Your most obt. Servt.
Thomas Brameld.

To Wm. Newman Esq.,

Customer's Name	Residence	Amt. of Goods sold Spring 1832			Amt. of Orders Autumn			
Alex. Reed	Newcastle				45	0	0	80 Cases of Cholera reported in N.C. the day J. W. B. was there—else orders probably very good.
Rob. Laws	,,	18	6	6				
W. Daniel	,,	8	15	0				
A. Hutton	Alnwick				80	0	0	
W. Johnson	,,				25	0	0	
T. Chartres	Berwick				18	0	0	
J. Macdonald	Dunfermline				9	0	0	
S. McCrea	Dundee	18	19	4	43	0	0	
J. King	,,				45	0	0	
J. Wilson	,,				18	0	0	
D. Machray	,,	17	19	3	13	0	0	

Name	Place	£	s	d	£	s	d
A. Gunn	Dundee				17	0	0
R. Brymer	,,				10	0	0
A. Mitchell	Montrose	1	10	4	36	0	0
A. Crighton	Arbroath	11	17	0	28	0	0
J. Ranson & Co.	Perth				30	0	0
P. Archer	,,	23	16	6	25	0	0
J. Ritchie	,,	34	0	0	28	0	0
W. Child*	Edinbro'	121	1	8	70	0	0
M. Sheppard	,,				20	0	0
R. Fairbairn	,,	44	13	7	52	0	0
T. Brumby	,,				12	0	0
Rt. Glenn	,,	9	4	9	17	0	0
D. Nicholson	,,				21	0	0
M. Smail	,,	3	18	8	15	0	0
J. Hendrie	,,				13	0	0
M. Robertson	,,	7	18	8	20	0	0
J. Cunningham	,,				35	0	0
J. Anderson	,,				34	0	0
J. Bailey	,,				36	0	0
W. Bailey & Co.	,,				56	0	0
J. Fraser	,,				58	0	0
E. & M. Smiles	,,				10	0	0
E. Johnston	,,	16	2	11			
		338	4	2	939	0	0
		338	4	2	939	0	0
J. Johnston	Leith	8	18	3	25	0	0
R. Clarkson	,,	12	11	0	32	0	0
J. Morrison	Peebles				26	0	0
J. Macdonald	Stirling				25	0	0
Amb. Dale & Co.	Glasgow				8	0	0
J. Anderson	,,				20	0	0
J. McFeat	,,	16	15	10			
T. Laurie	,,	5	11	6	12	0	0
J. Nielson	,,				9	0	0
Jas. Davis	,,	22	11	6			
Winchester & Co.	,,				21	0	0
		£404	12	3	£1117	0	0

*This Gentleman (one of the Magistrates of Edinbro') is a staunch friend of ours, but was taking Stock supposed with a view of turning over to his Son and therefore indisposed to order at present

Large Stock cannot order this Journey.

J.W.B. finds some of the Traders here actually ruined, and all very much injured by the effects of the Cholera:— but for which there is every reason to think his orders would have been 2 @ 300£ more in Glasgow.

Rockingham Works, 27th Sept. 1832.

My Lord!

I arrived at home last eveng. from Liverpool;—and learning from my Brother that your Lordship expressed a wish to see a <u>comparative</u> statement of my last four Journeys;—I have written one out, and beg to enclose it for your Lordship's inspection.

Part of my Journey is yet unfinished, which I hope will increase the amt. considerably;—but I came over for a day or two finding my Brother in so anxious a state of feeling.

> I have the honour to be, My Lord
> With much respect for Brothers and Self
> Your Lordship's most obliged and humble Servt.
> J. W. Brameld.

The Rt. Honble.
Viscount Milton.

Towns	Customers	1831 Feby. March, April	1831 Aug. Sept. Oct.	1832 Feby, March, April	1832 Aug. Sept.
Newcastle on Tyne	Eleanor Porter	£13	16 { Mr. Wm. Daniel / her Bro. in Law } 7		Cholera etc.
	Sewell & Donkin	15	14	Cholera kept out foreign ships	
	Rt. Laws	8	12	19	Cholera etc.
	T. V. J. Thompson	18	Full	Cholera etc.	Cholera etc.
	Alexander Reed	14	37		45
Alnwick	Wm. Johnson	Trade dull—Duke absent		Cholera etc.	25
	Anthony Hutton				80
Berwick upon Tweed	T. Chartres	20	25	Cholera etc.	18
	John Fleming	35	8	Does not pay well, very poor	
Edinburgh	Wm. Child Esq	227	96	125	65 to 70£
	David Johnston	36	4	Failed;—ruined by Cholera etc.	
	John Hendrie	3	Bad sale	Cholera etc.	13
	Elis^th Johnston	15	"	19	Full
	John Low	10	Rob^t Fairbairne	43	52
	Wm. Anderson	44	Failed		
	J. S. Russell Esq.	22	Private Order		
	Margt. Robertson	20	17	9	20
	James Stewart	13	Full	Cholera etc.	Cholera etc.
	James Sheppard	13	"	"	20
	Daniel Nicholson	18	13	"	24
	Robt. Cockburn	2	Failed, since dead of Cholera.		
	John Fraser	7	7	Cholera etc.	57
	Alexr. Allan Esq.	53	Private order		
	Thos. Brumby		9	Cholera etc.	12
	Alexr. Aithen			9	Private order
	Robert Glen		17	10	17
	Mark Smail		4	Cholera etc.	15
	Jas. Cunningham				35
	Jas. Anderson				34
	John Bailey				36
	Wm. Bailey & Co.				56
	E. & M. Smiles				10
	George Yule				7
Leith	E. Johnstone	7	15	7	25
	Thos. & Jas. Craig	45	Failed; goods saved by J. W. B. just in time. & sold to R. Glen.		
	Robt. Clarkson		28	12	32
Peebles	Jas. Morrison				27
Dunfermline	[?]. Macdonald				9
Kirkaldy	[?]. Methuen		11	4	Cholera etc.
Dundee	David Machray	17		17	13
	Jas. Ducat	29	1	Given up our Trade	
	Jas. Wilson		8	Cholera etc.	18
	Jas. King				45
	Robt. Brymer	8	9	Cholera etc.	10
	Sarah McCrea			19	43
	Anne Gunne				17
Arbroath	Alexr. Crighton	46	10	10	28
Montrose	Alexr. Mitchell	8	7	2	36
	Alexr. Smith	15		14	[?] Failure
		£781	£368	£326	£944

177

Towns	Customers	1831 Feby. March, April	1831 Aug. Sept. Oct.	1832 Feby, March, April	1832 Aug. Sept.
Perth	Josh. Ranson		18	24	30
	Peter Archer	8	13	Cholera etc.	25
	James Ritchie		8	25	28
Stirling	N. C. Birch	18	Says he wishes to give up		
	[?Ian]. Macdonald	17	Full	Cholera etc.	27
Glasgow	A. Dale & Co.	25	,,	,,	8*
	Jas. Anderson	22	21	,,	20
	Geddes & Co.	65	Full	12	Cholera etc.
	John m'Feat	25	23	20	Failed
	Jas. Neilson	15	1	Cholera etc.	9
	Jas. Davis			23	Cholera etc.
	Jas. Coupar	2		Cholera etc.	,,
	Thos. Laurie			5	12
	Winchester & Co.				24
Paisley	Jas. Williamson	12	Very dull	Cholera nearly ruined the	
	Jas. Robertson	15	,, & full	the town	
Kilmarnock	Rosina McAlister	25		2	12
	Jas. Davies			3	Cholera etc.
Dumfries	Janet Crosbie	16		5	18
	Hugh Wallace	7	9	12	12
	W^m. Thorburn				19
Carlisle	John Carrick	28	27	Cholera etc.	Cholera
	Arthur Thompson	14	15	8	Ill cholera himself
Penrith	George Sheffield	9	18		8
Kendall	N. C. Brummell			56	48
Lancaster	Wm. Barwick		30	12	Declining business
	George Burrough				64
					£1308
Liverpool	Alexr. Hunter	97	3	18	
	Rd. Holden	15	4	3	
	Thos. Thursfield	7	In a poor way, not trustworthy.		
	Wm. Whitby	29	Very dull & full of goods		
	Thos. Woolfield		7	20	
	Jas. Wordley	24	20	Probably next yr. full	
	Horatio Curzon	8	Declined business		
	T. & J. Carey			29	
Manchester	Hatfield & Hall		17	37	
Buxton	Chas. Crowder	20	∴ Cut up entirely with Hawkers, & undersold by them.		
		£1304	£602	£640	

∴ This part yet to finish; will probably be £150 to £200 as Spring 1831 or more

Memorandum. Sept. 27th 1832. The greatest quantity of Goods are sold generally in the Spring Journey, but for nearly twelve months past the sad ravages of Cholera, the great alarm it produced, and the unsettled state of men's minds with respect to Politics; (especially in Scotland), caused a great suspension of business. The alarm seems now wearing off, chiefly I think from the complaint being more familiarised to people; and times are a shade better. Besides which our last new shapes, and quality of improved Earthenware,—are highly approved of, and have helped sales much.

 J. W. Brameld.

* My orders here would have been 2 to 300£ this Journey but for the ruinous effects of Cholera. J. W. B.

[This remark would appear to apply to Glasgow as a whole.]

My Lord,

I feel more than usual delicacy and hesitation in addressing your Lordship, and should not now presume to do so,—but for a report, current around us, that the Works are intended to be recommenced—and therefore it is that I write, and I venture to hope that your Lordship will do me and my brother Frederic the favor to receive this kindly—and take our humble request into your indulgent consideration.

Before I proceed further I wish to express our sincere thanks to your Lordship for kindly consenting to our request to occupy the Flint Mill

The purport of our further respectful wishes, is, to be allowed the chance of carrying on our own favorite trade; the manufacture of China—and that you will kindly let us have the whole of the Works, and the use of the Fixtures, Models and other utensils:—for—in such case we feel confidently that we can find friends in the form of partners,—or otherwise, to furnish us with the money we should consider necessary to enable us to go on, in the circumscribed way we have laid down to ourselves, without ever thinking of asking pecuniary aid from your Lordship on account of the manufactory. I name the whole of the Works, because, altho' we should only carry-on the china, yet, as many of the Earthenware Forms, and Engravings are also occasionally used for China—and would be frequently wanted for matching up Setts for parties who have purchased of us, it would tend to the better success of our operations to have the whole—and I may truly say, we could but ill succeed without them.

We are desirous of proceeding very cautiously—being fully bent on only making goods for actual orders: and shall wish to take time for every necessary arrangement to be properly made ere we commence—for, we intend, at first, to limit it to the least establishment of people with which any regular business can be carried on. Our plan will be, to let alone all articles save those of most common use and demand, as Tea & Breakfast Ware, and a few common Desserts. To make some of the old superior sort of China, as hitherto;—but, also to introduce from our Formula a Common and cheaper sort of China—at such prices as will be likely to ensure a free sale. We propose doing all our business ourselves, without a Clerk or any expensive Managers.

I would here wish respectfully to suggest to your Lordship—that I feel no little anxiety to be allowed myself to use the Models etc which have cost me great care and attentive anxiety to produce—rather than they should be used by another party.

We respectfully suggest to be allowed to point out a considerable number of the old ruinous and useless Buildings, as desirable to be taken down.—The rest, we think it probable may be used to advantage ere long: and altho' we do not wish to ask for any expenditure of money which can be avoided yet we venture to hope that your Lordship will kindly allow us to have the useful part put into decent repair —without any fresh erections—until we can prove that we have good grounds to ask the favor of such alterations as will make the premises more suitable and

o 179

convenient.—But, at present one thing is very important—say to have the fence wall round the works made complete out of the Materials of the old buildings to be pulled down:—for, that we have always been most grievously robbed to a very serious extent, there is no doubt whatever.

There is not any doubt but profits may be made upon the manufacture of China, and indeed have been, by us—but, unfortunately they have merged in, and been swallowed up, by the general and sweeping expenses of the bad system we have so long labored under.

The circumstance of the works being at a distance from the Navigation, is of very much less importance in the manufacture of China than Earthenware—and our China really sells so well to the Trade, in fact, has such a preference in the markets,—that the quantity which could be produced would be sure to meet with a ready sale.—This is no fancied estimate but founded on the fact that we have always had great difficulty to produce sufficient for our orders;—and—that, had the works been capable of turning out more, we could readily have disposed of it to safe people. This is quite in accordance with our own experience in London,—for at Piccadilly we could always sell our own Tea, Bkfast & Dessert China, much more readily than that we had from 4 or 5 other manufactories.—My son finds it the case now—and is distressed because we cannot supply him with the articles so much wanted.

I have the honor to be, on the part of myself and my brother Frederic your Lordship's most grateful and obedient humble servant.

Thomas Brameld.

To The Rt. Hon. The Earl Fitzwilliam.

<div align="right">16th Dec: 1842</div>

Dear Sir,

Agreeable with your directions I now beg to hand you an Estimate of the Capital necessary to carry on the Flint Mill. I have not done it so soon as you wished, for I have had great hesitation—and repeated calculations—to try to reduce it the most possible; for, I have often known us to have as much as from 1200 to even 1500 or 1600 in the Mill departments, and as it is of so very material importance to us, I feel a proportionate degree of timidity in making the Statements—but, you kindly said you wished me to be candid—and therefore it is that I very respectfully state the lowest sum which I truly believe will enable us to be in a situation to supply the Customers—by the greatest good management and care.

Before I proceed on the subject of the Yard Wall I have a duty to perform in justice to decency—and the reasonable comfort of an excellent servant Sam¹. Parker; he has 4 Sons and 5 Daughters, nearly all young men and women—and only two Bedrooms for himself and his Wife and all the nine young persons. For several years I have wished to let him have some extra convenience; and as I now think there will be,—with your kind permission, an excellent chance to do it, I have very carefully gone into calculations and find that if you will allow me 100£ in money I can take down the requisite old dilapidated Buildings—selling the spare parts of them—further towards the cost—and then add the needful to Samuels House, build the Yard Wall—and remove all the rubbish out of the premises. I have no object of gain in this—as I trust you will think from the sum of 100£ being all I solicit in money to enable me to do all I wish—both for Samuel's accommodation and securing the premises from thieves: and I shall feel thankful if I can have the privilege of doing this myself—as I feel confident it cannot be done by any body else for so small an expenditure.

<div align="right">I am Dear Sir, very respectfully
Your obedient Servt.
Thos. Brameld.</div>

Wm. Newman, Esq.,

Estimate of Capital to carry on the Flint Mill—made December 1842.

		£	s.	d.
∵ We have often had in Stock 250 or 300 Tons— for safety.	∵ Stock of Stone—flint 16/6 —at least 150 Tons	123	15	0
× We ought to have 50 to 80 Tons of Stone—at all times	× 30 Tons of Cornish Stone @ 37/6	56	5	0
	40 Tons Chalk @ 31/–	62	0	0
	20 Tons Plaster 28/6	28	10	0

<div align="center">181</div>

		£	s.	d.

⊗ often runs 15,000
to 18,000 pecks.
*often 3,000 or
upwards
sometimes the credits
have been 600£
or more

} ⊗ 10,000 pecks Gro. flint
 @ 5d. 208 6 8

* 2,000 pecks Corn: Stone
 @ 7d. 58 6 8

} Credits in the Ledger
 will be not less than 200 0 0

Horses, gearing, Carts,
Hay, Straw, Corn
implements to be valued—
suppose 100 0 0

£837 3 4

 £
Towards this there probably will
be in Gro: flint @ 40/- Ton 120
Stone flint on hand 30
Chalk Stone on hand 45
Reid & Taylor's account if
turned over to us as paid 170
Valuation for same as above 100 465 0 0

£372 3 4

To the Right Honorable the Earl Fitzwilliam.

The Memorial of Willm. Green of Swinton.

Sheweth that your Memorialist deeply suffering under misfortunes, together with a Brother whose bodily afflictions have long rendered him incapable of exertion to support his numerous family, and feeling sensible that without the aid of some powerful arm he must despair of being able to bear them through this world, your Memorialist ventures humbly to approach your Lordship, to lay before a kind, considerate and benevolent neighbour and Landlord under whose family that of your Memorialist have continued upwards of a Century as Tenants in agriculture as well as manufacture; to explain, what he considers would be a first inquiry why the assistance which had been rendered to them by your Lordship has not been so effective as to prevent the calamity which has overtaken them and ended their commercial existence which has been precipitated undoubtedly by misunderstanding betwixt Trustee and Mortgagee of their Manufactory, as both now express regret at the unhappy consequences, but too late; had this unfortunate measure not been adopted your Memorialists, gradually reducing their burthens, would eventually have placed themselves in a state of Security, as well as overcome the grievous pressure which has so long borne heavily upon them through the failure of Messrs. Bramelds and the liquidation of responsibilities for them, to the serious amount of Four to Five Thousand pounds excessively increased by Law expenses and Interests, from which the Bankrupts were exonerated but not your Memorialists, the liquidation also of your Memorial' own Time debts consequent on the above mentioned and almost of equal amot. has been seriously burthemsome during a Time in which Trade has been in an unprecedented state of disorganisation nevertheless your Memorialists have been willing and determined so to bear themselves against disappointment that they had just hope before it should please the Almighty to remove them out of this world, they should have had it in their power to pay all their Creditors, little expecting the stroke of adversity, which the serious amot. made irresistible, would have come from such a quarter, so interested in preserving the property from being sacrificed, as in such cases is inevitable. Therefore your Memorialist having none other to flee to for help to save a distressed family from the horrors which present themselves to their appalled imagination beseech your Lordship to extend towards them that beneficent hand which is ever open to the distressed.

Your Memorialist would not have trespassed on your time at this moment but have awaited your return to Wentworth had not the assignees of the Estate who are willing to come to an arrangement about the property advantageous to your Memorialists, required an immediate answer and declaring their intention at the middle of this month to take measures which would extinguish all hope in your Memorialists of ever again being possessed of the Don Pottery, a loss to them more severe and painful than Death itself by consigning to want a family brought up to better prospects, with an unhappy parent stretched helpless on the bed of sickness, and

painful to your Memorialist (the Executive partner) convinced as he is that with much less means than generally has been said to be requisite they could gain a good livelihood and punctually pay the Interest as well as a portion of the Capital in a period of years not very extensive.

If therefore your Lordship in benevolence and pity to the unfortunate situation of your Memorialists distressed Brother & his distressed family will save them from utter ruin they must ever feel grateful and under the strongest obligation to make every compensation they can for the loss that their Bankruptcy has caused your Lordship to sustain.

And your Memorialist will ever pray

William Green.

[A covering sheet would seem to refer to this document inscribed 'Mr. Green—Swinton July 7 1834'.]

The Right Hon^{ble}. The Earl Fitzwilliam etc etc

Don Pottery 7th August 1834.

My Lord,

My infirm state of health, which alone prevented me from attending Your Lordship, when my Brother waited upon you at Wentworth House, and the extreme importance of the subject, are the only excuses I can offer for intruding again upon Your Lordship's Notice, a matter on which I am almost bound to consider that a final decision has been come to.

And firstly, My Lord, I cannot sufficiently express my gratitude for the extreme patience and great condescension with which Your Lordship listened to our former petition.

Since then, we have made considerable progress in procuring the Guarantee of various Friends for the purchase of our Stock etc., on terms, so highly advantageous to ourselves that it would be a very heavy additional calamity, to see so fair a prospect of success pass by us.

As a matter of business, I know, My Lord, I have no right to utter another word on the subject,—it is purely to Your Lordship's generosity that I venture to appeal, the unbounded extent of which, emboldens me to come before Your Lordship a second time, and in the present shape.

During the last fifteen years I have been totally unable to attend personally to active business, and incapable of moving even without assistance. My sons, however, who are numerous, are now arriving at an age to assist me: and it is the anxiety of a Parent, to lend his aid, while yet he may, in putting them forward in Life, that urges me to a step which I almost fear Your Lordship will scarcely pardon.

Powerful, or monied friends, My Lord, in our own sphere of life we have none: but if we could, thro' Your Lordships kindness, raise a Capital, of even less than we have before proposed, in addition to the profit on the purchase of the Stock, we could, with rigid economy, resume our business on a scale that would enable us to provide for our Families, and under circumstances so favorable (the cheapness of the purchase considered) that the least sanguine of our friends do not doubt our success.

It is these considerations, My Lord, (which perhaps have been already fully explained) that induces me to address Your Lordship again, and to implore You to take our case once more into your consideration, in the hope that some suitable means may occur to Your Lordship of conferring so essential a Favor upon us, the inexpressible value of which to us, could only be equalled by the unbounded liberality and benevolence of Your Lordship in granting it.

Craving your Lordship's pardon, for this second intrusion, I beg to subscribe myself with the most profound respect.

<div style="text-align:center">

My Lord,
Your Lordships most devoted
and obedient Servant.
John Green.

</div>

Bibliography

Modern Specialist Books:

Rockingham Ornamental Porcelain, D. G. Rice, 1965. (Publisher: The Adam Publishing Co., 23 College Hill, London, E.C.4.)

Deals in detail with the factory's ornamental porcelain and complements the present work. Nearly all the illustrations are different from those appearing in this book, and many are in colour.

The Rockingham Pottery, A. A. Eaglestone and T. A. Lockett, 1964. (Publisher: Rotherham Municipal Libraries and Museum Committee, 1964.)

Deals in detail with the Wentworth Papers and illustrates some of the specimens in the Clifton Park Museum, Rotherham.

Source Books:

Ceramic Art in Great Britain, Vol. 1, particularly pages 495–517, Llewellynn Jewitt, 1878.

A very important source book for much of our information on Rockingham. Jewitt lived very near the time of the factory, and was able to interview some of the original workmen. He also acquired important documents, which have now been lost.

Jewitt was a Victorian in the best and worst sense. He was ponderous, without humour, with blunted aesthetic sense, and lacking in style; but he was the very acme of accuracy and thoroughness. In his introduction to his book, he sets out his charter:

> I can honestly say I have left nothing undone, no source untried, and no trouble untaken to secure perfect accuracy in all I have written . . . I believe in *work*, in hard unceasing labour, in patient and painstaking research, in untiring searchings and in diligent collection and arrangement of facts—to make time and labour and money subservient to the end in view, rather than that the end in view, and the time and labour and money expended, should bend and bow and ultimately break before *time*.

A charter calculated to strike terror into any modern writer on ceramics.

The Old Derby China Factory, John Haslem, 1876.

Ceramic artists were nomadic—and although Haslem is really writing about the Derby factory, in giving an account of its various artists he nevertheless often

186

makes mention of their subsequent career after leaving Derby. In consequence, he occasionally produces valuable information about the Rockingham Works.

Like Jewitt, Haslem was contemporaneous with many of the Rockingham artists and was, in fact, a Derby artist of distinction himself.

Marks and Monograms on Pottery and Porcelain, William Chaffers, 4th ed., 1874.

This edition is both full and approximately contemporaneous with the writings of Jewitt and Haslem.

Modern Articles:
The Connoisseur Year Book, G. R. P. Llewellyn, 1962, pages 140–6.

The first serious attempt to classify Rockingham marks, including some fine illustrations of genuine Rockingham pieces.

The Connoisseur, July 1966, pages 172–5, Arthur A. Eaglestone and Terence A. Lockett.

A scholarly repudiation of traditional misattributions of Rockingham ware.

The Connoisseur, June 1967, pages 102–3, Terence A. Lockett, 'The Bramelds in London'.

The Connoisseur, March 1970, pages 171–6, Angela Cox and Terence Lockett, 'The Rockingham Pottery 1745–1842, a preliminary excavation'.

The Connoisseur, April 1970, pages 238–43, Alwyn and Angela Cox, 'New Light on large Rockingham Vases'.

The Antique Collectors Club
February 1969, pages 14–18 Mr. & Mrs. J. G. Evans
March ,, pages 26–30 ,,
April ,, pages 22–31 ,,
September ,, pages 24–30 ,,

Miscellaneous:

In addition, the various contemporary Directories, the Census of 1841 and 1851, advertisements in *The Connoisseur* (particularly before 1914), catalogues, topographical works, annuals, and certain references (where they have a foundation of scholarship) in a variety of books and articles on ceramics—some of which are set out in the Bibliography to *Rockingham Ornamental Porcelain*—all add particles of information adding up to a substantial whole. Most of these sources are mentioned in the text.

Index